Weaving Sacred Stories

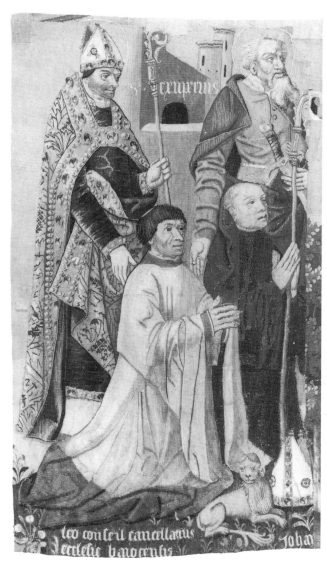

A VOLUME IN THE SERIES

Conjunctions of Religion and Power in the Medieval Past

Edited by Barbara H. Rosenwein

A full list of titles in the series appears at the end of the book.

FRENCH CHOIR
TAPESTRIES AND THE
PERFORMANCE OF
CLERICAL IDENTITY

Weaving

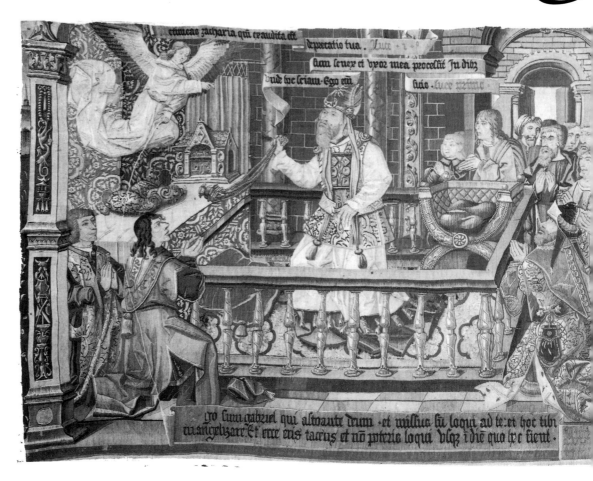

Cornell University Press ITHACA AND LONDON

Sacred Stories

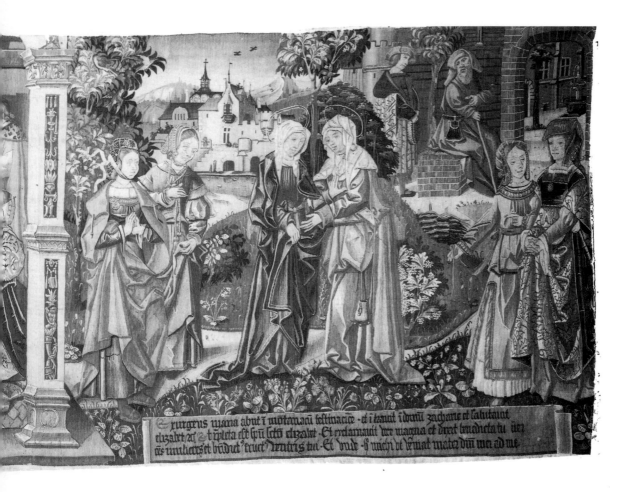

LAURA WEIGERT

Copyright © 2004 by Cornell University

Publication of this book has been aided by a grant
from the Medieval Academy of America.

First published 2004 by Cornell University Press

Printed in the United States of America

Library of Congress Cataloging-in-Publication Data

Weigert, Laura.
 Weaving sacred stories : French choir tapestries
and the performance of clerical identity / Laura
Weigert.—1st ed.
 p. cm.—(Cornell studies of religion and
power in the Medieval past)
Includes bibliographical references and index.
 ISBN 0-8014-4008-4 (cloth : alk. paper)
 1. Tapestry—France. 2. Church decoration and
ornament—France. 3. Christian saints in art. I.
Title. II. Series.
 NK3049.A1W37 2004
 746.7'2'0944—dc22
 2003019076

Cloth printing 10 9 8 7 6 5 4 3 2 1

FOR LILI

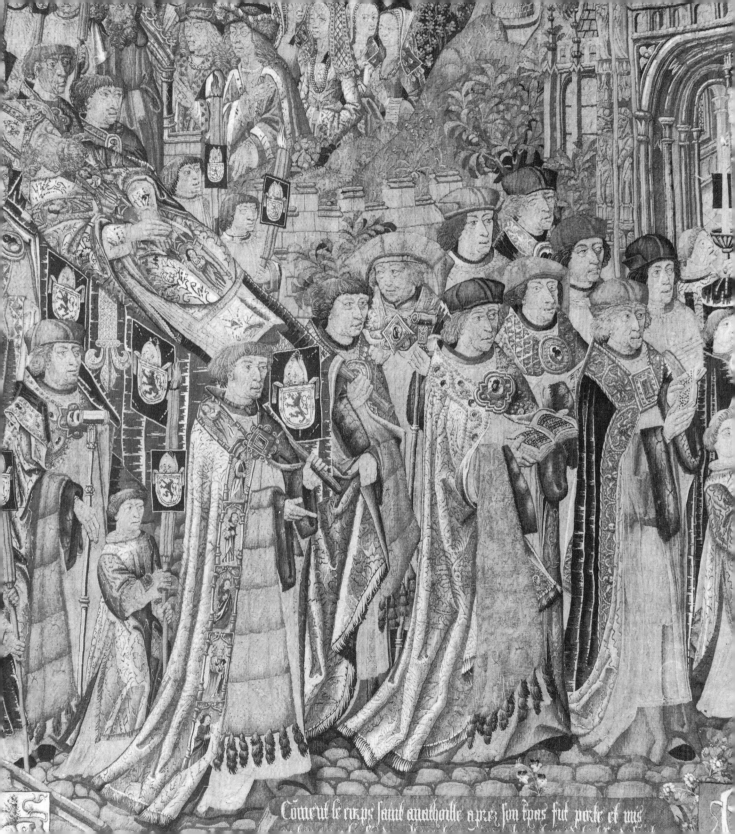

Comēt le cirps saint anathoile apres son trpas fut porte et mis

CONTENTS

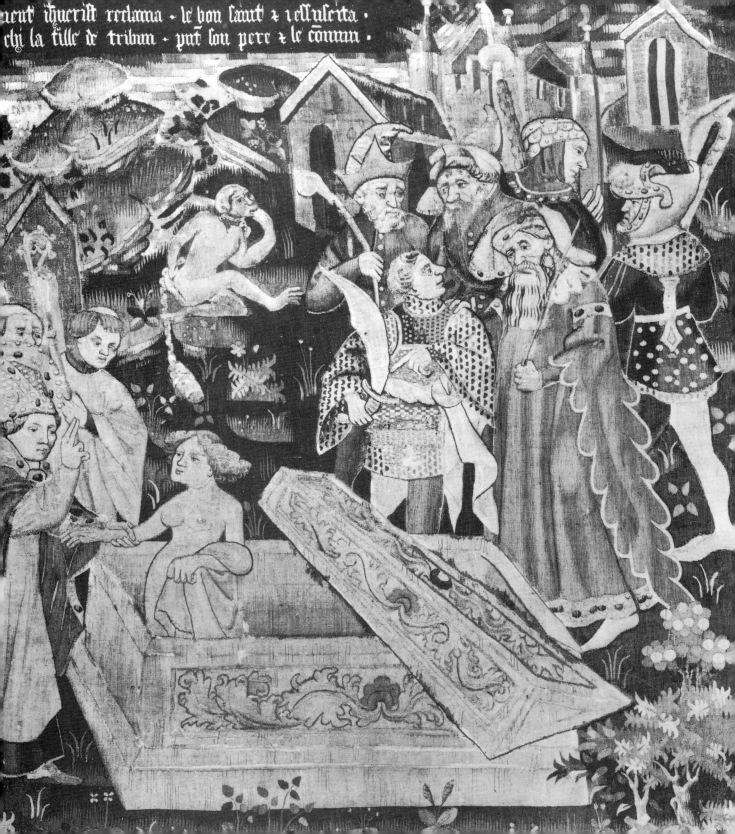

neut iһucriſt reclama · le bon ſaiut z reſſuſcita ·
chi la fille de tribun · puʒ ſon pere z le conuun ·

ILLUSTRATIONS

ACKNOWLEDGMENTS

A postdoctoral fellowship at the Institute for Research in the Humanities at the University of Wisconsin in 1996–1997 provided me with the luxuries of time and quiet, which were indispensable in writing this book. Discussions with other fellows inspired me to expand the scope of my research and to situate it within current work in related disciplines. Particular thanks are due the director of the institute, Paul Boyer, and Susan Friedman, Gordon Hutner, and Tim Dykstal for their helpful advice. A short-term grant at the Max Planck Institute for History (Göttingen) in 2001 helped me complete the final revisions; I thank its director, Otto Gerhard Oexle.

In revising my initial study of choir tapestries, I benefited from the contributions of diverse audiences. A lecture at the Courtauld Institute of Art in 1997 helped me develop the second chapter; I am particularly grateful to Scot McKendrick's persistent questions on that occasion. The Art Historical Association meeting in 1998, dedicated to the question of identity, prompted me to refine my argument concerning French clerical identity in the late Middle Ages. The comments of members of the Centre National de la Recherche Scientifique research group devoted to secular canons, as well as their published prosopographic studies, have helped me avoid some overgeneralizations on this topic. I thank in particular Hélène Millet, Monique Maillard-Luypart, and Vincent Tabbagh. Fabienne Joubert kindly invited me to speak in her seminar at the University of Paris IV and engaged me in a lengthy discussion, through which I worked out key aspects regarding the display of choir tapestries.

As they had on my first visits in 1992, librarians and archivists in France and Belgium offered me a warm reception. In Tournai, I repeatedly benefited from the generosity and knowledge of Jean Dumoulin and Jacques Pycke. Viviane Huchard, director of the Musée du Moyen Age, facilitated my work on the *Life of Stephen* series in conjunction with its exhibition at the Musée Saint Germain, Auxerre. I also thank the staff of the Institut de Recherche et de l'Histoire des Textes in Paris and Orléans.

The Ecole des Hautes Etudes en Sciences Sociales in Paris, where images are central to the study of the Middle Ages, has continued to provide a stimulating intellectual environment for discussion. Alain Boureau and Jean-Claude Schmitt gra-

ciously read chapters of this book; their contributions revised my thinking in numerous ways.

Guy Delmarcel initially suggested the topic, and Robert Suckale offered a suggestion that led to its reworking in the final book. Whitney Davis, Sandra Hindman, and Larry Silver, my dissertation advisers, have offered continuous advice and support. Richard Kieckhefer provided valuable help in the field of hagiography. In the middle of pressing commitments of her own, Kathryn Smith read and commented on the manuscript; her suggestions guided its reworking. Natalie Adamson and Walter Cahn generously offered to read the manuscript; Frédéric Duval corrected the appendixes. Susan Boynton and Isabelle Cochelin were always available to answer questions and provide encouragement. I also thank Barbara Rosenwein for accepting this book into her series with enthusiasm and efficiency and for her insightful comments on the manuscript.

Finally, my parents helped make this project possible through the example they set and their unfailing support. And I owe a special thanks to Fabien Capeillères. His insights directed my thinking at various stages; his excitement about the project helped me maintain my own.

Weaving Sacred Stories

Iceluy pasteur venerable,
meu d'une vertueuse plante,
l'an mille quatre cents soixante
fist faire de bonne duree
ce tapis où est figuree
la belle vie de saint Pierre.
Il a revestu mainte pierre
en ce cueur. Dieu qui est paisible
lui doint vesture incorruptible.

Inscription on the now-lost final panel
of the *Life of Peter*, donated by the bishop
of Beauvais to his cathedral in 1460

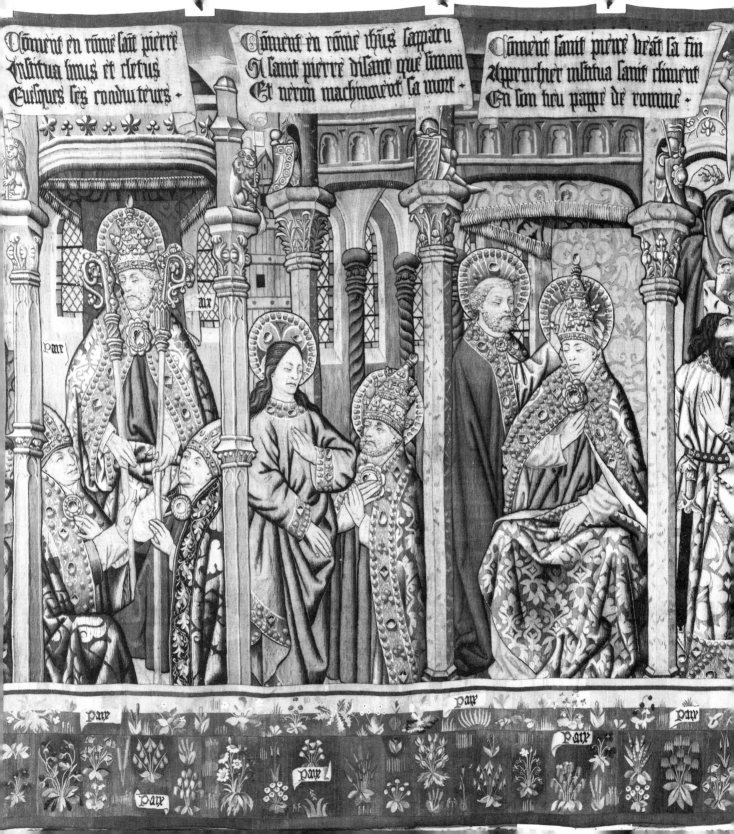

Côment en rôme saît pierre
Institua linus et cletus
Euefques les conduiteurs.

Côment en rôme thus sappaiu
A saint pierre disant que simon
Et néron machinerêt la mort

Côment sanit pierre brât la fin
Approrher inftitua sanit climent
En son lieu pappe de romme.

pax · pax · pax · pax · pax · pax

Setting the Stage

An inscription woven into a tapestry given to the cathedral of Beauvais by Bishop Guillaume Hellande in 1460 (plate 1) evokes its function with a play on words: the stones (*pierres*) of the church are adorned with woven cloth that brings to life events relating to its patron saint, Peter (Pierre). This statement sums up the dual role choir tapestries played in transforming the interior of late medieval churches. Adorning the walls with colorful and luxurious textiles, they enclosed the space of the choir with large-scale representations of the lives of saints: choir tapestries were both ornament and story.

These tapestries were reserved for the celebration of high feast days, which were dramatic visual, aural, and olfactory events. On these days, the chapter of clerics and its officials took their assigned places in the choir. Textiles, golden reliquaries, and candles transformed this space by colors and lights. The smell of incense and the sound of sung and spoken words filled the church. As the ceremony unfolded, members of the clergy moved from their seats along the edges of the choir to its center, following the directions prescribed for the occasion. In many churches, the preparations for these days included unrolling and hanging immense scrolls of tapestry along the rows of stalls that lined the sides of the choir. Spanning the length of the stalls above the heads of the clergy, choir tapestries enclosed the stage of the liturgy with stories of the saints.

More than twenty of these tapestries survive from the fifteenth and early sixteenth centuries, and many more are documented (see appendix 1). Although most are fragmentary, they all consist of a series of interwoven scenes that unfold the length of the tapestry, punctuated by written inscriptions that provide clues to the subject matter of the pictures. Each tapestry prompts and encourages a desire to read and decipher its story. At the same time, the profusion of animals, flowers, and foliage that cover each woven surface with patterns undercuts the idea that the image can be summarized as a list of concise events and emphasizes the ornamental quality of the woven hanging.

In this respect, such tapestries were an important element of the church decoration, forming part of the *ornamenta ecclesiae* reserved for high feast days. Designed to fit the length of the choir stalls perfectly, they added color and pattern to the stone pillars or wood panels along the north and south side of the choir and to the rood screen that demarcated its western limit. The terms of each tapestry's donation stipulated that it was to be displayed on the most important and best-attended festivals of the year.

Since the woven *vitae* were integral parts of liturgical ceremonies, which, in turn, informed the way they were read, an examination of these tapestries can provide evidence for the content and organization of ritual spectacles in late medieval churches. Choir tapestries served as both backdrops and scripts for the celebration of high feast days. As remnants of actual ceremonial events, they allow us to re-create essential elements of the stage for the liturgy and the performances that took place on it.

Moreover, these narrative fragments are documents of the goals, desires, cultural environment, and social position of the individuals involved in their making and telling. They tell us about the patrons and audience of the tapestries: the clergy in the fifteenth and sixteenth centuries. The stories they conveyed and the reorganization of space and of the ritual that resulted from their display make choir tapestry a fundamental source for understanding how the corporate identity and aspirations of the clergy manifested themselves in a particular church.

I locate the meanings of these monumental stories in the interaction between the woven strips of words and pictures and the environment in which they were seen. My readings of choir tapestries situate them within the ritual setting of the choir and the social experience of the clergy, environments about which they, in turn, provide valuable information. By isolating and describing this interaction between a pictorial text and its context, I re-create the process whereby stories were communicated at a specific time and place.

WOVEN HANGINGS AND THE LITURGY

Choir tapestries continued a custom already established in the first Christian churches. As part of the liturgy of important feast days, churches were *ornatur* or *paratur,* and the fundamental component of this adornment or embellishment was textiles of various kinds: silks and other luxury fabrics lined the walls of the nave and the choir; woven and embroidered cloths covered the altars; and the clergy donned richly embroidered vestments. The display of ornate and precious textiles filled the church with color and transformed the sound of the words and music emanating from the choir.

The impulse to adorn medieval churches with rich textiles stemmed from two distinct sources: the Bible and Roman imperial ceremony. Following God's instructions, Moses enclosed the tabernacle in a variety of textiles, described in vivid detail in the Book of Exodus. It was lined with ten curtains of "fine twined linen and blue and purple and scarlet stuff" and covered by "eleven curtains of goats' hair"; a veil of "blue and purple and scarlet stuff and fine twined linen" and embroidered screens served as further ornamentation.[1] For medieval writers on liturgical practice, the fact that these layers of resplendent fabrics protected and glorified the ark of the covenant provided the symbolic justification for the display of textiles in later church ceremony. Moses' and Solomon's divinely dictated initiatives also served as a model for the appropriate way to honor God, by clothing His house.[2]

Luxurious hangings also stood for the wealth and splendor of the imperial court. Textiles had played a fundamental role in the mise-en-scène of the emperor's power, their dramatic parting exposed him to view at presentation ceremonies and then operated as a frame to differentiate him spatially and visually from others. The association of textiles with imperial magnificence was incorporated into church ceremony, heightening its splendor. Their dramatic function in imperial ceremony was also adopted to convey visually the idea of revelation, through the unveiling or disclosure of sacred images, sites, or objects.[3]

Contemporary documents confirm that luxury textiles formed part of the ornamentation of early Christian churches in and around Rome and Constantinople.[4] Paulinus of Nola describes the variety of hangings that adorned the tomb of Saint Felix: they "originated in foreign lands and consisted of either pure and resplendent linen or cloths dyed with colors and woven with figures."[5]

Textiles were essential to the establishment of liturgical ritual, as evidenced by the foundation of a church near Tivoli in 471; its charter designated three sets of silk and linen hangings, each to be displayed on a specific occasion: high feast days, other festivals, or ordinary weekdays.[6] The *Liber pontificalis* (Book of pontiffs) captures the splendor churches in Rome had achieved by the eighth and ninth centuries, when they were entirely covered with textiles during the celebration of high feast days. The popes were the major source of this ornamentation; the records of their donations give us a sense of the size of the collections housed by churches in Rome. Pope Hadrian (772–795), for instance, donated more than one thousand hangings of silk and precious metals to churches in and around Rome, including 67 costly silk hangings to Saint Peter's; 72 to Saint Paul's, 44 to Santa Maria Maggiore, 58 to Saint John the Lateran, and 87 to Saint

Laurence's.[7] In contrast, the hangings that adorned Byzantine churches continued, in most cases, to be the gift of the imperium: for example, Justinian I and Theodora donated a historiated antependium to Hagia Sophia in the sixth century.[8]

Cathedrals and wealthy churches in Germany, England, France, and Italy maintained impressive textile collections throughout the Middle Ages. Although early descriptions are rare, Gregory of Tours mentions the hangings that adorned the churches of Reims at Clovis's baptism, and Dagobert's reconstruction of Saint-Denis included the donation of rich textiles.[9] Inventories compiled for churches constructed or reconstructed in the eleventh and twelfth centuries document the scale of such collections, which increased through purchase and donation through the sixteenth and often into the seventeenth century.[10] The fourteen inventories compiled between 1297 and 1643 for the cathedral of Angers give a sense of the kinds of textiles that comprised such a collection.[11] Among the textiles mentioned were groups of hangings, displayed against the walls or the stalls of the church, which already numbered ninety-eight in the first inventory; individual cloths, destined for the rood screen, episcopal throne, or chanter's stall; curtains that enclosed the altar, affixed to eight brass columns; canopies placed above it; coverings reserved for reliquaries and tombs; cushions placed on seats; veils that obscured the altar and sanctuary or cloaked the crucifix and the statues of the rood screen during Lent; and rugs, placed in the choir and sanctuary.

The fabric and ornamentation of this variety of textiles can be gleaned from contemporary descriptions, inventory accounts, and surviving examples. Silk, the material mentioned most frequently, was a luxury item, imported throughout the Middle Ages from the East but also produced in Italy and Spain, and, by the fourteenth century, in France and England as well.[12] This precious material, which existed in several varieties, each given a different name,[13] was dyed a solid color and either woven or embroidered with repeated motifs or figural groups. Cloths of linen and cotton, which were used primarily for less sacred occasions, were frequently white but could also be painted or embroidered with motifs, single figures, or events, as in the case of the eleventh-century Bayeux embroidery. Wool was used for both rugs and hangings. The sixth-century tapestry of the Virgin and Child, now in Cleveland, and the cycles preserved in Halberstadt and Quedlinburg, dating from the eleventh and twelfth centuries, are among the few surviving historiated hangings in wool produced prior to the fourteenth century.[14]

The most widely read treatises on liturgical practice and symbolism, written in the twelfth and thirteenth centuries, include lengthy passages on textiles. Furnishing the church with textiles on feast days served as a metaphor for different kinds of spiritual

adornment.[15] For Honorius Augustodunensis, these textiles represent the miracles that glorified Christ.[16] In contrast, Rupert of Deutz, also writing in the twelfth century, associates the church with the Virgin, and the textiles that adorn it with her purity and sinlessness.[17] Finally, the thirteenth-century liturgist William Durandus draws a parallel between the textiles that ornament the church and the virtues and good works that should embellish man, each of which is represented by a different color.[18] For all these writers, the textiles that clothe the church allude in a visible way to a kind of clothing that is invisible. The functional and symbolic nature of textiles, as covering or embellishment, differentiates them from other instruments of liturgical ceremony.

This characteristic of textiles was exploited to the fullest; both their display and their removal contributed to the orchestration of liturgical ceremony. The hanging of embroidered and woven cloths, or the donning of ornamented vestments, signaled the beginning of a festival, whose nature was in turn identified by the type of textile or its color.[19] Woven hangings that covered a sacred object were removed at a key moment in the ceremony, revealing an altar, reliquary, or statue. Just as the cloths over statues of the Virgin and of Christ were removed during Epiphany plays,[20] curtains, which blocked the faithful's view of the altar during Lent, parted or dropped on the Wednesday of Passion week, during the reading of Luke's account of Jesus' death, with the words, "The curtain of the temple was torn in two."[21] Representations of textiles in painting and other media reinforced the symbolic association between textiles and the concealment or revelation of the fundamental mysteries of the Church.[22]

The woven hangings and cloths displayed on feast days had a striking and symbolic impact, and they also conformed to a strict three-part division within the church: the furnishings of the altar, that of the choir, and that of the rest of the church. Durandus writes, for example:

Moreover, the adornment of the church consists in three types, namely, the adornment of the church in general, the choir, and the altar. That which adorns the church in general consists in curtains, canopies, and matching palls of silk and purple. That which adorns the choir, in backings, rugs, coverings, and bench hangings; the backings are the hangings behind the backs of the clerics in the choir; the coverings are those that are spread underneath their feet; the rugs are likewise the textiles that are underneath the feet, as it were, the blanket of the feet, with priority given to the bishops' feet which they give to cover the worldliness of their feet; bench hangings are the

textiles which are placed above the seats or the stalls in the choir. The true ornamentation of the altar consists in reliquaries, palls, phylacteries, candelabras, crosses, golden objects, banners, codices, veils, and curtains.[23]

This categorization of the textiles destined for distinct parts of the church on high feast days is repeated in other liturgical treatises and was adopted in directives for practice preserved in Customaries and Ordinals through the fifteenth century.[24]

In the terminology of medieval liturgical treatises and inventory accounts, choir tapestries fit the category of *dorsalia*, those textiles that hung behind the clerics, also called simply "choir hangings." They were displayed in conjunction with additional hangings — those placed above the seats of the dignitaries, along the rood screen, and on the lecterns — and with the rugs placed under the clerics' feet. *Dorsalia* were a well-established part of the ornamentation of French churches, documented in inventories from the eleventh century on.[25]

In wealthy churches, the majority of these hangings were silk. In the case of the cathedral of Angers, the inventory of 1467 includes six silk hangings of gold with diverse motifs, intended to adorn both sides of the choir, from the high altar to the western entrance.[26] However, by the time this inventory was compiled, silks and other materials destined for the choir had been replaced by a new textile: tapestry. As the inventory puts it, "the silk hangings were displayed in the choir before there were tapestries."[27]

TAPESTRY PRODUCTION AND THE VOGUE OF CHOIR TAPESTRIES

It was following the first appearance of specialized weavers at the end of the thirteenth century that tapestry replaced silk as the luxury textile of choice with which to adorn the choirs of churches in northern France and Flanders. The earliest surviving examples of textiles made using the technique known as "tapestry weave" were found in Egyptian tombs and date to the fifteenth century B.C.E. The technique was probably practiced at that time throughout the Middle East and the Mediterranean Basin. Tapestries were also made in the Latin West until late antiquity; surviving examples dating from after that time are extremely rare.[28] Although it is possible that tapestries continued to be woven in isolated pockets of the Latin West, the technique was also propagated by Muslim weavers, who settled in Spain in either the seventh or ninth century. Whether or not these weavers were responsible for the later expansion of tapestry production in the West, the technique was considered to be of "oriental" or "non-Christian" origin: in Germany in the fourteenth and fifteenth centuries, it was called "hea-

then's work" (*Heidnischwerk*); and, in France, woven hangings in general were called *tapis sarrazinois* by the thirteenth century.[29] The surviving tapestries in Halberstadt attest to the proficiency that weavers working in this technique had achieved in Germany by the twelfth century.

The earliest references to an organized association of tapestry weavers in Europe date to the beginning of the fourteenth century. The list of guild regulations compiled during Etienne Boileau's tenure as provost of Paris (1258 to 1270/1271) and their revisions (1277 and 1290) includes two groups of artisans making luxury woolen textiles in Paris. These weavers are called makers of *tapis nostrez*, probably woolen cloths used primarily for upholstery or as other coverings, and of *tapis sarrazinois*, which historians have argued could refer to either textiles of a carpet weave known as "knotted pile," or to textiles made on pedal-operated horizontal looms.[30] A conflict in 1303 between workers in the latter method and weavers using a different technique, *haute lice*, which subsequently became a common term to designate tapestry, is traditionally considered the first evidence for the existence of tapestry workshops in Paris.[31] The fluidity of this newly adopted French vocabulary to describe woolen weavings makes it difficult to ascertain whether tapestries were being woven in Paris before that date.[32] This initial reference to makers of *haute lice* is followed by the notation of a payment made by Mahaut, countess of Artois, in 1313, for five hangings of "hautelice." This document confirms that workshops were established in Arras as well.[33] However, it is not until the 1370s that references to tapestries become frequent in inventories and account records.

The number of tapestry workshops remained small through the fourteenth century but the scale and quality of the few surviving tapestries from this period, such as the *Angers Apocalypse* (1378–1379), attest to the skill and productivity of these weavers. By the fifteenth century, tapestry had become a major industry, with workshops established in numerous cities in northern France and Flanders. Besides Paris and Arras, weavers operated primarily in Bruges, Brussels, Ghent, Lille, and Tournai, as well as in other cities in northern France and the southern Netherlands.[34] Workshops were also set up in Hungary and Italy to meet the needs of specific patrons; however, they employed weavers who had learned their trade in northern France and Flanders.[35] The major centers of production were still confined to a relatively small geographic region from the fourteenth through the first half of the sixteenth centuries.

The scale of tapestry production expanded quickly in northern France and Flanders for several reasons. First, it was integrated into the trades that formed the basis of urban industry in the late Middle Ages, protected by and subject to the laws of city govern-

ments. Unlike the case in Germany, where weavers were employed by lay or religious patrons who supplied the materials and equipment, tapestry production in northern France and Flanders took place in specialized workshops and formed part of a highly organized urban industry.[36] The tapestry industry developed where a trade in wool, as well as looms and weavers trained in cloth production, already existed.[37] In Arras, tapestry played a more specific role in the economic stability of the city, replacing the cloth industry that had suffered from foreign competition.[38] Second, the tapestry industry developed as a result of the mobility and wealth of a small group of merchants. These individuals, who also dealt in wine and other luxury goods, initiated, oversaw, and provided the capital for large tapestry projects, and acted as intermediaries between artists and noble and royal patrons.[39]

However, the impetus for the emergence and growth of the tapestry industry came from members of the royalty and nobility, who invested in and promoted the medium. The purchase of this luxury product was initially associated with the lay and clerical elite, which continued to be the primary source of tapestry commissions through the fifteenth century.[40] The centers of tapestry production were situated within the spheres of influence of the French kings and Burgundian dukes. Their success contributed to the economic productivity of the region and consequently served the interests of these rulers.[41]

By the fifteenth century, the commission and display of tapestries constituted a key component of the public identity that members of the royalty and nobility sought to portray. The scale of certain commissions (the *Angers Apocalypse* measured about 6 meters by more than 140 meters,[42] and the tapestry depicting the Battle of Roosebeke, during which the rebellion of Flemish cities was suppressed, measured more than 5 by 41 meters)[43] as well as the size of individual collections attested to their wealth. The display of tapestries became a requirement in the orchestration of all important ceremonies, which reached new heights of splendor under the dukes of Burgundy. Moreover, these patrons and their advisers reinvented the Roman and Byzantine tradition, in which textiles were a fundamental component of the imperial regalia, by using tapestries in the mise-en-scène of the ruler's authority. In each case, the medium of tapestry symbolized the status, prestige, and power of a ruler.

The donors of choir tapestries — if not noble, then with close connections to the nobility — formed part of this social elite, who had made tapestry an essential mark of prestige. Members of the ecclesiastical hierarchy ornamented their houses and palaces with tapestry. And they chose tapestry as the most luxurious and valuable object they

could offer their church. For these clergy, as for their lay counterparts, tapestries stood for their wealth and served as an attribute of their power. Tapestries became part of the most important ceremonies that took place in their churches. Consequently, the *dorsalia* that spanned the walls of the choir on important feast days were tapestries.

Although individual commissions may have existed in the fourteenth century, the first references to and extant examples of historiated tapestries intended for the choir date to the beginning of the fifteenth century. The *Lives of Piat and Eleutherius,* a tapestry woven in Arras for the cathedral of Tournai in 1402, is the earliest. The majority of preserved and documented choir tapestries were made between the second half of the fifteenth century and the first third of the sixteenth (see appendix 1). Some wealthy cathedrals replaced their choir tapestries in the seventeenth century, but these isolated cases do not constitute a coherent group or a true revival of what had been the fashion during a particular chronological period.[44] The tradition was limited primarily to churches in northern France and Flanders, although three tapestries, depicting the lives of local saints, are preserved from the German-speaking region in what is now Alsace. Two of them measure only 1 meter in length, but the third, which depicts the life of Adelphus, measures 30 meters. The organization of tapestry production in this area and the circumstances of the commission and display of these tapestries set them apart from contemporary Franco-Flemish choir tapestries.[45]

Choir tapestries share characteristics of subject matter, format, production, patronage, and use. Events in the lives of the patron saint or saints of the church, of the Virgin, or, in rare cases, of Christ, as at the Chaise-Dieu, are depicted the length of the tapestries. In cases where churches had changed their dedication, these woven *vitae* told the stories of the first patron of the church. The tituli written along the bottom or top are usually in French, with only a few in Latin. The height of these tapestries is relatively standard, each measuring approximately 1.70 meters. The *Life of Peter,* made for the cathedral of Beauvais, demonstrates that the height of individual panels sometimes varied; two of the surviving panels measure 2.70 meters, no doubt to fit the particular configuration of the choir. The length of the tapestries was determined by the dimensions of the stalls, which in turn were constructed based on the size of the choir and the number of clerics who occupied it: these strips of fabric measured between 40 and 60 meters.

A unique set of documents from churches in Troyes allows us to follow the stages in the making of a choir tapestry and also provides unprecedented insights into tapestry production in general.[46] In entries dating from between 1425 and 1430, the accounts of the collegiate church of Mary Magdalene include payments to individuals for their role

in the production of a tapestry of the life of its patron saint. Brother Didier, who oversaw the accounts of the Fabric, was responsible for a written version of the life of Mary Magdalene. Jaquet, the painter, provided a preliminary sketch on paper. Then, with the help of Symon, the illuminator, he transformed this sketch into a large-scale cartoon on bedsheets, which had been stitched together by Poinsète, the seamstress, and her assistant. These paintings on cloth were often carefully preserved by a church.[47] Thibault Climent and Jehan Climent's nephew wove the *Life of Mary Magdalene* in tapestry, and it was lined by Poinsète. The production of the tapestry required the cooperation of all these individuals, whose work was overseen by a group appointed by the chapter. In the majority of cases, however, tapestries were not made in the city in which the church was located and it is likely that a merchant coordinated the different parties involved in its production.

The accounts from the church of Mary Magdalene provide important evidence that the cleric was involved in compiling the written description of the saint's life.[48] Not only was Father Didier paid for his text, he was present with the weaver, Thibault Climent, when the contract was drawn up, and he consulted with Climent on at least two occasions. The chapter footed the bill for the wine and dinner at these meetings, during which Didier and Climent "ont avisié ensemble." The remarkable survival of a written description of a saint's life destined for another church in Troyes, the papal collegiate church of Saint-Urbain, indicates the extent to which an adviser, fulfilling a role similar to that of Didier, contributed to the execution of the tapestry. The anonymous author of the directions to the artists for the *Lives of Urbain and Cecilia* not only supplies a description of events and the accompanying tituli but also specifies the organization of scenes, the figures and their clothing, and the architectural and natural setting. The astounding detail of this lengthy text and its survival in two almost identical versions suggest that it served a dual purpose. On the one hand, it provided a guide to the artists, in a situation where the adviser could not transmit his directions orally, as Didier had done during his meetings with Climent. On the other hand, it provided a preview of the tapestry for the patron, on the basis of which the contract was drawn up and signed. It is likely that such a document existed for the majority of choir tapestries.

The control the patron and advisers clearly exercised over all aspects of the production of a choir tapestry, as well as the interaction between workers involved in its making, should lead us to be cautious about attributing the creation of a choir tapestry to a single painter or group of weavers. The methodological inadequacy of such an approach is further exacerbated by the difficulty of identifying these artists based on sur-

viving tapestries.[49] Because tapestry merchants moved between cities, often transporting tapestry cartoons with them, it is almost impossible to connect individual tapestries with centers of production or workshops on the basis of their style.[50] The names of the weaver and the city in which it was produced are rarely documented. Mentions of the names of the painters responsible for either the preliminary sketch or the large-scale cartoon are even rarer, and any attempt to associate a known painter with a tapestry is complicated by the transformation from one medium to another.[51]

There is, in contrast, quite specific information about the circumstances of their donation and the intended use of individual choir tapestries. We know who donated the majority of choir tapestries and when, how, where, and in what circumstances each was seen. Despite the specificity of these documents, no scholar has considered them as a coherent group, and existing studies on individual choir tapestries have not addressed the question of how the local communities for which they were made and their ritual use are related to their content.[52]

Choir tapestries have the same liturgical function and symbolic associations as other types of textiles displayed in churches on high feast days. The development of the tapestry industry in the late Middle Ages offered a new possibility for adorning churches with large-scale historiated images. In turn, not only was tapestry the most fashionable luxury textile of the time, the medium was also invested with a particular force through its associations with court ceremony. Tapestry was reserved for important celebrations; in some churches the paintings on cloth that had served as their model replaced them on ordinary days. The fact that choir tapestries depict the lives of saints, however, differentiates them both from other types of liturgical textiles and from other contemporary tapestries, and raises a distinct set of questions. Why were these stories chosen and displayed on particular feast days? What impact did the architectural and ceremonial setting in which they were displayed have on how they were read? What function did they serve for their donors and audience?

SAINTS AND THEIR STORIES

The patron saint of a city or church was both the focus of its devotion and a key instrument in asserting its economic and political status. Consequently, he or she played an important role in the construction of a community's identity. Visual images of saints made a fundamental contribution to this process. Entire portals and stained-glass windows were commonly dedicated to the patron saint of the church; manuscripts presented detailed hagiographic accounts in text and image; and golden reliquaries holding

the saint's precious remains shone with depictions of his or her life. Like other pictorial *vitae*, choir tapestries organized and channeled a community's experience and understanding of a saint.

The connection between the needs and concerns of a particular community and the production of texts regarding the lives of the saints they venerated has been the subject of lively discussion in recent years.[53] Scholars have argued that a desire to promote the sanctity of an individual or a community's privileged relationship with a saint prompted the writing or rewriting of his or her *vita* and determined the nature of the first and of subsequent versions of such texts. The distribution and contestation of power within towns, inside and among monasteries or ecclesiastical communities, and between Church and royal or imperial authorities were expressed through a particular representation of the saint's life. Many *vitae* convey a community's claim to a saint's body, particularly when the possession of his or her relics was under dispute.

Illuminated manuscripts have provided important evidence about the function of hagiographic texts in particular communities. Because they emphasize or deemphasize events included in the written *vita*, miniatures provide an index of what a community considered important about its patron saint at a given time. Studies of such manuscripts have revealed how one manuscript diverges from other versions of a *vita* and from other pictorial traditions.[54] The context in which a manuscript was produced can explain these differences. Issues of power and property were often at the center of choices about how to represent the life of a saint.

Another approach to hagiography emphasizes the structural parallels within the *vitae* of different saints. Continuing the work of Delehaye, who surveyed an extensive corpus of *vitae*,[55] scholars have identified recurring topoi in saints' lives. In line with these studies, art historians have explored the motifs and organization specific to pictorial versions of saints' lives.[56] A different project, one that draws specifically on narrative theory grounded in structuralism, has been to isolate the organizing principles that underlie diverse written hagiographic texts.[57]

However, within the study of medieval art, narrative theory has been applied most consistently to nonhagiographic pictorial texts.[58] Wolfgang Kemp's analysis of the stained-glass windows depicting the story of the prodigal son at the cathedrals of Bourges and Chartres identifies two distinct ways of organizing events.[59] His results confirm that medieval pictorial narratives are structured by a limited set of underlying principles and that these structures themselves convey meaning.

These diverse approaches to the study of written and pictorial texts provide the basis

for an interpretation of the narrative structure of choir tapestries of saints' lives. It is crucial to recognize the topoi recurring in each woven *vita*, which link them to the telling of a saint's life in other representations of his *vita*. Moreover, the contribution of narrative theory informed by structuralism allows us to move from particular events within these pictorial biographies to an overall structure that can, in turn, be isolated in other historical artifacts. This too, as Kemp demonstrates so effectively, provides a framework within which to understand pictorial narrative as a logically constructed and meaningful system rather than as a haphazard collection of events. However, neither Delehaye's topoi nor certain canons of narrative theory provide an adequate model for defining the specificity of pictorial stories and the process of reading they engage.

Scholars have addressed the methodological inadequacy of narrative theory grounded in structuralism by integrating the notion of performance into their analyses of pictorial narrative.[60] According to Mieke Bal's and Whitney Davis's arguments, stories are comprehended and acquire their meaning as the viewer establishes connections between elements within the pictorial field. In both cases, the object or group of objects — be it a painting by Rembrandt or a series of Egyptian cosmetic palettes — provides the evidence for this process, offering clues to how they were meant to be read.[61]

Explicit in both these studies is a twofold definition of narrative. First, a narrative comprises not just the core events and their organization within a story but their specific manifestation in a communicable form, their "textualization." This definition allows for the possibility of comparing shared structures between different kinds of texts — one of the major contributions of structuralist models of narrative — but insists on the fact that different media engage distinct techniques to prompt a particular understanding and experience of a story. The second implicit component of this performative model follows from the first: narrative is constituted by the viewer, who, by establishing the connections between events, creates a story.

The wealth of documentation on the audience of choir tapestries and the circumstances of their display provide the basis for extending theoretical insights about the construction of narrative in Bal's and Davis's work to a description of this process in action. In the present study, the performative model is not just a theory about how meaning is constructed but a description of the conditions under which this performance takes place. Consequently, reading is historicized.[62] I describe the construction of narrative as an actual event that involved identifiable individuals in a specific location rather than as an abstract process with ideal viewers.

Like other sociohistorical accounts of saints' lives, I argue that the distinct character-

istics of a hagiographic text, in this case certain choir tapestries, are related to the context in which they were produced. However, this context alone does not explain the significance of the texts. Rather, a tapestry formed part of a liturgical setting that was necessary to its coherence as narrative. A historically convincing reading of each woven *vita*, I argue, hinges on its consistency with other elements within both the ceremonial system and the broader social environment in which a tapestry was seen.

THE CLERGY AND THEIR CHURCHES

I focus on two related components of the viewing context: the physical setting of the tapestry's display and the social experience of its viewers.

The directions to artists for the *Lives of Urbain and Cecilia* make clear that the specific placement of the tapestry was taken into account at its conception. Each section of the tapestry is designated to be hung over a distinct set of choir stalls: for instance, the third piece begins above the dean's stall and stretches to the western entrance into the choir; the sixth and final piece ends just before the chapter's entrance, on the northeast side of the canons' choir.[63] The majority of choir tapestries spanned two sides of the choir and went across the rood screen. They were suspended from cloth ribbons affixed to the tapestry and strung through wooden or metal bars or chains that were placed on hooks attached to the backs of the stalls or columns. Bertran the metalworker supplied eighty-eight hooks for the *Life of Mary Magdalene* in Troyes, and the chapter of Saint-Omer paid Guillaume Hanicque for two hundred metal hooks from which to hang the life of their patron saint.[64] The chapter paid workers to put up choir tapestries and to take them down, thereby regulating the moments of their display.

Choir tapestries were always seen in conjunction with the architecture and ornamentation of the choir and the ceremonies that took place on these days. The production of choir tapestries corresponded to other additions to the choir, such as wooden stalls, rood screens, and reliquaries. Their display formed part of an individual church's liturgy, a ceremonial system that included the content and organization of ritual celebrations as well as their placement within an annual cycle.[65] The story that was told on high feast days thereby integrated both the woven *vita* and aspects of its physical surroundings.

The meaning of choir tapestries was also informed by the nature of the space for which they were intended, the section of the choir known in contemporary usage as the "canons' choir." This area was divided from the sanctuary on the east end, where the bishop performed the mass, and from the nave on the west, where the laity witnessed the liturgical celebrations. It was the site of capitular decisions, the celebration of daily of-

fices, and the focus of ceremonies on high feast days. The "canons' choir" was reserved for the chapter and legally under its jurisdiction.[66] Consequently, the woven *vitae* became associated with this group and were hung over its head. In turn, these lives of saints in tapestry contributed to the experience and meaning of a distinct zone in the cathedral, the limits of which they demarcated and emphasized.

Participation in the celebration of high feast days was part of the duties of members of the cathedral chapter and of their function in urban centers: these were the rare occasions when the chapter gathered together in a public ceremony. The financial investment in these occasions and the highly orchestrated nature of all aspects of the liturgical ceremony point to the chapter's concern to represent itself in a particular way. The ensemble of ceremony and tapestry can provide insight into the identity of these members of the clergy, that is, both the image that they sought to portray and their actual social experience.[67]

We know a great deal about the lives of the donor of each choir tapestry. The woven *vitae* were in most cases gifts from secular canons and their officials. Less frequently, the donor was an abbot. In only four of the documented cases did a member of the laity donate a choir tapestry to his parish church. The donor was typically a wealthy and educated member of the ecclesiastical hierarchy, who often profited from multiple benefices based on appointments in different parish and cathedral churches or within royal or noble chapels. The choir tapestry was usually just one of his donations and liturgical foundations to the cathedral and to other churches. Because the donors of choir tapestries all held ecclesiastical offices and had similar class and educational backgrounds, we are justified in moving from a discussion of these individuals to that of a broader group, the chapter.[68]

The tapestries directed their stories toward the members of the chapter. This organized body assured the administrative and ritual functioning of the church and, in some cases, oversaw the community services linked to it, such as hospitals and schools in the city. The chapter, which was governed by the dean, or by the abbot in the case of monastic chapters, included a fixed number of canons, other lower-ranking clerics, and some lay employees. Canons were elected to a particular chapter by the chapter itself, the bishop, the pope, or the king of France. At the ritual marking his entry (or "installation") into a chapter, each canon was appointed a particular stall in the choir, which thenceforth represented his right to a prebend, or annual salary. To assure that a canon would actually occupy his stall on high feast days, many chapters offered their members additional financial incentives. The woven *vitae* displayed above the stalls on these occasions are indications of the image that this group of individuals sought to project, in-

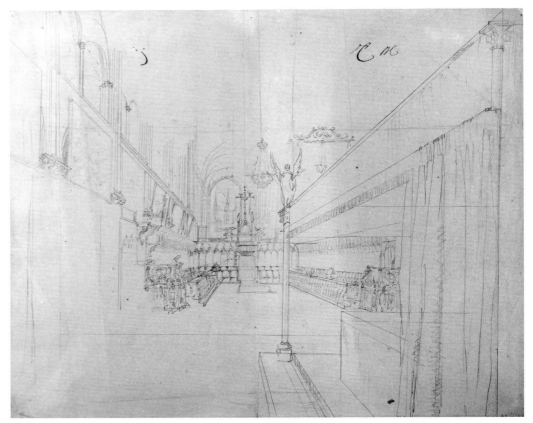

FIGURE 1. *Drawing of canons' choir prior to its seventeenth-century reconstruction, Notre-Dame, Paris (Department of Graphic Arts, Musée du Louvre, Paris, inv. 33009).*

cluding its cohesiveness, its internal hierarchy, its relationship to the bishop, and its investment in the city and the saints with which it was associated.

Choir tapestries, in turn, offer particular insight into the cultural practices of the clergy in the fifteenth and early sixteenth centuries. For instance, two of their defining features — the vernacular tituli and reliance on events from the *Golden Legend* — are not considered part of the official version of saints' lives. This has led to the only general interpretation of these tapestries as a group, namely, that they were made for a lay audience, who would have understood the French text and appreciated the choice of scenes depicted.[69] However, when we take into account the fact that the clergy commissioned and formed the audience for choir tapestries, certain assumptions about the nature of

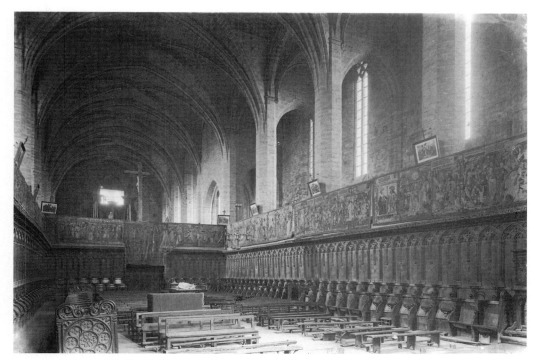

FIGURE 2. *Interior of the abbey church Saint-Robert, the Chaise-Dieu, with tapestry,* Lives of Mary and Christ *(1501–1518) above stalls.*

"lay" and "clerical" cultural production become problematic, and the categories of artifacts to be associated with the clergy become broader.[70]

I am interested in this group not only because of its direct connection to choir tapestries, as their primary donors and audience, but also because it represents the clerical elite, who were among the richest and most powerful people in the church and government in the fifteenth and early sixteenth centuries. Members of cathedral chapters and their officials, through the art they commissioned and the ritual performances they organized and participated in, defined the official forms of cultural production in the French Church.

My goal is to demonstrate how the meaning and significance of choir tapestry is intimately connected to its viewing context. These woven saints' lives interacted with their surroundings during each liturgical celebration, forming part of a larger social drama. By reconstructing these performances, I provide an interpretation not just of stories from the past but of storytelling within a defined time and place and among distinct

members of a community. In the process, I show how one group continued to assert its success in the social field as it revised its cultural practices according to its changing needs.

ORGANIZATION OF THE BOOK

Although my approach is relevant to all choir tapestries, given the characteristics they all share, my argument hinges on the specificity of each woven saint's life. To locate the meaning of these pictorial stories within the social conditions of their production and reception, we need to isolate both an individual story and the circumstances in which it was told. The relationship between the two can only be established through detailed readings of specific tapestries. My study therefore focuses on three of these, chosen for their physical condition and the relevant documentation available on their viewing context: the tapestries made for the cathedrals of Tournai, LeMans, and Auxerre.

The main chapters of the book present a detailed analysis of one woven *vita* within a particular viewing context. I read each tapestry from a different perspective: the Tournai tapestry is read in terms of its reception, the Le Mans tapestry with respect to its donation, and the Auxerre tapestry in relation to its ritual setting. All three aspects are essential to understanding the stories of choir tapestries in historically specific terms.

Chapter 2 addresses the *Lives of Piat and Eleutherius* from the perspective of its audience in the choir of Tournai cathedral. I define this audience and suggest how it contributed to the process of storytelling in which the tapestry played a central role. Chapter 3 addresses the *Life of Gervasius and Protasius* from the perspective of its donor. I interpret his act of donation based on what we know about his life and the image of it that the tapestry conveys. Chapter 4 situates the *Life of Stephen* within the liturgy of Auxerre. I focus on the choir of Auxerre cathedral and the ceremonies that took place there to describe the dynamic and complex relationship between the liturgy and woven saints' lives.

The conclusion reconciles these three aspects of the viewing context of choir tapestry. Indeed, each woven *vita* relied on its audience, its liturgical setting, and the act of its donation to convey a particular story. I expand the discussion to include other contemporary woven *vitae.* Then I consider the implications of the tradition of choir tapestries for understanding the social organization and projected identity of late medieval chapters. Finally, I describe the process through which choir tapestries became museum objects, divorced from the setting on which they had relied to tell their stories.

The *Lives of Piat and Eleutherius*

The Audience of Choir Tapestry and Its Stories of the Past

The *Lives of Piat and Eleutherius,* donated to the cathedral of Tournai by Canon Toussaint Prier, is the earliest extant choir tapestry. A woven inscription on the now-lost final episode stated that Pierre Feré completed the tapestry in December 1402 in the city of Arras. During selected feast days in the liturgical calendar, the *Lives of Piat and Eleutherius* spanned the walls of the choir of Tournai cathedral. When the tapestry was returned from Ghent in 1568, where the chapter had sent it for safekeeping during the religious wars, it was displayed in the choir. In 1742, the chapter removed the tapestry from that location and placed it on the walls of a storage room in the cathedral. It was probably at this juncture that over half of the tapestry was either lost or sold. Fearing this possibility, the master of the cathedral fabric, Canon Waucquier, had transcribed the tituli in their entirety. This document describes the basic events depicted on the missing section. The chapter had the tapestry restored several times: in 1767; in 1875, when a floral border was added and fragments were joined; and in 1938, when this border was removed. In 1875 the tapestry was displayed in the Chapel of the Holy Spirit, where it can be seen today. *The Lives of Piat and Eleutherius* was cleaned and rebacked in 1998.

Through the *Lives of Piat and Eleutherius* we can read a history of Tournai.[1] Along the forty-meter scroll of fabric, events in the lives of the two saints unfold in tandem with the story of the foundation and development of the Christian city. The *vitae* of Piat and Eleutherius thereby provided an account of the city's past to members of the cathedral chapter and to lay citizens of Tournai. It was, however, to the members of the cathedral chapter that this history was specifically addressed. They participated in and witnessed a liturgical spectacle in the choir that incorporated the sequence of woven

events. In the process, the cathedral chapter became part of a history of Tournai that continued into the present.

The following discussion situates the *Lives of Piat and Eleutherius* within the social environment of its primary audience, the members of the cathedral chapter. Reading the tapestry in conjunction with other evidence about Tournai's cathedral chapter in the early fifteenth century provides clues to the nature of the identity this group sought to project and the tensions inherent in its realization. Moreover, with this example, we begin to understand how the audiences of choir tapestry contributed to the telling of the lives of saints.

An Ordinal, which includes directions for the celebration of high feast days in Tournai cathedral, suggests how the tapestry once spanned the back of the stalls occupied by the chapter and its bishop in the choir.[2] Before each of these ceremonial occasions, the *clocquemani*, or bell hands, who were also responsible for guarding the cathedral and ringing the bells,[3] unrolled and hung the woven *vita* around the choir. At the end of the festival, they returned the tapestry to its place in the sacristy, where it remained until the next high feast day.[4]

Drawing from the fifteenth-century Ordinal and other documentation, we can imagine what the choir might have looked like on these special days of the liturgical year (diagram 1, fig. 3). The *Lives of Piat and Eleutherius* hung above the wooden stalls, newly constructed in 1400.[5] Two golden hangings were placed over the entrances on the north and south sides of the choir.[6] The tapestry stretched from these points down the length of the choir and across the rood screen on the west end.[7] During the day, the stained-glass windows around the choir provided sufficient light with which to see the woven story. At vespers, compline, and matins, and at High Mass on the feast day, it was illuminated by a row of candles along the upper arcades of the choir.[8]

The tapestry enclosed a section of the choir associated with the chapter, delimiting the boundaries of its space in the cathedral. The silk copes worn by the canons during the cathedral feast days surrounded them in an expanse of silk that made them a single unit of uniform color. Moreover, the sequence of woven events, progressing horizontally above their heads, visually connected the individuals seated side by side in their stalls. The tapestry and the clergy formed two long strips of color and pattern, framing three sides of the choir.

The *Lives of Piat and Eleutherius* surrounded this distinct space with events from Tournai's past. Within the *vita* of these local saints, we witness the history of the Christianization of the city, a process to which both the religious and lay members of the community contributed. Displayed during the most sacred ceremonies, the tapestry

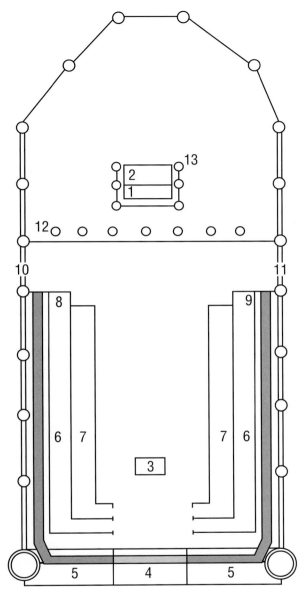

DIAGRAM 1. *Choir of Notre-Dame, Tournai, in the fifteenth century.*

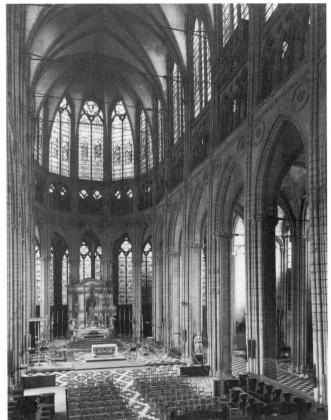

FIGURE 3. *Choir of Tournai cathedral.*

1	High altar
2	Reliquary of Eleutherius
3	Eagle lectern
4	West door
5	Rood screen
6	Upper stalls
7	Lower stalls
8	Dean's stall
9	Bishop's stall
10	Dean's entrance
11	Bishop's entrance
12	7 candlesticks
13	6 brass pillars

 Lives of Piat and Eleutherius
Possible break in tapestry

Center of crossing piers to
the center of the 4th pier = 22m

Interior of northeast
crossing pier to interior of
southeast crossing pier = 11m

underscored the role of the cathedral chapter in the religious leadership of Tournai. As it participated in the celebration of each cathedral feast day, the chapter became part of the story of its own past, which defined its identity in the present.

PIAT AND ELEUTHERIUS IN TOURNAI

Historians of saints argue that we can isolate certain "facts" concerning Piat and Eleutherius based on the manuscript tradition of their *vitae*.[9] Piat was a contemporary of Saint Remi, who ordained the future apostle of Tournai at the end of the third century, in Rome. Like Remi, Piat preached the faith in Gaul; he settled in Tournai, and was subsequently martyred there. The accepted "facts" concerning Eleutherius are more specific. He was born in 456 in Blandain, where his parents had fled from Tournai to avoid Clovis's persecution. In 496 Eleutherius became bishop of Tournai. He died in 531 and was buried next to his parents in Blandain.

The importance of Piat and Eleutherius's cults in Tournai made their *vitae* particularly effective vehicles for conveying a local history of the city. Both saints were associated with the Christianization of Tournai. Piat, venerated as the first apostle to Tournai and patron of the city, was credited with the foundation of the Christian city and the conversion of its citizens. Although he was more likely the second or third, Eleutherius was honored as the first bishop of Tournai and patron of the cathedral. Unlike Saint Stephen, to whom the first church was dedicated in the fifth century, and the Virgin Mary, to whom the cathedral was dedicated upon construction of a second church in the episcopal group, shortly after the first,[10] Piat and Eleutherius were local saints; their *vitae* involved Tournai and its church directly.[11]

Because the cathedral possessed the relics of Eleutherius, it was the devotional center of the saint's cult. Eleutherius's relics were moved to the cathedral on August 25, 1064. On the same day in 1247, Bishop John transferred his relics to a new, ornate reliquary.[12] This reliquary was displayed behind the high altar and was carried in processions. Readings on the saint's feast days repeatedly state that Eleutherius's bodily remains in their entirety were present in the cathedral.[13]

Although Saint-Piat in Seclin, a nearby church within the diocese of Tournai, claimed the body of Piat, members of the cathedral chapter and its bishop demonstrated their particular devotion to the saint. Bishops of Tournai were responsible for the invention and for two translations of Piat's relics. Members of the cathedral chapter of Tournai conducted an annual procession from Tournai to Seclin in honor of the saint.[14] This continual affirmation of the importance of Seclin as the site of Piat's relics

was all the more important given that their location was a matter of dispute. Both the church of Saint-Piat and the cathedral of Chartres argued they possessed the body of Piat. This debate continued until the nineteenth century. Even now, one can visit the body of the saint in Seclin and in Chartres.[15]

Consistent with these competing claims to Piat's body, manuscript versions of his life are said to have been produced in both the diocese of Tournai and in Chartres. The first complete version of his *vita*, contained in a manuscript dating from the ninth century, is from the library of the monastery of Anchin near Douai, a city within the diocese of Tournai. The second, which repeats the deeds mentioned in the first, was falsely attributed to Fulbert, bishop of Chartres (1007–1029). In 1143 the canons of Seclin composed a third version of the *vita* of their patron saint, which is now lost.[16] Devotion to the saint and competing claims to his relics provided the impetus for recording and preserving events in Piat's life.

Similarly, the strength of Eleutherius's cult in Tournai prompted the writing of his *vita* in the city. The presence of a manuscript in Tournai of the earliest known *vita* of the saint, compiled in the ninth century, is the only evidence to link this first version to the city. However, the circumstances in which the three other versions of his *vita* were written reflect the needs of the local community of Tournai. On the occasion of his translation of the saint's relics in 1247, Bishop John commissioned a new life of the saint from Guibert of Tournai. The fourth version is contained in the Breviary lessons read during the feast days celebrated in honor of the saint in the churches within the diocese of Tournai.[17]

Both Guibert's *Life of Eleutherius* and the Breviary version of his *vita* repeatedly state that events in the life of the saint took place in or close to Tournai, thereby underscoring the ties between the saint and the city. Guibert's *Life of Eleutherius* establishes the relationship between the two saints and their connection to Tournai by integrating events in the *Life of Piat* into the *vita* of the later saint. Here, Piat's *vita* provides an introduction to the account of Tournai and its first bishop, which situates the *Life of Eleutherius* at a defined moment in the city's past. After a description of the centuries of Roman rule in Tournai, Guibert presents a synopsis of Piat's *vita*. Although Piat is the primary actor in this section of the text, the events described display his association and cooperation with Eleutherius's ancestors. Piat's actions in Tournai thereby both introduce and lead into the events in the *Life of Eleutherius*, which are located within a larger narrative account of the city's history.

Through this brief description of the written *vitae* of Piat and Eleutherius, we can conclude that the tapestry follows an existing tradition that incorporates events in the lives of the two most honored saints in Tournai into an account of the city. In both the written and the woven *vitae*, the lives of the saints became a part of the past of the city

for which they were produced. However, as I will argue, the tapestry version, in conjunction with the ceremonies that always accompanied its display, added an immediacy and relevance to the *vitae* of the saints not found in other versions of their lives.

READING THE WOVEN *VITAE*

Although most existing studies of the *Lives of Piat and Eleutherius* neglect to mention it, any complete description of the woven *vitae* must first recognize its fragmentary state.[18] At least two-thirds of the tapestry disappeared when the chapter removed it from the choir in 1742.[19] As a result, only half the events relating to Piat and half those relating to Eleutherius survive.

A precious document helps us imagine what the woven text might have looked like in its entirety.[20] Fearing the loss of the tapestry, Canon Waucquier, who became guardian of the cathedral's treasure in 1744, transcribed the written text that punctuated the tapestry over its entire length. These tituli indicate some of the key narrative events depicted in the now-missing sections and provide the basis for a discussion, albeit incomplete, of the tapestry as a whole.

Moving from left to right along the scroll of fabric, we see the topoi of a typical saint's life: a career devoted to God, the performance of miracles, martyrdom, and veneration of his or her relics. The surviving portion of the tapestry begins with Piat's work as a missionary to Tournai. God enlists him for this task (fig. 4a, plate 2); he travels to the city (fig. 4b), converts its inhabitants (fig. 4c), preaches to them (fig. 4c), and builds the cathedral (fig. 5b) within which he performs the first baptism (fig. 5c). Events from the life of Eleutherius follow, starting with his election as bishop (fig. 6b), his papal confirmation (fig. 6c), and his consecration (fig. 6d). After assuming his episcopal office, the sexual advances of the Roman tribune's daughter test Eleutherius's chastity and confirm his sanctity (fig. 7a). After he resurrects (fig. 7b) and baptizes the girl (fig. 7c), her father, the tribune, refuses to convert to Christianity, as he had promised. A deadly plague strikes the city (fig. 7d).

Events relating to the saint's martyrdom, and the subsequent fate of his relics, continued along the now-missing section of the tapestry (see appendix 2). The Romans decapitate Piat, who walks to the site of his burial carrying his own head. His relics cause a large number of people to convert to Christianity and miraculously cure the sick. Eleutherius's *vita* includes similar events. Imprisoned by the tribune, he escapes, but heretics beat him to death. His body is buried first in Blandain and then in Tournai; on both occasions, the display of his relics results in miracles.

None of these events are new to the hagiographic corpus of Piat and Eleutherius. If

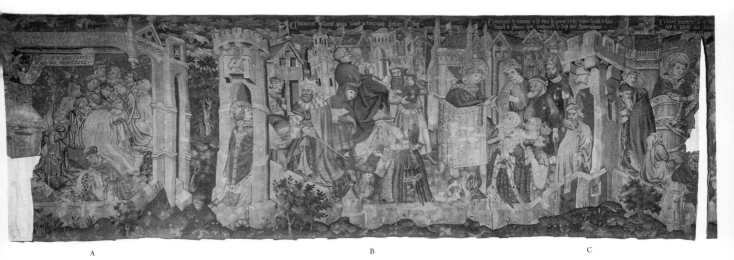

A B C

FIGURE 4. Lives of Piat and Eleutherius, *1402, Notre-Dame cathedral, Tournai.*

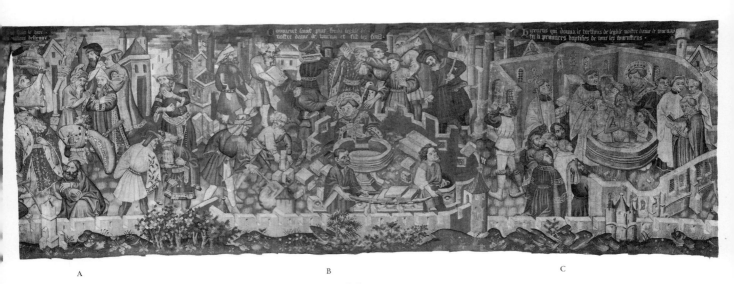

A B C

FIGURE 5. Lives of Piat and Eleutherius, *1402, Notre-Dame cathedral, Tournai.*

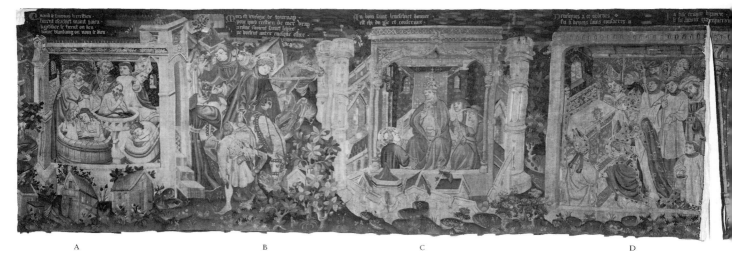

FIGURE 6. Lives of Piat and Eleutherius, *1402, Notre-Dame cathedral, Tournai.*

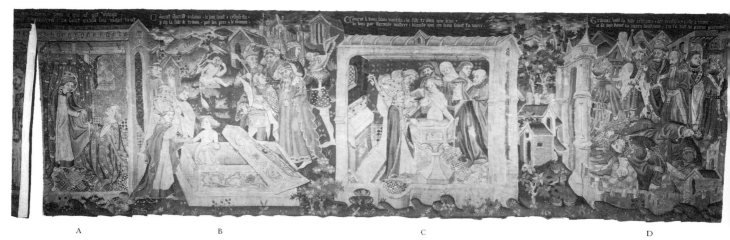

FIGURE 7. Lives of Piat and Eleutherius, *1402, Notre-Dame cathedral, Tournai.*

we return to the *vitae* written between the ninth and thirteenth centuries, we find references to every incident included in the tapestry. Moreover, the actions of Piat and Eleutherius that establish their sanctity are common to saints' lives in general. However, the choice of episodes, the way they are depicted, and their organization into a story differentiates the woven *vitae* from written versions of their lives. And although the tapestry establishes the sanctity of Piat and Eleutherius through topoi that relate them to

26 CHAPTER 2

other saints, the story it tells is not limited to a biography of them. In conjunction with the deeds that establish the sanctity of Piat and Eleutherius, the tapestry traces the foundation and development of a Christian city.

The selection of events included in the woven *vitae* limits the geographic scope of the story to the city of Tournai and to towns both in its proximity and within its diocese. Since the tapestry omits events that do not pertain directly to Tournai, it excludes Eleutherius's journeys to Rome to combat the Arian heresy, which written *vitae* discuss in substantial detail. Piat's early life in Italy, central to his formation as a saint, is also left out of the woven text.[21]

Instead, the beginning of the saint's life coincides with the foundation of the Christian city of Tournai. The first scene depicts God's command to Piat to convert the people of Tournai (fig. 4a, plate 2). His words, emerging on a scroll held in God's hands, attest to God's direct involvement in the conversion of its citizens. God's speech begins Piat's *vita* just as it founds Christian Tournai.

As we move along the tapestry, the actions of people the tituli identify as the citizens of Tournai ("les Tournisiens" or "li cytoien de Tournay"), represent the advances and obstacles involved in converting from a pagan to a Christian city. They reappear in almost every event of the woven story:[22] it is these people to whom Piat preaches and with whose help he builds the first church (figs. 5a–c). When the Roman tribune banishes them to Blandain, they are still identified as "les Tournisiens," and they continue to be baptized and to elect a bishop (figs. 8, 6b). They are contrasted both to the people of Blandain and to those who support the tribune and remain in Tournai.

Following the deaths of Piat and Eleutherius, *les Tournisiens* take on an active role in the veneration of their relics. After Piat is decapitated and he has carried his head to the nearby town of Seclin, the citizens of Tournai transport the body to the church, where they bury it. Many years later, these same citizens, withstanding the attack of the people of Blandain, carry Eleutherius's body from Blandain to Tournai, where they bury the saint in the cathedral. They are again differentiated from the people of Blandain, who try to prevent the translation of the saint's relics by shooting arrows at the citizens of Tournai. Through a miracle performed by the saint, the arrows return to their starting place (appendix 2).

A certain Hireneus stands as a model citizen of Tournai. He listens to Piat preach, destroys the pagan idol in the city, helps to construct the church, and is, with his family, the first of the citizens of Tournai whom Piat baptizes (figs. 9, 10). His richly ornamented cloak and his long white beard suggest he is a prominent and wealthy member of this community. The tituli, which identify him by name, also establish that Hireneus

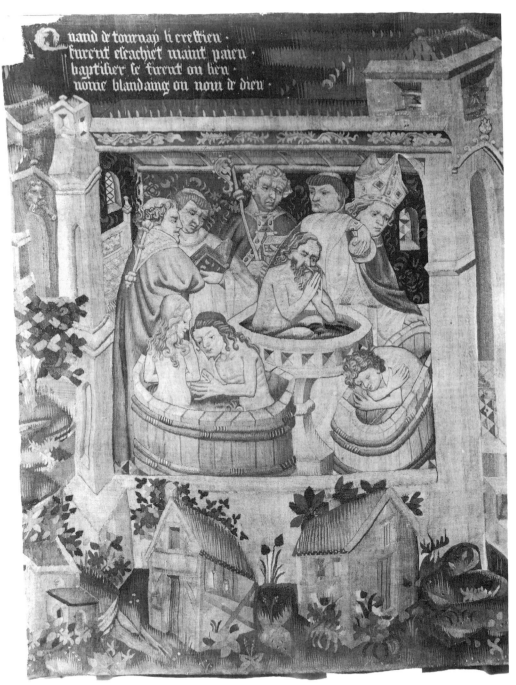

FIGURE 8. *People of Tournai baptized in Blaindain.* Lives of Piat and Eleutherius *(detail), 1402, Notre-Dame cathedral, Tournai.*

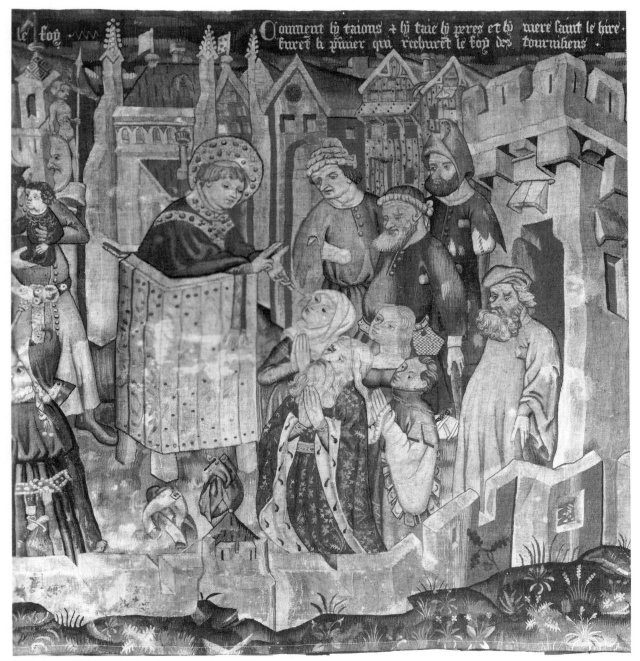

Comment li taions + hi taie li peres et hi
tures li pmier qui rechuret le roy des
tourniliens·

le roy

FIGURE 9. *Piat preaches to Hireneus, his family, and other citizens of Tournai.* Lives of Piat and Eleutherius *(detail)*, 1402, *Notre-Dame cathedral, Tournai.*

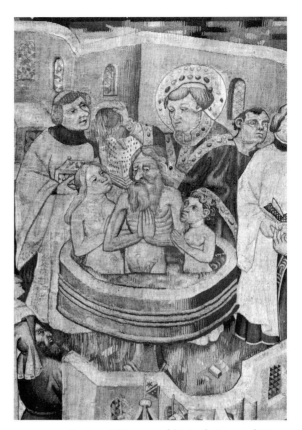

FIGURE 10. *Baptism of Hireneus and his family.* Lives of Piat and Eleutherius *(detail), 1402, Notre-Dame cathedral, Tournai.*

is Eleutherius's great-grandfather. Hireneus's life is therefore representative of the early history of the lay population of Tournai, from which Saint Eleutherius is descended.

It is the actions of this model citizen and his family that establish the synchronicity between the city's past and its saints. Hireneus's contribution to the Christianization of Tournai is depicted in tandem with Piat's work. Along the extant section of the tapestry devoted to this saint, Hireneus appears just behind Piat, working toward a common goal. As Piat preaches to the people of Tournai, Hireneus orders the destruction of their pagan idol (fig. 5a). As Piat lays the final stone on the baptismal font, Hireneus adds a stone to the walls of the cathedral (fig. 11). The activities of the two merge when Piat raises his hand above Hireneus's head to baptize him (fig. 12).

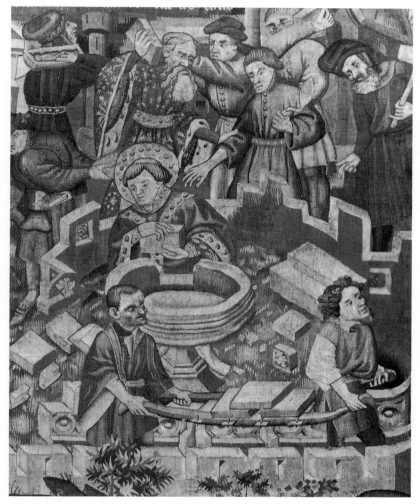

FIGURE 11. *Piat and Hireneus build the cathedral of Notre-Dame, Tournai.* Lives of Piat and Eleutherius *(detail)*, 1402, Notre-Dame cathedral, Tournai.

All events in the woven *vitae* are situated either within the walled city of Tournai or in relation to it. The written tituli, inscribed along the top of the fabric, repeatedly insist that the events take place in Tournai and identify the actors as citizens of Tournai. The site where Piat is decapitated is specified more precisely — this spot is, according to the titulus, "what is called the Cross of Saint Piat, in Tournai." Towns within the diocese of Tournai are also identified by name: Piat is buried in Seclin; the power of his relics spreads throughout the county of Lille; and Eleutherius escapes to Blandain.

The Lives of Piat and Eleutherius

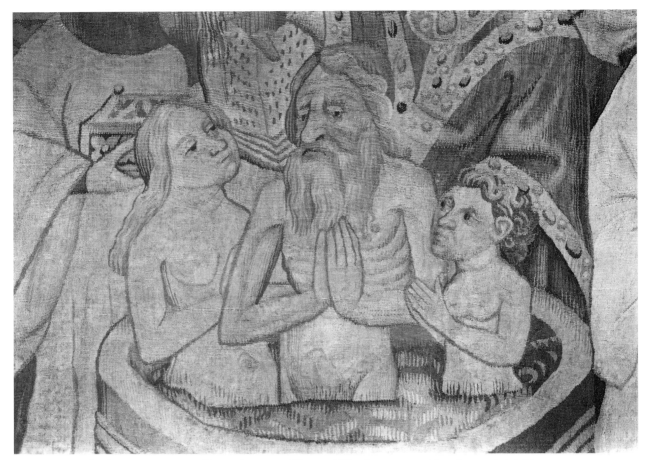

FIGURE 12. *Detail of baptism of Hireneus and his family.* Lives of Piat and Eleutherius, *1402, Notre-Dame cathedral, Tournai.*

In addition to the written tituli, recognizable architectural structures situate the story within this particular urban setting. The initial events in the *Life of Piat* take place within its walls, along which we see the belfry and the church of Saint-Quentin to the right of the destroyed idol (figs. 13, 5a).[23] Piat baptizes Hireneus and his family within a structure that resembles the choir of the cathedral, constructed in the thirteenth century (fig. 10). The five towers of the cathedral in the background locate events that take place outside Tournai in terms of their proximity to the city (fig. 14).[24]

Unlike the written references to Tournai, which tell the reader or viewer where the story occurs, these visual clues show the events taking place in the city. Piat and Eleutherius move, act, and react within and around Tournai and in relation to the ac-

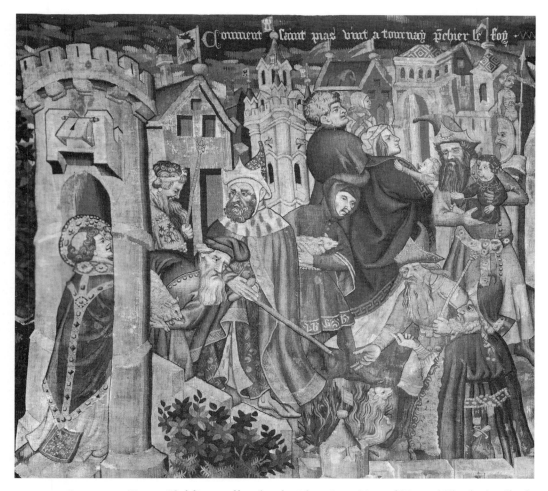

FIGURE 13. *Piat arrives in Tournai. The belfry is visible to the right of the city's gate.* Lives of Piat and Eleutherius *(detail),* 1402, *Notre-Dame cathedral, Tournai.*

tions of its citizens. The architectural details, not described in written *vitae,* convey a recognizable setting, a view of both the interior and exterior of the cathedral and of the monuments around it. For the viewer, the addition of familiar buildings and places confirmed that these saints had actually lived in Tournai.

While maintaining the local specificity of the account, the tapestry places it within the borders of a larger Christian community. The foundation of the Christian city of Tournai is situated within the broader process of the Christianization of Gaul. Piat receives his divine charge, surrounded by the other saints credited with the conversion of

The Lives of Piat and Eleutherius

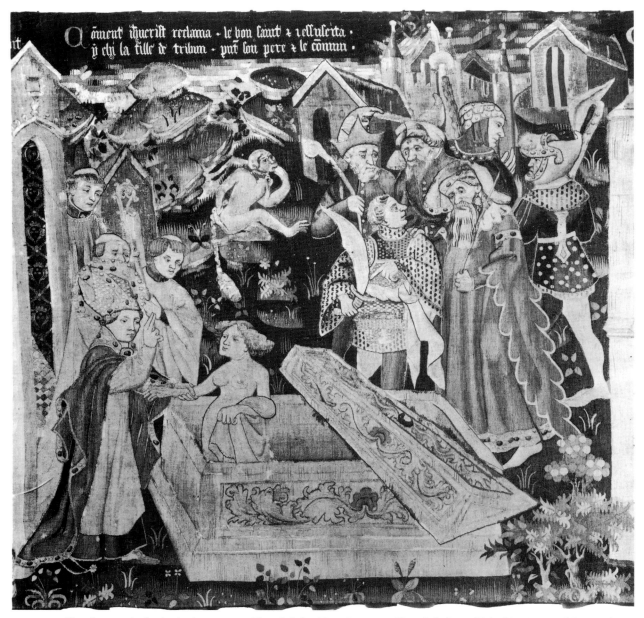

FIGURE 14. *The tribune watches his daughter's resurrection. The cathedral of Notre-Dame is visible in the background behind him.* Lives of Piat and Eleutherius *(detail), 1402, Notre-Dame cathedral, Tournai.*

Gaul. This event takes place in Rome, a city that reappears when Eleutherius voyages there for his papal confirmation. After Eleutherius escapes from prison, Clovis travels to Tournai to visit him.[25] Although the titulus only permits us to glean the content of the now-lost woven image, it indicates that the king pays homage to Eleutherius when he "confesses to a sin for which he implores the saint to pray for God's forgiveness." God hears the saint's prayers. As a divine agent, Eleutherius plays a crucial role in the life of the first Christian king of France, whose realm includes Tournai.

In addition to expanding the geographic scope of the *Lives of Piat and Eleutherius*, Clovis's appearance situates their *vitae* within a chronology defined by the French monarchy. Through the woven *vitae*, histories of the city and the French monarchy intertwine; the Christianization of the two proceeds simultaneously.[26]

The tituli that span the tapestry underscore Tournai's linguistic identification with the French monarchy. Rather than Latin, the language of the universal Church, or Flemish, the language of cities whose allegiance to the French monarchy remained tenuous and whose relation with it was often conflictual, the woven inscriptions confirm that Tournai is a French city. However, it is only *this* French city that can claim the story of Piat and Eleutherius as part of its history.

Yet it was not only the focus on events relating to Tournai and taking place there that characterized these monumental saints' lives as a history of Tournai. The relationship established among these events spanning the length of the tapestry also contributed to their meaning. The structure of the woven *vitae*, to which I now turn, was essential to the story they told, a version of the past that hinged on the cohesion and cooperation of the laity and the clergy.[27]

Pictorial devices establish the spatial continuity between episodes. Strips of foliage below, and of sky above, span the length of the tapestry, unifying the space. Doorways, which divide the text into different episodes, also provide passageways between them. For instance, Eleutherius steps from the chapel in which the tribune's daughter accosts him into the landscape where he resurrects her (fig. 15).

This interconnected series of events proceeds in time from the earliest episode, God's charge to Piat, to the latest, the veneration of Eleutherius's relics. The episodes are arranged chronologically, consistent with the way people apprehend and understand events in their lives.[28]

The progression of these events in the past can be measured and described in terms of a human, experiential perception of time; this is underscored by a genealogy based on biological reproduction.[29] Members of Eleutherius's family are introduced the

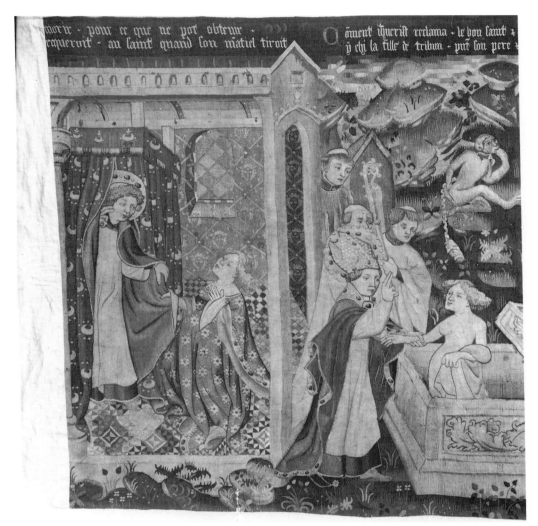

FIGURE 15. *Eleutherius steps from the chapel where he is accosted by the tribune's daughter to the spot where he resurrects her.* Lives of Piat and Eleutherius *(detail), 1402, Notre-Dame cathedral, Tournai.*

length of the tapestry. After Hireneus acts in conjunction with Piat, his daughter, Blande, helps Eleutherius to baptize the tribune's daughter (plate 3). Appearing in both halves of the tapestry, Eleutherius's grandfather and mother bridge the lives of the two saints, melding them into a single *vita*. Within this overarching framework, events occur as part of the natural progression of a familial lineage, which situates actors in relation to one another according to their position within this genealogy.

A second genealogy, structured by the succession of episcopal rule, provides another framework for the woven events.[30] Piat and Eleutherius are placed within a genealogy composed of the inheritance of certain qualities, the possession of which constitutes sanctity. It is the transmission of these qualities from one individual to the next that provides the basis for and justification of an episcopal line. Generations of bishops, who earned and then inherited their positions as leaders of the Christian community of Tournai, link Eleutherius to Piat.

Although he is not depicted as a bishop, Piat stands for the divine origin of the episcopal line of Tournai, since he received his charge as the city's religious leader directly from God.[31] Following God's command, Piat begins the process of Christianizing Tournai, a project continued by the later bishops of the city. Piat therefore links all subsequent Christian leaders of the city to God.

Focusing on Eleutherius as the immediate heir to Piat's saintly qualities, the tapestry further underscores the sanctity of Tournai's episcopal line. Beyond the numerous miracles his relics perform, Eleutherius's divine connection is confirmed when God hears his prayers on behalf of Clovis. Although the tapestry includes an intermediary bishop between Piat and Eleutherius, the titulus does not name him, nor do his actions distinguish him in any way (fig. 8).[32]

In the woven account, Eleutherius also links the bishops of the city to the early members of its lay community. He is related to the most prominent member of this community, Hireneus. He continues the Christianization of the city and belongs to the episcopal lineage of its church. In him, two genealogical chains converge and overlap; the bishop and his successors are made part of the past of the city and its citizens.

The Christian city of Tournai and its episcopal line stem from a common source, Piat. Ultimately, God's words to Piat initiate the Christianization of Tournai and prompt the events that follow. God therefore stands at the origin of Christian Tournai, its religious leaders, and the story itself. From this moment, the events proceed chronologically, structured by two overlapping genealogies. Consequently, this uninterrupted account of the lives of the two saints continually refers back to the first

episode, which confirms the sacred origin of Christian Tournai and of its Christian leaders.

PERCEIVING THE TAPESTRY IN SPACE

Although the adjectives "unified" and "expansive" are associated with the interior of medieval churches, the latter were, in fact, segmented into numerous discrete parts.[33] These churches within the church fulfilled distinct functions, often carried out simultaneously. For instance, a chaplain celebrated mass at an altar in the nave, while others were assigned to chapels off the ambulatory, and members of the chapter or their representatives said the prayers that punctuated their days and nights in the canons' choir, or participated in the mass performed in the sanctuary.

To describe the *Lives of Piat and Eleutherius* simply as a "choir tapestry" is to overlook the divisions that existed within that part of the cathedral. What is now called the choir of Tournai cathedral was composed of three distinct areas in the fifteenth century, each with a different meaning and function (diagram 1, fig. 3).[34]

The high altar, behind which the reliquary containing Eleutherius's body was visible, was located at the center of the east end of the choir. The honor bestowed on these objects and their centrality in important ceremonial occasions defined the sacred nature of this part of the choir and hence its denomination, "the sanctuary." The bishop celebrated mass at this altar when he officiated in the cathedral, a fact that contributed to the sanctity of the space around it, which was reached by a series of steps.[35]

The rood screen, or "pulpitum," on the west end of the choir, created both a barrier and a point of connection between the clergy in the choir and the laity in the nave. This stone structure reached from the floor of the cathedral to the base of the arcades, thereby blocking direct visual access to the choir from the nave. However, one of the two pulpits placed at either end of the top of the rood screen faced west, the direction from which the priest addressed the laity.[36]

The "canons' choir" formed an interspace between the sanctuary and the rood screen. The rood screen defined that choir's western limit, and the set of stairs leading to the sanctuary, its eastern. Two rows of stalls lined three of its sides with a solid wall that measured at least 2 meters in height. Seated in these stalls, the canons assisted in the liturgical rituals that structured their daily life and the calendar of feast days.

Ritual gestures, codified in the cathedral's Ordinal, underscored the boundaries of this section of the choir associated with the chapter. As they entered the choir, canons and their officials were supposed to kneel at the foot of the sanctuary, a gesture that

underscored its separation from the canons' choir. At designated points in the mass, the deacon and subdeacon climbed to the top of the rood screen to face the laity. This gesture of turning toward the nave shifted the focus of the ceremony from the lectern at the center of the canons' choir to beyond its western border, thereby replicating the existing division between the canons' choir and the nave.

During the celebration of the cathedral feast days, textiles and lights further defined and differentiated the three sections of the choir. Twenty candles encircling the ensemble of altar and reliquary focused attention on the sanctuary. The physical separation between this area and the rest of the choir was dramatized by the row of seven candles at the bottom of the steps leading to the sanctuary.[37] Fabric of the appropriate liturgical color spanned the top of the rood screen, and candles illuminated the crucifix at its center. Finally, the *Lives of Piat and Eleutherius* underscored the separation between the sanctuary and the canons' choir. Continuing without interruption down the backs of the choir stalls on the north and south sides and across the rood screen, the tapestry emphasized the boundaries of the canons' choir within the choir as a whole.

This adornment and illumination transformed the choir on the most important occasions of the liturgical calendar, distinguishing them from less important ritual performances and stressing the spatial and social divisions within the cathedral. Moreover, the association of the two sections of the choir with the chapter or the bishop was heightened by their presence, since it was on the cathedral feast days that the bishop officiated in his cathedral and the canons were expected to attend the services.

CREATING A COMMUNAL PAST

Seated below the events that defined the early history of the church of Tournai, the chapter and the bishop became the successors of the first religious leaders of the city, Piat and Eleutherius. The visual similarity between ceremonial rituals in the tapestry and those performed in the choir further associated them with a tradition of leadership that stretched into the distant past.

Images of historic ceremonies along the tapestry conform to the directives for high feast days in the cathedral's fifteenth-century Ordinal, as exemplified by the scene of Piat's baptism of Hireneus and his family (fig. 10). Canons and choir boys, identifiable by the vestments appropriate to their rank and reserved for high feast days, surround the baptismal font. They hold the instruments required on these days: a golden cross, books, and a reliquary. Eleutherius's consecration as bishop is depicted with similar con-

temporary exactness (plate 4). Here, bishops in their richly ornamented copes and miters, deacons holding their staffs, and a choir boy holding a censer participate in the ceremony. Through these visual analogies, the woven ceremonies established a historical origin for the actual celebrations in the choir.

Woven ceremonies and celebrations enacted in the choir could play a role in a larger spectacle in part because they shared the same reference points. The annual procession to Seclin on the feast day of Piat would have followed the same path as the people of Tournai when they carried the saint's relics for burial in the church of Seclin. The relics of Eleutherius were the focal point of high feast days in the cathedral of Tournai, as they were in the ceremonies woven in tapestry. On high feast days, the reliquary that contained the saint's relics was visible, elevated on a table just behind the altar. Both the altar and the reliquary glowed in the light of the twenty candles that encircled this ensemble. This ritual display attested to the persistence of a tradition of devotion to Eleutherius in the city, established by Tournai's early Christian community.

Visually exact references to the current sites of veneration of Piat and Eleutherius's relics no doubt figured along the missing section of the tapestry. The image that accompanied Piat's burial in Seclin probably depicted the actual church of Saint-Piat, where the canons argued that the relics of the saint lay. An elaborate procession, recalling those enacted in the fifteenth century, surely accompanied Eleutherius's translation into the cathedral, depicted with an exactitude equal to its representation in the scene of Hireneus's baptism. It is also likely that the reliquary holding Eleutherius's remains in the final scene of the tapestry recalled the ornate reliquary, elevated in the sanctuary. This woven reliquary, whose contents were made explicit by the preceding translation scene, would have confirmed the historic origin of Eleutherius's relics in the choir of Tournai cathedral, and thereby their authenticity.

Following traditions established in the past, high feast days in the cathedral became part of a history of Tournai and its church. The actors in the liturgical ceremony contributed to a story that began with God's command to Piat and continued with the celebration of each high feast day in the cathedral. Witnessing this spectacle, the canons incorporated their ceremony into the account of the past of Tournai that surrounded them. In the process, they constructed a history that each member of the chapter could share.

THE COMMUNITY OF CANONS

This image of a united group of *Tournisiens*, projected into the choir on high feast days, leads us to wonder about the actual composition of the chapter and the connec-

tion its members had to the city. It is clear the chapter's members were associated with one another and with Tournai by virtue of the prebend they received and their institutional affiliation with the cathedral of Notre-Dame. The display of the tapestry reinforced their relationship to the city and its saints. But to what extent did these individuals actually occupy a communal space and identify with Tournai and its past, the elements that constituted their cohesion on high feast days?[38]

The chapter was composed of forty-three canons, one of whom received a partial prebend.[39] The number of prebends, which had been set in the thirteenth century and remained fixed until the end of the ancien régime, ranked Tournai among the largest of the twelve cathedral chapters in the ecclesiastical province of Reims. Only canons with significant experience were recruited. According to Jacques Pycke's survey, at the end of the thirteenth century 67 percent of the canons had a university diploma of some kind and the majority already occupied a rank in the church hierarchy. The majority of these canons came from noble families, the rest were of bourgeois origin.[40] The fifteenth-century Ordinal, however, refers to all the canons seated in the choir as "lords" (*domini*).

The number of local appointments to the chapter had decreased dramatically by the thirteenth century. The majority of canons came from outside the diocese of Tournai.[41] The pope and the kings of France were primarily responsible for filling vacancies in the chapter and they appointed men with no previous contact with the city.[42] Contacts in Rome, Paris, or at the Burgundian court were more likely to lead to an appointment in Tournai. Canon Toussaint Prier, donor of the tapestry, is a case in point: he originally came from Cambrai and served as chaplain to the duke of Burgundy.[43]

An appointment to the cathedral chapter did not automatically solidify a canon's link to Tournai. The accumulation of benefices was extremely common during this period, allowing canons to profit financially from multiple prebends. Their institutional affiliation with more than one church often divided their loyalties and their period of residence among several cities. Toussaint Prier, for example, simultaneously received prebends from the chapters of Saint-Omer, Cambrai, and Tournai. We therefore cannot take for granted either a canon's symbolic or physical connection to the chapter from which he received a prebend or to the city in which it was located.

One visible indication that a cohesive community of canons existed in Tournai would be the architectural structures and living quarters they shared. However, by the time Toussaint Prier commissioned the tapestry, structures such as the refectory and dormitory, which had once defined the canons' shared life and daily rituals, were no longer in use.[44] Although the canons lived in the same part of the city, this area was not physically

set apart from the rest of Tournai, as it had once been by the walls around the chapter enclosure. Whereas the bishop's palace represented his episcopal property and jurisdiction, the chapter's property was diffuse. Consequently, the function of the canons' choir, as a symbol of the chapter's communal existence, was particularly important.

Once appointed to the chapter of Tournai, each canon retained his own property and salary. When he first assumed his canonicate, the dean, spiritual and political leader of the cathedral chapter, performed the codified ceremony in which each canon was appointed a stall, an assigned seat that was physically separated from those on either side by massive armrests.[45] This process symbolized the canon's entry into the chapter but also asserted his right to a particular place in the choir and the income associated with his position. The canons lived in their own houses and, though they donated the majority of their possessions to the chapter as a whole, they profited from their individual property during their lifetime.

The connection to the past of Tournai and its saints, which the tapestry helped forge for those seated in the choir on high feast days, seems to have required the presence of the group whose existence it confirmed. Because of cathedral canons' social and religious obligations, we would assume that they were present in the choir and hence participated in the story. A canon's attendance at cathedral feast days had economic as well as symbolic implications. When he occupied his stall, a canon asserted his right to the prebend it represented and his continued position within the chapter's hierarchy. Furthermore, canons were paid to participate in important ceremonies.[46] Nevertheless, many stalls remained empty on these days.

Canons enjoyed multiple benefices and could not be physically present at every feast day in each church from which they received a prebend. In addition, with the rise in the educational level and expectations of secular canons, university study became much more common.[47] To attend university, they were obligated to travel to a large city. Canons also left Tournai on pilgrimages or for health reasons.[48] Even when they were in town, canons were often involved in activities and projects apart from their duties in the choir, such as those connected with the hospital, school, charity house, or those involving the affairs of the commune and needs of parish churches in the community. The celebration of the daily offices restricted their time and did not fit into the busy schedule of many canons.[49]

Regulations and restrictions on absenteeism point to the cathedral chapter's concern that its members be present. The number of days a canon had to live in Tournai was fixed and enforced.[50] In addition, the fee paid canons for participating in the mass on

particular ceremonial occasions was raised in the second half of the thirteenth century.[51] To accommodate the educational needs of the chapter, the bishop and pope granted exceptions to the time a canon was required to reside in Tournai. Jacques Pycke concludes his discussion of the education of cathedral canons in Tournai by stating that, if the canons had actually devoted to study the amount of time for which they were granted exceptions to the residence requirement, they would have all been doctors of law and theology.[52] This, of course, was not the case.

The cathedral's Ordinal reveals a major concern about absenteeism in the planning of liturgical ceremony in the choir. In each case where the dean, cantor, or another canon is to carry out a specific activity, a lengthy list follows of alternate members of the clergy who might take over this function in the event he is not present.[53]

The Ordinal's inclusion of this list of substitutes suggests that the chapter was seeking a way to respond to the canons' absences. The celebration of cathedral feast days clearly was not contingent on the participation of all its members. Officials assigned to particular tasks in the mass were replaced following a predetermined order of substitution. As for the rest of the chapter, any absent member left an empty seat in the choir.

Given that not all the canons occupied their stalls in the choir on high feast days, must we modify our reading of the *Lives of Piat and Eleutherius?* It has become clear that the corporate identity of the chapter was not based on physical or geographic ties among its members or even on their participation in ritual ceremony. The very celebration of high feast days, incorporating the woven *vitae* and ceremony in the choir, implied the presence of each canon in his stall. This spectacle thereby confirmed the chapter's existence as a cohesive and unified group.

DEFINING THE NATURE OF THE CHAPTER'S IDENTITY

A closer examination of the liturgical ceremonies that included the display of the *Lives of Piat and Eleutherius,* however, suggests a more complex image of the cathedral chapter than the words "cohesive" and "unified" suggest. In fact, these ceremonies also incorporated two fundamental divisions within the institution of the chapter: an internal hierarchy of its members, and a separation between the chapter and its bishop. The celebration of high feast days both established and resolved these divisions, which potentially prevented the physical and symbolic cohesion of this group, thereby making them part of the very identity of the cathedral chapter.

An internal hierarchy divided the members of the cathedral chapter. The dignitaries, including the dean, the archdeacon of Tournai, the treasurer, and the cantor profited

from both the honor and financial rewards of their privileged status within the chapter. Although their prebends were the same as those of the other canons, they benefited from added revenues associated with their positions. These revenues, often the proceeds of an altar, could be as much as three times the amount of a single prebend. The other canons were also divided into different categories, depending on their age, the date of their entry into the chapter, and on whether they had reached the rank of priest.[54]

This hierarchy manifested itself and was confirmed at every feast in the form of the assigned seats in the choir. The cathedral dignitaries occupied the seats of honor closest to either the altar or the western entrance to the choir. The first seats of the upper row on the eastern ends were reserved for the bishop and the dean. Seated beside the bishop was the archdeacon of Tournai, followed by the two archdeacons of Flanders. The treasurer and then the cantor were next to the dean. The rest of the canons occupied the remaining seats in the upper row of stalls just below the tapestry. The dean determined their stall in the choir based on their ecclesiastical rank and the date of their entry into the chapter. The most important canon, based on these criteria, was seated next to the archdeacons of Flanders, with the second in line directly across from him. The rest of the canons were assigned their place within this same hierarchy. In the lower stalls below them were the vicars, the chaplains of the high and low forms, the curates, and the choir boys.[55] Processions leading into and out of the choir were also organized according to an individual's position in the chapter. The Ordinal indicates the proper hierarchy structuring processions and other aspects of the celebration.[56]

A fundamental division and a potential for conflict existed between the chapter and its bishop. Although they cooperated on ceremonial occasions and in many important decisions, they formed two distinct bodies of ecclesiastical power, maintaining separate spheres of influence and distinct bases of economic support. In addition, they exercised jurisdiction and control over different spaces in the city and in the cathedral.

In fulfilling its functions in Tournai, the chapter operated independently from the bishop's control. It either elected its own officials or appointed them based on their seniority in the chapter. Duties required for the maintenance of the cathedral and celebration of the divine office rotated among the other canons. Chapter meetings, which the canons and their officials organized and ran, took place on a regular basis and also when special decisions were required or conflicts arose.[57] The bishop did not have a vote in these decisions and only rarely participated in chapter meetings. The pope, the king of France, or the duke of Burgundy often imposed his candidate on the chapter, which was thereby obliged to give up its power of election.

The cathedral was the seat of the episcopacy but the bishop's power extended beyond the city limits to encompass the diocese of Tournai. His activity was not focused in the city nor was he involved in its daily life. It was only on special occasions that he participated in liturgical ceremony in the cathedral. Unlike the chapter, which maintained many of Tournai's necessary institutions, the bishop remained a figurehead of ecclesiastical power within the city.[58]

Part of the reason for the bishop's lack of involvement in Tournai was that the city provided him with no direct financial or political rewards. The bishop had lost the part of his feudal domain when the king declared Tournai a commune. Although the magistrates of Tournai pledged obedience to the bishop, he did not play a role in the government of the city. Rather, it was the chapter that benefited from trade in and through Tournai, a privilege the king granted it. Members collected a tax imposed on all alcoholic beverages that were sold in Tournai or that passed through it. The chapter also profited from donations of land and money for the celebration of masses.[59]

It was more beneficial for the bishop to advance his career in the royal circle in Paris or at the Burgundian court than in Tournai. Louis de la Trémoille, for instance, demonstrated a greater attachment to Paris than to the seat of his episcopacy. He spent a large part of his career in this city and chose to be buried there.[60] This decision had great symbolic significance in that it broke with a long-standing tradition in which the bishops of Tournai were buried in the choir of their cathedral.

Ritual performances in the choir on cathedral feast days incorporated this division between the chapter and its bishop, just as it incorporated the internal hierarchy within the chapter. The bishop's stall was the first on the south side and that of the dean, the highest official in the chapter and its leader, the first on the north side.[61] The stalls on the south side were associated with the bishop and those on the north with the dean. On the south side sat the archdeacons, who represented the bishop in the chapter and carried out various services for him within the diocese. On the north side sat the cantor and the treasurer, responsible for the administrative and ceremonial tasks in the cathedral; they also governed the chapter in conjunction with the dean.[62] Two different processions entered the choir: the one with the bishop entered on the south side, the one with the dean on the north. The entrances, and the side of the choir to which they corresponded, are designated throughout the ordinal as the "bishop's" or "dean's" entrance, or the "bishop's" or "dean's" side.[63]

The separation of the bishop's jurisdiction and control over the choir from those of the dean mirrors Tournai's topography. In both cases, the place the official occupied in

the choir corresponded to the site of his power and the boundaries of his domain in the city. To the north of the cathedral lay the majority of the canons' houses, as well as the twelfth-century cloister, around which were placed the chapter school and library; to the south was the bishop's palace.[64] The proximity of the two entrances to the site where the officials lived and worked suggests they chose one side or the other based on practical concerns. But the choice also had symbolic implications: as the bishop faced the dean, each occupied his side of jurisdiction and property in the city.[65]

The display of the tapestry underscored the ritual and symbolic division in the choir. The *Life of Piat* is not only an introduction to Eleutherius's actions but also a distinct *vita* that occurred hundreds of years before the later saint's birth. According to Canon Waucquier, who saw the tapestry in the choir, the *Life of Eleutherius* began on the dean's side of the choir, after the final event in which Piat's relics were placed in Seclin.[66] The break between the *vitae* of the saints occurred at the center of the rood screen, thereby corresponding to the internal division in the choir. The *Life of Piat* spanned the length of the bishop's side and the *Life of Eleutherius* that of the dean.

On these special days, selected seats, including those of the bishop and the dean, were covered with fabric, probably silk, that highlighted the presence of these men.[67] As we have seen, the first stall on the southeast side of the choir was reserved for the bishop; opposite him, at the east end of the north side, was the dean. The bishop and the dean occupied the places of honor in relation to the tapestry, the former marking the beginning of the story, the latter, its end. Each time the tapestry was displayed in the choir, the same events hung over the heads of these two men, thereby solidifying their association with the bishop and the dean of the cathedral chapter.

The bishop sat directly under the image that confirmed the divine origin of his episcopal line, that is, the first scene, in which God charges Piat to convert the people of Tournai (plate 2, fig. 4a). Piat, to whom his command, inscribed in a banderole, is directed, kneels in the foreground of the image, separated from his companions celebrating mass. This is the only scene in the tapestry in which God appears, a fact that underscores the sanctity of this particular seat and of the bishop's privileged relationship to God. At each ceremony, the juxtaposition of this image and the bishop confirmed that God had created Tournai's episcopal line and that the power of this bishop in particular was invested directly from above.[68]

His appointment as bishop made him the most recent representative of Tournai's episcopal line. During the ceremonies in the choir, the woven story made his position clear. The genealogical chain inscribed in the tapestry, linking Piat to Eleutherius, con-

tinued into the space of the choir to include the current bishop of the cathedral. The spectacle in the choir, in which the tapestry played a central role, thereby positioned the bishop within a spiritual genealogy that began with the first saintly leader of Tournai's Christian community and continued into the present.

This story had particular resonance in 1402, when the bishop of Tournai, Louis de la Trémoille, saw the right to his title challenged. Tournai experienced major repercussions from the Great Schism, namely, the appointment of two bishops to the same see.[69] Louis de la Trémoille was supported by both the pope in Avignon and the king of France.[70] Opposing him was William de Coudenberghe, whom Urban VI invested with the same office.[71] Although Louis de la Trémoille occupied the episcopal throne, the Flemish part of the diocese did not acknowledge his appointment, and its representatives showed their opposition by refusing to attend when he officiated in churches within their region.[72] The entire diocese recognized Louis de la Trémoille as bishop by the end of the thirteenth century, when William of Coudenberghe left Flanders, but that did not change the problematic nature of his appointment and of his original claim to the episcopal title.

Toussaint Prier would have had a personal stake in a story that legitimated the current episcopal appointment, with whom he shared the patronage of the duke of Burgundy, Philip the Bold. Louis de la Trémoille was a councilor to the duke from 1393 on, and Toussaint Prier served as his chaplain for thirty years.[73] Yet his act of donation went beyond these specific historical circumstances, with a story that placed Louis de la Trémoille's successors within the lineage that stretched back to Piat.

Moreover, through his donation, Toussaint Prier demonstrated a more general allegiance to the cathedral chapter of Tournai, and to its dean in particular. The titulus on the final section of the tapestry identified its weaver, Pierre Feré, and the place (Arras) and date (December 1402) at which he wove the series. It is extremely likely that the *Lives of Piat and Eleutherius* followed the model of other extant choir tapestries, including a portrait of Toussaint Prier kneeling before the relics of Saint Eleutherius, accompanied by the inscription that charted the donation.

The portrait of Toussaint Prier would have therefore occupied the spot above the dean's head, opposite the beginning of the tapestry and the bishop's stall. As the head of the cathedral chapter, the dean exercised power over the canons and all cathedral personnel. Toussaint Prier was an important canon in the history of the chapter. Positioned above the dean, who personified the chapter's present, his portrait represented the historic past of the chapter as a whole and served as a model for the dean in particular.

The first and last episodes of the tapestry underscore the functions of the officials seated below them. The initial scene, representing the altar toward which God descends, refers specifically to the bishop's role as officiant in the masses performed in his cathedral. Toussaint Prier, representative of the cathedral chapter, was identified with its leader, the dean. The veneration of Eleutherius's relics, which Prier exemplified in the tapestry, continued to be a central part of the rituals of the cathedral and its chapter. At these two junctures in the woven text, the historical account of the saints expanded to include the contemporary representatives of the chapter on the one hand and the episcopal office on the other. In the process, it juxtaposed the two sources of power within the cathedral of Tournai.

The ornamentation and choreography of liturgical ceremony thereby divided the choir into halves, each identified with a religious leader and the site of his power and property. The equality between these representatives was underscored by the similarity of their seats in the choir. There is no evidence that the bishop sat on an episcopal throne. Moreover, his stall and that of the dean were both decorated on high feast days with a silk cloth and candles.[74] As they faced each other in the choir, their distinct but equal status was recognized.

However, the presence of the bishop on these days seems to have been even less assured than that of the canons. The first paragraph of the Ordinal makes it clear that his presence was not an essential part of the celebration of high feast days.[75] In fact, these days could no longer be defined as those on which the bishop performed mass. They became the "cathedral feast days," during which the bishop *might* perform mass. If he did not, his seat was left unadorned. In that case, the ornamentation in the choir privileged the dean's position as leader in the city. Not only was his place visually emphasized, but the dean literally took the place of the bishop as celebrant in the performance of the mass.[76]

But, just as the woven events implied the existence of the chapter as a cohesive and unified group, the celebration of the liturgy suggested that the bishop maintained power and control in Tournai. Eleutherius stood for the episcopacy and events depicted from his life verified its ritual and political role in the city. The story performed in the choir defined the bishop as a vital force in the city, by tracing this institution from its beginning to its contemporary manifestation in the choir. The office of the bishop was integrated into Tournai's history. In this account, the bishop was not merely an absent figurehead but a central agent in the city's Christianization.

The account of the saints' lives in tapestry also linked the bishop directly to the city.

Eleutherius was born into a family with long-standing ties to Tournai and a stake in its Christian community. The citizens of Tournai elected him bishop, thereby participating in the establishment of the episcopal institution and its leadership role in the city. As we have seen, the *vita* focuses exclusively on the saint's activities in Tournai; the bishop is a necessary part of the religious life of that community.

Liturgical ceremony in the choir thus incorporated two distinct institutional bodies within Tournai and within the French Church into a single drama. As the bishop and the dean faced each other across the choir, each represented his respective position and power within the city and the cathedral. The tapestry underscored this division through a juxtaposition of the *vitae* of two saints. However, the uninterrupted sequence of woven events that framed the canons' choir linked the two sides of the choir. It represented the cohesiveness of this group and the bishop's place within it, and connected both to a common past in their city. The dean and the bishop were joined through the members of the chapter, whose seats spanned the choir from one end to the other.

Finally, the woven series of events and the officials below them prompted a reading that breached the division of the choir into two parts. In fact, although the first event in the *Life of Piat* related to the bishop and the last event in the *Life of Eleutherius* to the dean, Eleutherius was associated with the bishop and Piat with the dean. Eleutherius, the first bishop of Tournai, stood for the institution of the episcopacy in the city, and the bishop was its current representative. Contemporary documents referred to the bishop as "the successor of Eleutherius."[77] Piat, as missionary to Tournai and founder of its church, was more closely connected with the dean, head of the chapter, which provided religious and social services in the urban community. We must therefore cross the line dividing the choir to link the *vita* of the saints to the appropriate official in his stall.

This spatialized reading reproduces the line of vision of those who participated in the ritual celebration. The bishop and others seated on his side of the choir faced the events in the *Life of Eleutherius,* while the dean and the members of the chapter on his side looked across the choir to Piat's *vita.* The bishop and the dean therefore saw the *vita* of the saint with which each was associated. As they read these events, they incorporated the opposite side of the choir into their ritual experience and visual domain. It was not only their symbolic and physical position in the church that defined their identity in this liturgical setting, but also the view before them.

Both sides of the choir became part of the chapter's experience of the ceremony. The tapestry enclosed the two halves into a unified space. Each canon occupied a stall that corresponded to his position in the chapter. At the same time, he engaged the other side

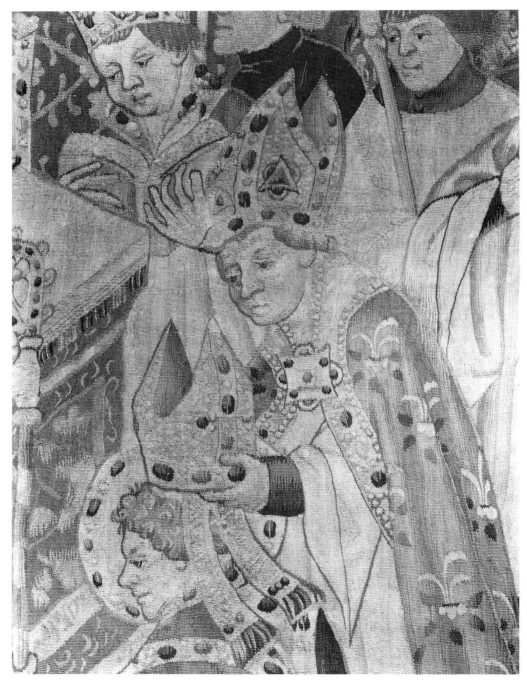

FIGURE 16. *The episcopal miter is placed on Eleutherius's head.* Lives of Piat and Eleutherius *(detail)*, 1402, Notre-Dame cathedral, Tournai.

of the choir, reading the woven text that faced him. For the members of the cathedral chapter, the celebration of the liturgy therefore involved a constant interaction between the two sides of the choir, with which he identified in different ways. Like an antiphonal arrangement of voices, where one member sings and the other responds to create harmony, the story performed in the choir integrated two parts into a whole.

The *Lives of Piat and Eleutherius* was not a static image of past events but an integral part of a living ceremony that recurred on every high feast day. During these ceremonial events, the woven *vitae* contributed to the chapter's self-definition, by constructing a history and a space these individuals could share. However, the intended and restricted audience for the tapestry was also part of its story. The chapter, its dean, and its bishop were not passive recipients of a pictorial text but active participants in the telling of a story. To understand the meaning of this story, we must imagine its audience not as ideal or abstract beholders but as historically specific viewers, that is, as the members of Tournai's cathedral chapter.

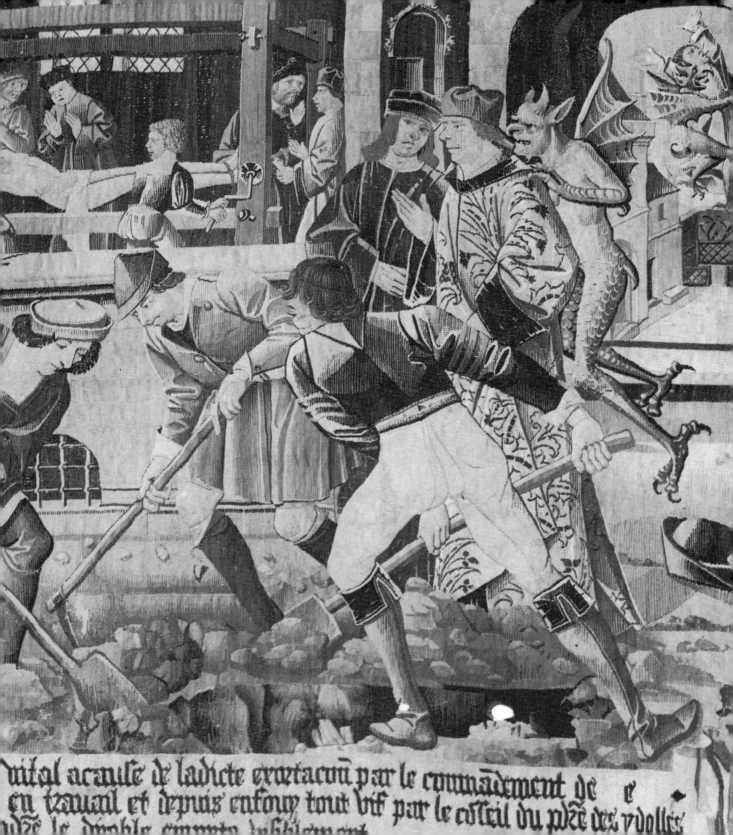

nital acaufe de ladicte ervetacōn par le commādement de ē
en travail et depuis enfoup tout vif par le cōfeil du pere des vdollrs
...se le dyable empertā...

The Gift of the *Life of Gervasius and Protasius* and Its Donor

Martin Guerande, canon of Le Mans and secretary to its bishop, Philip of Luxembourg, donated the *Life of Gervasius and Protasius* to his cathedral in 1509. The final episode of the tapestry documents this gift and describes the donor. Following the terms of Martin Guerande's will, the *Life of Gervasius and Protasius* was displayed on either side of the choir during high feast days celebrated in the cathedral of Le Mans from the time of its donation until the eighteenth century, when it was moved into the Chapel of Our Lady, a side chapel off of the ambulatory. Although the tapestry was originally two continuous strips of fabric, one intended for each side of the choir, it was divided at an unspecified point in its history into five individual pieces. Moreover, two pieces of the tapestry, which depicted the trial, martyrdom, and burial of Ursinus, a friend of Gervasius and Protasius's parents, were destroyed in 1562 during the religious wars. And a third piece, which depicted Saint Paul's appearance to Saint Ambrose, disappeared in 1857, at the time of the tapestry's restoration, initiated by Albin, canon of Le Mans, and carried out by Louis Joubert, canon of Angers. After this restoration, which rejoined sections of the tapestry and filled in holes in the fabric, the tapestry was returned to the choir above the canons' stalls. In 1966 and 1984, the restoration firm Maison Aubry removed the backing and cleaned the tapestry; it was cleaned again in 2001 by Chevalier restorers. The *Life of Gervasius and Protasius* is currently displayed above the choir stalls in Le Mans cathedral.

The *Life of Gervasius and Protasius* confirms the possibility of a universal sainthood that incorporates individuality. Gervasius and Protasius were twins, a fact central to the content and structure of the woven *vita* and a metaphor for unity in diversity. Moreover, the tapestry, by integrating similar events from the lives of other saints,

stresses the commonality of a larger group. But the contemporary significance of the *Life of Gervasius and Protasius* stemmed not only from this model of sanctity but also from the image of Martin Guerande that the tapestry projected and his act of donating it to the cathedral.

The following discussion reads the *Life of Gervasius and Protasius* in conjunction with the circumstances of its donation. Through a gift that represented his personal devotion to the saints and his hopes for salvation, Martin Guerande also manifested the concerns of the cathedral chapter of which he was a member and the bishop of Le Mans, Philip of Luxembourg, for whom he served as secretary for twenty-seven years. The tapestry was one component in the renovation of the choir, which included stalls donated by the chapter in 1507 and the rood screen constructed by Philip of Luxembourg between 1497 and 1507.[1] The woven *vita* also provided a story of its patron saints that spoke to the chapter as a whole and responded directly to a matter of central concern to Philip of Luxembourg, the place of the French Church within the larger Christian Church centered in Rome. Through this example, we can begin to understand the role the donors of choir tapestry played in telling the lives of the saints.

The earliest reference to Gervasius and Protasius dates to 386, when Ambrose discovered their relics in the basilica of Saints Nabor and Felix in Milan and transported them to his new basilica. He describes this event in a letter to his sister, Marcellina.[2] A Passion of the Saints, written under the name of Philip, a first-century Milanese noble, but actually composed in the fifth or early sixth century, dates their martyrdom to the first century, during the reign of Nero.[3] This text supplies the basic events in their lives: the martyrdom of their parents, Valery and Vital; their retreat from the world; their arrest and martyrdom by Astasius; and Philip's recovery of their relics. The manuscript tradition of their *vita*, including the version of their lives in the *Golden Legend*, perpetuates this account, though there is no evidence of Christian communities in Milan before the second century. Additional details about their lives are provided in the *History of the Church of Milan*, attributed to Saint Datius, bishop of Milan (d. 552), but probably compiled between the eighth and ninth centuries.[4] Like the Passion, this text contains chronological inconsistencies and it is likely that Gervasius and Protasius were, in fact, martyred in the third or early fourth century — unless, of course, they were a complete fabrication on Ambrose's part.[5]

Martin Guerande's choice of Gervasius and Protasius was prompted by considerations similar to those that had inspired Toussaint Prier to donate a woven *vita* of Piat and Eleutherius: his cathedral possessed the saints' relics, which had inspired local veneration. Saint Innocent, eighth bishop of Le Mans (532–543), dedicated the church in Le

Mans to them, placing the relics in the choir he added to the existing structure.[6] These relics had been acquired from Saint Martin, bishop of Tours, who distributed in Gaul the relics given to him by Saint Ambrose just after the latter's "invention" of the saints.[7] Gervasius and Protasius were also considered the early protectors of the city of Le Mans. A Carolingian onyx and coin attest to this tradition, representing the saints on either side of the city gate, and above it the hand of God.[8]

The cathedral was dedicated from the tenth century on to Saint Julien,[9] the first bishop of Le Mans. However, the high altar, beneath which the relics of the brothers were housed, was still dedicated to Gervasius, Protasius, and the Virgin.[10] Although the first church had been dedicated to the Virgin and Saint Peter, Gervasius and Protasius were associated with the origin of the church of Le Mans. As the entry in the cathedral's necrology regarding Martin Guerande's donation puts it, "in their memory the church of Le Mans was originally founded."[11] The early bishops of Le Mans made substantial donations to honor the twin saints and made their relics the focus of solemn ceremonies held in the choir. Maynard (940–960) had a gold antependium made to be placed in front of the altar, and Hildebert (1096–1125) added a gold altarpiece.[12] Canon Jean Brissart donated gold figures of Gervasius and Protasius for the same altar in 1477, and Philip of Luxembourg followed the example of the early bishops, remodeling the altar at the beginning of the sixteenth century.[13]

Martin Guerande made sure that his contribution to this tradition of donation and devotion to the twin saints would be remembered. His will specifies that, like other choir tapestries, the woven *vita* was to be displayed "in the cathedral's choir behind the canons in their stalls on certain solemn festivals of the year" (diagram 2, fig. 17).[14] The final panel of the tapestry includes the canon kneeling in prayer beside the relics of Gervasius and Protasius, accompanied by his patron saint, Martin of Tours (plate 5, fig. 18b). An inscription identifies him and confirms his donation of the tapestry:

> In the year of our Lord fifteen hundred and nine, Master Martin Guerande, priest, originating from Angers, canon of the church of Le Mans, and secretary of the most reverent fathers, of illustrious birth, Cardinal Philip of Luxembourg, until recently bishop of Le Mans and Francis of Luxembourg, his nephew, the current bishop of Le Mans, gave to the same church of Le Mans this tapestry to adorn its choir in praise of God, the blessed martyrs, Gervasius and Protasius, and the celestial hierarchy. May God spare the donor. Amen.[15]

Such an overt intrusion of the donor into the woven *vita* and the terms of its display

The Gift of the Life of Gervasius and Protasius *and Its Donor*

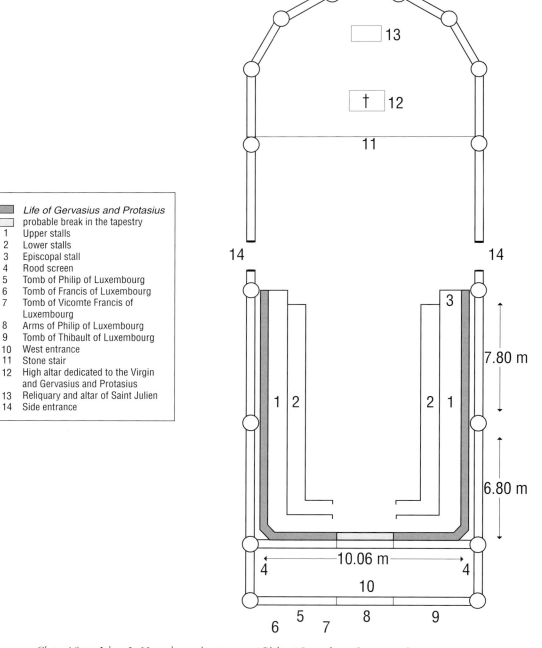

DIAGRAM 2. *Choir of Saint-Julien, Le Mans, during the episcopate of Philip of Luxembourg (1477–1519).*

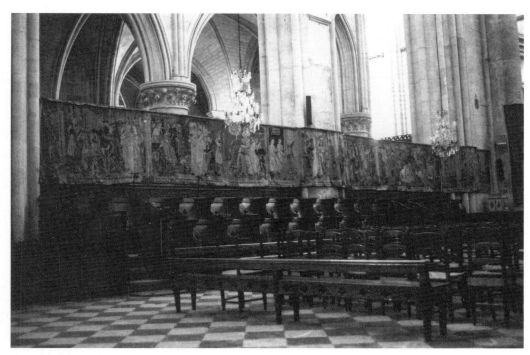

FIGURE 17. *The* Life of Gervasius and Protasius *as it is currently displayed above the choir stalls in the cathedral of Le Mans.*

is a feature common to almost all choir tapestries. Like Martin Guerande, the donor is often depicted at the end, or sometimes at the beginning, of the *vita*, accompanied by an inscription that provides details about him and his donation. In the unusual example of the *Life of the Virgin,* given to the collegiate church of Notre-Dame in Beaune, the donor, Canon Hugues le Coq, appears in the middle of the *vita* and then once again at its conclusion (fig. 57). The inscriptions often provide the only textual documentation of a tapestry's production; in the case of the *Lives of Piat and Eleutherius,* for instance, we learn the name of its weaver and the city in which he worked. As in Auxerre's *Life of Stephen,* the arms of the donor are frequently included the entire length of the tapestry. The viewer is thereby reminded throughout the woven *vita* of the donor's role in its making.[16] In return, the donor guaranteed the association between choir tapestry and liturgical ceremony by requiring that the chapter comply with limitations pertaining to its display. The *Life of Gervasius and Protasius* provides a starting point for asking how the various ways that the donor asserted his presence in his gift of a choir tapestry informed the story it told.

The Gift of the Life of Gervasius and Protasius *and Its Donor*

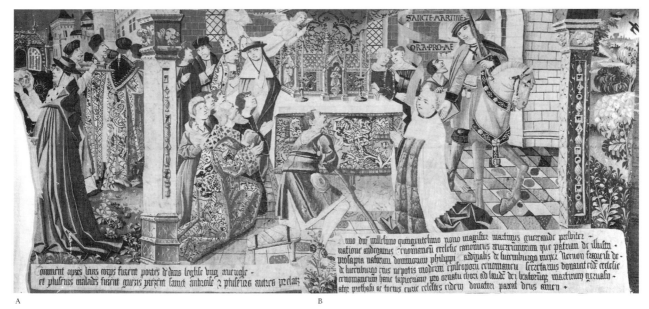

A

B

FIGURE 18. Life of Gervasius and Protasius, *1509, Saint-Julien, Le Mans. (a) Ambrose's elevation of the relics of Gervasius and Protasius, (b) Veneration of the relics and donor portrait.*

THE WOVEN *VITA* OF GERVASIUS AND PROTASIUS

The *Life of Gervasius and Protasius*[17] is composed of topoi common to hagiographic texts: the saints' entry into a professional career, attestation of sanctity, martyrdom, and the veneration of their relics. In this case, events in the life of the two brothers and of contemporary saints transpire along the tapestry: the martyrdom of Gervasius and Protasius's parents, Vital and Valery (figs. 19a–b), and perhaps of Ursinus, their friend; the career of Gervasius and Protasius, including their donations to the poor, their baptism, the performance of a miracle, the construction of a chapel (figs. 19c, 20a–c); their arrest by Nero and their subsequent imprisonment, torture, and martyrdom (figs. 20d–e, 21a–e, 22a–b); Saint Paul's appearance to Ambrose in a dream and Ambrose's invention and translation of their relics (fig. 18a).[18]

The *Life of Gervasius and Protasius* underscores that the saints are identical. Within the tapestry, they resemble each other in size, coloring, and stature; their facial features and clothing are the same. They are clothed in identical white tunics for most of the *vita* and the similarity of their bodies is revealed when they shed these cloaks to be baptized. They engage in the same activities, perform the same miracles, and suffer the same fate.

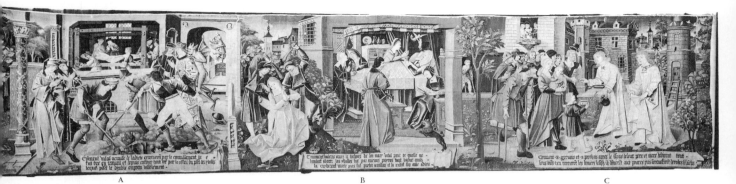

FIGURE 19. Life of Gervasius and Protasius, *1509, Saint-Julien, Le Mans.*

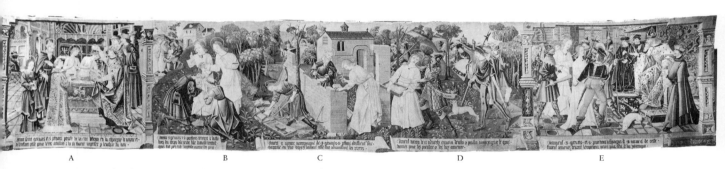

FIGURE 20. Life of Gervasius and Protasius, *1509, Saint-Julien, Le Mans. (a) Baptism of Gervasius and Protasius, (b) Miracle performed by the saints, (c) They construct a chapel, (d) and (e) They are arrested and brought before Nero.*

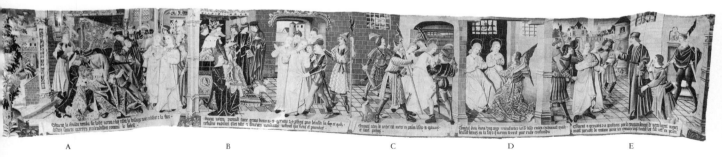

FIGURE 21. Life of Gervasius and Protasius, *1509, Saint-Julien, Le Mans. (a) Nero is struck by lightning, (b) Nero asks the saints to venerate idols, (c) Gervasius and Protasius put in prison, (d) An angel comforts the twins, (e) Gervasius and Protasius brought before Nolin, provost of Milan.*

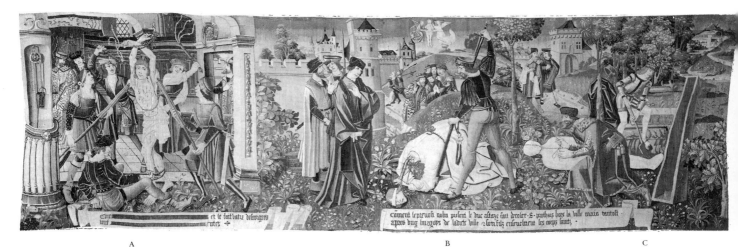

A B C

FIGURE 22. Life of Gervasius and Protasius, *1509, Saint-Julien, Le Mans.*

They donate their possessions together, they are baptized together, they exorcize and baptize together, they are prosecuted together. Finally, they are venerated in a single reliquary.

Their gestures create a further symmetry between Gervasius and Protasius. For instance, when Nero promises them fortune and fame if they agree to worship idols, they make the same sign to signal their refusal (fig. 23). Standing in line one behind the other with their heads slightly bowed, one foot peeks out from beneath each of their robes and their right hands are raised. Similarly, when the angel visits them in prison, the saints sit with their hands clasped and their heads bowed slightly forward (fig. 24). And, as they donate their possessions to the poor, are baptized, and perform a miracle, Gervasius and Protasius stand side by side, mirroring each other's gestures (fig. 25, plate 9, fig. 20b). In each case, the two act and react in synchronicity.

The distinctiveness of this treatment of Gervasius and Protasius can be seen through a comparison with other versions of their *vita.* In the remaining three episodes of a choir tapestry donated to the cathedral of Soissons by Jean Millet, bishop of Soissons (1443–1502),[19] Gervasius and Protasius are systematically differentiated by the name inscribed under each figure; Gervasius is identified in red letters, Protasius in white (plate 6). A depiction of the saints from an early thirteenth-century illuminated Bible with martyrology underscores the physical differences between the saints (plate 7). One is taller than the other; one has curly hair, the other straight; one is clothed in pale orange,

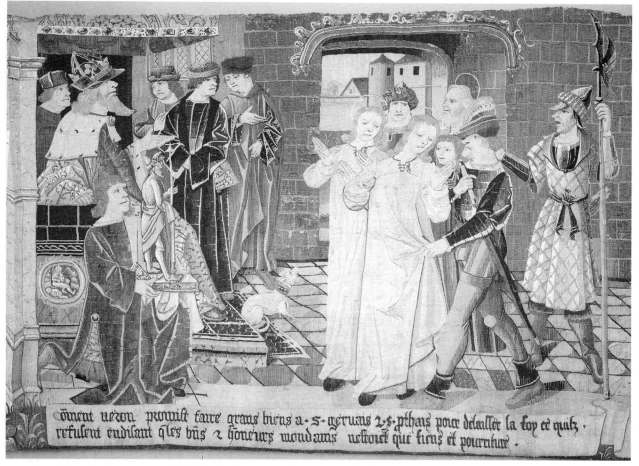

FIGURE 23. *Nero asks them to venerate idols.* Life of Gervasius and Protasius *(detail), 1509, Saint-Julien, Le Mans.*

the other in green.[20] And, in the *Golden Legend*, Jacobus de Voragine individualizes the two brothers. Gervasius and Protasius engage in distinct activities; each one defends himself with a lengthy speech; they are tested and killed separately.[21]

The woven *vita* from Le Mans further departs from other versions of their lives by focusing on the conflict between the saints and Nero. The various secular rulers who confront Gervasius and Protasius are condensed into this one. Astasius, for instance, who arrests the saints and orders their death, is absent from the woven *vita.* Nero appears five times within the tapestry and, though he sends the saints to the provost Nolin for

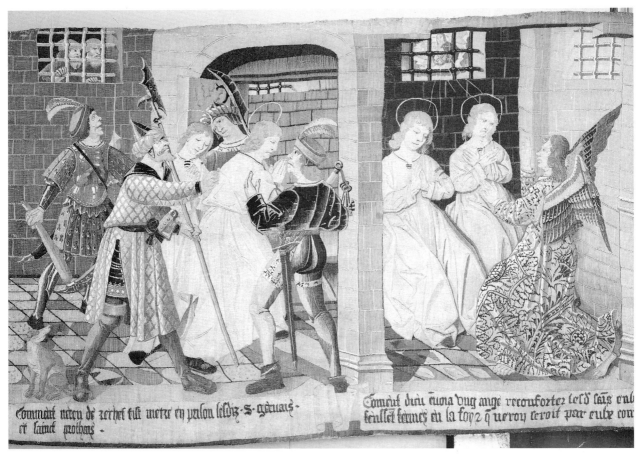

FIGURE 24. *Gervasius and Protasius put in prison; an angel visits the twins in prison.* Life of Gervasius and Protasius *(detail),* 1509, Saint-Julien, Le Mans.

execution, he witnesses the saints' martyrdom from the background. Following the deaths of Vital and Valery, eleven of the remaining fourteen episodes directly or indirectly involve Nero.

This fundamental opposition between the twins and the emperor is depicted formally in the tapestry. When Nero is struck by lightning, he falls diagonally, followed by those who attempt to catch him and by Nolin, who wrings his hands in distress (plate 8). The diagonal of this group contrasts with the upright, vertical position of the two saints. This distinction is repeated in the titulus, which opposes the darkness of Nero to the brightness of Gervasius and Protasius.[22] Nero resembles the idol to whom Gerva-

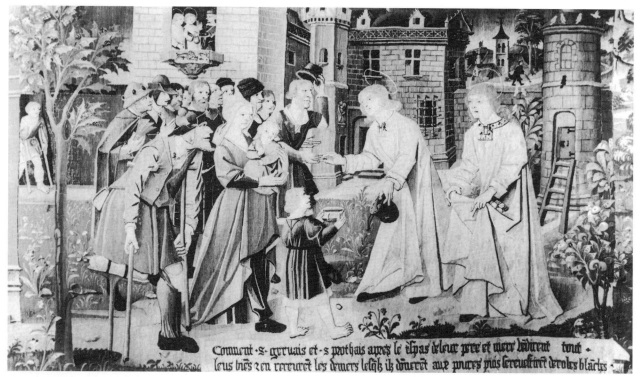

FIGURE 25. *Gervasius and Protasius give their possessions to the poor.* Life of Gervasius and Protasius *(detail), 1509, Saint-Julien, Le Mans.*

sius and Protasius are asked to pray, while the white garments of the saints illuminate them the length of the tapestry.

Through a similar process of condensation, events in the lives of the other saints depicted in the tapestry are encapsulated at the moment when their sanctity is confirmed, that is, at their martyrdom. A single panel represents the test of each saint's faith and its confirmation in his or her death. Vital is stretched on a rack and then buried (fig. 26). Valery is beaten and then dies in bed (fig. 27). It is likely that the panel destroyed in 1562 repeated the same stages in Ursinus's martyrdom: his torture by Paulinus and his burial while still alive.[23]

Alain Boureau, in his book on the narrative structure of the *Golden Legend*, argues it is organized according to a strategy of accumulation and recurrence. Each *vita* consists of successive moments in the saint's life that are not mutually dependent. These events form a series of narrative fragments, collected and arranged into a list. The resemblance among individual *vitae* structures the *Golden Legend*; events recur within each chapter and

The Gift of the Life of Gervasius and Protasius *and Its Donor* 63

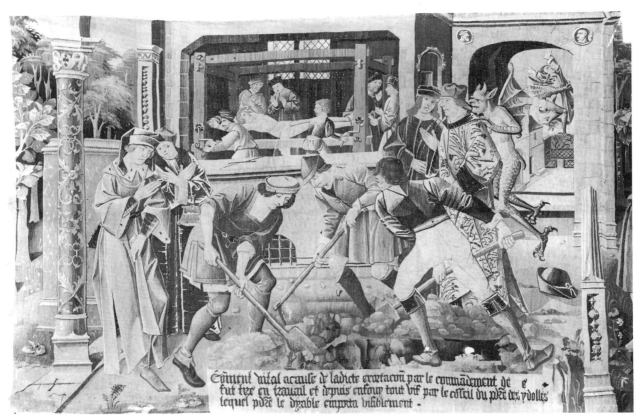

Comment vital acause de ladicte exortacoū par le commādement de q̄
fut tꝛe eu tꝛauail et depuis enfouy tout vif par le cõseil du pꝛe des ydolles
lequel pꝛe le dyable empoꝛta inuisiblemēt ·

FIGURE 26. *Torture and death of Vital.* Life of Gervasius and Protasius *(detail)*, 1509, Saint-Julien, Le Mans.

within the book as a whole. Jacobus de Voragine's compilation thus provides a list of examples of saintly behavior, ordered by the date on which their feast was celebrated in the liturgical calendar.[24]

Similarly, the *Life of Gervasius and Protasius* is structured as a series of examples of sanctity. Each of the secondary saints (Vital, Valery, and probably Ursinus) undergoes a trial and is martyred. This sequence occurs three times as an introduction to the life of the twins, which itself, repeats the same sequence: their trial by Nero and their subsequent martyrdom.

Pictorial devices within the tapestry organize these individual episodes of sanctity into a list of events which are linked neither chronologically nor causally. Ornamented columns, introduced at regular intervals along the tapestry, either between every episode or every other episode, are the primary organizing feature of the woven *vita*. They are

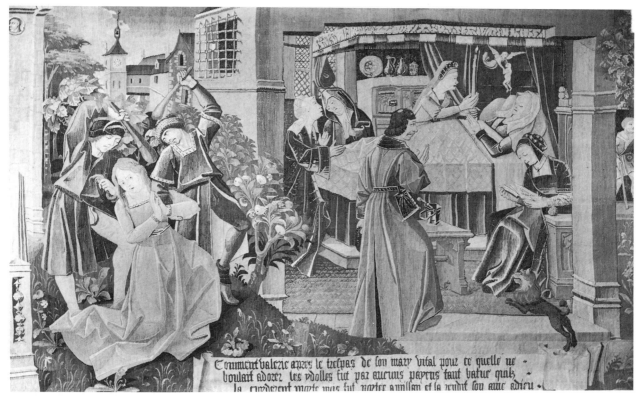

FIGURE 27. *Torture and death of Valery.* Life of Gervasius and Protasius *(detail), 1509, Saint-Julien, Le Mans.*

decorated in a variety of ways: in some cases they are simple supports for an architectural structure, in others they are surmounted by an ornate capital; most are overlaid with a chain of gems of different shapes framed in gold. These columns divide the *vita* into evenly spaced units and create a visual rhythm the length of the tapestry.

The autonomy of each event is maintained even when two events transpire in the same place. In the *Lives of Piat and Eleutherius,* doorways inscribe a temporal and causal relationship between events. The city gate signals the passage of time during Piat's journey from Rome to Tournai. Eleutherius steps from the chapel, where the tribune's daughter accosts him, into the landscape, where he resurrects her; the transition from one location to the other links the events causally (figs. 13, 15). In the *Life of Gervasius and Protasius,* in contrast, actants rarely move from one scene into the next. In the scene of the martyrdom of Gervasius, for example, the doorway on the right provides a view of

the crenellated walls, which extend into the scene of the decapitation of Protasius (fig. 22a). The doorways in two of the scenes taking place within Nero's audience chamber open onto a view of the city (plate 8, fig. 23). In the first case, the opening indicates the geographic proximity between the two events and; in the second, it situates them within the same city.

The woven *vita* does not chart the development of an individual's life through time, as do the *Lives of Piat and Eleutherius,* but presents an ideal saintly experience that is repeated again and again. This experience transcends geographic boundaries; the local specificity of the story is reduced to a minimum. When they designate a place, the tituli situate the story in relation to the city of Milan. Valery, after she is beaten by pagans, is carried to that city. The twins forsake their possessions and leave Embrun for Milan, where they are baptized.[25] Nero sends Gervasius and Protasius to the provost of Milan and Protasius is decapitated "outside of the city," where a bourgeois and his son find their bodies. Ambrose is identified as the city's bishop. However, the tituli do not identify where the saints build a chapel, perform a miracle, confront Nero, or where their relics are venerated. Nor does the pictorial text provide additional clues for identifying these settings.

Moreover, the tapestry designers exploited the implications of twinship to make an even stronger statement about the universal potential of this ideal of sanctity: one saint can actually stand for and replace the other. For example, the construction of the chapel and the arrest of the saints are condensed. A single saint is the protagonist in both events (fig. 28), one of the rare cases in which a figure bridges successive episodes. This twin, who could be either Gervasius or Protasius, carries mortar, helping to build the chapel. At the same time, he is accosted by one of the soldiers who emerge from behind a hill on the right. In the scene of their burial, the titulus states that Philip and his son recover and bury the bodies of the saints (fig. 22c). However, the image depicts the unearthing of just one body, and a single coffin awaits it on the right. Finally, at their invention by Ambrose (the titulus reads, "after their bodies were brought into the church"), Ambrose places a single skull in a reliquary (fig. 18a). In these three episodes, Gervasius and Protasius substitute for each other, one twin's actions consuming and assuming the other's.

Similarly, the sequence of images depicting Gervasius's and Protasius's martyrdoms can be read either as two separate deaths or as the two-part process characteristic of a saint's martyrdom. One of the saints is whipped and burned by torches; the other is decapitated (fig. 22a–b). The former is stripped to his waist, and his body shows the marks of the hot irons and whips; the latter remains clothed, his severed head on the ground

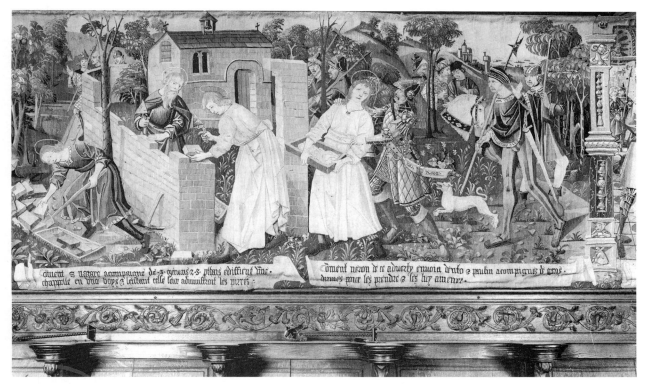

FIGURE 28. *Gervasius and Protasius build a chapel and are arrested.* Life of Gervasius and Protasius *(detail), 1509, Saint-Julien, Le Mans.*

before him. Although the titulus for the first scene is missing, Protasius is identified as the protagonist of the second. The nature of the twins' deaths corresponds to the accounts in the written *vitae.* In the woven version, however, Gervasius does not die. It is therefore possible to read the two scenes as the torture and then death of a single saint. Through this process of condensation, we witness the two-stage death of the saintly unit: Gervasius and Protasius.

The *Life of Gervasius and Protasius* responds to a question asked in all societies: How can a single pregnancy produce two individuals? Or, in more general terms, how is duality possible within an image of unity?[26] Some stories of twins deny this possibility, stressing the inequality between them, which ultimately leads to the triumph of one twin over the other, like Romulus's murder of Remus. The story of Gervasius and Protasius, in contrast, responds to the anomaly of twins by affirming that duality within unity is possible. One saint does not supplant or succeed the other; they receive the crown of mar-

tyrdom together. According to the Ambrosian missal, upon which Jacobus de Voragine relies, Gervasius and Protasius are all the more saintly because they overcame the competition inherent in their birth: "Oh what a glorious bond of rivalry, when they were crowned side by side, those whom a single maternal womb brought forth."[27] In contrast to the *Golden Legend,* however, in the tapestry the unity of the twins is confirmed not just at the moment of their martyrdom but throughout their *vita.*

THE DONOR'S PORTRAIT IN THE *LIFE OF GERVASIUS AND PROTASIUS*

The likeness of the canon and the accompanying inscription in the final panel work against the universal ideal of sanctity that structures the woven *vita* (plate 5, fig. 18b). They introduce the specifics of time and place, the characteristics that define an individual, and a personal devotion to the saints. Martin Guerande is presented by his patron saint, from whom he requests intercession with the words, "Sancte Martin Ora Pro Me."[28] His clothing immediately identifies him as a canon: he wears a soutane, a long surplice, and a fur cloak. He kneels, however, removed from his peers, alone in his veneration of the saints. The inscription further differentiates him from other clerics: he comes from Angers; he is not only canon of Le Mans, he has also reached the rank of "priest," and is therefore authorized to celebrate mass; and he has obtained a level of education that grants him the title "magister." He alone served as secretary to the "most honorable fathers, born from an illustrious family," namely, Philip of Luxembourg and then his nephew, Francis.

This image of Martin Guerande functions as a colophon to the tapestry, an internal reference to the circumstances of its donation. The inscription dates the gift and situates it within the cathedral's history, that is, during the dynasty of the Luxembourg bishops: "Cardinal Philip of Luxembourg, until recently bishop of Le Mans and his nephew, Francis, current bishop of Le Mans." The tapestry was given to the cathedral of Le Mans, specifically to adorn its choir. The Latin text, standing in contrast to the French of the other tituli, gives a documentary status to this attestation of the donor's identity and of the intended destination of his gift. The figure of Martin Guerande further testifies to his role as donor and to his devotion to the saints, in whose honor he has given the tapestry. The portrait and inscription are distinct from the rest of the *vita* in their mode of telling, subject matter, and in the time and location in which they take place.

The separation between the Milan of Gervasius and Protasius's *vita,* that of the first and fourth centuries, and the Le Mans of Martin Guerande's donation in the sixteenth

century is, however, not as complete as this description suggests. The canon occupies the same space as the participants in Ambrose's translation of the saints' relics. The bishop of Milan stands to the left of the reliquary, accompanied by another bishop and two canons. Kneeling before the clerics, a group of men, women, and children join them in venerating the saints. Directly in front of the altar on which the reliquary is placed, a pilgrim, missing a foot and supported by crutches, confirms the healing power of the saints' relics and the realization of the titulus below him, which reads, "after their bodies were carried into the church, a blind man and many sick people were cured." Martin Guerande takes part in the veneration of Gervasius and Protasius, presumably in Ambrose's basilica.

The integration of the donor into the object of his or her donation and the temporal conflation that results is an extremely common feature of late medieval pictures. Like Martin Guerande, the donor, whose rank is indicated by clothing, arms, or an inscription, generally kneels in prayer, presented by his or her patron saint. The donor's inclusion within the sacred event is a privilege derived from his political position or buying power.[29] It also prompts a variety of interpretations: Is the donor supposed to be actually present at the historic event? Are we witnessing the donor's vision of it, or its liturgical celebration, in which the donor participates?[30] Late medieval donor portraits integrate all these possible meanings, playing on the fundamental ambiguity of sacred events that were thought to have happened in the past but which also were repeated in the present.

The designers of the *Life of Gervasius and Protasius* also drew on the properties of the medium and the nature of its display to provide an additional gloss on the historic event in which Martin Guerande's portrait is incorporated. The veneration of Gervasius and Protasius's relics in Milan is, in fact, divided into two separate events: two distinct groups are distributed on either side of the reliquary and each half of the image corresponds to a titulus. Martin Guerande's patron saint serves as a bridge between the two events, since Saint Martin distributed the saints' relics in Gaul, offering part of them to Saint Victurius, bishop of Le Mans. The bishop of Tours therefore provides a direct link between the relics Ambrose discovered in the fourth century and those deposited in the cathedral of Le Mans. Martin Guerande is at the center of what becomes an additional and final event in the uninterrupted series that proceeds the length of the tapestry: the veneration of the saints' relics in sixteenth-century Le Mans.

Placed at the northeast corner of the canons' choir (diagram 2), the reliquary depicted in the final event recalled the relics that Saint Innocent placed on the altar in the

sanctuary. The reliquary containing the relics of Gervasius and Protasius was destroyed in 1562; the terse description and low price accorded to this "trunk" in the *Plaintes et doléances* suggest it was not particularly ornate.[31] There is also no evidence that the relics were regularly displayed. However, the altar, which continued to be dedicated to the saints, was the focus of important donations, including the most recent additions by Philip of Luxembourg. Martin Guerande's veneration of the relics of Gervasius and Protasius was visually linked to the high altar in the sanctuary. As a result, the woven reliquary offered a concrete image of the presence of the saints' relics, otherwise confirmed abstractly by the dedication of the high altar in their names, and the memory of their relics in the distant past of the cathedral.

The portrait of Martin Guerande not only offers an alternate conclusion for the *vita*, through an additional event in the history of the saints' relics, it also provides a clue for localizing earlier events in their lives. If we return to the baptism of the saints, the resemblance of this space to Le Mans cathedral at the time of Martin Guerande's donation is apparent (plate 9). A series of columns supporting the arches of the tribune vaults and a section of the triforium above them, and the ambulatory with its radiating chapels, situate the event at the juncture of the nave and the transept. Philip of Luxembourg's rood screen forms a backdrop for the event, complete with the organ and clock on either side, wooden crucifixion at its center, and two altars.[32]

This event, which does not occur in any of the other written or woven *vitae* of the saints,[33] is given particular attention within the tapestry. Blue columns enclose the space and differentiate it from the episodes on either side. The exaggerated perspective, constituted by the patterned tiles and the series of bays, orients the image toward the actual choir of Le Mans cathedral and toward the viewer. Suspended above the heads of the saints, the bishop's gesture introduces a pause, arresting the action at the sacred moment of baptism.

The visual allusions to the cathedral of Le Mans in the baptism scene serve to associate the bishop who performs the ceremony either with Philip of Luxembourg, whose renovations to the choir are depicted in tapestry, or with his nephew, or with his father.[34] The bishop is clothed in full episcopal regalia and baptizes the saints in a font ornamented with the arms of the Luxembourg family. Furthermore, the saints have just arrived from Embrun, a city between Le Mans and Milan. The titulus, which identifies the celebrant as the "bishop of that place," underscores the ambiguity between the two places: is it the bishop of Milan or that of Le Mans who baptizes the saints?

The convergence of Milan and Le Mans is established even more forcefully by the

figure of Ambrose. In the two episodes in which he is depicted, and probably in the previous scene in which Saint Paul appears to him, the bishop of Milan is clothed in cardinal robes and cap (figs. 18a and b; appendix 3). Ambrose was never a cardinal and, as far as I can ascertain, this is the only case in which he appears dressed as one. However, Philip of Luxembourg, who was appointed cardinal by Pope Alexander VI in 1495, wore the vestments appropriate to this title for all official functions.[35] The last titulus identifies Philip as a cardinal and this title was used in manuscripts he commissioned and in documents that mention him.[36] The emblem of the cardinal's cap, a personal motif of Philip's, is included throughout his Missal and it ornamented the stone relief work of his rood screen.[37] Each appearance of Ambrose in the *Life of Gervasius and Protasius* thus functions as a portrait of Philip of Luxembourg as well. Moreover, the bishop standing next to him at his last appearance could represent Philip's nephew, Francis, who assumed his position as bishop of Le Mans when Philip was appointed cardinal.

This pairing of the bishop and the cardinal in the final episode of the woven *vita* replicated the seating arrangement in the choir of Le Mans cathedral. When Philip of Luxembourg gave his episcopal office to his nephew, Francis, he also relinquished his stall on the easternmost end of the canons' choir on the south side. On his subsequent visits to the cathedral, Philip occupied the stall immediately to the west of Francis. His nephew spent most of the two years he served as bishop of Le Mans in Rome, where he died in 1509. When Philip of Luxembourg and Francis participated in ceremonies in the cathedral of Le Mans together, they sat side by side, Francis in his episcopal throne and Philip in the first stall to his right (diagram 2). The final episode offered the pair an image of themselves, directly across from their seats in the choir; after their death, it recalled the special occasions when the cardinal visited Le Mans and attested to the importance of the Luxembourg bishops, Philip in particular.[38]

THE CANON AND HIS BISHOP

Philip's political and religious aspirations explain why he would endorse a story in which he plays the role of Ambrose, the most important and influential bishop in history and a model for episcopal rule.[39] Philip demonstrated the scope of his ambitions by transforming the cathedral of Le Mans into a monument to the Luxembourg bishops, who occupied the episcopal seat for over a hundred years.[40] The rood screen served as a mausoleum, where Philip, his father, and his brother were all buried, and which commemorated them through sculpted inscriptions and symbolic references. However, the renovations in the choir clearly emphasized his preeminent position in this family:

his tomb was isolated on the north side of the entrance and his personal motif, the cardinal's cap, was placed at the center of the rood screen.

Saint Ambrose's diplomatic skills provided an appropriate model for Philip. Just as the bishop of Milan achieved harmony within the Christian community at a time of conflict, Philip attempted to resolve disputes between two bodies within the Christian Church: the papacy in Rome and the French Church and monarchy. He was a top adviser to the popes during his episcopate and played an influential role in the policies of the kings of France. He sought throughout his career to accommodate the two parties but was never willing to accept papal control over the French Church.

A large part of Philip's career was spent in Rome; he returned to Le Mans only for visits. He directed his activity to the concerns of the popes, with whom he maintained a close relationship: Alexander VI (1492–1503), Julius II (1503–1513), and Leo X (1513–1521). Alexander VI named him cardinal in 1495 and bishop of Thérouanne in 1498. When Julius II succeeded Pius III, whose pontificate lasted only a month in 1503, he demonstrated his long friendship with Philip, with whom he had studied in Paris, by bestowing additional titles and honors. In 1507, Philip accepted Julius II's invitation to Rome, where he stayed until 1509. In 1512, Julius II offered Philip the bishoprics of Albano and Tusculum and appointed him papal legate to France.[41]

He honored these popes in his cathedral. Alexander VI's arms were placed on the rood screen next to those of Philip of Luxembourg and are included in the bishop's Missal.[42] The chapter placed an inscription between the columns that separate the nave from the transept, "Julio Secundo Pontifici Maximo Benefactori," and they resolved to celebrate a mass in honor of Julius II, who had granted abundant indulgences to the church of Le Mans the day after the dedication.[43]

His role as papal legate placed Philip of Luxembourg at the center of conflicts between the French monarchy and the pope, which led to the French invasions of Italy, first in 1494, when Charles VIII secured Lucca, Pisa, Florence, and Siena, and then in 1499, when Louis XII occupied Milan. Philip was instrumental in the treaty signed between Alexander VI and Charles VIII, which led the latter to withdraw from Italy in 1495. Julius II maintained a pro-French policy until Louis XII's alliance with Emperor Maximilian made the French threat too great. When it came to this stand-off, Philip's allegiance lay with the French king; he sided with the other French cardinals, taking a stand with Louis XII and Emperor Maximilian to depose Julius II. When Louis XII sought a reconciliation with the pope, Philip wrote to Julius II, begging him to accept the initiative.[44]

The *Life of Gervasius and Protasius* provided a suitable metaphor for Philip's agenda. As Peter Brown has argued in the case of the early Christian period, the frequent pairing of saints fulfilled a need to represent the unity of divisive communities.[45] It could be that, because they were twins, Gervasius and Protasius made an even stronger case for the unity for which paired saints stood. At any rate, Saint Ambrose demonstrated their effectiveness as representations of unity when their "invention" reduced the threat of Arian dissent among the Christians of Milan.[46] The division in the recent past between the papacy and the Gallican Church was a likely impetus for the choice of the twins for Le Mans's choir tapestry. Moreover, a *vita* of Gervasius and Protasius, which stresses how a multiplicity of saints can be unified within a general model of sanctity, had particular resonance within the agenda of Philip's ecclesiastical career: to maintain the position of the French Church within a larger unified body centered in Rome.

This ideal of a unified Christian Church was represented explicitly in a second, smaller tapestry, which Martin Guerande donated to his cathedral. This tapestry depicted the twelve apostles, the four Church fathers, the four cardinal virtues, and the twelve sibyls.[47] Three fragments, including the woven portraits of Saints Ambrose, Augustine, and Jerome, survive (fig. 29). In accordance with Martin Guerande's will, the narrow strip was suspended above the *Life of Gervasius and Protasius* from the wooden canopy that stretched the length of the stalls. In this tapestry ensemble, the universal sainthood expressed in the woven *vita* was juxtaposed with another image of a unified Church. The thirty-two portraits depicted those who stood for its foundation, from the pagan prophets, who foretold Christ's birth, to his twelve disciples and the four early spiritual leaders of the Church, and finally to the personifications of the virtues of its chief administrators.

The nature of the *vita* of Gervasius and Protasius and the row of portraits Martin Guerande commissioned for the cathedral suggests he promoted and probably shared Philip's ideal of a universal Church, a conception in which the Gallican Church occupied a privileged place. He took care of Philip of Luxembourg's affairs while the latter was away from Le Mans, and was no doubt informed of the bishop's trips to France on behalf of the pope, and of the negotiations he fostered between the papacy and the kings of France.[48] The canon, moreover, had received a special favor from Charles VIII in 1490, when the king appointed him canon of Saint-Peter of the Court, a royal foundation in Le Mans. However, Martin Guerande intended the significance of the tapestry to extend beyond the temporal limits of Philip of Luxembourg's episcopate. In fact, through his donation of the *Life of Gervasius and Protasius*, the canon expressed his desire

FIGURE 29. *Portraits of Saints Ambrose, Augustine, and Jerome. Saint-Julien, Le Mans.*

that the tapestry should testify to the importance of Philip of Luxembourg in the Christian Church, and, by association, to that of his secretary, until the end of time.

GIFT GIVING AS PROCESS

Within the context of gift giving in late medieval churches, Martin Guerande's donation took on complex meanings that informed how the tapestry was understood.[49] Through a system of ritualized gift practices, which increased in number in the fourteenth and fifteenth centuries, individuals sought to insure their soul's tranquility during the period between death and the Last Judgment. In Chiffoleau's apt turn of phrase, this was their "book-keeping for the afterlife."[50] Various types of gifts to religious institu-

tions functioned to prompt the prayers of those still alive, on behalf of the donor, his or her family and friends, and the other souls in purgatory. The donation of works of art, often with a portrait of the donor or an inscription referring to his or her gift, assured that the donor would be incorporated into the prayers said before the object or in the chapel in which it was placed.[51] The foundation of masses and chaplaincies to honor the deceased formalized the saying of these prayers. Charitable donations elicited the prayers of the poor in particular, who were considered privileged intercessors.[52] By financing works of art and liturgical ceremonies, and by giving to the poor, these donors hoped not only that their memory would be kept alive but also that they themselves would remain present among the living, as their names were evoked in prayers.[53]

In the will "written and signed by his own hand," Martin Guerande describes the variety of gifts he donated in an attempt to assure the tranquility of his soul. His charitable donations added the prayers of Le Mans's poor children to his tab: for the boys, he established a scholarship and bequeathed his large collection of books; and, for the girls, he instituted a dowry fund.[54] He funded a chaplaincy to assure the celebration of a mass in honor of Saint Martin, after vespers on his feast day, in the cathedral's chapel dedicated to the saint. But the canon surely profited most from the solemn mass he founded in the cathedral for the anniversary of his death. This ceremony was to take place on November 10, the vigil of the feast of Saint Martin. On the same day, he founded an anniversary in the other church from which he received a prebend: the royal foundation of Saint-Peter of the Court. The proceeds from his house and from all its furnishings were earmarked to cover the cost of these anniversaries.[55]

In contrast to the short paragraph it devotes to the *Life of Gervasius and Protasius,* Martin Guerande's will provides a detailed account of the anniversary to be celebrated in the cathedral. The entry focuses on the specific amount that each member of the chapter was to receive at the end of vespers for participating in the anniversary, ranging from the canons, who received four loaves of bread and two pints of wine, to the deacon who served the altar, who was awarded a roll and one pint of wine. The bishop received twice as much as the canons, that is, eight loaves of bread and four pints of wine. If Philip of Luxembourg graced the cathedral with his presence, provided he was no longer bishop of Le Mans, he would receive three times that, twelve loaves of bread and six pints of wine.

These generous incentives were meant to attract the maximum number of prayers on behalf of Martin Guerande, "the canons of his church, his parents, his friends, and his benefactors." On this day, presumably after the mass, the sacristan read the article of the will that dictated that each participant should bring his bread and wine to the meal,

place it on the table, and say the following words: "Oh Martin, renowned ruler of the faithful, accept our diligent prayers with clemency now that the souls of all the faithful deceased rest in peace. Amen."[56] The chapter was supposed thereby to call upon Saint Martin in its prayers for a group encompassing the "souls of all the faithful." The anniversary, however, was Martin Guerande's, and through its foundation he assured that his presence would be invoked annually in his cathedral.

The *Life of Gervasius and Protasius* was also part of Martin Guerande's accounting for his afterlife. The inscription verbalized his ultimate goal with the words, "God save the donor."[57] His portrait reminded the chapter of his generosity and assured that he would be associated with the tapestry that adorned the walls of the choir. As part of the *ornamenta ecclesiae* of high feast days, the tapestry's connection to Martin Guerande meant he would be commemorated, that his presence would be acknowledged, on these sacred occasions. Consequently, his soul could potentially profit from the increased force of the best-attended and most elaborate ceremonies of the year.

To preserve this added benefit for the donor, the gift of a choir tapestry included restrictions on when it could be displayed. As in the case of Martin Guerande, whose will limited the display of the *Life of Gervasius and Protasius* to "certain solemn festivals of the year," the donors specifically stipulated that their tapestry should be reserved for high feast days.[58] Léon Conseil, canon of Bayeux, went to the additional precaution of supplying a trunk in which to store his *Life of the Virgin* when it was not being displayed at the "solemn festivals." Limiting the time these precious textiles were exposed to light, dust, and other hazards of daily use increased the chances that they would resist the passage of time. Yet these restrictions also guaranteed that the choir tapestry's status as one of the liturgical objects reserved for high feast days would be maintained and that the donor would thus be integrated into these celebrations. Moreover, they assured that the gift of a choir tapestry was not a one-time event but, like the foundation of an anniversary, would continue to elicit prayers on behalf of its donor.[59]

Martin Guerande's gift of the *Life of Gervasius and Protasius* was, in fact, inseparable from the foundation of his anniversary. The year of its donation, according to the inscription, was 1509, that is, the year of his death. The canon's anniversary was thus commemorated not just on November 10 but at the celebration of each high feast day, when the display of the tapestry reminded the viewer both of the date of his gift and the year of his death. Moreover, by adopting the language of the liturgy, the inscription situates Martin Guerande's gift outside the fixed historical moment of its donation to the cathe-

dral, into the eternal present of ceremonial ritual in the choir. This liturgical present also looks forward to the moment at the end of time, when Martin Guerande might profit from the fruits of his generous gifts to the cathedral.

The specification that the tapestry was destined for the choir assured that the donor of choir tapestries would be commemorated in the choir and that, given the social and legal status accorded the dead during this period, he would continue to occupy this sacred space after his stall had passed on to another member of the chapter.[60] In some cases, the reference was even more direct: the portrait of the donor was situated above his stall. The portraits of Canon Léon Conseil and Bishop Guillaume de Hellande, for instance, valorized the cleric seated below them, proclaiming his responsibility for the tapestry; after their deaths, the portraits substituted for these clerics, participating in the ceremony from their place in the choir (fig. 30). In more general terms, the placement of the portrait and inscription at the end or beginning of the tapestry located the memorial to the donor nearest the high altar and relics of the saints, the most privileged spot in the spatial hierarchy of the cathedral.

The requirements concerning the place and time in which choir tapestries were meant to be displayed point to the nature of gift giving as a reciprocal exchange based on predetermined or assumed conditions. As in Martin Guerande's will, which describes each stage of placing the *Life of Gervasius and Protasius* around the choir — from its unrolling to its hanging to its display — accepting the gift of the tapestry implied an agreement to enact this ritual of display.[61]

Jean Ruffault's donation of the *Life of Stephen* to the collegiate church of Saint-Stephen in Lille makes the consequences of not adhering to these conditions explicit. In return for his gift of the tapestry, the chapter had to fulfill certain obligations, had to display the tapestry only on specified feast days and never lend it out.[62] If these conditions were not met, the chapter lost its right to the tapestry and had to return it to the donor's family. The gift of the *Life of Stephen* was therefore contingent on the chapter's continued fulfillment of the terms of the exchange.[63]

The reciprocity inscribed in the donation of a tapestry, as in the foundation of an anniversary, involved more than two parties.[64] In both cases the religious community received a concrete object; in one case the tapestry, in the other, bread, wine, or money. Both acts instilled an obligation on the part of the recipients: in one case, they had to participate in the celebration of the anniversary; in the other, the chapter had to display the tapestry. The chapter assumed the responsibility on each of these occasions to pray to a third party (through the mediation of a fourth, usually a saint or group of saints)

Portrait of Canon Léon Conseil. Life of Mary *(detail), Museum of the Middle Ages — Cluny, Paris. This likeness of the canon was placed above his stall in the choir of Bayeux cathedral.*

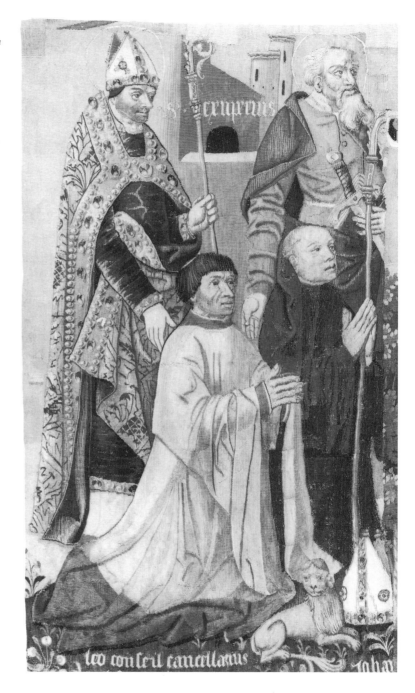

on behalf of the donor. The canons of Lyons articulated the nature of their debt to one of their benefactors in the following terms: "To keep the memory of his gift alive and not be stained by ingratitude."[65] It is God, the third party, who ultimately rewards the donor, thereby reciprocating his gift.

By explicitly describing the terms of his donation in his will, Martin Guerande put in play a cycle of gift giving from which he hoped to gain. The fulfillment of this cycle relied on the members of the cathedral chapter, who initiated and participated in the celebration of high feast days. They profited, in turn, from the way the *Life of Gervasius and Protasius* transformed their choir on these occasions and from the story it told.

THE DONOR AND HIS CHAPTER

The woven *vita* offered the canons of Le Mans a particular account of the saints who represented the distant past of their cathedral. Gervasius and Protasius are baptized in the choir of Le Mans cathedral, an event that reduces the temporal and geographic distance between Milan of the first century and Le Mans of the sixteenth. And, in the final panels, the bishop of Le Mans is also the bishop of Milan. Philip of Luxembourg, one of the most important figures in the French Church at the time, was thus associated with the chapter, even on days when he did not occupy his stall. The relics, purported to have been given to the church of Le Mans, were identified with those discovered by a figure who was both Ambrose and Philip of Luxembourg. The cathedral of Le Mans was accorded a place in the history of Christianity, comparable to that of Ambrose's basilica in Milan; and its patron saints exemplified an ideal of sanctity, that united the community of Christian saints.

Martin Guerande had a personal stake in this story, which ultimately served to heighten the status of the chapter of Le Mans, which was where his primary interests lay. Although he was born in Angers, his career was based in Le Mans. He spent a large sum of money on the restoration of his house, located on the rue Saint Vincent.[66] He demonstrated his allegiance to the church of Le Mans through his various gifts to the chapter. In the final episode of the tapestry he is represented as a canon and member of the chapter of Le Mans. The foundation of his anniversary and his donation of the tapestry inscribed him in this group forever.

Martin Guerande is in many ways representative of the canons who comprised the cathedral chapter. The level of education he attained was common for those in his position. Like many canons, he was accorded prebends thanks to personal connections to royal and ducal patrons. Through him, we see the privileged lifestyle and luxuries en-

The Gift of the Life of Gervasius and Protasius *and Its Donor*

joyed by many cathedral canons, whose multiple benefices permitted them to acquire their own wealth and possessions. He owned an extensive library and his house was furnished in the most up-to-date fashion of the time.[67] The status these canons reached during their lifetimes was preserved in portraits, inscriptions, and other types of memorials. But, in addition to proclaiming their notoriety for future generations, they sought to assure their afterlife, through the foundation of anniversaries, charitable donations, and, occasionally, works of art.[68]

As in the case of Martin Guerande, however, these gifts, meant to assure an individual canon's salvation, benefited the chapter as a whole. The chapter of Le Mans received the proceeds from his wealth upon his death, through the annual allocation of bread and wine. And the tapestry adorned the stalls that the chapter had recently reconstructed, making its choir more luxurious and beautiful. Within the tradition of adorning churches with textiles, for which Moses' tabernacle provided a dramatic precedent, displaying the tapestry in their church on high feast days honored God. Preserving the tapestry as well as its liturgical associations could thus contribute to their own salvation.

The perfect cycle of gift giving set in motion with Martin Guerande's donation of the *Life of Gervasius and Protasius,* and repeated with the subsequent display of the tapestry on high feast days, did not last as long as he had hoped. Twenty years after the donation of the tapestry and the canon's death, the chapter modified the directives in his will. At a chapter meeting on July 1, 1529, the canons passed a motion extending the period of time in which the tapestry would be displayed in the choir, thereby reducing the labor required to put it up and take it down.[69] The *Life of Gervasius and Protasius* continued to hang in the choir during high feast days. The donor could still profit from the commemoration of his gift and the collective prayers of the chapter on these solemn occasions. But its display was not strictly limited to them. The chapter thereby took one step toward what would ultimately be a total dissociation of choir tapestries from their liturgical signification.

The *Life of Stephen*

The Liturgical Setting of Choir Tapestry and Its Performance of the Saint's *Vita*

Jean Baillet, the bishop of Auxerre from 1478 to 1513, donated the *Life of Stephen* to his cathedral. Although the lack of documentation from the episcopate of Jean Baillet makes any assertions concerning the terms and date of this donation hypothetical, the bishop's arms, woven nine times along the length of the tapestry, confirm his role in its making. The *Life of Stephen* is first mentioned in the cathedral inventory of 1569. During the religious wars in 1567, the tapestry was removed from the cathedral and sold, but the chapter quickly recovered it. The tapestry is mentioned in the inventories of 1641, 1726, 1733, and 1752. These references make clear that, like other choir tapestries, the *Life of Stephen* was displayed over the choir stalls and along the rood screen on certain feast days. The tapestry enclosed three sides of the canons' choir during these liturgical celebrations until 1771 when the chapter began its plans for the modernization of the cathedral. In 1777, it sold the tapestry to the Charity Hospital of Auxerre. Two sections of the tapestry passed into a private collection before the Louvre purchased them in 1838. In 1880, the Cluny Museum bought the sections of the tapestry still in the Charity Hospital and in 1897 acquired the two sections in the Louvre. Restorations of various kinds are recorded in 1882, 1914, and 1937. In 1997, the tapestry was cleaned, and the entire series was exhibited in the Papal Palace in Avignon. In 2000, the *Life of Stephen* was returned to Auxerre, where it was the focus of an exhibition at the Saint-Germain Museum. It is currently on display in the Museum of the Middle Ages, Paris.

A reading of the *Life of Stephen* will allow us to visualize the liturgy of Stephen as it was celebrated in Auxerre cathedral. Each of the four sections of the tapestry documents a single stage in the saint's life and the journey of his relics. These episodes, in

turn, provided the basis for Stephen's feast days in Auxerre: his martyrdom, the invention of his relics, and their translation, first to Constantinople and then to Rome. Moreover, the veneration of the saint depicted along the woven *vita* mirrored the actual celebrations in his honor in Auxerre. Consequently, at each of these festivals the processions of Stephen's body in the tapestry seemed to transport these relics from the three capitals of Christendom into the choir. The story told on high feast days confirmed the saint's presence in Auxerre's cathedral and the central place of the city within a Christian universe.

How did the performance of the liturgy in the cathedral of Auxerre inform and transform the woven text, and what was the story of Stephen that this ensemble produced? By responding to that question, we can begin to understand how choir tapestries became integral parts of the liturgy.

Stephen's place in Christian history accorded him a privileged status among all saints. He was elected deacon by Saint Peter and the other apostles, who provided a direct link between him and Christ. The circumstances of his life and death are recounted in the New Testament (Acts of the Apostles 6–7). His sacred position stemmed from the fact that he was considered the first martyr. Stephen became an example for all saints who followed after him and his death was equated with Christ's sacrifice. The parallel between Stephen and Christ was inscribed in the liturgy: his feast, or "birth into heaven," was celebrated on December 26, the day after Christ's birth.

Stephen was an object of universal veneration: more cathedrals were dedicated to him than to any other saint, with the exception of the Virgin Mary. Stephen's relics were dispersed in the fifth century and hundreds of churches claimed to possess a remnant of the saint or one of the stones with which he was martyred.[1] The invention of these relics in the fifth century is recounted in a letter written by the priest Lucien, who witnessed their miraculous discovery. Anastasius provides a description of their subsequent translations to Constantinople and then to Rome.[2] Drawing on these letters and the account in Acts, Jacobus de Voragine recounts the story of Stephen's life and the fate of his relics in two chapters of the *Golden Legend,* one set on the day of his feast, December 26, the other on that of the invention of his relics, August 3.

The beginning of Stephen's cult in Auxerre corresponded to the foundation of the church in the city. Bishop Amatre (385–415) dedicated the cathedral of Auxerre and its high altar to the saint in 415.[3] It is not clear when the cathedral received Stephen's relics: Bishop Hugues of Montaigue (1111–1136) swore an oath on the hand of the saint;[4] Bishop William of Seignelay (1207–1220), who was also responsible for the new Gothic church, donated one of Stephen's fingers, which he had brought from Constantinople; Stephen's

arm is listed in the fifteenth-century inventory of the cathedral's relics, which also includes an unidentified bone and stones from his martyrdom.[5] William of Seignelay ordered an annual procession in honor of the saint on December 25, the vigil of his feast day, for which the cathedral chapter was to wear their silk copes and hold candles.[6]

The connection between the cathedral and the first martyr served to distinguish it from the monastic church of Saint-Germain located to its west. The association between the chapter and Stephen differentiated its members from the monks of Saint-Germain, who guarded the relics of Germain, the city's first bishop (418–448). The seals of the chapter confirm its identification with the first martyr: an image of Stephen holding the palm of martyrdom was represented on the chapter's seal of 1120 and 1194, and the dean's seal of 1431 included a scene of Stephen's stoning. Jean Baillet, donor of the tapestry, also chose an image of the saint's martyrdom for his episcopal seal.[7]

This long-standing tradition of devotion to Stephen, however, did not distinguish Auxerre from the multitude of other centers of his cult. Whereas Saint Germain's *vita* already takes place in Auxerre,[8] a story needed to be created that linked Saint Stephen and his relics to the cathedral of Auxerre. To this end, Jean Baillet and his advisers commissioned a woven *vita* that worked in conjunction with its liturgical setting to forge a link between Stephen and the church of Auxerre.

THE WOVEN *VITA*

As the first study devoted to the tapestry observes, the episodes depicted in the *Life of Stephen* draw from Jacobus de Voragine's account in the *Golden Legend*.[9] Beginning with the circumstances of the saint's life and martyrdom, also recounted in Acts, the *Golden Legend* and the tapestry supplement the *vita* of Stephen with the fate of his relics — their invention and then their translation, first to Constantinople, and finally to Rome.

In this *vita* Stephen is one of the seven deacons elected by the apostles to mediate between the Jews and the Greeks in Jerusalem (figs. 31a–b). Peter places his hands on Stephen, ordaining him a deacon. Peter, however, is merely an instrument of God, whose hand, descending from the sky, emits a ray of light onto Stephen's head. Stephen's preaching places him in opposition to the leaders of the synagogue, who arrest him and accuse him of blasphemy against God and Moses (figs. 32a–b). The Jews refuse to listen to Stephen, who recounts that he sees God, with His Son at His side, in the sky (fig. 33). They lead him outside the city where he is stoned, an event that Saul, later Paul, witnesses (figs. 34a–b). Gamaliel and his son discover Stephen's body and remove it for burial (figs. 35–36a).

The second chapter relates events surrounding the discovery of Stephen's body in the

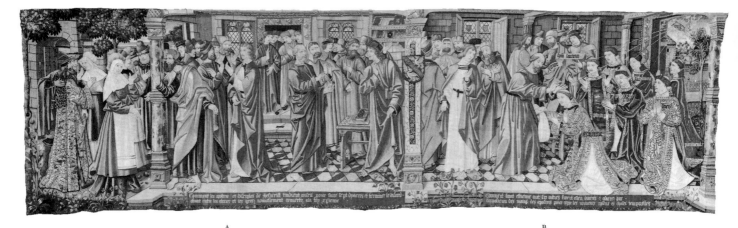

FIGURE 31. Life of Stephen, *ca. 1500, Museum of the Middle Ages — Cluny, Paris.*

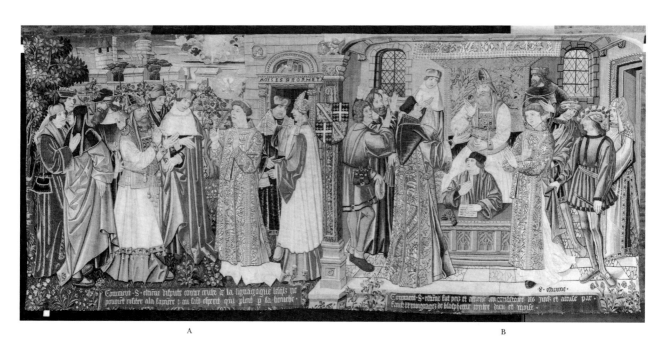

FIGURE 32. Life of Stephen, *ca. 1500, Museum of the Middle Ages — Cluny, Paris.*

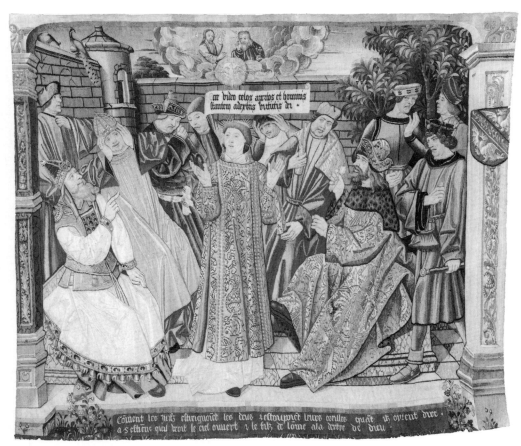

FIGURE 33. Life of Stephen, *ca. 1500, Museum of the Middle Ages* — *Cluny, Paris.*

fifth century. Gamaliel appears three times to the monk, Lucien, as he sleeps, and discloses the location of Stephen's body (fig. 36b). Lucien then recounts his dreams to John, bishop of Jerusalem (fig. 36c). The latter, with his entourage, looks in vain for the saint's body (fig. 37). At the same time, Gamaliel reveals the precise location of the body to another monk named Migetius, who transmits this information to Bishop John (fig. 38a). Another search takes place, this time successfully, and the body of Stephen is carried inside the walls of Jerusalem (fig. 38b, plate 11).

Stephen's translation from Jerusalem to Constantinople is depicted in the third chapter of the tapestry. Juliana asks the bishop of Jerusalem to transfer the body of her husband, the Byzantine senator Alexander, back to Constantinople. Alexander had been

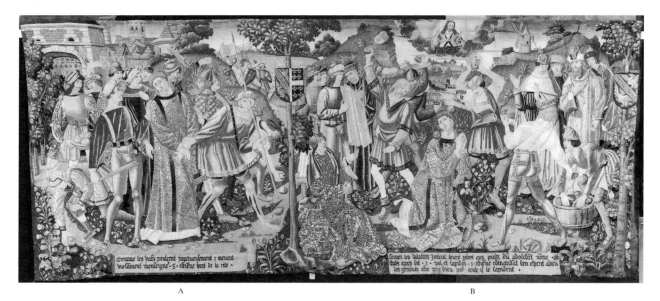

FIGURE 34. Life of Stephen, *ca. 1500, Museum of the Middle Ages — Cluny, Paris.*

buried next to Stephen's relics in an oratory he constructed for the saint in Jerusalem (fig. 39a). Her wish is granted; however, she inadvertently takes the casket containing the saint's body, rather than her husband's remains. When a violent storm strikes the ship, Stephen intervenes, guiding the group safely to Constantinople (fig. 39b). Once there, Stephen's relics are carried in a procession, led by Eusebius, bishop of Constantinople (fig. 39c, plate 10). Eventually, the mules drawing the wagon with the relics refuse to advance any farther; this spot becomes the saint's new burial place (plate 12).

The fourth chapter shows how Stephen's relics were moved from Constantinople to Rome. This event takes place for the benefit of Eudoxia, the daughter of Theodosius, Byzantine emperor in Rome. She is possessed by a demon who demands that Stephen's body be brought to Rome. The emperor, her father, consults with the pope, and they send an emissary to Constantinople to retrieve the body of Stephen in exchange for that of Lawrence, already in Rome (fig. 40a). Stephen's body arrives and is placed in the church of Saint Peter in Chains (fig. 40b). The demon, however, is still not satisfied: Stephen must be placed next to Lawrence (fig. 40c). When the agents from Constantinople attempt to take the body of Lawrence, they are struck dead (fig. 40d). Finally, the two saints are united; the demon leaves Eudoxia; and Stephen and Lawrence are venerated (fig. 41).

Stephen's journey from Jerusalem to Rome traces not only the decisive stages in the

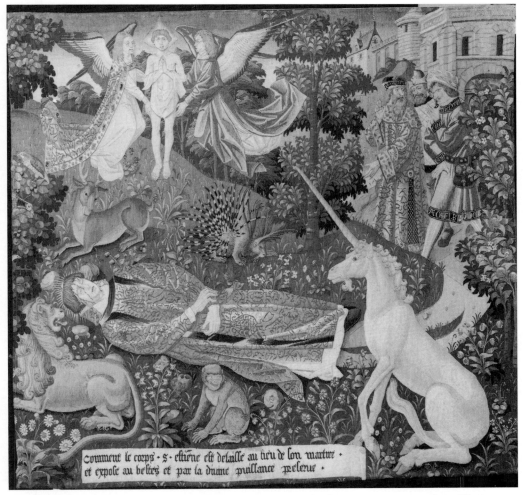

FIGURE 35. *Stephen's soul rises; Gamaliel approaches.* Life of Stephen *(detail), ca. 1500, Museum of the Middle Ages —* Cluny, Paris.

saint's *vita* but also the annual ceremonies in honor of the saint, celebrated in Auxerre from the fourteenth to the early sixteenth centuries. The Martyrdom of Saint Stephen (December 26) was an annual feast day with an octave, as was the Invention of Saint Stephen's Relics (August 3). Duplex feast days celebrated the translation of his relics to Byzantium (November 17) and to Rome (May 6).

The majority of extant liturgical manuscripts for the use of Auxerre include all four

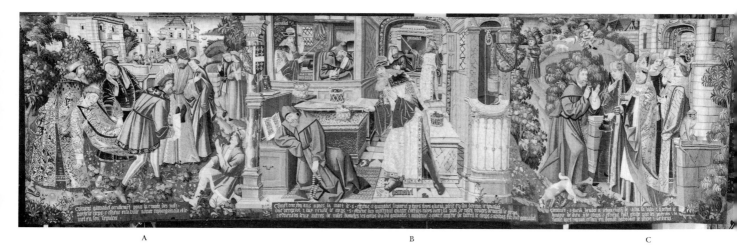

A B C

FIGURE 36. Life of Stephen, *ca. 1500, Museum of the Middle Ages — Cluny, Paris.*

of these feasts, though two manuscripts omit the saint's translation to Rome, and the status of the two translations — whether they were duplex or solemn feasts — varies depending on the manuscript.[10] However, the frequency with which both Stephen's translations appear in Auxerre's liturgical calendar distinguished the cult of Stephen in that diocese from its celebration in other religious communities. The two translations of Stephen's relics were not included in the Roman calendar, nor were they celebrated uniformly in the other cathedrals dedicated to the protomartyr.[11]

The four feasts associated with Stephen were spaced evenly over the year in Auxerre's liturgical calendar, with each feast corresponding to a different season. References to a feast day often identify it not in terms of the event it commemorates but by the season in which it takes place, thereby underscoring this association. Thus, the celebration of the saint's martyrdom is called "Winter Saint Stephen," and that of the translation to Rome "Summer Saint Stephen."[12]

The four feasts that took place at distinct times in the annual cycle paralleled the four major feasts celebrated in honor of Christ and the Virgin.[13] A bull drafted by Pope Clement V (1305–1314) granted indulgences for the celebrations in Auxerre of the four major feasts of Christ, the Virgin, and Stephen.[14] Indeed, in Auxerre's liturgical calendar, Stephen was accorded a status comparable to that of the Virgin and Christ.

Jean Baillet played a significant role in the standardization and propagation of the liturgy of Stephen within his diocese. He commissioned a Missal for use in the cathe-

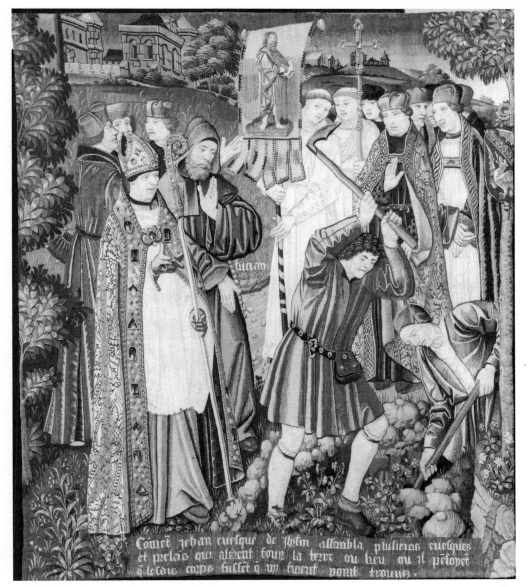

FIGURE 37. *Bishop John digs for Stephen's body.* Life of Stephen *(detail), ca. 1500, Museum of the Middle Ages — Cluny, Paris.*

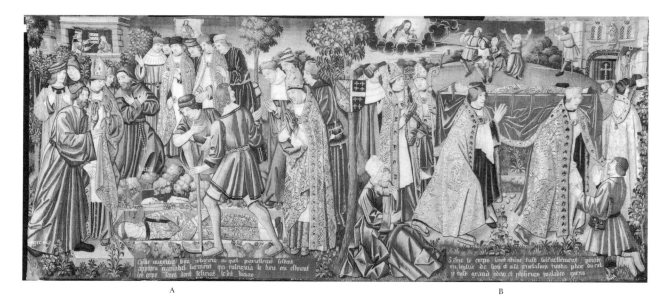

FIGURE 38. Life of Stephen, *ca. 1500, Museum of the Middle Ages — Cluny, Paris.*

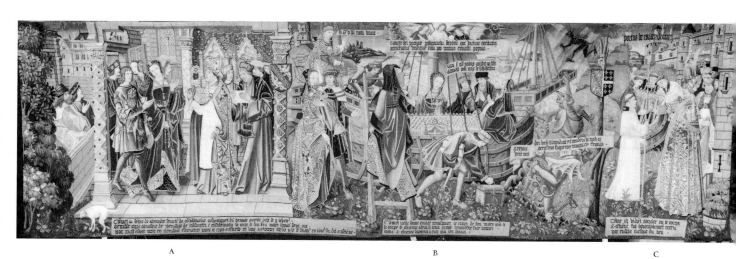

FIGURE 39. Life of Stephen, *ca. 1500, Museum of the Middle Ages — Cluny, Paris.*

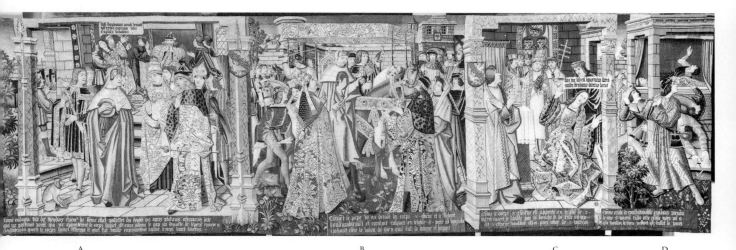

A B C D

FIGURE 40. Life of Stephen, *ca. 1500, Museum of the Middle Ages — Cluny, Paris.*

dral, which includes the readings for the four celebrations in honor of the first martyr.[15] This luxury manuscript, ornamented with two full-page illuminations and the bishop's arms, no doubt served on the occasions when he officiated in his cathedral. At his death, he donated the manuscript to the chapter so that it would continue to be used in the cathedral. Jean Baillet was among the first bishops to have liturgical texts printed for the use of his diocese: his manuscript served as the basis for a Missal, printed around 1490; and he was responsible for the printed Breviary of 1483.[16] These texts provided priests in Auxerre with the readings for the four feasts of Stephen.

In turn, Jean Baillet's donation, the woven *vita* of Stephen, provided a visual panorama of the annual cycle of feasts in honor of the saint in Auxerre's liturgical calendar. On each of the saint's feasts celebrated in the cathedral, the events commemorated on all four feasts were displayed simultaneously on the walls of the choir. Like the distribution of Stephen's feasts over the course of the year, the events relating to these feasts are separated into four temporally and geographically distinct chapters. Stephen's life and martyrdom take place in Jerusalem in the first century. Lucien's letter explaining the circumstances under which Stephen's body was discovered outside Jerusalem dates the invention to the year 415.[17] According to this same account of Stephen's relics, the first translation to Constantinople occurred thirteen years later.[18] Stephen made his final journey to Rome during the pontificate of Pelagius II (578–590).[19]

The interaction between liturgical manuscripts and printed books for use in Auxerre

<div align="right">

The Life of Stephen 91

</div>

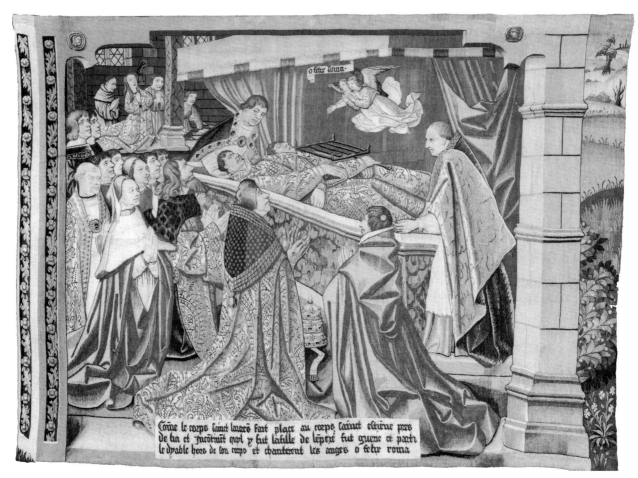

FIGURE 41. *Stephen is moved next to Lawrence and is venerated; the devil leaves Eudoxia.* Life of Stephen *(detail), ca. 1500, Museum of the Middle Ages — Cluny, Paris.*

and the *Life of Stephen* is demonstrated further by the overlap between individual episodes. Following Monceaux, existing studies on the tapestry identify the *Golden Legend* as the "source" for the tapestry. As for the events de Voragine does not include, Véronique Notin and then Fabienne Joubert locate their "sources" in Lucien's letter of 415 recounting the invention of Stephen's relics (the episode of Gamaliel's appearance to Migetius), and in Anastasius's letter (the mules' refusal to transport Stephen's relics; fig. 38a, plate 12).[20] However, Auxerre's liturgical texts provide references to these episodes that are more directly relevant to the religious setting in which the tapestry was seen.

Gamaliel's appearance to Migetius is included in the description of the invention of Stephen's relics in the printed Breviary.[21] This text does not mention the scene in which the mules refuse to transport Stephen's relics as part of the readings for November 17, and since all the summer festival sections of the fifteenth-century manuscript Breviaries for Auxerre have disappeared, it is impossible to verify whether they included this event. But the Missal, commissioned by Jean Baillet's successor, François of Dinteville, does recount the circumstances of the mules' refusal, suggesting either that this Missal relied on a now-lost manuscript for this episode, or that the tapestry served as its "source."[22] In either case, this event formed part of Auxerre's official liturgy for the feast of Stephen's translation to Constantinople.

Since three of Stephen's feasts in the liturgical calendar focus on his relics, the *Life of Stephen* shifts attention from the saint's deeds to the devotional acts of Stephen's cult worldwide. Eight episodes concern Stephen's life and death, whereas fifteen depict the posthumous events related to the veneration of his relics. The four phases in Stephen's *vita* are linked thematically by a shared devotion to Stephen that crosses geographic and temporal boundaries. These elaborate processions underscore the ceremonial aspect of a community's veneration of the saint, a form of devotion that unifies the capitals of Christendom: Jerusalem, Constantinople, and Rome.

Further, the motif that establishes the junctures among the four chapters of the tapestry is a procession carrying Stephen's body. Gamaliel takes Stephen's body to its place of burial, helped by his son and accompanied by groups of spectators (fig. 36a). John, bishop of Jerusalem, follows the open casket, carried by two members of the ecclesiastical hierarchy, toward the walls of the city (fig. 38b, plate 11). Three mules transport the golden reliquary containing the saint's body toward Constantinople. The bishop of Constantinople, with his clergy, leads this group, while the senator's wife, with her entourage, follows behind (plate 12). Each chapter of the story concludes with an image of devotion to Stephen's relics, and the story ends with the veneration of the saint at his final destination (fig. 41).

These processions are immediately followed by the first episode in the succeeding chapter. Gamaliel, helped by his son and another man, carries Stephen's body to be buried. The episode directly to the right depicts Lucien's dream of Gamaliel, in which the latter discloses the location of Stephen's body. The intermediate scene of Stephen's burial is left out. The woven *vita* also skips from the procession into Jerusalem to the oratory in which Stephen's body has already been placed; the scene of the actual deposition of the body is missing. Then we move from the procession into Constantinople to a scene depicting the emperor sending an emissary to bargain for Stephen's body; the scene depicting the burial of the

relics is omitted. Hence, in each of the first three chapters, the causal logic of the story is suspended, since the actual burial of the saint is not shown. The divisions between the chapters are demarcated by a procession of the saint's body and by an ellipsis in the woven text.

This organizational system distinguishes the *Life of Stephen* from other versions of the saint's *vita*. The Stephen cycle on stained glass in Auxerre is so fragmentary that a narrative analysis of it is not possible, but the stained-glass *vita* in the cathedral of Bourges offers a striking comparison with the tapestry (fig. 42).[23] In the window devoted to the invention and translation of the saint's relics, situated in the first chapel on the north side of the ambulatory, Gamaliel and his son place the body of Stephen in his tomb. And, following the discovery of his body by Bishop John, the relics are venerated in a golden reliquary in a chapel, where, in the next scene, Juliana arrives to recover the body of her husband. Like the Bourges window, the *Golden Legend* marks the end of the invention of the relics and their first translation with a description of the saint's burial. These two sections of the *vita* conclude with the phrase, "thus Stephen was buried with ceremony."[24]

THE *LIFE OF STEPHEN* IN THE CHOIR

The architectural setting of the *Life of Stephen* reproduced the division of the *vita* into four separate chapters. The references to the tapestry in the cathedral inventories confirm that it was displayed above the choir stalls, which the chapter had commissioned in 1462.[25] Based on the length of the series and the dimensions of the cathedral, we can conclude that the tapestry began at the south side of the canons' choir, at the start of the fourth bay from the nave, and continued along the stalls, across the rood screen, and along the stalls on the north side of the choir (diagram 3, fig. 43). Therefore, the distribution of the tapestry within this space conformed to the organization of Stephen's *vita*: the martyrdom of the saint stretched along the south side of the choir; the invention of his relics occupied the length of the rood screen; and the two translations of his relics spanned the north side of the choir.

Like other choir tapestries, the *Life of Stephen* ornamented the choir, in all probability, only on high feast days. This is supported by the description of the tapestry in the cathedral's inventories of 1726 and 1752. A collection of documents concerning the liturgy of the cathedral of Auxerre helps to specify the particular days on which the tapestry was displayed.[26] A marginal note to a list of the high feast days on which rugs (*tapis*) are placed in the choir mentions that the tapestries had once also been displayed on these same days, namely, Easter, Pentecost, Corpus Christi, the Invention of Stephen's Relics

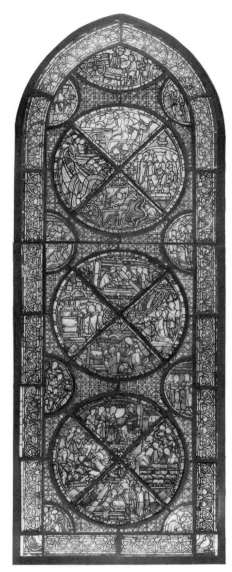

FIGURE 42. *Invention and translation of Stephen's relics. Stained glass, thirteenth century, Saint-Etienne, Bourges.*

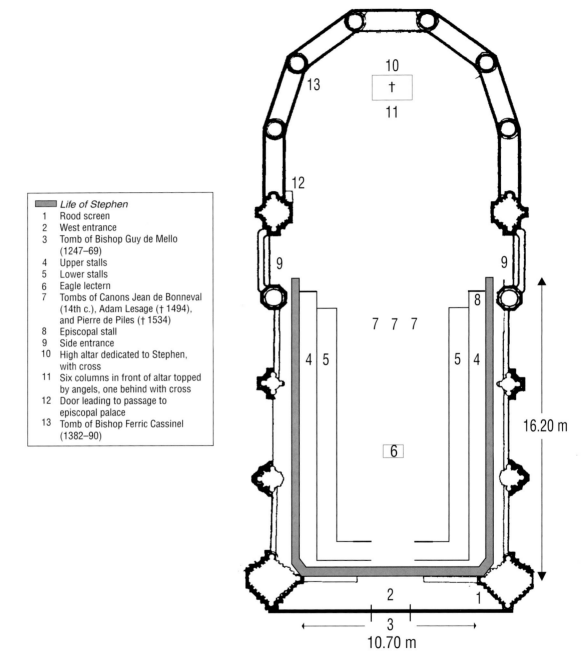

Life of Stephen
1 Rood screen
2 West entrance
3 Tomb of Bishop Guy de Mello
 (1247–69)
4 Upper stalls
5 Lower stalls
6 Eagle lectern
7 Tombs of Canons Jean de Bonneval
 (14th c.), Adam Lesage († 1494),
 and Pierre de Piles († 1534)
8 Episcopal stall
9 Side entrance
10 High altar dedicated to Stephen,
 with cross
11 Six columns in front of altar topped
 by angels, one behind with cross
12 Door leading to passage to
 episcopal palace
13 Tomb of Bishop Ferric Cassinel
 (1382–90)

16.20 m

10.70 m

DIAGRAM 3. *Choir of Saint-Etienne, Auxerre, during the episcopate of Jean Baillet (1478–1513).*

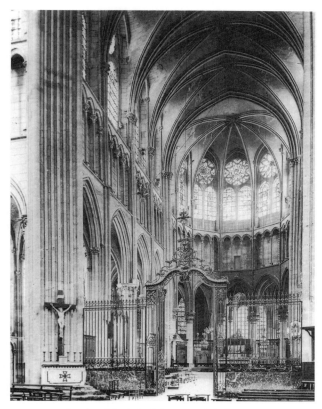

FIGURE 43. *Interior of the choir of Auxerre cathedral.*

(August 3), the Assumption of the Virgin, All Saints' Day, and Christmas. Since the tapestry was to remain in the choir during the octave of these feasts and from the Invention of Stephen's Relics through the Assumption of the Virgin on August 15, it would have been displayed for three feasts in honor of Stephen: the Martyrdom (December 26), the Invention of the Relics (August 3), and the Translation of the Relics to Rome (May 6).

The altar dedicated to Stephen was the visual and ceremonial focus of high feast days in Auxerre cathedral. The devotional significance of the altar lay in part in the relics it had once housed. In the twelfth century, Hugues of Montaigue took his oath to the chapter "on the hand of Saint Stephen [placed] above his altar."[27] Throughout the history of the cathedral, bishops demonstrated their devotion to Stephen[28] with donations destined for the high altar. Aaron (800–813) reconstructed it and added a ciborium of gold and silver.[29] His successors Angelelme (813–828),[30] Héribalde (824–857),[31] and

Humbaud (1087–1114) contributed other precious ornaments.[32] Gaudry (918–933) gave a golden hand decorated with jewels in honor of Stephen, which was to be placed on his altar.[33] It cannot be verified whether Stephen's relics were placed on the altar during the episcopate of Jean Baillet. What is more important, however, is that from the foundation of the cathedral, the altar had always been associated with the saint.[34]

The *Life of Stephen* extended the reference to the saint from its devotional focus in the middle of the sanctuary to the walls of the choir. The tapestry broadcast in large format the association established at the cathedral's foundation between the sacred site of the choir and Stephen. It also provided a detailed account of the saint's relics, whose placement on the altar was part of the cathedral's history. Particular attention is accorded the woven reliquary holding Stephen's relics: as it moves from Jerusalem to Constantinople, we glimpse its ornamentation of gold and blue stone from various sides (figs. 39a–c, plate 12). It is revealed, just after the saint's invention and then again when Stephen is placed next to Lawrence in Rome, that it contains his unscathed and complete body (figs. 38b, 41). By extension, the fragments of the saint in the cathedral's possession were associated with this image of his body.

Stephen's altar supplemented the woven *vita.* As we have seen, the deposition of the saint's body at its site of veneration is omitted from the end of the first three chapters of the story. Instead, Stephen is carried processionally three times, first his body is transported by hand, then it is exposed on a bier, and finally it is concealed in a reliquary. The association of the altar with Stephen and the implied presence of his relics supplied the event missing three times from the woven text, filling in the ellipses that punctuate the *vita.* In the process, the altar provides a potential destination for the processions: each one transports Stephen into the choir of Auxerre cathedral.

The display of the tapestry confirmed the authenticity of Auxerre's relics and established an analogy between the veneration of Stephen's relics in Auxerre and the journeys of his relics recounted in the tapestry. But the woven *vita* also made a stronger statement, namely, that the processions of the saint led ultimately to Auxerre. Consequently, this city was situated at the center of a Christian world around which Jerusalem, Constantinople, and Rome radiated.

THE PERFORMANCE OF THE SAINT'S LIFE

Manuscripts and printed books used for the celebration of Stephen's feasts in Auxerre vividly illustrate the conception of time on which the liturgy is based.[35] First, the liturgical calendar is composed of a cycle of annually repeated celebrations. The posi-

tion of each feast day within this cycle is symbolic, and does not correspond to the actual date on which these events supposedly took place. For example, Stephen's martyrdom, his birth into the sky, was celebrated the day after Jesus' birth, and a feast day in honor of the saint falls during each season of the year.[36] Second, the feasts of Stephen's martyrdom, invention, and translations are not considered the anniversaries of events that occurred in the past but rather their reenactment in the present. Following the script provided in liturgical texts, the deacon and subdeacon assume the voices of Stephen and his persecutors, staging important moments in the saint's life during the office. For them, the event honored on each feast day takes place *hodie*, the "today" of the liturgy that recurs every year.[37]

Liturgical temporality stands in distinct contrast to the presentation of events the length of the tapestry. The conception of time in the tapestry is a linear one in which events are positioned sequentially according to their location on a temporal axis. We read the *vita* as a series of temporally and geographically distinct events that occurred once in history.

Within its ceremonial system, however, the *Life of Stephen* also accommodates the time of the liturgy. The procession of the saint's body that winds across the tapestry (figs. 36a, 38b, plate 12, fig. 40b) introduces the repetition of events that structures the liturgical calendar. The destination of each procession is omitted from the woven *vita* and its origin is obscured: disappearing behind a hill or through a gateway in one episode, the procession reappears at a later juncture. A banner depicting John the Baptist holding the Lamb is carried in each of these processions, underscoring their similarity. The floral border spanning the length of the tapestry creates a spatial continuity between the stages of the saint's journey. Consequently, separate events occurring in Jerusalem, Constantinople, and Rome merge into a single procession of Stephen's relics, which is repeated over the course of history.

Through visual correspondences to the performance of similar ceremonies in Auxerre, this processional event from the past was reenacted in the present. On high feast days, all members of the chapter, as well as its bishop, processed into the choir clothed in the finest liturgical vestments, carrying liturgical instruments reserved for the occasion.[38] Throughout the tapestry, we see components of these rituals: bishops wearing miters and copes and carrying episcopal staffs, canons in their copes, and choir boys clothed in white, carrying golden crosses (figs. 37, 38a–b, 39c, plates 10–12). At these junctures, the route of the procession in the tapestry continued into the space of the choir, merging with the route of Auxerre's clergy.

The visual parallels between the celebration of high feast days in Auxerre and the ceremony depicted in the tapestry were, in some cases, even more specific. The inventory of the cathedral treasury compiled in 1531 describes three copes given to the cathedral by Bishop Enguerrand Signart (1473–1477),[39] Jean Baillet's predecessor. Made of expensive materials,[40] the copes were embroidered with historiated scenes, one depicting the Annunciation of the Virgin, another the stoning of Stephen, and the third a crucifix.[41] Two of the copes in the tapestry resemble Signart's donations to the cathedral: the bishop of Constantinople wears a cope ornamented with the Annunciation and, in the scene immediately following, a canon on the right-hand side wears one that depicts the stoning (fig. 39, plates 10, 12).

Further, the actual readings for the feast days of Stephen in Auxerre appear within the woven *vita*. The saint's words, "Ecce video celos apertos et filium ad dextrum dei"[42] formed a leitmotif, repeated over and over during each mass performed in his honor.[43] Stephen says these same words in the tapestry. The Latin phrase is twice woven above the saint's head: at his trial and at his martyrdom (figs. 33, 34b).[44]

But the *Life of Stephen* also shares a broader organizational feature with these readings on Stephen's feast days: the invention and translations of the saint's relics return to the event of his martyrdom. In the tapestry, the references to this event are made through a series of paths that wind in and out of the woven *vita*. These paths appear for the first time as Stephen is led to his martyrdom; they provide the stones for his executioners and guide a group of observers in the background (fig. 34a). At the saint's death, the four gray strips converge at the kneeling saint (fig. 34b), and, in the next scene, they lead directly to Stephen, disappearing under, then emerging from, his prone body (fig. 35). The path reappears on the three occasions when his relics are carried processionally: it leads Gamaliel to Stephen's body and directs his movement as he carries the saint; it runs directly under the bier when the saint is transported into Jerusalem; and it stretches along the route of the procession toward Constantinople (figs. 36a, 38b, plates 11, 12).

The significance of this path is underscored by the symbols of Stephen's death along its edges. The stones with which he was killed, first depicted at his martyrdom, reappear at each procession of the saint's body. When he is finally placed next to Lawrence, a single stone recalls the moment of his death (fig. 41). Red roses first appear in scene 10, distinguishing his coffin from those of Gamaliel, Abibas, and Nicodemus (fig. 36b). Roses are included directly below his bier outside Jerusalem and are worn as garlands by the men carrying the baldachin above his reliquary in Constantinople (plate 12). It is confirmed that these roses refer to the saint's death in the reading for the saint's inven-

tion in Jean Baillet's Missal, which equates the roses on Stephen's coffin with the saint "who, blazing like a rosy flower, bloomed crimson in martyrdom."[45]

Like the woven processions running the length of the tapestry, the liturgical readings for each feast day in honor of Stephen in Jean Baillet's manuscript and printed Missal return repeatedly to the martyrdom of the saint, the event commemorated on December 26.[46] The readings for the high mass on this day are structured as a dialogue. The opening prayers include the voices of Stephen and those who praise him, spoken by members of the choir. The celebrant continues with speeches that had first been given by Stephen and Jesus. Interspersed within this dialogue is the account from Acts (6–7) of Stephen's election as deacon, his trial, and his martyrdom.

The event commemorated on the three other festivals is specified in the Preface, but the readings, prayers, and chants of the mass are, with slight variations, the same as those for the ceremony for Stephen's martyrdom. In all three cases the celebrant, following directives for each ceremony, was meant to turn the pages of the Missal back to December 26.[47] Only the Prose of the mass differentiates the Invention and the Translations to Constantinople and Rome from the Martyrdom. The first text describes Lucien's vision of the roses that marked Stephen's grave, comparing these flowers to the blood the saint shed at his martyrdom.[48] The second is devoted entirely to the martyrdom of the saint: his sacrifice and the evil of his executioners.[49] The celebration of Stephen's Translation to Rome is even closer to the feast on December 26; it adopts the second part of the Prose for Stephen's martyrdom: Jesus' speech in Matthew 23.[50]

By recalling Stephen's martyrdom at successive moments in the saint's life, the liturgical readings for Stephen's feasts and the tapestry depicting his *vita* thematize his sacrifice. In so doing, they underscore Stephen's relationship to Christ, whom he imitated with his death. The saint's life becomes, by extension, a demonstration of the sacrifice performed at each mass. The enactment of Stephen's martyrdom in the woven and spoken versions of his *vita* represented in the choir provided a historical parallel for the Eucharistic celebration at the high altar.

The detailed references to the Crucifixion that appear on each depiction of the reliquary underscore the parallel between Jesus' and Stephen's deaths. The three side views of the reliquary carrying the body of the saint include a representation of Christ's death: in the first, a gold cross is placed on a bright blue enamel surface; in the second, this symbol becomes an event, with a golden representation of Christ on the cross, flanked by Mary and John the Evangelist; in the third, a detailed scene in gold against a blue enamel background elaborates on this image. In addition, the three reliquaries are

The Life of Stephen

topped by golden crucifixes and, in the second scene, a Crucifixion held by a choir boy provides a third visual reference to Christ's death above the reliquary.

It is also possible that the woven reliquaries provide a more direct reference to the Eucharist, by recalling the *joyau,* a precious golden reliquary that Jean Baillet donated to the cathedral. The inventory of 1531 describes its ornamentation: a Crucifixion scene in enamel adorned one side and another in sculpted gold graced the top.[51] Although it might also have housed relics, the *joyau* served primarily to transport the Host processionally during the feast of Corpus Christi in Auxerre.[52] The woven reliquary in the tapestry would have thus provided repeated visual references to the ceremonial exposition of the Host, thereby underscoring the connection between the bodies of Stephen and of Christ.

The copes embroidered with scenes, first, of the Annunciation, and then of Stephen's martyrdom further strengthen the Eucharistic associations within the *Life of Stephen.* The second cope, worn by a canon in the procession into Constantinople, encapsulates the theme of the tapestry as a whole, the saint's sacrifice. In relation to the first cope, which it directly follows, however, this image takes on an added meaning: Stephen's birth in heaven is modeled on the Incarnation, the event for which the Eucharist stands.

These symbolically charged points in the tapestry prompt the viewer to contemplate the significance of Stephen's death. Each one introduces a pause in the succession of events that form the woven *vita,* addressing the viewer with a direct reference to the saint's sacrifice. As he is incited to supplement the ellipses within the tapestry with the altar dedicated to Stephen in the sanctuary, or to relate the woven processions to the ceremony in the choir, these moments in the tapestry actively engage the viewer. Here, through an additional visual reference to the sacrifice that takes place on the altar, the viewer is led to reflect on Stephen's sacrifice in relation to the ceremony performed at the altar.

On the feast days that did not honor Stephen directly, the woven *vita* functioned without the added support of the readings that incorporated the saint's story into the liturgy. The woven panorama of events in the life of the first martyr was made part of all the major celebrations in the cathedral, those in honor of Christ (Easter, Corpus Christi, Christmas, Pentecost) and those of the Virgin (Assumption and Annunciation) as well as the festival of All Saints' Day. Displayed around the walls of the choir, the tapestry linked Stephen's sacrifice to the Eucharistic sacrifice performed at each mass.

In this way, the *Life of Stephen* and ceremonial performance constructed a liturgical ensemble on high feast days, each complementing and elaborating on the other. Within its ceremonial setting, the *Life of Stephen* reinforced a dual association between the high altar and the cathedral's patron saint: it confirmed the presence of his relics, and it inscribed

his martyrdom within a history that began with God's sacrifice. The Christian liturgy was thereby linked to a story of Stephen, which, in turn, revolved around Auxerre. The cathedral and its chapter's privileged relationship to the first martyr were established at the celebration of each high feast day.

The *Life of Stephen* was also a particularly effective means for Jean Baillet to assert his presence in the choir on these occasions.[53] The woven *vita* introduced references to the bishop and other members of his family through the repetition of their arms along the tapestry. In addition, Jean Baillet became part of the saint's *vita*. He shared the name of the bishop of Jerusalem responsible for "discovering" Stephen's body, identified in the titulus as "Bishop John." Because each procession displayed a banner with an image of Jean Baillet's patron saint, John the Baptist, the viewer was reminded at each stage in the saint's journey of Baillet's role in the tapestry's making (figs. 37, 38a–b, 39c, plates 10–12). Finally, it is tempting to see a likeness of Jean Baillet in the particularly detailed features of the cleric who joined the pope and emperor in venerating Stephen and Lawrence in the last event of the woven *vita*. Like the Breviary and Missal he commissioned for his diocese, Jean Baillet's donation of the tapestry contributed to the specificity of Auxerre's liturgy.

Given the circumstances of his arrival in Auxerre, Jean Baillet had good reasons to integrate himself into the liturgy of Auxerre and the space of the cathedral chapter. He came from a long line of members of the Parliament of Paris and was therefore a foreigner to the diocese of Auxerre. Unlike his predecessor, Enguerrand Signart, whom the chapter elected unanimously, Jean Baillet was nominated by Pope Sixtus IV, at the suggestion of Louis XI. Moreover, Signart resigned from his position for unexplained reasons and Jean Baillet agreed to pay him an annual pension.[54] In this respect, Jean Baillet purchased his episcopal title.

The chapter's decision to sell the *Life of Stephen* in the eighteenth century was part of broader changes, which included renovating the interior of the cathedral and reforming its liturgy.[55] The feast days in honor of Saint Stephen were reduced to the celebration of the saint's death and the Invention of his relics.[56] This revision of Auxerre's liturgical calendar was related to the motion to sell the tapestry. Indeed, without its correspondence to the liturgical celebrations in honor of the saint, the events in the woven *vita* seemed out of place. The *Life of Stephen* relied ultimately on this ceremonial setting in the choir of Auxerre cathedral to tell its story of the saint.

Comment saint urbin fut present quant on lapid
saint estienne et rexamassa le sang lequel depuis il aporte
a twurges

Woven *Vitae* of the Saints and Clerical Identity 5

EXPANDING THE STUDY

To describe the story told by any choir tapestry displayed in a church on high feast days, we would have to study its particular narrative structure and viewing context. Each of my readings, of the *Lives of Piat and Eleutherius,* of the *Life of Gervasius and Protasius,* and of the *Life of Stephen* is incomplete in that it emphasizes only one facet of this context. But, from these partial readings, we can begin to imagine how the audience, the circumstances of donation, and the liturgical setting interacted with a woven *vita.* Drawing on these three cases and on a survey of the other extant or documented examples, we can isolate certain elements of the stories to which choir tapestries contributed and the process whereby they were told.

All the saints chosen for the woven *vitae* were the focus of devotion and donations dating from the foundation of the early Church. The cult of a particular saint usually originated in a gift of his relics, which were subsequently placed in ornate reliquaries in the choir of a city's church. The reliquary containing Eleutherius's relics was visible behind the high altar of Tournai cathedral; the arm of Saint Cyricus was preserved in the choir of the cathedral dedicated to him in Nevers;[1] and the head of the city's first bishop, Vaast, was displayed in the abbey church of Saint-Vaast in Arras.[2] The production of a tapestry often coincided with a recent translation of these relics. Philip of Luxembourg transferred the relics of Gervasius and Protasius to a new reliquary shortly before Martin Guerande donated the tapestry depicting their lives. On June 25, 1480, the relics of Saint Florent were translated into the new reliquary commissioned by Louis XI, which was placed above and behind the high altar in the abbey church of Saint-Florent, Saumur; twenty-four years later, Abbot Jacques le Roy donated the *Lives of Florent and Florian* to his church.[3] In some cases, the church preserved only the memory of relics it had once housed, through a dedication of the high altar or of the church itself in the saint's name.

Possession of the saint's relics was often a matter of contention among different communities. The dispute over Florent's relics, which lasted from the eleventh to the fifteenth centuries, provides a striking example.[4] During the Norman invasion, the monks of Saint-Florent hid the saint's relics in Burgundy. After the invasion, an abbot of Saint-Florent, anxious to retain his monastery's claim to the relics, stole them from the Burgundians and returned them to Saumur. Florent's relics were stolen again in 1077 and brought to the city of Roye in Picardy. After invading the city of Roye, Louis XI demanded that the relics be returned to Saumur, an order that resulted in a sixteen-year ordeal. The relics ultimately were divided between Saumur and Roye. The *Lives of Florent and Florian* was one response to this ongoing battle to secure the saint's relics. The five surviving pieces of the tapestry underscore Florent's role in protecting Saumur and the importance of his relics in making the city a pilgrimage site (figs. 44 and 51).[5] Whether or not relics were the cause of actual disputes, few churches could claim to possess the entire body of a saint. It was an ongoing project, therefore, to justify a privileged relationship with the saint and his or her relics.

To this end, the events chosen for the woven *vitae* emphasize the connection between the saint and the church of a particular city. In Tournai's choir tapestry, for example, the lives of Piat and Eleutherius intersect with the past of the city. Similarly, the *Life of Ursinus*,[6] donated to the collegiate church of Saint-Ursin in Bourges by its prior, Guillaume Breuil, in about 1520, takes place within and in relation to this city. Ursinus transports Saint Stephen's blood from Jerusalem to Bourges (fig. 45), an event that both associates Ursinus with the city and authenticates the relics of the first martyr housed in the cathedral; a cityscape locates later episodes in the *vita* near Bourges. In the *Life of Anathoile*,[7] donated to the church of Saint-Anathoile in Salins in 1501, the saint plays a crucial role in the city's past: he saves the city from fire and protects the Burgundian troops in Salins from the French invasion (fig. 46).

When the name of the city is not evoked directly, other devices relate the saint's life to the community in which the tapestry was displayed. Visual references to the interior of the church are common: the baptism of Gervasius and Protasius takes place in the choir of Le Mans cathedral (plate 9); the *Life of Quentin*, made for the collegiate church of Saint-Quentin in about 1485, includes three reliquaries that resemble in every detail those housed in the church (plate 14).[8] The inclusion of the arms of the donor or his chapter, and portraits of the donor or of other clerics of the church, also establishes a connection between the woven *vita* and the community for which it was made. This connection is solidified further by the inclusion of events that recall the liturgical readings

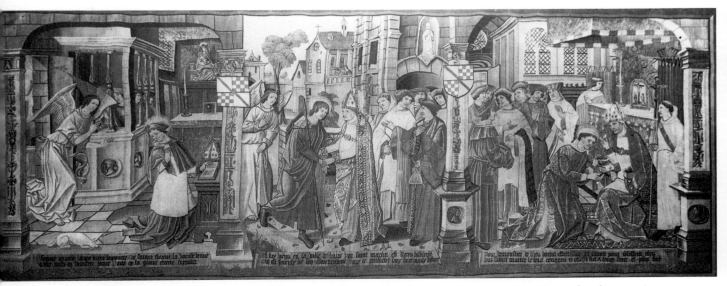

FIGURE 44. *Saint Florent is visited by an angel, who tells him to spread the word of God; he travels to Tours, where Saint Martin ordains him priest.* Lives of Florent and Florian *(detail), 1524, church of Saint-Pierre, Saumur.*

specific to a church. The inclusion of Saint Martin's miracle of the armbands in the tapestry that the bishop of Montpezat donated to the abbey church of Saint-Martin replicates the reading of the event in this church on his feast (fig. 47).

The frequent representations of ceremony also locate the woven saints' lives within the experiential realm of the chapter. Liturgical vestments and instruments recall the clothing of diverse members of the ecclesiastical hierarchy. As is the case in Auxerre's *Life of Stephen*, the two extant fragments of the *Life of Martin*, donated to the collegiate church of Saint-Martin in Angers,[9] include a diversity of clerics. Canons and monks witness Martin's miracle, and another group of ornately clothed ecclesiastics watches him bury the blood of Saint Maurice and of his companions (fig. 55, plate 13). An episode from the *Life of Peter*, donated to the cathedral of Beauvais in 1464 by its bishop, Guillaume de Hellande, exemplifies the splendor of the ceremonial costumes in these tapestries.[10] The jeweled and richly patterned copes of the ecclesiastics stand out in the scene in which Peter ordains Linus and Cletus as bishops (plate 1).

As a group, therefore, these woven *vitae* contributed to stories that legitimated a church's claims to its patron saint(s) and authenticated the relics it possessed or had once housed. Each tapestry served to introduce events in the saint's life into the celebra-

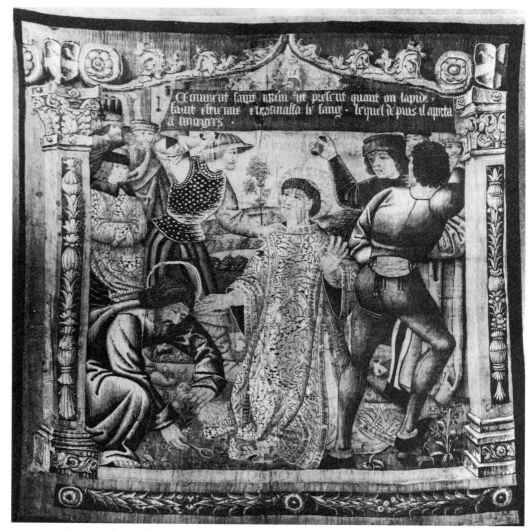

FIGURE 45. *Ursinus collects the blood of Saint Stephen.* Life of Ursinus *(detail), collegiate church of Saint-Ursin, Bourges, before 1500 (Musée de la Ville, Bourges).*

tion of high feast days, thereby particularizing the liturgy of this religious community. The specificity of a local church was thereby defined and incorporated into the festivals that formed part of the liturgical calendar of all Christian churches.

To tell these stories, the designers and weavers of choir tapestries worked from contemporary assumptions concerning the devotional and ritual function of artworks and

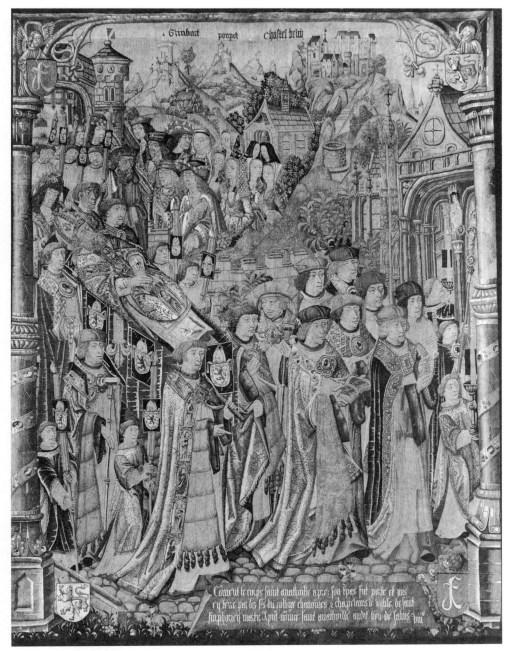

FIGURE 46. *Burial of Anathoile.* Life of Anathoile *(detail), collegiate church of Saint-Anathoile, Salins, Jura, 1502–1506 (Musée du Louvre, Paris).*

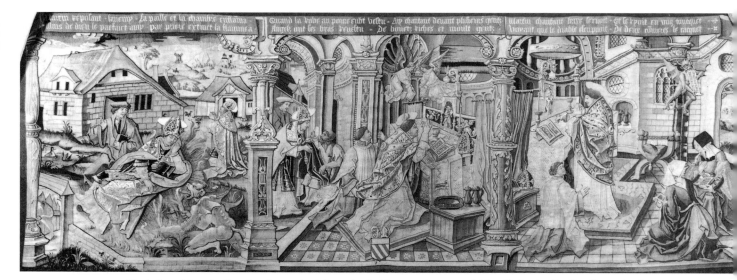

FIGURE 47. *The devil sets Martin's cell on fire; the miracle of the armbands; Martin performs mass.* Life of Martin *(detail), collegiate church of Saint-Martin, Montpezat, 1519–1539.*

the broader representational and temporal models within which they signified. These cultural assumptions — a conception of time, the notion of presence, and a performative model of signification — were part of a particular strategy of pictorial storytelling. The narrative theory that guided the making of the woven *vitae* can be deduced through a study of the choir tapestries themselves.

First, the efficacy of the tapestries relied on a notion, at the center of the Christian liturgy, that events recognized to have occurred in the past could be reenacted — indeed, could recur — in the present. This belief laid the foundation for a story in which episodes in the saint's life occurred at the celebration of each feast day. In the case of Tournai, the chapter and its bishop assumed the leadership role of the saints; in Le Mans, the gift of the tapestry was renewed; and in Auxerre, woven processions of the saint's relics ended in the choir. References in the tapestry itself to features of contemporary ceremony and its local environment literalized the correspondence between past and present, perhaps making it easier to comprehend them intellectually. Within their liturgical context, the woven *vitae* no longer merely stood for events in the now-absent past; they also reenacted them in the choir.

This representational force of choir tapestries is also related to the contemporary understanding of relics to which the woven *vitae* attest. The first articulations of the cult of relics by the Church Fathers made clear that a remnant of a saint not only stood for

the whole body but also confirmed his or her presence in the church in which it was housed.[11] The significance of each woven *vita* derives, to a large extent, from its association with the relics of the saint and hence from his or her presence in the choir. Similarly, the donor of the tapestry was considered present at each instance of its liturgical display. In both cases, the tapestry gave an account of these individuals and invoked their presence.

Finally, choir tapestries operate according to a visual dynamic that has been observed by scholars of devotional art, in which the viewer actively engages with the object she or he contemplates. This engagement ranges from visions, which images are supposed to produce, to an invitation to the viewer to touch or manipulate the object.[12] The woven *vitae* form part of this tradition, in that they require the viewer to draw connections between the tapestry and its immediate visual field. It was the audience of choir tapestries that realized the stories that this ensemble told. Within these specific viewing contexts, however, reading was a highly regulated and ritualized process. Choir tapestries generated a particular and channeled version of a saint's life that participated in the creation of the chapter's image.

Crucial to this image was the ornamentation and orchestration of high feast days, to which choir tapestries contributed. The representations of luxurious vestments and the profusion of motifs and patterns, an aesthetic common to tapestries of this period, heighten their ornamental value. Moreover, the multiplication of details on and around individual figures and between episodes connect the events into a seamless whole. By supplying this adornment for the church, the chapter expressed its devotion to God and the saints.

Choir tapestries also contributed to the nature of the community of clerics that was projected on feast days. In enclosing the section of the choir associated with the chapter, these continuous strips of fabric emphasized the cohesion of the group. At the same time, the choir's internal hierarchy was maintained: carefully detailed liturgical vestments identify the rank of the participants in each representation of ceremony, a rank that is replicated in the seating arrangement and in the ordering of processions. The bishop is accorded special treatment in the extant examples of ceremonies. Often, he assumes a primary role in the veneration of the saint, initiating the elevation and subsequent translations of his relics.

While the bishop performed mass in the sanctuary, his predecessors, depicted in the woven *vitae*, remained visually integrated within the chapter's space. A bishop's gift of a tapestry meant that his presence was evoked at each appearance of his arms, as in the *Life*

of Stephen in Auxerre or the *Life of Peter,* which begins with Guillaume de Hellande's portrait and concludes with the inscription documenting his donation, at the two most privileged sites in the choir.

This insistence on the figure of the bishop is one way that choir tapestries incorporated the distribution of power within a local ecclesiastical community into the celebration of high feast days. As in the *Lives of Piat and Eleutherius,* the pairing of saints thematized the distinction between the chapter's sites of power and its bishop, a distinction that was also manifested in the geography of the cathedral and of the city, and in the choreography of processions and of ceremony in the choir. The *Lives of Maurille and Maurice,* donated to the cathedral of Angers, incorporated a different type of opposition. During the celebration of the feast of Saint Maurille, the cathedral chapter of Saint-Maurice occupied one side of the choir, that of the monastery of Saint-Maurille the other. The tapestries that adorned the walls of the choir represented the coexistence and cooperation of these separate ecclesiastical entities in Angers at the feast of the saint and on the other high feast days celebrated in the cathedral.

For the chapter as a whole, each woven *vita* solidified a connection between the individuals seated below it and their association with the church to which they had been appointed. In turn, the tituli asserted their linguistic affiliation with the French language. Other features in the woven *vitae* underscored their link to a specifically French church. Many of the saints chosen for the monumental *vitae* participated in the conversion of Gaul. The appearance of Martin of Tours, who played an essential role in the foundation of Christianity in that region, often situates the woven *vitae* within the early history of the Gallican Church. For instance, he ordains Saint Florent priest (fig. 44) and gathers the blood of Saint Maurice and his companions (plate 13). As the members of the chapter participated in the celebration of high feast days, they enacted this image of its cohesion and its place within a local community that also formed part of the French Church.

FRENCH CLERICS AND THE GALLICAN CHURCH

When choir tapestries were in vogue, French cathedral and collegiate chapters were the focus of reforms that highlighted their own internal divisions and those within the Latin Church as a whole.[13] The initial objective of the successive general councils called in the fifteenth century was to resolve the Great Schism. Their program, however, went beyond this specific crisis to encompass a general reform of the Church, "in head and in members," by limiting papal abuses of power and regulating the conduct of clerics and

their chapters. Through these ongoing discussions, the Gallican Church defined and so-lidified its distinct position.[14]

The sacred status of the king, who reserved his independence from papal authority in the exercise of his temporal power, made the churches within his domain the focal point in the struggle for power between the councils and the pope. To confront the defenders of papal infallibility, the council invoked the ancient immunities and privileges of the Gallican Church, which the king was responsible for protecting.[15] Due to the geographic proximity of Avignon and the succession of French popes, French chapters in particular had been marked by papal intervention in the recent past. The pope often rewarded his associates and supporters with lucrative prebends and titles, thereby bypassing the pre-rogative of individual chapters to appoint their own members and dignitaries.[16] Conse-quently, the French clergy had a particular stake in supporting the superiority of the council, which would protect their right of election.

General assemblies of the French clergy, in which the king participated, determined its policies in relation to the council's programs. At the synod held in Bourges in 1438, this body adopted the decisions of the Council of Basel, with revisions of some of its articles. Charles VII instituted this reform, known as the Pragmatic Sanction, within his realm. The measures adopted in Basel and Bourges confirmed the authority of the coun-cil over the pope and restricted his power of nomination and his right of taxation. Al-though Charles VII's successors applied it to varying degrees, the Pragmatic Sanction re-mained the focus of continued disputes between the French king and the pope, until it was revoked in 1516 at the Concordat of Bologna signed between Francis I and Leo X.[17]

The move to limit the pope's power in clerical nominations was an attempt to avoid recurring conflicts over canonical appointments and the naming of Church officials. The schism had exacerbated the ferocity of these debates in communities where each pope had assigned his own candidate to an episcopal throne. But the pope's continued imposition of his candidates remained a point of contention after 1417, when the Coun-cil of Constance formally ended the Great Schism. The Pragmatic Sanction ordered that chapters were to elect their own head but also provided an explicit provision for the king to recommend appropriate candidates.[18] Nevertheless, the legitimacy of many episcopal nominations was contested throughout the fifteenth century.[19]

As choir tapestries integrated the bishop into the space of the choir, they masked the conflictual nature of many episcopal appointments.[20] For instance, Louis de la Tré-moille's appointment as bishop of Tournai by Clement VII was opposed by William of Coudenberghe, who had been given the episcopal throne by Urban VI in Rome. Tré-

moille was accepted as bishop by the diocese as a whole only after a lengthy standoff with his opponent, who finally conceded the position. Jean Baillet's nomination as bishop of Auxerre by Pope Sixtus IV, at the suggestion of Louis XI, was also contested: Jacques Juin, archdeacon of Coutances, claimed he had received a letter of appointment from the archbishop of Sens. The Parliament of Paris quickly asserted Jean Baillet's right to the title but the nature of his succession remains mysterious. He inherited the episcopal seat not at the death but at the resignation of the previous bishop, Enguerrand Signart, whom Jean Baillet agreed to pay an annual pension.[21] As the cases of Tournai and Auxerre demonstrate, a bishop's place within the episcopal lineage of a diocese or as the natural successor of a bishop saint in its history could not be taken for granted in the climate prevailing within the French Church.

Both papal and royal intervention in the composition and leadership of French chapters threatened their cohesion and potentially diminished the investment of their members in a local community. Individual chapters were repeatedly deprived of the right to choose their own members and head. Because the pope and then the king used coveted prebends to reward their associates, chances increased that clerics with no loyalty to or experience with a particular community would be accorded prebends within a chapter.[22]

Other factors contributed to the lack of involvement of canons within the local communities to which they were nominated. Many of them resided only intermittently in the city to which they were appointed, a situation exacerbated by the collection of multiple benefices. The less prestigious and wealthy chapters could offer fewer incentives for canons to take part even in the celebration of high feast days. Moreover, parish churches fulfilled the citizens' daily liturgical needs. Clerics no longer directed the large-scale projects that had engaged whole urban populations, such as the reconstruction of cathedrals.

The communal nature of individual chapters was also threatened by the distinctions made among their members, from the moment of their election to their commemoration after death. The wealth of individual canons varied depending on the property they acquired through inheritance and the premiums and gifts they received as chaplains, advisers, and secretaries. Not all canons participated in the chapter's community service and ceremonial rituals; many received dispensation and paid absences, or financed chaplains to replace them. The special relationship that certain canons maintained with the bishop also distinguished them from the rest of the chapter. Martin Guerande and Léon Conseil (donor of the *Life of the Virgin* to the cathedral of Bayeux) negotiated between the interests of the bishop whom they served as secretary and the chapter from which they

received a prebend. Finally, the foundation of a mass was above all an individual invest-ment; it singled out one canon from this group for commemoration.

The reforms of clerical conduct in the fifteenth century were, in part, a response to these fissures in the desired image of a unified and committed clergy. The articles passed by the Council of Basel and reiterated in the Pragmatic Sanction of Bourges sought to renew visible demonstrations of the piety and collective presence of cathedral and col-legiate chapters.[23] On the one hand, these decrees restricted absenteeism and enforced participation in the daily office and celebration of feast days. On the other, they regu-larized the performance of ceremony: clerics were required to arrive on time, wear ap-propriate clothing, and stay until the end; they had to speak only at the prescribed mo-ments, avoiding all comments to their neighbors; they had to perform the correct movements and gestures in the proper order and in unison with the others. Religious ob-servance, they were reminded, was a communal event, "assembled to pray together, they must not remain with their mouths closed but must all, especially those with the highest rank, voice in a lively manner the psalms, hymns, and canticles."[24] The solemnity due high feast days in particular had to be observed with appropriate pomp and ceremony.

The purported goal of the reform of the Church "in head and in members" was a re-turn to an earlier time when the pope ruled with appropriate constraint and clerics exer-cised their appropriate religious duty. Behind the explicit threat of papal abuse of power and clerical laxity lay the implicit threats posed by reform movements and the mendi-cant orders.[25] The king had to face the pope's new military power. At stake for French clerics was the preservation of their institutions and hierarchy; for the king, it was the assurance of his role in their operation and his position within the geopolitical arena. Defining and maintaining the status of the Gallican Church was essential to assuring both interests.

The participation of French clerics in this program did not imply their opposition to papal authority in general or to the institution of his power in Rome. The decision to revoke their obedience to the pope in 1398 had been extremely contentious, as was that to support the successive invasions of Italy at the end of the fifteenth century.[26] Many clerics owed their positions to the pope and maintained close contacts with Rome. Philip of Luxembourg's role as intermediary between Pope Alexander VI and King Charles VIII, and between Pope Julius II and King Louis XII, provides an example of the conflicted interests that some French clerics were forced to deal with.

When the pope appears in the extant choir tapestries, he is accorded an honored place within the ecclesiastical hierarchy. Eleutherius assumes his episcopal office in three

stages: the Christians of Tournai propose his election; the pope confirms his nomination in Rome; and the bishops consecrate him in Tournai. In Auxerre's *Life of Stephen*, the pope acts on behalf of the emperor when he requests the saint's relics and he is then responsible for receiving and transporting them. The two rulers kneel side by side in devotion to the saint in the final panel, while angels broadcast the news, "Oh happy Rome." After he has been elected bishop of Constantinople, Saint Anathoile is confirmed by "our holy father the pope, the cardinals, and the holy apostolic see."[27] These examples underscore the fact that the pope shared his power with others in the overall operation of the Church. In contrast, the *Life of Peter* from the cathedral of Beauvais granted the pope a more prominent role: Peter, wearing the papal tiara, invests Linus and Cletus with their episcopal offices (plate 1). Choir tapestries as a group do not express an antipapal sentiment, nor do they present a clear agenda to increase the king's participation in Church affairs at the pope's expense.

They do, however, reflect the contemporary concerns of the French clergy to uphold their institutions and to insure their smooth functioning. To that end, French clerics invoked their ancient rights and privileges and they demonstrated the cohesion of each chapter through the renewed order and splendor of ceremonial rituals. Choir tapestries contributed to both these projects. The lives of the founding saints represented the chapter's origin in a city's distant past. Their display heightened the solemnity of high feast days and the ceremonial presentation of the chapter; the vividness of their imagery may have also offered an added incentive for clerics to participate in these special occasions. The surviving fragments of these tapestries thus serve as vestiges of a moment when the French clergy sought to define and defend its communal identity in the face of challenges from within and without.

THE FATE OF CHOIR TAPESTRIES

By the mid-eighteenth century choir tapestries were no longer part of the celebration of high feast days in France. This change in the ornamentation of the choir was a symptom of more general cultural and ritual changes in the French Catholic Church. Tapestries had no place in the choirs, reconstructed in accordance with the new aesthetic and liturgical demands of the period.[28] Concurrently, many chapters deemed the events depicted in the woven *vitae* inappropriate for display in their churches.

The renovations of French churches during this period were not a simple or strict application of the directives of the Council of Trent. In fact, these directives were first interpreted to mean that churches should be reconstructed exactly as they had been before

the damage caused during the religious wars, in order to conserve the ancient practices.[29] Later reflections on the nature of the post-Tridentine Church led to a variety of solutions for adapting medieval churches to new liturgical demands, put into effect primarily in the 1740s and 1750s. Underlying these changes was the concern to make the altar visible to the faithful. It was at this time that rood screens were reduced in size, replaced by grills, or removed entirely. In some cases, as at the cathedral of Angers, the altar was moved to the transept, making it even more accessible to the laity; the saint's relics were moved with it (figs. 48–49).[30]

One of the impetuses for these reconstructions was what the clergy conceived as a validation of Gothic architecture, through the unification of the interior space of the church and the installation of decorations fitting its new dimensions.[31] This aesthetic concern required the removal of a large part of its ornamentation, including the tapestries. The new conception of the liturgical ornamentation for the choir was accompanied by a different notion of acoustics, with which the tapestries also interfered. The canons of Angers decided in 1767 that "the tapestries caused a grave detriment to the

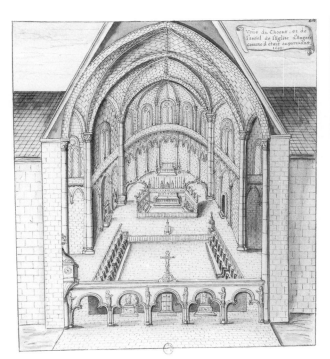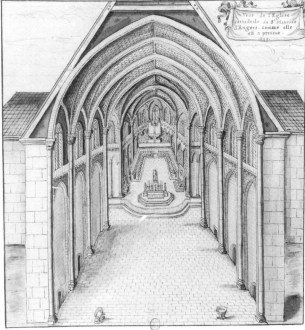

FIGURES 48 AND 49. *Drawings by Roger de Gaignières: choir of Saint-Maurice, Angers, before and after 1699.*

FIGURE 50. *Display of the* Life of Stephen *in Auxerre cathedral, July–August 1948.*

voices and would no longer be displayed."[32] After the chapter of Bourges redid their choir in 1757, they appointed a commission to "inspect and sort through the old tapestries that the church can do without."[33] In 1768 they decided to sell everything that "is no longer of use in the choir, like antependia, altarpieces, and tapestries."[34] The woven *vitae* were relegated to side chapels or sold.[35]

A chapter's decision to dispose of its choir tapestry often coincided with a discomfort with its content. The debate within the cathedral chapter of Auxerre around the sale of the *Life of Stephen*, for example, reveals its distaste for the version of his *vita* depicted in tapestry. The opinion of Lebeuf, a canon and well-known historian of Auxerre, was that "since we have purged the lives of the saints of the myths that distorted them, we must also get rid of the images that represented these legends, the type of images that only serve to excite the rantings of libertines and unbelievers."[36] Although some canons argued that the tapestry should be retained for its artistic merit, no one disagreed that it was apocryphal. As the inventory of 1752 puts it, the woven *vita* was "mixed up with fabulous features."[37] This argument was repeated in the nineteenth-

century literature on the tapestry.[38] For both eighteenth-century canons and nineteenth-century art historians, the *Life of Stephen* was produced at a time when the Church indulged in fantastic tales.

These woven images could still prove effective tools with which to represent the cultural heritage and traditions of a city and its church. Despite the earlier discomfort with its content, the *Life of Stephen* was displayed in 1948 around the choir of Auxerre cathedral for a mass celebrated by the archbishop of Sens to welcome home those citizens displaced during the war (fig. 50). Once again a choir tapestry participated for a brief moment in the enactment of a fragmented community's identity.

Extant and Documented Choir Tapestries

This is not a comprehensive list. It is intended to indicate the characteristics shared by choir tapestries and the range of differences among them. Where known, I have indicated the subject, the original location, the donor of the tapestry, and the date of its commission. A brief description of the tapestry, its history, a transcription of the tituli, and studies on individual tapestries follow. References to some of these tapestries can also be found in the major histories of tapestry: Jules-Joseph Guiffrey, *Histoire de la tapisserie depuis le Moyen Age jusqu'à nos jours* (Tours: A. Mamé et fils, 1886); Jules-Joseph Guiffrey, Eugène Müntz, and Alexandre Pinchart, *Histoire générale de la tapisserie*, 3 vols. (Paris: Société anonyme de publications périodiques, 1880); Heinrich Göbel, *Wandteppiche*, vols. 1–2 (Leipzig: Klinkhardt and Biermann, 1923, 1928); Achille Jubinal, *Les anciennes tapisseries historiées, ou Collection des monuments les plus remarquables de ce genre qui nous soient restés du moyen-âge, à partir du XIe siècle au XVIe inclusivement* (Paris: Galerie d'armes de Madrid, 1838).

§ § §

Anathoile, Life of. Collegiate church of Saint-Anathoile, Salins, Jura. Canons of Saint Anathoile, 1502–1506. Three surviving pieces (Paris, Musée du Louvre; fig. 46).

The tapestry had fourteen sections. The tituli were transcribed in 1787 and at the beginning of the nineteenth century, when the tapestry was presumably complete.

The tapestry depicted the following episodes:

1. Anathoile leaves his parents, the king and queen of Scotland, to study in Constantinople
2. He disputes with his master in Constantinople.
3. After the death of the bishop of Constantinople, he is elected bishop.
4. He is confirmed bishop by the pope, the cardinals, and the holy apostolic see.
5. He converts the Arians and other infidels.
6. He becomes a hermit and retires to his hermitage at Chastel-Belin (Salins).
7. He asks for fire at the salt mines; it is refused him unless he carries it in his garments, which he does, without being scorched.

8. His body is carried processionally to its burial by the canons and chaplains of the church of Saint-Simphorien, now called Saint-Anathoile in Salins.
9. After he is canonized, his relics are translated into a reliquary, with many bishops, canons, and other clerics present.
10. His relics heal people from numerous afflictions.
11. The saint's arm, carried processionally by the canons and chapter of the church and thrown onto the flames, saves the city from fire and emerges unscathed.
12. The saint's skull saves the salt mines of the city.
13. The city of Dole is besieged by the French in 1477. The clergy and laity of Salins carry the reliquary of Saint Anathoile in procession, giving the saint the keys of the city to protect it. The French lift the siege and the two cities are saved.
14. In 1492 nine hundred French attack four hundred Burgundian soldiers, who are bringing weapons to Salins. They flee behind a rock, leaving the arms in a field, but defend themselves. The French return on the feast day of Saint Anathoine to retrieve the weapons. The reliquary of Saint Anathoile is carried in procession; soldiers from Salins arrive to help; the French leave. The city and the artillery are saved.

An inscription states that the fourteen panels of tapestry were made in Bruges, in the shop of John Sauvage in 1501, for the canons' use, to the glory of Saint Anathoile, bishop of Constantinople and son of the king of Scotland.

The eighth, twelfth, and thirteenth panels survive.

TITULI
1. "Comment saint Anathoille print congié du roy et de la reine d'Escosse, ses pere et mere, pour aller estudier à Constantinoble."
2. "Comment saint Anathoille, estant à l'estude à Constantinoble, disputoit contre son maistre."
3. "Comment saint Anathoille, aprés le decés de l'evesque de Constantinoble, fut eslu evesque dudit lieu de Constantinoble."
4. "Comment saint Anathoille fut confirmé evesque dudit Constantinoble par nostre saint pere le pape, les cardinaux et le saint siege apostolique."
5. "Comment saint Anathoille, ayant convoqué le concile à Contantinoble, par ordonnance du pape, prescha et convertit les Ariens et aultres infidels de leurs erreurs et les reduisit à la foy chrestienne."
6. "Comment saint Anathoille, veuillant laisser la vie mondaine et mener une vie d'hermite, print congié du pape et eslut son hermitage sous Chastel-Belin, donnant congié à son serviteur."

7. "Comment saint Anathoille, estant en son hermitage, contraint de froid, vint aux bernes de la saulnerie demander du feu pour l'amour de Dieu, qui lui fut refusé s'il ne l'emportoit dans son escource, ce qu'il fit sans aulcune lesion."

8. "Comment le corps saint Anathoille, aprez son trepas, fut porté et mis en terre par les sieurs du college, chanoinnes et chapelains de l'eglise de Saint-Sinphorien, martir, à present nommée Saint-Anathoille audit lieu de Salins."

9. "Comment aprés ce que saint Anathoille fut deument canonisé et approuvé par l'Eglise romaine, fut solemnellement relevé par l'archevesque de Besançon, presens nombre d'evesques, chanoinnes et aultres gens d'eglise, et mis en fiertre."

10. "Comment les pauvres creatures, comme les possedés de l'ennemi, comme aussi les aveugles, boiteux, sourds et aultres entechis de diverses maladies, qui se sont rendus et rendent audit saint et le visitent devotement, s'en sont retournés et retournent guaris et quictes de leurs douleurs et maladies."

11. "Comment la ville de Salins ardoit, estant le feu si impetueux que l'on n'y sçavoit remede, fors de recourir a monsieur saint Anathoille, duquel saint les chanoinnes et college de ladite eglise portèrent en devote procession le bras et jettèrent icelui dans ledit feu, lequel fut incontinent eteint, ladite ville preservée et le bras retrouvé sain et entier."

12. "Comment la fontainne du puis à muire fut perdue et comment par l'intercession de saint Anathoille, duquel le chief fut devotement porté audit puis, fut recouvree, et sortit icelle fontainne plus bas que par avant."

13. "Comment le dernier jour de septembre l'an mil IIIIc LXXVII, la ville de Dole estant assigee des François, le clergié, gens de loy, bourgois et commune de Salins, doubtans la perdiction de ladite ville et consequanment dudit Salins, se mirent en très devote procession et a teste et piedz nuz porterent la fiertre où le corps et relicques du glorieux saint Anathoille reposent, lui presentant et laissant les clefz de ladite ville de Salins, en luy requerant devotement vouloir estre garde dudit Salins, auquel jour et heure lesdis François leverent leur siege, et furent icelles deux villes preservees par le merite du glorieux saint Anathoille."

14. "Comment en janvier mil IIIIc IIIIxx XII, veille de saint Anthoine, aulcuns gens de guerre du parti de Bourgongne, en nombre seulement d'environ quatre cens, amenans artillerie à Salins, furent envahis auprés de Dournon par environ neuf cens François gens de guerre, tellement que leur convint abandonner ladite artillerie et la laisser enmi les champs et eux retirer auprés d'un roc où ils furent assaillis desdis François; mais ils se deffendirent si bien que leur fut force de eux retirer; desquelles nouvelles ceux dudit Salins furent esbahis. Et arriva que le lendemain, jour de saint Anthoine, du matin, ainsi que l'on portoit en procession devote la fiertre du glorieux saint Anathoille, lesdis

François retournans pour cuider prandre et emmener icelle artillerie, veiant un bon nombre de gens d'armes dudit Salins à l'aide desdis quatre cens Bourgongnons, s'en allerent et retirerent du tout. Et par ainsi, par l'intercession du glorieux saint Anathoille, fut ladite artillerie preservee et sauvee, et ladite ville aussi."

Inscription following fourteenth panel:
> Ces quatorze pieces de tapis
> Furent a Burges faits et construits
> a l'hostel de Jehan Sauvage
> En incarnation a nostre usage
> l'an 1501, et furent pour saint Anathoille, evesque de
> Constantinoble, fils du roi d'Escosse.
>
> (Prost, *La tapisserie*, 496–99).

LITERATURE

Delmarcel, Guy, and Erik Duverger. *Bruges et la Tapisserie*, 170–79. Bruges: Louis de Poortere, 1987.

Prost, Bernard. "La tapisserie de Saint Anatoile de Salins." *Gazette des Beaux Arts*, 3d ser., 34, no. 8 (1892): 496–507.

Versyp, J. *De Geschiedenis van de Tapijtkunst te Brugge*. Verhandelingen van de Konninklijke Vlaamse academie voor wetenschappen, letteren en schone kunsten van Belgie, klasse der schone kunsten 8. Brussel: Paleis der Academiën, 1954, 167–68.

§ § §

Boniface, Life of. Cathedral Notre-Dame, Bruges. Louis de la Gruuthuse, lord of Gruuthuse, 1472. Eighteen panels. Lost.

The tapestry depicted the life and martyrdom of the saint and included the arms of Louis de la Gruuthuse and of Marguerite Van Borselle, his wife, and a portrait of the donor in the first panel.

The eighteen panels were as follows:
1. Donor portrait
2. Birth of Winfrid
3. Winfrid leaves his parents for Rome on a boat that takes him to the city of Treth (Friesland).
4. Here, Willibrord had his episcopal residence; Winfrid declines the offer to become his successor.

5. He arrives in Rome and is received joyously by Gregory II.

6. He is sent as a missionary to Hesse and Thuringia.

7. He carries out his mission flawlessly as bishop in the name of Christ.

8. Winfrid has the idols destroyed; converts the people of Hesse and Thuringia with his sermons, and they desire to be baptized.

9. Heresy divides the Francs; his fame spreads; the ruler Charles (Martel) sends him back to Rome.

10. Gregory, seeing his good deeds, changes his name: "Winfrid, you will be Boniface"; and he adds the title of archbishop.

11. In the year 751, Pepin is crowned king of the Francs by Boniface.

12. Here he is archbishop of Mainz; Lull is anointed bishop and takes over his charge.

13. He assumes with dignity his role of preaching the Gospel and teaching virtue to the clergy.

14. He turns toward Friesland, where he preaches and destroys idols; he joins his companions; they are confronted by a hostile crowd.

15. Fifty-two are killed with him; their bodies travel by boat to Utrecht.

16. In 1338, Notre-Dame of Bruges receives his body on the octave of the Assumption.

17. Nicolas of Lyra in his thirteenth vision: "And I see a second angel, that is Saint Boniface, sent from Rome by the pope to preach to the people of Thuringia, Austria, and Friesland."

18. March 10: Vivar transfers the bones of Boniface, Hilary, and Cyrobaldus to Bruges.

The tituli, in Latin, were transcribed by Beaucourt de Noortvelde in his description of Notre-Dame of Bruges, 1773, and reprinted in Delmarcel and Duverger, *Bruges*, 32–33:

1. "Miles hic ingenuus de Gruuthuuse Ludovicus / Iste Tapeta dabat lux viva poli sibi fiat. CCCC.LXXII."

2. "Nobilis Anglorum puer is Winfrid Vocitatus, / Christo pergratus cupiens documenta bonorum."

3. "Hic Romam tendit linquens patriamque parentes, / Navim conscendit Treth castrum fest venientem."

4. "Illuc tunc praeses Willebrordus residebat, / Winfrid dando preces mitram gerat hic renuebat."

5. "Romam pervenit Gregorius ecce secundus / Hunc laetabundus recipit Sacra Dogmata propter."

6. "Legat et hunc Hessis Turingis maxima Messis / Non operatores ibi sectos deteriores."

7. "Factus perrexit legatus eos bene rexit Christi fando fidem sectas dimisit ibidem."

8. "Idola quassantur Winfrid sermone beantur / Hessi Turingi jubet omnes flumine tingi."

9. "Sectas divisit Francorum, Fama volavit, / Et Ducis hinc Caroli precibus Romam remeavit."
10. "Gregorius bona facta videns nomen variavit / Winfrid eris Bonifacius Archiepiscopus addens."
11. "Septingenteno quinquagesimo quoque primo / Francus Pipinus ab eodem Rex fuit unctus."
12. "Hic Moguntinus est Praesul, Pontificatur, Lul / tenet officium populum committit eidem."
13. "Suscepit Digne Trajecti verba salutis / Praesul virtutis Clero dans dogma benigne."
14. "Frisia post capit hunc et praedicat idola cassat, / Consortat socios quos turba ferox vere lassat."
15. "Quinquaginta duo mortem secum subierunt / Corpora per navim Trajectum vecta fuerunt."
16. "M. Semel et C. Ter, triplicatis octo Maria / Corpus habet Brugis Octavo Assumptio lucet."
17. "Nicolaus de Lira, ape XIIII. Et vidi alterum Angelum videlicet / Sanctum Bonifacium a Pontifice Romano Missum ad Praedicandum Gentibus Turingiae, / Austriae, Frisiae."
18. "Marti die dena Vivar Transfert Brugis ossa / Quae Bonifacii, Illarii sunt, et Cyrobaldi."

LITERATURE

Delmarcel, Guy, and Erik Duverger. *Bruges et la Tapisserie*, 31–33. Bruges: Louis de Poortere, 1987.

Van Praet, Joseph. *Recherches sur Louis de Bruges, seigneur de la Gruthuyse, suivies de la notice des manuscrits qui lui ont appartenu et dont la plus grande partie se conserve à la Bibliotèque du roi*, 13. Paris: De Bure frères, 1831.

Versyp. *De Geschiedenis*, doc. 27, p. 161.

§ § §

Cyricus (or Quiricus) and Julitta, Lives of. Saint-Cyr cathedral, Nevers. Marie d'Albret, sister of Jacques d'Albret, appointed bishop of Nevers in 1519, and Charles de Clèves, 1521–1549. Five surviving pieces (Nevers, Musée de Nevers).

The five fragments are in extremely poor condition. Drawings of two of the panels were made by Commandant Barat (fig. 51) and the tituli of the surviving pieces were transcribed by Morellet. The donors are identified by the arms depicted on the tapestry. The series spanned

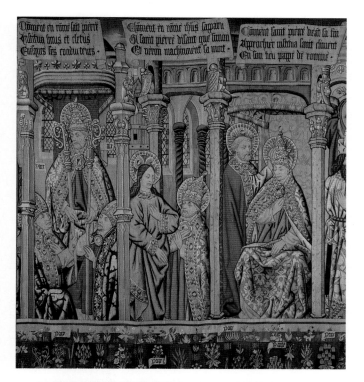

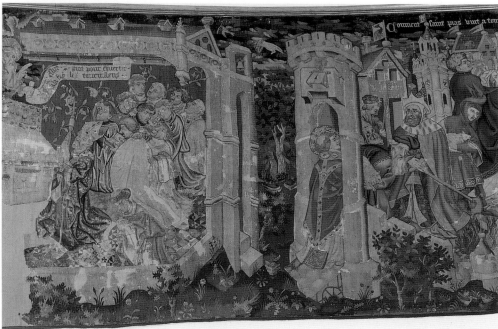

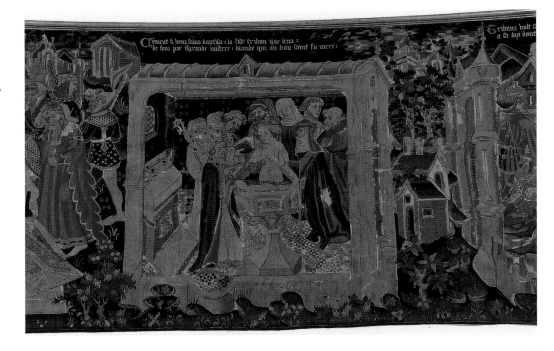

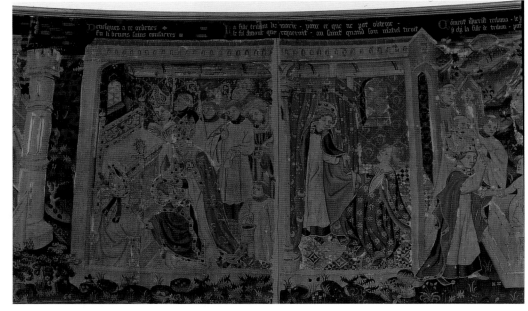

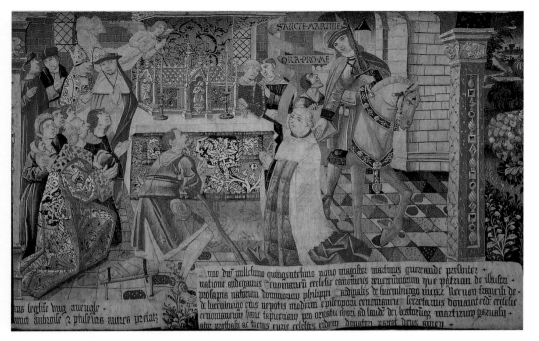

PLATE 5.
*Veneration of the saints'
relics.* Life of
Gervasius and
Protasius *(detail),
Le Mans cathedral.*

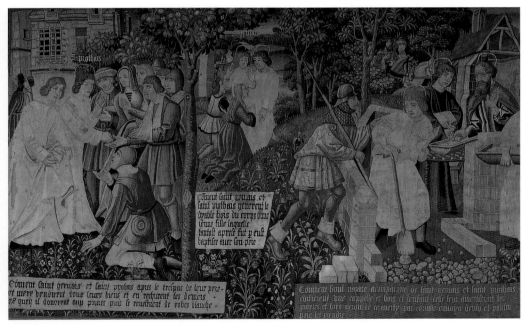

PLATE 6.
*Gervasius and
Protasius give their
possessions to the poor,
baptize a girl and her
father, and build a
chapel. Remaining panel
from the* Life of
Gervasius and
Protasius, *Soissons
cathedral.*

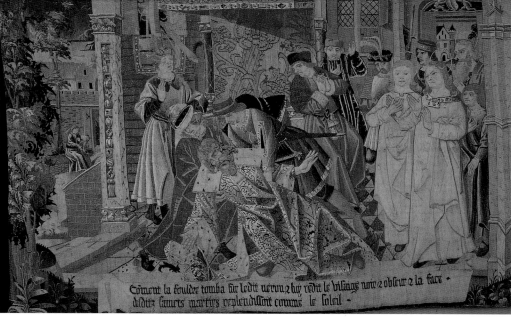

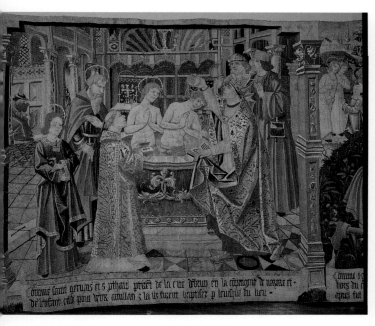

PLATE 9. *The baptism of Gervasius and Protasius.* Life of
Gervasius and Protasius *(detail), Le Mans cathedral.*

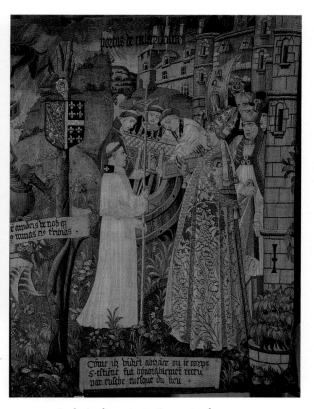

PLATE 10. *Stephen's relics arrive in Constantinople.*
Life of Stephen *(detail), Museum of the Middle Ages—*
Cluny, Paris.

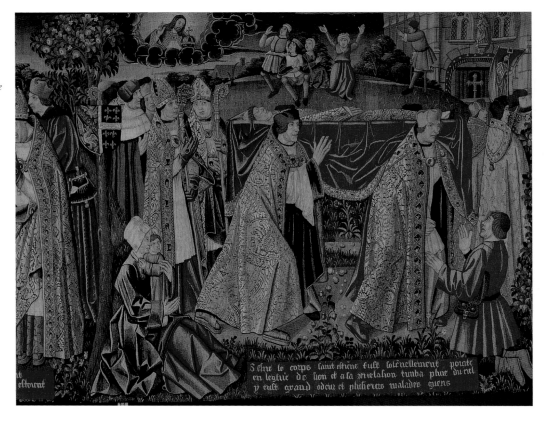

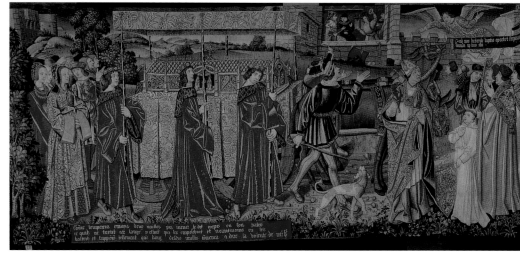

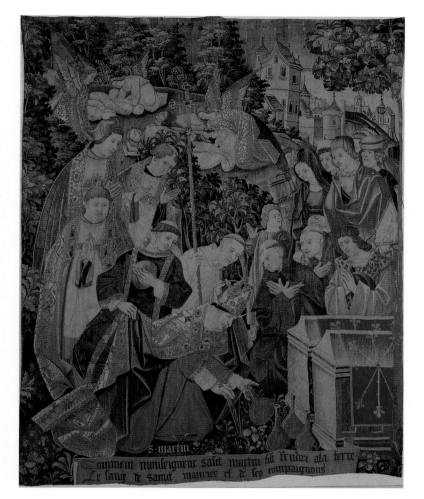

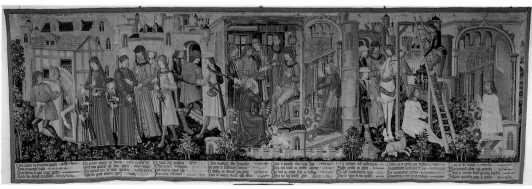

PLATE 15.

Maurille as gardener and Maurille offers the king and queen fruit. Life of Maurille *(detail), Angers cathedral (Musée des Tapisseries, Angers).*

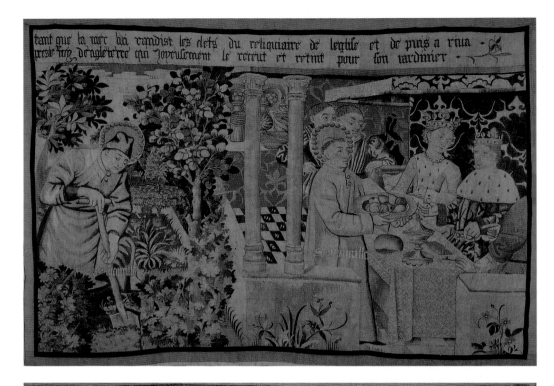

PLATE 16.

Vaast tames a bear. Life of Vaast *(detail), Musée des Beaux-Arts, Arras.*

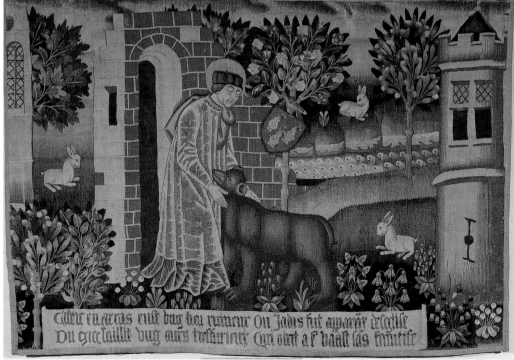

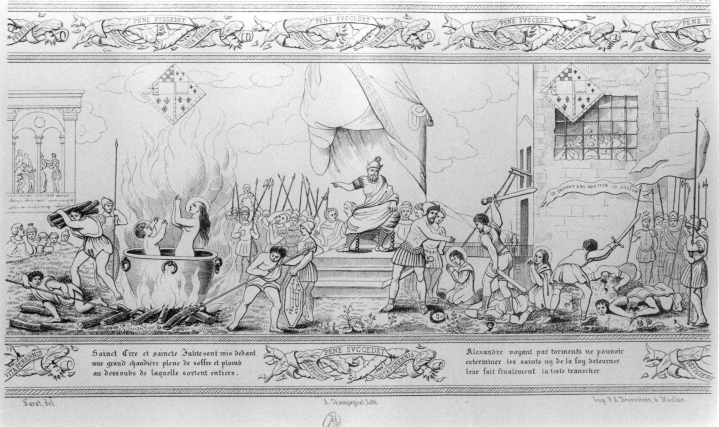

FIGURE 51. *Julitta and Cyricus are placed in a large cauldron and emerge unscathed; Alexander has the saints decapitated.* Lives of Cyricus and Julitta *(detail), print after a drawing by Commandant Barat.*

three arcades on either side of the choir and along the rood screen, above the canons' stalls. The hooks (twenty pitons) on which they were displayed still exist in the cathedral of Saint-Cyr.

The tapestry contained five principal episodes with secondary scenes on either side. The principal episodes of the five surviving fragments represented are:

1. Julitta and Cyricus, persecuted, leave the city of Ycaune and arrive in Tharses.
2. The provost Alexander comes to the city of Tharses and orders Julitta to be brought before him.
3. Julitta and Cyricus are placed in a large cauldron and emerge unscathed.

APPENDIX I 127

4. Alexander orders three large nails to be hammered into the body of Cyricus and his body to be sawed in half.

5. Alexander has the saints decapitated.

TITULI

1. "Saincte Julitte et sainct Cire persecuté lessent la cité d'Ycaune et viennent es Tharses."

2. "Alexandre le presvost tousjours persecutant chrestiens, arrivé a la ville de Tharses, commanda saincte Julitte estre prinse et par devant luy amenee."

3. "Sainct Cire et saincte Julitte sont mis dedans un grand chaudiere plene de souffre et plomb au dessoubs de laquelle sortent entiers."

4. "Alexandre faict traverser du hault jusques en bas sainct Cire de troys grands clous esgus puis cruellement le cier par le corps."

5. "Alexandre, voyant par tormens ne pouvoir exterminer les saincts ny de la foy detourner, leur faict finalement la teste trancher."

LITERATURE

Beaumont, Charles de. *Les tapisseries de Marie d'Albret aux Musées de Nevers.* Orléans: H. Herluison, 1900.

Crosnier, Augustin-Joseph. *Monographie de la Cathédrale de Nevers,* 65–69. Nevers: I. M. Fay, 1854.

Morellet. "Des tapisseries de haute lice qui étaient ou sont encore dans la cathédrale de Saint-Cyr, à Nevers." *Bulletin de la Société Nivernaise des Sciences, Lettres et Arts* 1 (1854): 193–200.

§§§

Florent and Florian, Lives of. Royal abbey church of Saint-Florent, near Saumur. Jacques le Roy, abbot of Saint-Florent, 1524. Six sections survive (Angers, Musée des Tapisseries, and Saumur, church of Saint-Pierre; figs. 44, 52).

The tapestry originally contained twenty-seven episodes in nine sections. The remaining fragments together measure 1.80 by 30 meters.

1. a) Diocletian and Maximian order the persecution of Christians.
 b) Aquilien of Bavaria receives the message.
 c) Aquilien shows the edict to the brothers, Florent and Florian.
2. a) The saints are imprisoned.
 b) They are beaten harshly.
 c) Aquilien orders that they be beaten again.
3. a) Acquilien threatens to drown them if they do not renounce their faith.

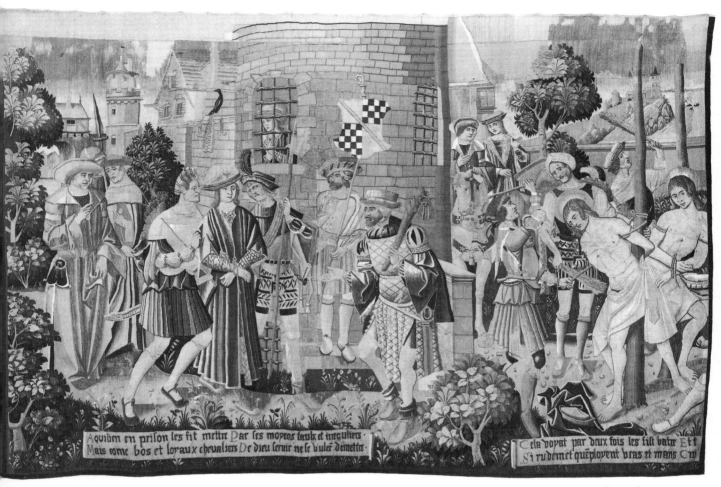

FIGURE 52. *Arrest and torture of Florent and Florian.* Lives of Florent and Florian *(detail), 1524, church of Saint-Pierre, Saumur (Musée des Tapisseries, Angers).*

b) Soldiers lead the brothers away to be tortured.

c) They are bound; an angel appears to announce Florian's death.

Only fragments of the fourth piece survive; the fifth piece is lost.

6. a) An angel announces the arrival of Florent to Saint Martin.

b) Saint Martin greets Saint Florent.

c) Saint Martin ordains Saint Florent priest.

7. a) An angel advises Florent to settle on Glaune Mountain.

b) The chapel of Saint-Pierre is constructed and Florent prays inside.

c) The inhabitants implore Florent to save them from a dragon.

8. a) A blind woman asks Florent to bring back her drowned child, three days dead.

 b) Florent resurrects the child.

 c) Florent saves the people from the serpent.

9. a) The chapel of Saint-Pierre is filled with unfortunates asking for the saint's help.

 b) Florent dies; his soul rises.

 c) The funeral procession of Saint Florent; four clerics carry his coffin.

 d) A chapel is dedicated to the saint, with an altar containing his statue. The donor, Jacques Le Roy, prays before the altar.

The tituli of the tapestry in their entirety are conserved in the municipal library of Angers (Angers, Bibliothèque Municipale MS 857).

TITULI (partial transcription)

1. "Comme empereurs et tirannicques princes
Dioclecian et Maximian ensemble.
Leurs messaigers affin que crie se assemble
Ilz envoyent en diverses provinces."

2. "Aquilien du paÿs de Baviere
Estoit prevost lequel sans contredict
Des empereurs vient recevoir le edit
Pour publier par cruelle maniere."

3. "Aquilien fit le edit publier
Qui contenoit adorer les idoles,
Mais Florian et Florent par parolles
Le Dieu des Dieulx ne veullent oublier."

4. "Aquilien en publicque assistance
De les noyer a donné jugement;
Graces a Dieu rendent devotement,
Prenans en gré la cruelle sentence."

5. "De la prison il les feist retirer
Et devant luy les mena tout batant,
Mais en la foy chacun d'eulx est constant
Et pour icelle ilz se offrent martirer."

6. "Dessoubz ung arbre ilz se sont endormis;
L'ange du ciel a sainct Fleurent se addresse,

Le desliant luy dit parolle expresse
Que confesseur il est a Dieu promis."

7. "A sainct Martin l'ange vient annoncer
De sainct Florent la joieuse venue,
Sa vie aussi en saincteté tenue
Pour en la gloire eterne s'exaulcer."

8. "Et luy venu en la ville de Tours
Par saint Martin est receu humblement,
Qui est joyeux de son advenement;
Puis le conduict sans faire aucuns destours."

9. "Pour demonstrer de Dieu l'entier effect
Qui l'avoit pour confesseur eleu;
Par sainct Martin le tout congneu
Il fut a Tours sacré et pretre fait."

10. "A sainct Florent l'ange magnifesta
Que au mont de Glonne il feroit sa demeure,
Et la venu divinement labeure
Tant que serpens hors d'icelluy jecta."

11. "Ung oratoire assis sur ferme pierre
Sainct Florent feit dessus le mont de Glonne;
La plusieurs gens ayans vaillance bonne
Honorent Dieu et monseigneur sainct Pierre."

12. "Prez Meur sur Loyre avoit ung gros serpent
Qui vomissoit le venin serpentin
Et au retour conseil de sainct Martin
Preserve tous du mal qui en depend."

13. "Pour son enfant une femme aveuglee
Le vint prier de cueur a Dieu rengé
En luy disant: 'En l'eaue est submergé
Troiz jours y a, dont je suis desolee.' "

14. "Le sainct se met en devote oraison
Et pour l'enfant humblement prye Dieu.
En vie appert puis, tyré hors du lieu,
Donne a la mere entiere guerison."

15. "A sainct Martin en la ville de Tours,
Du vil serpent repairant pres de Meur.
Fait le recit par parler doulx et meur,

Puis au retour le chasse en loings destours."
16. "De toutes pars venoient a l'oratoire
De sainct Florent pour santé recevoir
Les languissans ayans fait leur devoir;
Sains retournoient par oeuvre meritoire."
17. "Six vingtz trois ans obtint vie en le monde
Et en octobre a Dieu l'esperit rend.
De tout cecy es cieulx est apparent,
Par mort fut prins la dixiesme kalende."
18. "Aprés sa mort fut si bien estimé
Que tous lieux accouroient a grans taz,
Pretres, clercz et gens de tous estas
Jusques au lieu ou il fut inhumé."

The donation is attested by the arms of the abbot on the surviving fragments (golden shield divided in quarters, checkered with gold and blue; shield with two crosiers back to back) and an inscription on the final panel of the tapestry:

Par tres reverand pere en Dieu
Mons. l'abbé Jacques le Roy.
Je fuz donnee a ce sainct lieu,
Ce moyennant devot arroy.
Priez vostre souverain Roy,
Que de tout mal defendu
Ung bienfait n'est jamais perdu.
1524

LITERATURE
Barbier de Montault, Xavier. *L'épigraphie du département de Maine et Loire*, 90–93. Angers: P. Lachèse, 1869.
———. "Appendice aux Actes de Saint Florent, Prêtre et Confesseur." *Mémoires de la Société Impériale d'Agriculture, Sciences et Arts d'Angers*, 2d ser., 8 (1863): 93–105.
———. "Une tapisserie du XVIe siècle à Saumur (Maine et Loire)." *Revue de l'Art Chretien*, 4th ser., 14 (March 1903): 222–24.
Godard-Faultrier, Victor. *Tapisserie de Saint-Florent, dessinée par P. Hawke.* Angers: Imprimerie de Cosnier et Lachese, 1842.
———. "Découverte récente de deux fragments de la tapisserie de Saint-Florent-lez-Saumur." *Réunion des Sociétés des Beaux-Arts des Départements*, 12th session, 715–17. Paris: Plon-Nourrit, 1888.

§ § §

Gaugericus (Géry), Life of. Destination, donor, and date of donation unknown (1496). Lost.

The information surviving on this tapestry relates to its production. In 1496, the Arras painter Jacquemart Pilet, who had worked in Baudoin de Bailleul's shop, designed five pieces of a choir tapestry, *Life of Saint Géry*. The tapestry was woven in Arras by Jean de Saint Hilaire.

LITERATURE
Cavallo, Adolfo. *Medieval Tapestries in the Metropolitan Museum of Art*, 67. New York: Metropolitan Museum of Art, 1993.

§ § §

Germain, Life of. Saint Germain des Prés, Paris. Donor and date of donation unknown (fifteenth century). Lost.

§ § §

Gervasius and Protasius, Life of. Saints Gervais-et-Protais cathedral, Soissons. Jean Millet, bishop of Soissons (1443–1502), tapestry donated during his episcopate. Four pieces, one fragment survives (Soissons, Notre-Dame cathedral; plate 6).

The fragment, which measures 1.50 by 3 meters, contains three separate events, each described in a titulus.
1. Gervasius and Protasius give their possessions to the poor.
2. Gervasius and Protasius exorcise a possessed girl; they baptize her and her father.
3. Gervasius and Protasius construct a chapel and are arrested.

TITULI
1. "Comment saint Gervais et saint Prothais, aprés le trespas de leur pere et mere, vendirent tous leurs biens et en rechurent les deniers, les quels il donnerent aux pouvres puis se revestent de robes blanches."
2. "Comment saint Gervais et saint Prothais gesterent le dyable hors du corps d'une jeune fille, laquelle tantost aprés fut par eux baptisee avec son pere."
3. "Comment saint Nazare accompagné de saint Gervais et saint Prothais edifierent une

cappelle es bois et l'enfant Celse les amenistront les pierres; et lors Neron de ce averty par Corneille envoya Deuto et Paulin pour les prendre."

LITERATURE

Darcel, Alfred. "Fragment de tapisserie dans la cathédrale de Soissons (xve siècle)." *Revue des Sociétés Savantes des Départements*, 7th ser., 5 (1882): 325–26.

§ § §

Gervasius and Protasius, Life of. Saint-Julien cathedral, Le Mans. Martin Guerande, canon, 1509. Five sections survive, two lost (Le Mans, Saint-Julien cathedral; figs. 18–28, plates 5, 8, and 9).

The extant tapestry contains eighteen episodes from the lives of the saints.
1. Death of Vital.
2. Death of Valery.
3. Gervasius and Protasius donate their possessions to the poor.
4. Baptism of Gervasius and Protasius.
5. Miracle performed by the saints.
6. Saints build chapel.
7. Nero's soldiers arrest saints.
8. First meeting with Nero.
9. Lightning strikes Nero.
10. Nero tempts Gervasius and Protasius with fame and fortune.
11. Gervasius and Protasius sent to prison.
12. Angel visits saints in prison.
13. Gervasius and Protasius sent to Nolin, provost of Milan.
14. Martyr of a saint (Gervasius).
15. Martyr of Protasius; burial of the saints.
16. Paul apppears to Ambrose.
17. Elevation of relics of Gervasius and Protasius.
18. Donor portrait.

For detailed information on this tapestry and literature, see chapter 4; for the tituli, see appendix 3.

§§§

John the Baptist, Life of. Collegiate church of Saint-Julien, Angers (previously dedicated to John the Baptist). Donor and date of donation unknown (end of fifteenth century). Two fragments survive (Angers, Musée des Tapisseries; fig. 53).

The tapestry was originally displayed in the church of Saint-Julien during the principal festivals of the liturgical year. The fragment, which measures 1.70 by 4 meters, represents the following scenes:

1. Angel appears to Zacharius in the temple.
2. Visitation.

Internal dialogue and exclamations in choir tapestries are frequently in Latin. This tapestry is unusual in that the tituli are also in Latin.

Episode 1

1. "Gabriel: Ne timeas Zacharia quem exaudita est

deprecatio tua. Luce Primo

Zacharius: Unde hoc sciam

Ego enim sum senex et uxor mea processit in diebus suis.

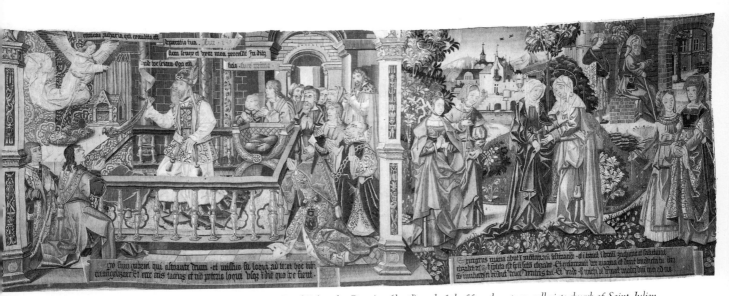

FIGURE 53. *Zacharius in the temple and the Visitation*. Life of John the Baptist *(detail), end of the fifteenth century, collegiate church of Saint-Julien (previously dedicated to John the Baptist), Angers (Musée des Tapisseries, Angers).*

Luce Primo
Gabriel: Ego sum Gabriel qui asto ante Deum.
Et missus sum loqui ad te
Et hoc tibi evangelizare
Et ecce eris tacens et non poteris loqui usque in dictae quo hec fient Luce."
Episode 2
2. "Exurgens Maria abiit in montana cum festinacione
Et intravit in domum Zacharie et salutavit Elizabet
Et repleta Spiritu Sancto Elizabet
Et exclamavit voce magna et dixit benedicta tu inter
omnes mulieres et benedictis fructis ventris tui
Et unde
Hic michi ut veniat mater Domini mei.
Ad Lucam Primum."

LITERATURE
Farcy, Louis de. *Histoire et description des tapisseries de l'Eglise Cathédrale d'Angers,* 43–44. Angers: Germain et G. Grassin, 1897.

§ § §
John the Baptist, Life of. Destination, donor, and date of donation unknown (end of fifteenth century). Five fragments (Pau, Museum of the Chateau).

The inventory of the château of 1578 lists eight pieces of this tapestry, but only five survive. The first three represent the life and martyrdom of the saint (each one measures 1.12 by 1.15 meters). The last two include events related to the invention of the saint's relics and their translation from Cappadocia to Constantinople (each one measures 1.20 by 2 meters).

LITERATURE
Lafond, Paul. "Histoire de Saint Jean-Baptiste au château de Pau. Suite de tapisseries de la fin du XVe siècle." *L'Art* 12, no. 1 (1886): 120–25.

§ § §
Julien, Life of. Saint-Julien cathedral, Le Mans. Baudoin de Crépy, canon of the cathedral, d. 1518. Two sections and four fragments survive (Le Mans, Saint-Julien cathedral; fig. 54).

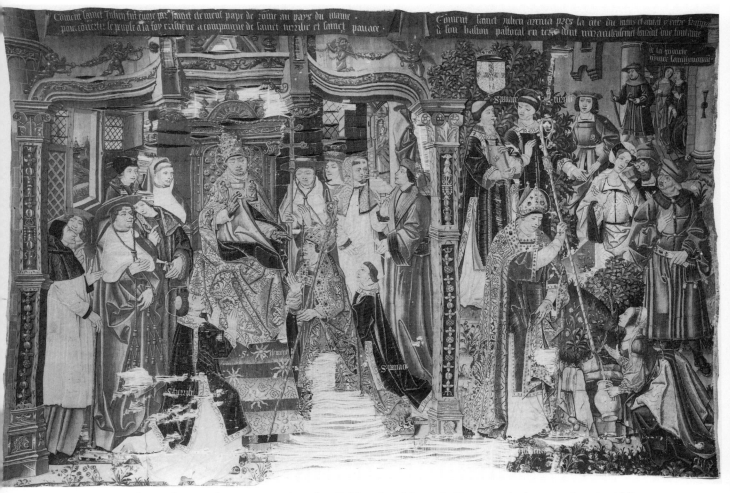

FIGURE 54. *Saint Julien sent by Saint Clement to convert the people of Le Mans; Saint Julien, in Le Mans, miraculously creates a fountain with his episcopal staff.* Life of Julien *(detail), before 1518, cathedral of Le Mans, photo before restoration.*

Each of the surviving sections of the tapestry contains two episodes and measures 3 by 3 meters. A third section was sold at the Lottengard sale; a photograph of it exists in the archives of the Bibliothèque des Arts Decoratifs, Paris. Four fragments also survive. A fifth fragment, containing the arms of the donor, Baudoin de Crépy, was stolen from the cathedral in June 1907. His arms also appear on one of the surviving fragments and on the piece sold with the Lottengard collection. That piece is unpublished and is not mentioned in Rouyer's

recent study of the series. The size of each section and the existence of the *Life of Gervasius and Protasius* for the choir indicate that the *Life of Julien* was displayed in the sanctuary of the cathedral, not in the ambulatory, as Rouyer argues (*Les tentures*, 180).

The surviving panels represent the following episodes:

1. a) Saint Julien sent by Pope Clement to convert the people of Le Mans.
 b) Saint Julien makes a fountain appear at the entrance to the city.
2. a) Saint Julien preaches to the people of Le Mans.
 b) He heals a blind man at the entrance of the palace of "Le Defensor," ruler of the city.
3) Julien heals a child; Julien heals the lame.

The surviving fragments depict these episodes:

1. The death of Saint Julien.
2. The saint heals a blind man.
3. The baptism of "Le Defensor."
4. Repetition of panel 1a.

LITERATURE

Ledru, Ambroise. *La cathédrale Saint-Julien du Mans, ses évêques, son architecture, son mobilier.* Le Mans: L. Chaudourne, 1920.

Rouyer, Claire. "Les tentures de Saint Julien." *303 Arts, Recherches et Créations* (*La Revue des Pays de la Loire*) 70 (2001): 176–81.

§ § §

Martin, Life of. Collegiate church of Saint-Martin, Angers. Donor and date of donation unknown (end of fifteenth century). Two fragments survive (Angers, Musée des Tapisseries; fig. 55, plate 8).

The tapestry was originally divided into six sections, three of which were displayed on either side of the choir. The remaining fragments together measure 2.37 by 4.40 meters.

They depict:

1. Martin bound under a pine tree; demons flee; pine tree falls.
2. Two angels prepare the bodies of the martyrs; they are placed in ornamented sarcophagi; Martin fills vials with their blood.

TITULI

1. "Comment aulcuns paÿens avoient dedié au diable ung arbre de pin; pour quoy sainct Martin se submist de le recepuoir tout copé luy estant lié, mais en faisant le

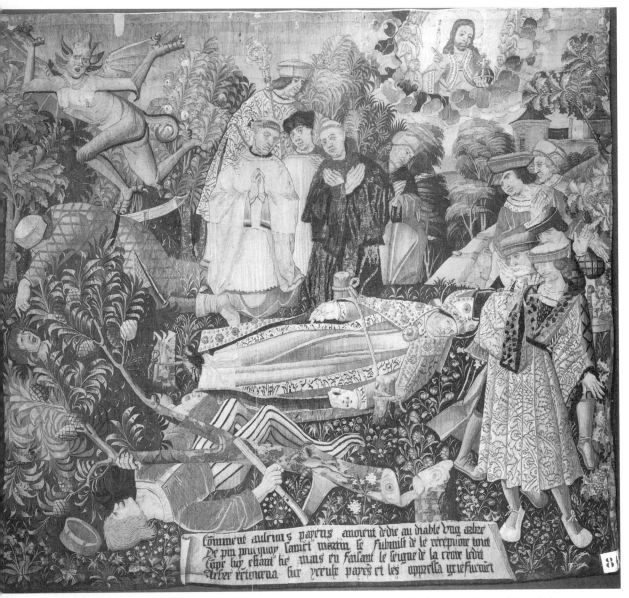

Comment aultruis paieus emoient dde au diable Ung arbre
De pin puis quoy laimct martin le submist de le verepuoie tout
tope bup estant he mans eu faisant le seigne de la croiu ledit
arbre verenowa sur ycule paieus et les oppressa grieffurnict

FIGURE 55. *Miracle of Saint Martin.* Life of Martin *(detail), end of the fifteenth century, collegiate church of Saint-Martin (Musée des Tapisseries, Angers).*

seigne de la croix, ledit arbre retourna sur yceulx païens et les oppressa griefvement."

2. "Comment monseigneur sainct Martin fist rendre a la terre le sang de sainct Maurice et de ses compaignons."

LITERATURE
Farcy, Louis de. *Histoire et description des tapisseries de l'Eglise Cathédrale d'Angers*, 41–43. Angers: Germain et G. Grassin, 1897.

§ § §

Martin, Life of. Cathedral Saint-Etienne, Bourges. Pierre de Crosses, canon 1466. Lost.

This tapestry was displayed along the rood screen of Saint-Etienne, Bourges.

LITERATURE
Mater, D. "Les anciennes tapisseries de la Cathédrale de Bourges. Pierre de Crosses." *Mémoires de la Société des Antiquaires du Centre* 27 (1903): 329–59.

§ § §

Martin of Tours, Life of. Collegiate church of Saint-Martin, Montpezat. Jean IV Desprez of Montpezat, bishop of Montauban, 1519–39, dean and benefactor of the collegiate church of Saint-Martin, Montpezat, tapestry donated during his episcopate. Five pieces survive (Montpezat, Saint-Martin; fig. 47).

The tapestry is divided into five pieces that measure: 1.82 by 5 meters; 1.85 by 5 meters; 1.93 by 4.75 meters; 1.93 by 4.75 meters; and 1.95 by 5 meters. It represents fifteen episodes.

1. Saint Martin divides his tunic and gives part of it to a beggar; God appears to Saint Martin in a dream; Saint Martin accosted by brigands during his voyage to Italy.
2. Consecration of Saint Martin; the destruction of the idols; the miracle of the pine tree.
3. Destruction of a pagan temple; Martin heals a paralytic and exorcizes a possessed woman at Trier; the saint performs mass and heals a leper with the Host.
4. The saint falls in a stairwell; the Virgin heals the saint of his wounds; the devil, disguised as Christ, appears to Saint Martin.
5. The devil sets the saint's cell on fire; the miracle of the armbands; Saint Martin

performs mass, assisted by Brice. Brice conceals his laughter at two gossips, whom the devil has afflicted with a need to chat through the sacrament of the mass.

The donor of the tapestry is identified by the presence of his arms (gold with three bands in blue, with three gold stars above a miter and crosier).

TITULI

1. "Quant de Amiens Martin se partist,
Lors chevalier soubz loy païenne,
Au povre son manteau partist,
Faisant oeuvre de foy chrestienne."
2. "Lui reposant come transy,
Dieu se apparut avironé
De angelz auquels disoit ainsi:
'Martin ce manteau m'a doné.' "
3. "Alpes dep ——— larrons deux
Lui feirent quelque arestement,
Voeillantz rober, mais l'ung de eulx
Mercy lui pria prestement."
4. "Luy baptisé suppedita
Diable, chair, monde et leurs faux tours.
Pour ce que en vertus proufita,
Sacré fust evesque de Tours."
5. "Ydoles Martin destruisoit,
Quand pour le occir ung payen vint.
Mais come fraper le cuydoit,
Ne sceut que son coulteau devint."
6. "Mescreantz a ung pin lierent
Martin, puis le pin abatirent.
En ce point tuer le cuyde,
Mais eulx mesmes la mort sentirent."
7. "A l'aide de angels celestes
Ung aultre temple il subvertist,
Dont païns lui firent molestes,
Mais chascun puis se convertist."
8. "Martin à Treves feist miracle
Sauvant une paraliticque,

Puis guerist ung demoniacle,
Dont Tetrad se feist catholicque."
9. "Comme Martin chantoit la messe,
Son hoste estoit de lepre plain;
En baisant la paix, eubt liesse,
Car il fust guéri tout à plain."
10. "Le diable fist tomber Martin
Dont le tint navré grievement,
Mais sain et sauf fust le matin
Par vertu de ung saint ungement."
11. "Qui ———— ———— de nuit aporté,
Par la Vierge et mere Marie;
Duquel fust oing et conforté
Dont la froissure fust guerie."
12. "A Martin se apparut ung jour
Le dyable illustre comme roy,
Soy disant Christ; mais sans sejour,
Il le chassa par vraie foy."
13. "Martin reposant, l'anemy
La paille et la chambre enflama.
Mais de Dieu le parfaict amy
Par priere extinct la flamme a."
14. "Quant la robe au povre eubt vestu,
Luy chantant devant plusieurs gents,
Angels ont ses bras revestu
De bovets riches et moult gentz."
15. "Martin chantant, Brixe servoit,
Et se ryoit en ung toucquet,
Voyant que le diable escripvoit
De deux commeres le cacquet."

Tituli transcribed in Devals Sr., "La tapisserie de Montpezat," in *Les Annales Archéologiques,* ed. Adolphe-Napoléon Didron Sr., 3:102–6. Paris: H. Fournier et Cie., 1845.

LITERATURE
Bertrand, Pascal-François. "Deux remarques sur la tenture de la *Vie de saint Martin* de l'ancienne collégiale Saint-Martin de Montpezat-de-Quercy." *Bulletin de la Société Archéologique de Tarn-et-Garonne* 118 (1993): 225–38.

Crazannes, Chaudruc de. Note in *Bulletin du Comité des Arts et Monuments* 1 (1838–1841): 120.

———. "Tableau chronologique des monuments historiques du département de Tarn-et-Garonne." *Bulletin Monumental* 4 (1838): 28–29.

Darcy, Alfred. "La Messe de Saint Martin." In *Les Annales Archéologiques*, edited by Adolphe-Napoléon Didron Sr., 15: 122–23. Paris: H. Fournier et Cie., 1855.

Devals Sr. "La tapisserie de Montpezat." In *Les Annales Archéologiques*, edited by Adolphe-Napoléon Didron Sr., 3:95–106. Paris: H. Fournier et Cie., 1845.

Grandmaison, Charles de. "Les tapisseries de Montpezat et la relique appelée les bonets de saint Martin de Tours." In *Réunion des Sociétés des Beaux-Arts des Départements*, 22d session, 550–56. Paris: Typographie de E. Plon, 1898.

§ § §

Mary, Life of. Notre-Dame, cathedral of Bayeux. Léon Conseil, canon of Bayeux. Before 1499 (figs. 30, 56). The tapestry was complete in the eighteenth century. By the beginning of the nineteenth century six pieces survived; one has since disappeared.

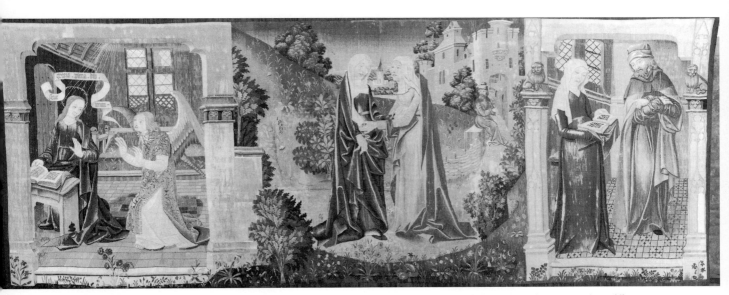

FIGURE 56. *Annunciation, Visitation, and Mary and Joseph.* Life of Mary *(detail), before 1499, cathedral of Bayeux (Museum of the Middle Ages —* Cluny, Paris).

1. Donor portrait (Paris, Museum of the Middle Ages).
2. Annunciation, Visitation, Meeting of Mary and Joseph (Paris, Museum of the Middle Ages).
3. Herod orders the killing; Massacre of the Innocents; Flight into Egypt (Greenville, Bob Jones University collection).
4. Jesus among the Doctors (Louisville, J.B. Speed Art Museum).
5. Mary and Joseph before the temple with the Doctors (lost).
6. Marriage at Cana (Louisville, J. B. Speed Art Museum).

LITERATURE

Deslandes, Eucher. *Le trésor de l'église Notre-Dame de Bayeux, d'après les inventaires manuscrits de 1476, 1480, 1498, conservés à la Bibliothèque du chapitre de Bayeux, 420.* Paris: Imprimerie Nationale, 1898.

Farcy, Louis de. *Notices archéologiques sur les tentures et les tapisseries de la cathédrale d'Angers, 64.* Angers: P. Lachése, Belleuvre et Dolbeau, 1875.

Joubert, Fabienne. *La tapisserie médiévale au Musée de Cluny, 60–65.* Paris: Réunion des musées nationaux, 1987.

§ § §

Mary, Life of. Collegiate church of Notre-Dame, Beaune. Hugues le Coq, archdeacon, 1500. Five sections (Beaune, Notre-Dame; fig. 57).

Each section of the tapestry measures 1.86 by approximately 6 meters. A portrait of the donor appears both after the second section and at the end of the tapestry.
1. Anna and Joachim.
2. Birth of the Virgin.
3. Presentation of the Virgin in the temple.
4. Joseph and the flowering rod.
5. Marriage of the Virgin.
6. Mary at her husband's house.
7. Annunciation.
8. Visitation.
9. Nativity.
10. Circumcision.
11. Adoration of the Magi.
12. Presentation in the temple.
13. Flight into Egypt.

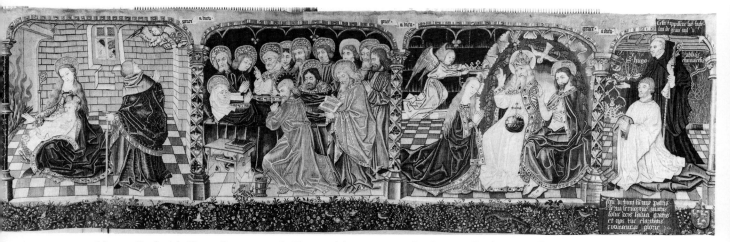

FIGURE 57. *Nativity, Death of the Virgin, Coronation of the Virgin, and donor portrait.* Life of Mary *(detail), 1500, collegiate church of Notre-Dame, Beaune.*

14. Massacre of the Innocents.
15. Flight of the Holy Family into Egypt.
16. Death of the Virgin.
17. Coronation of the Virgin.

LITERATURE

Erlande-Brandenburg, Alain. "La tenture de la vie de la Vierge à Notre-Dame de Beaune." *Bulletin Monumental* 1 (1976): 37–48.

Inventaire général des monuments et des richesses artistiques de la France, ed. *La tenture de la vie de la Vierge, Collégiale de Beaune, Côte-d'Or.* With texts by Brigitte Fromaget, Judith Kagan, and Martine Plantec. Dijon: Association pour la Connaissance du Patrimoine de Bourgogne, 1994.

Joubert, Fabienne. "Nouvelles propositions sur la personnalité artistique de Pierre Spicre." In *La splendeur des Rolins. Un mécénat privé à la cour de Bourgogne,* edited by Brigitte Maurice-Chabard, 169–91. Paris: Picard, 1999.

§ § §

Mary, Life of. Cathedral of Notre-Dame, Paris. Theobaldus de Vitriaco, canon, 1448. Lost.

The description of this donation in the cathedral's cartulary provides a clear idea of the scenes it contained (Benjamin Guérard, ed., *Cartulaire de l'église Notre-Dame de Paris* [Paris: Crapelet, 1850], 4:208–9). The five sections of the tapestry depicted:

1. The Annunciation.
2. The Presentation in the temple.
3. Jesus among the Doctors.
4. Pentecost.
5. The Assumption of the Virgin.

§ § §

Mary, Life of. Cathedral of Saint-Bertrand, Comminges. Jean de Mauléon, bishop of Comminges (1519–1537), tapestry donated during his episcopate. Two pieces survive (Comminges, Saint-Bertrand; fig. 58).

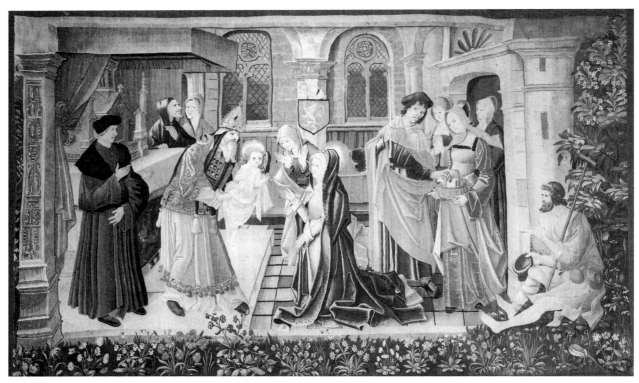

FIGURE 58. *Presentation in the Temple.* Life of Mary *(detail), 1519–1537, Saint-Bertrand cathedral, Comminges.*

1. Adoration of the Magi.
2. Presentation of Jesus in the temple.

LITERATURE

Trey-Signales, D. "Tapisseries de la cathédrale de Comminges." *Revue de l'Art Chrétien* 12 (1893): 173–75.

Sapène, Bertrand. *Saint-Bertrand-de-Comminges,* 57–64. Toulouse: Douladoure, 1966.

Tapisseries et laitons de choeur. Catalog, no. 13. Tournai, 1971.

§ § §

Mary and Christ, Lives of. Made for Christ Church, Canterbury. Thomas Goldstone, prior of Canterbury cathedral (1495–1517), and Richard Dering, monk and sacristan, 1511. Purchased by the cathedral chapter of Saint-Sauveur, Aix, in 1656. (Aix, Saint-Sauveur). Events span the period from the birth of the Virgin to her Assumption.

LITERATURE

Fauris de Saint-Vincent. *Mémoire sur les tapisseries de choeur d'église cathédrale d'Aix.* Aix: Impr. de A. Pontier, 1816.

Rapp Buri, Anna, and Monica Stucky-Schürer. *Burgundische Tapisserien,* 372–74. Munich: Hirmer Verlag, 2001.

§ § §

Mary and Christ, Lives of. Chaise-Dieu, abbey church of Saint-Robert. Jacques of Saint-Nectaire, abbot, date of donation unknown; the tapestries date to 1501–1518.

The tapestry is complete and is displayed in the choir of Saint-Robert, the Chaise-Dieu (fig. 2). For the episodes depicted, please consult literature.

LITERATURE

Burger, Pierre. *Les tapisseries de l'abbatiale Saint-Robert de la Chaise-Dieu.* Brioude: Watel, 1975.

Gaussin, Pierre-Roger. *L'abbaye de la Chaise-Dieu (1043–1790).* Paris: Editions Cujas, 1962.

§ § §

Mary, Life of. Notre-Dame cathedral, Reims. Robert of Lenoncourt, archbishop of Reims, 1530. Seventeen panels (Reims, Palais du Tau). The tapestry is complete. For the episodes depicted, please see page 157.

§§§

Mary Magdalene, Life of. Parish church of Mary Magdalene, Troyes. Donor and date of donation unknown. Tapestry produced 1425–1430. Lost.

The tapestry originally had six pieces. Documents concerning the production of this tapestry are preserved in the departmental archives of l'Aube, Troyes (Comptes de la Fabrique of the church of Mary Magdalene). A portion of the references to the tapestry has been transcribed (Guignard, *Mémoires*, x–xiii). These references provide important insights into the production of choir tapestries. The stages of work were divided: different individuals were responsible for the written text of the episodes to be depicted, a drawing in small format, a full-scale drawing on cloth, and the tapestry itself.

§§§

Maurice, Life of. Saint-Maurice cathedral, Angers. Hugues Fresnau, canon, October 30, 1459. Lost.

The inventory of the cathedral compiled in 1467 states that the tapestry consisted of six pieces: "Item alia tapiceria in sex peciis continens vitam sancti Mauricii ad parandum totum chorum, data per magistrum Hugonem Fresneau" (Farcy, *Histoire et description*, 64). These six sections were placed on either side of the canons' choir with the *Life of Maurille* linking them across the rood screen.

§§§

Maurille, Life of. Saint-Maurice cathedral, Angers. Cathedral chapter, February 4, 1460. One fragment (Angers, Musée de la Tapisserie; plate 15).

The *Life of Maurille* consisted originally of three sections, which were commissioned by the chapter of Saint-Maurice to ornament the rood screen on high feast days. The surviving fragment (1.55 by 1.80 meters) depicts the following episodes:
1. Maurille as gardener.
2. Maurille presents a plate of fruit to the king and queen of England.

TITULUS
"La mer lui ——— les clefs du reliquaire de l'eglise et depuis a ——— le roy d'Engleterre qui joyeulsement le receut et retint pour son jardinier."

LITERATURE

Farcy, Louis de. *Histoire et description des tapisseries de l'Eglise Cathédrale d'Angers*, 47–48, 64–65. Angers: Germain et G. Grassin, 1897.

————. *Monographie de la cathédrale d'Angers.* Vol. 3: *Le mobilier*, 82, 124–25. Angers: Josselin, 1901.

Urseau, Charles. *Le musée des tapisserie d'Angers*, 12. Paris: H. Laurens, 1930.

§ § §

Omer, Life of. Saint-Omer cathedral, Saint-Omer. Canon Jean Coquillan, ca. 1455. Lost. Tapestry mentioned in the canon's will (Saint-Omer, Archives municipales 2G473). My thanks to Ludovic Nys for this reference.

§ § §

Peter, Life of. Saint-Pierre cathedral, Beauvais. Guillaume de Hellande, bishop of Beauvais, 1460. Ten fragments survive (Beauvais cathedral [plate 1, fig. 59]; Paris, Musée du Moyen Age; Washington, National Gallery of Art; Boston, Museum of Fine Arts; private collections in France and the United States). The donor's arms and those of the chapter appear on the existing fragments.

The surviving fragments represent the following episodes:
1. Healing of saint Petronilla; resurrection of George; healing of Aeneas.
2. Resurrection of Tabitha; an angel appears to Cornelius.
3. Vision of impure animals; baptism of Cornelius; imprisonment of Peter.
4. Deliverance of Peter.
5. Peter beaten; Paul feeds Peter in prison; resurrection of Theophilus's son; Theophilus makes Peter pray before him.
6. Peter ordains bishops Linus and Cletus; Jesus announces that Simon and Nero are conspiring against him; Peter appoints Clement as his successor; Peter resurrects a young man before Nero.
7. Peter leaves Rome.
8. Crucifixion of Peter.
9. Decapitation of Paul.
10. Marcellus and Apuleius (Peter's disciples) bury Peter.
11. Apparition of Peter and Paul to Nero.

A lengthy inscription at the end of the tapestry, preserved in a manuscript now in Paris at the Bibliothèque Nationale, identifies the donor of the tapestry:

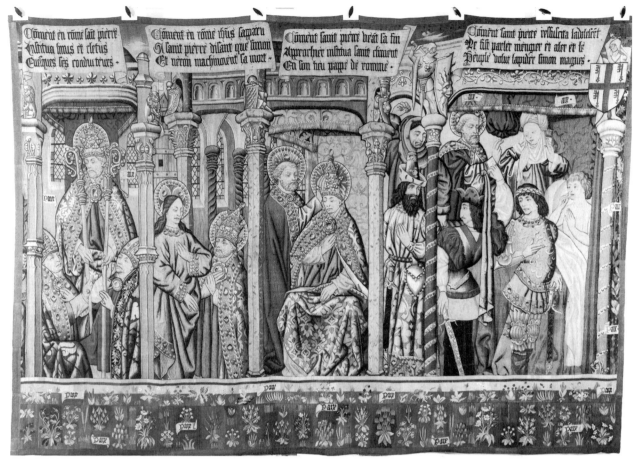

FIGURE 59. *Peter ordains bishops Linus and Cletus, Jesus announces that Simon and Nero conspire against him, Peter appoints Clement as his successor, and Peter resurrects a young man before Nero.* Life of Peter *(detail), cathedral Saint-Pierre, Beauvais.*

L'an de grace mil quatre cens
Et quarante quatre en tout sens
Dieu modera nostre souffrance.
Treves furent faites en France
Entre le puissant Roy Franchois
Appellé Charles de Valois
Et Henry le Roi d'Angleterre
Au doux mois de may, que la terre

Se pare de mainte couleur.
Audit temps, homme de valeur,
De noble extraction et grande,
Maistre Guilleaume de Hollande
Fut fait l'evesque de Beauvais,
Profitant aux bons et mauvais,
Qui, le jour saint Barthelemi,
Fit son entree aprés midi,
Laquelle fut moult honnorable.
Iceluy pasteur venerable,
Meu d'une vertueuse plante,
L'an mille quatre cents soixante
Fist faire de bonne duree
Ce tapis ou est figuree
La belle vie saint Pierre.
Il a revestu mainte pierre
En ce cueur. Dieu qui est paisible
Lui doint vesture incorruptible.
(Paris, BN MS fr. 8581, 3:1401–1402)

TITULI

1. a) Comment saint Pierre gary des fievres sainte Prenelle, sa fille, a la requeste de Titus
disciple.

 b) Comment par la vertu du baton saint Pierre, George son disciple resuscita qui avoit
esté mort quarante jours.

 c) Comment en Lidde st Pierre gary Enee palitique, qui VIII ans avoit esté au lit.

2. a) Comment an Joppe saint Pierre resusita Thabita, femme bonne aumosniere.

 b) Comment l'angle se apparu a Cornille centurion, disant qu'il envoiast querir saint
Pierre pour son salut.

3. a) Comment saint Pierre, en la maison Cimon le coriaire, vit le ciel ouvert et les angles
lui apportans ung lincheul plain de bestes ordes et venimeuses pour mengier.

 b) Comment le saint Esprit descendi sus Cornille centurion, et sa famille, saint Pierre
preschant devant luy.

 c) Comment en la prison de Herode saint Pierre dormoit entre deux chevaliers et
l'angle le frappa par le costé.

4. Comment l'angle mena saint Pierre hors de la prison Herode.

5. a) Comment en Anthioche saint Pierre fut prins et batu des tirans de Theophile, prince de icelle ville.

 b) Comment en la prison de Theophile saint Pierre mouroit de faim et de soif et saint Pol en habit de entailleur lui ouvry les dens et donna a boire et a mangier.

 c) Comment a la promesse de saint Pol saint Pierre ressuscita le fils de Theophile, qui avoit esté mort par XIIII ans.

 d) Comment Theophile fist eslever saint Pierre en caiere haulte et honnourable pour estre veu et oÿ preschier.

6. a) Comment saint Pierre disputa contre Symo magues, lequel se disoit fils de Dieu.

 b) Comment en Rome saint Pierre Institua Linus et Cletus Evesques ses coadjuteurs.

 c) Comment en Rome Jhesus s'apparu a saint Pierre, disant que Simon et Neron machinoient sa mort.

 d) Comment saint Pierre, veant sa fin approchier, institua saint Climent en son lieu pappe de Romme.

 e) Comment saint Pierre ressuscita l'adolescent, le fist parler, mengier et aler et le peuple volut lapider Simon magues.

7. Comment saint Pierre issant ——— de Romme vit Jhesucrist venir ——— de lui et lui demanda ou il al ———

8. Comment saint Pierre fut loyé en la crois, les piés vers le ciel, les angles lui apportans couronne de roses et de lis et ung livre ouquel il lisoit ce qu'il disoit au peuple.

LITERATURE

Hermant, Guillaume. *Histoire ecclésiastique et civile de Beauvais et du Beauvaisis rapportée à la vie de chacun de ses évêques*, 3:1401–1402, 1412. Paris, BN MS fr. 8581.

Bonnet-Laborderie, Philippe. "Les tapisseries de la cathédrale de Beauvais." *Groupes d'Etudes des Monuments et Oeuvres d'Art de Beauvais* 14–15 (1982): 1–58.

Joubert, Fabienne. *La tapisserie médiévale au Musée de Cluny*, 17–25. Paris: Réunion des musées nationaux, 1987.

§ § §

Peter, Life of. Benedictine church of Saint-Pierre, Vienne. Donor and date of donation unknown; tapestry dates to the last quarter of the fifteenth century. Two fragments survive (private collection; fig. 60).

The tapestry originally depicted nine episodes in the saint's life. The donor's arms are included in the two surviving sections; they have not been identified. The two fragments represent Peter before Nero and Jesus appearing to Peter.

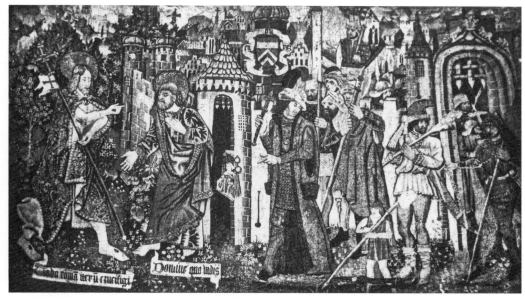

FIGURE 60. *Jesus appears to Peter.* Life of Peter *(detail), Saint-Pierre, Vienne.*

TITULI (A single titulus from six of the pieces was transcribed in 1884. The other three represented: Christ in majesty; the crucifixion of Peter; and one described simply as containing fleurs de lys.)

1. "Domine quo vadis?"
2. "Domine ostende ei vanas artes suas."
3. "In nomine Jesu Christi surge et ambula."
4. "Nunc scio vere quia misit dominus."
5. "Domine salvum me fac."
6. "Venite post me."

LITERATURE
Prudhomme, A. "Le trésor de St-Pierre de Vienne." *Bulletin de l'Academie Delphinale,* 3d ser., 19 (1884): 119–35.

§ § §

Peter, Life of. Cathedral Saint-Pierre, Troyes. Louis Raguier, bishop of Troyes, 1483. Lost.

LITERATURE
Viollet-le-Duc, Eugène. *Dictionnaire raisonné du mobilier français. De l'époque Carolingienne à la Renaissance,* 1:274–75. 2d ed. Paris: A. Morel, 1868.

§ § §

Peter, Life of. Church of Saint-Pierre, Saumur. 1542 (or 1544–1546).

A detailed description of the production process of the *patron* for this tapestry exists, suggesting that the cloth was meant to be preserved (Victor Gay, *Glossaire archéologique du Moyen Age et de la Renaissance* [Paris: Picard, 1928], 2:213; Célestin Port, *Les artistes angevins: Peintres, sculpteurs, maitres-d'oeuvre, architectes, graveurs, musiciens* [Paris: J. Baur, 1881], 94]). It is possible that either the chapter never intended to have a tapestry woven and that the document refers to "tapestry" in the general sense of a "hanging," or that the painted cloth was meant to be displayed in the choir at a different time than the tapestry. Several cases have been documented for painted cloths, or *patrons,* being substituted for tapestries during Lent. The episodes depicted were:

1. Healing of the sick.
2. Death of Sapphira.
3. Resurrection of Tabitha by Saint Peter at Joppa.
4. Death of Ananias.
5. Saint Peter among the soldiers; appearance of Christ to Saint Peter.
6. Saint Peter in prison; trial of Peter.
7. Second scene of Peter before emperor; crucifixion of Peter.
8. Death of the Virgin.

§ § §

Peter, Life of. Location unknown, ca. 1500. One piece of the tapestry entered a private collection in a sale by Jacques Seligmann and Company. It represented Peter and Paul appearing to Nero. A related piece entered a private collection from the Lawrence collection; it depicted the appearance of Christ to Peter. The titulus is in Latin.

LITERATURE
Ackerman, Phyllis. *Catalogue of a Loan Exhibition of Gothic Tapestries,* no. 10. Chicago: The Arts Club of Chicago, 1926.

§ § §

Piat and Eleutherius, Lives of. Notre-Dame cathedral, Tournai. Toussaint Prier, canon, 1402. Four sections survive (Tournai, Notre-Dame cathedral; plates 2–4, figs. 4–16).

For a description of this tapestry and literature, see chapter 2. For the tituli, see appendix 2. The extant fragments depict the following scenes:
1. God enlists Piat to convert the people of Tournai.
2. Piat arrives in Tournai.
3. Piat preaches.
4. Piat preaches.
5. Piat founds church.
6. Piat baptizes.
7. People of Tournai baptized outside their city.
8. Eleutherius travels to Rome.
9. Eleutherius confirmed by the pope.
10. Eleutherius consecrated.
11. Eleutherius accosted by the tribune's daughter.
12. Eleutherius resurrects the tribune's daughter.
13. Eleutherius baptizes the tribune's daughter.
14. A plague strikes Tournai.

§ § §

Quentin, Life of. Collegiate church of Saint-Quentin, Saint Quentin. Donor and date of donation unknown; the tapestry dates to about 1485. One section survives (Paris, Musée du Louvre; plate 14).

The section of the *Life of Quentin* preserved in the Louvre represents the following events:
1. Thief steals a horse from a priest.
2. Priest reports theft to the provost.
3. Thief arrested.
4. Priest prays to the relics of Quentin for the thief to be forgiven.
5. The provost condemns the thief to hang.
6. Thief is hanged but the chain breaks.
7. Thief prays to the relics of Quentin.

1. "Pour coeurs en devotion mettre
Notez ce miracle louable
D'ung larron, lequel a ung prestre
Robba son cheval en l'estable."
2. "Ce prestre adverti du larcin
S'en vint plaindre par mos exprés
Au prevost lors de Sainct-Quentin,
Qui ses gens envoya aprés."
3. "Le larron ainsi poursievy
Affin du larcin renseignier
Fust trouvé, du cheval saisy,
Prins et emmené prisonnier."
4. "Puis doubtant estre irregulier
Se pour ce s'ensievoit sentence,
Le prestre au prevost vint prier
Qu'au larron remist cette offense."
5. "Mais le prevost comme vray juge
Rien n'en voult au prestre accorder,
Dont vint au corps sainct au refuge,
Priant qu'il lui voulust aider."
6. "Et cependant fut condempné
A estre pendu au gibet,
Ou fust honteusement mené
Pour le loyer de son mefaict."
7. "Pendu en se point par justice,
Incontinent la chaine et lacs
Par miraculeux artifice
Rompirent et vif cheut en bas."
8. "Lors ce fet donné a entendre
Au prevost, plus n'y proceda
Dont le larron vint grace rendre
A sainct Quentin qui le garda."

LITERATURE

Bacquet, Augustin. "La tapisserie de Saint Quentin." In *Bulletin Archéologique du Comité des Travaux Historiques et Scientifiques 1938–40*, 116–17. Paris: Imprimerie Nationale, 1942.

———. "Tapisserie française du XVe siècle représentant un miracle de saint Quentin." *Mémoires de la Société Académique de Saint-Quentin* 51 (1935): 307–31.

§§§

Remegius, Life of. Abbey church of Saint-Remi, Reims. Robert of Lenoncourt, archbishop of Reims, 1531. Ten panels (Reims, Musée Saint-Remi). The tapestry is complete.

This archbishop also donated a *Life of Mary* to his cathedral. For the episodes depicted in both tapestries, see Marguerite Sartor, *Les tapisseries, toiles peintes et broderies de Reims* (Reims: L. Michaud, 1912), 68–101, 138–58.

LITERATURE
Erlande-Brandenburg, Alain. *La tenure de saint Remi, exposée au Musée Saint-Remi*. Reims: Centre régional de documentation pédagogique, 1983.

§§§

Saturnin, Life of. Church of Saint-Saturnin, Tours. Jacques de Semblancay, 1527. Four sections survive (three belong to the Saint-Maurice cathedral, Angers, and one is in a private collection).

The tapestry originally consisted of eight sections. The surviving pieces are organized with a principal scene in the center surrounded by scenes on either side. Together they measure 2.67 by 9.60 meters. These three scenes are joined by a textual inscription of eight verses. Jacques de Semblancy paid the Florentine painter André Polastron to draw the cartoons for the tapestry. This artist received payments of one hundred pounds in 1528 and four hundred pounds in 1536. The remaining fragments depict the following episodes:

1. Christ elects Saturnin; Crucifixion; Resurrection; Ascension; Pentecost; Miraculous draft of fish.
2. Peter bids farewell to Saturnin, to whom he has given his keys; Paul instructs Saturnin; Saturnin founds a church; Saturnin ordains a priest.
3. Saturnin exorcises the daughter of the king; king condemns Saturnin; martyrdom of Saturnin, who is dragged by a bull.
4. Donor portraits.

TITULI

1. "Sainct Saturnin doncques, aprés que tout en appert
 eut prins congé de sainct Jehan, ne tarda venir

a Jesus Christ, preschant et baptizant come pert
es sainctz Evangiles, lesquelz nos fault tenir.
Alors de notre dict Saulveur le bon plaisir
fut de recevoir benignement et baptiser
sainct Saturnin, que pour premier voulut choisir
des septante deux disciple sans nul despriser."
2. "De sainct Saturnin brevement dire ne somer
on ne scauroit la grande prerogative
que notre doulx saulveur Jesus doigna luy doner
tant en sermon qu'en vertu operative;
car aprés la passion tres afflictive
de notre Seigneur, il alla prescher en maint lieu,
convertissant par sa belle traditive
plusieurs infideles a la saincte loy de Dieu."
3. "Finablement sainct Saturnin, aprés avoir sceu
qu'il devoit endurer mort pour le nom divin,
a Tholoze retourna; par quoy fut tantost
veu guarir la fille de l'empereur Antonin,
lequel attribuant ce par vouloir malin
a malfice fist trayner a ung grand taureau
par les degrez du capitol sainct Saturnin,
en sorte qui lui brisa le corps et le cerveau."
4. "O, bon martir evesque et premier disciple de
Jesuschrist, prie pour nous."

LITERATURE

Benoît de la Grandière. *Histoire de la Touraine.* Angers, Bibliothèque Municipale.

Farcy, Louis de. "L'auteur des cartons de la tapisserie de saint Saturnin de la cathédrale d'Angers." *Revue de l'Art Chrétien,* 4th ser., 7 (July 1896): 305–6.

———. *Histoire et description des tapisseries de l'Eglise Cathédrale d'Angers,* 36–38. Angers: Germain et G. Grassin, 1897.

§ § §

Stephen, Life of. Saint-Etienne cathedral, Auxerre. Jean Baillet, bishop of Auxerre, date of donation unknown (about 1500). Nine pieces survive (plates 10–12, figs. 31–41).

The tapestry depicts the following events from the saint's life:

1. Apostles meet to resolve discord between the Greeks and Hebrews.
2. Stephen elected deacon.
3. Stephen disputes with members of the synagogue.
4. Stephen brought to trial.
5. Stephen has vision of the Trinity.
6. Stephen led to martyrdom.
7. Stephen stoned.
8. Stephen's soul transported by angels.
9. Gamaliel recovers Stephen's body.
10. Gamaliel appears to Lucien.
11. Lucien tells Bishop John his dreams.
12. Bishop John searches for Stephen's body.
13. Stephen's body discovered.
14. Stephen transported into Jerusalem.
15. Alexander's wife requests his body.
16. She transports Stephen's body across the ocean.
17. Stephen's relics arrive in Constantinople.
18. Procession into Constantinople.
19. Emperor sends emissary to fetch Stephen's relics.
20. Stephen's relics arrive in Rome.
21. Stephen's relics placed in Saint Peter in chains.
22. Those who attempt to move Lawrence are killed.
23. Stephen placed next to Lawrence.

For a description of this tapestry and literature, see chapter 4; for the tituli, see appendix 4.

§ § §

Stephen, Life of. Parish church Saint-Etienne, Lille. Jean Ruffault, lord of Neuville, 1518. Lost.

LITERATURE

Fremaux, A. "Histoire généalogique de la Famille Ruffault." (*Souvenirs de la Flandre Wallone*, 2d ser., 5 [1885]). Douai: L. Crépin, 1887.

§ § §

Stephen, Life of. Cathedral Saint-Etienne, Bourges. Pierre de Crosses, canon of
the cathedral, October 8, 1466. One surviving fragment (Bourges, Musée de la
Ville; fig. 61).

The tapestry consisted of six pieces, which were displayed on each side of the choir and
depicted the life of the saint and the invention and translation of his relics. Pierre Crosse's
donation is acknowledged in the accounts of the chapter: "Conclusum fit quod fiat littera
magistro de Crossis de fundatione facta eidem pro tapissaria" (Bourges, Archives du Cher,
Chapter Registers of Saint-Etienne, 6, fol. 47v). In 1768 the chapter decided to dispose of the
tapestries.

A fragment of the tapestry survives in the Municipal Museum, Bourges; it depicts Alexan-
der's wife, Juliana, transporting the body of Stephen from Jerusalem to Constantinople (view
of ship with Juliana and her entourage around reliquary, as lame, possessed, and leperous
people wait on the shore). Dimensions: 2.15 by 2.48 meters. Includes arms of donor (silver
shield on blue ground with three golden crosses).

TITULUS
"Coment la nef sait Eteve fit ecal pres Calecide; pluseurs malades furent gueris."

LITERATURE
Mater, D. "Les anciennes tapisseries de la Cathédrale de Bourges. Pierre de Crosses."
Mémoires de la Société des Antiquaires du Centre 27 (1903): 329–59.

Girardot, Baron. *Histoire et inventaire du trésor de la Cathédrale de Bourges*, 33. Paris: Typographie
de Ch. Lahure et Co., 1859.

Lassus, Jean-Baptiste-Antoine. "Les anciens autels." In *Les annales archéologiques*, edited by
Adolphe-Napoléon Didron Sr., 9:95. Paris: Claye et Taillefer, 1849.

§ § §

Stephen, Life of. Location unknown, donor unknown, ca. 1520. Two pieces
survive.

The pieces measure 2.30 by 3.35–3.70 meters and 2.30 by 1.94 meters. They depict seven
events.
1. Peter appoints Stephen deacon.
2. Stephen preaches; in the background members of the temple appear to engage him in
 a discussion.

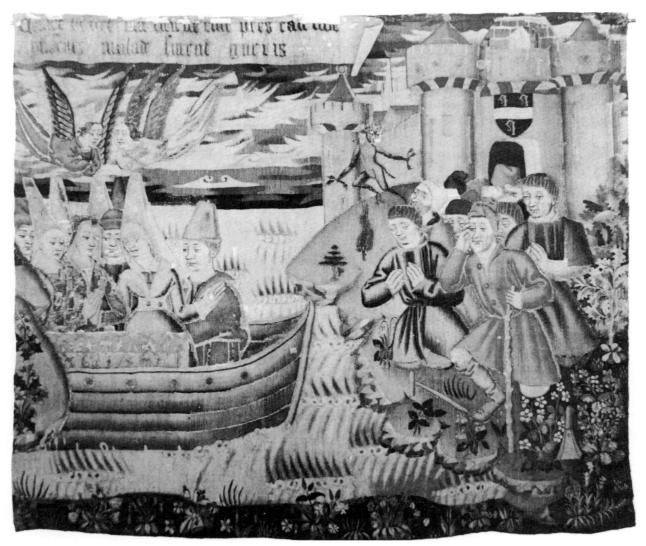

FIGURE 61. *Juliana transports Stephen's relics to Constantinople.* Life of Stephen *(detail), 1466, Bourges cathedral (Musée de la Ville de Bourges).*

3. False accusations are made against Stephen.
4. Stephen's trial.
5. Stephen's vision.
6. Stoning of Stephen.
7. Stephen's burial.

LITERATURE

Hinrichsen, J., and P. Lindpainer. *Ausstellung Gotische Bildteppiche, Plastiken, Tafelbilder.* Catalog, tapestry no. 9. Berlin: n.p., 1928.

§ § §

Stephen, Life of. Sens Cathedral. Canons of Sens, 1503–1505. Lost.

The accounts of the cathedral chapter include payment to a tapestry maker in Paris named Guillaume Rasse. This includes the amount paid a painter who went to Melun to see a painting of the martyrdom of Stephen for use as a model for the tapestry. The document is mentioned by Véronique Notin ("La légende de saint Etienne: Histoire et Genèse," in *Histoires tissées,* edited by Sophie Lagabrielle, 39–40 n. 26 [Avignon: RMG-Palais des Papes, 1997]).

§ § §

Urban IV, Life of. Collegiate church and papal foundation of Saint-Urbain, Troyes. Claude de Lirey, canon, 1525. Lost. These tapestries may have replaced those of the *Lives of Urban and Cecilia,* if the latter were ever produced.

LITERATURE

Courtalon-Delaistre, Jean-Charles. *Topographie historique de la ville et du diocèse de Troyes,* 2:155. Troyes: Vve. Gobelet, 1783.

§ § §

Urban and Cecilia, Lives of. Collegiate church and papal foundation of Saint-Urbain, Troyes. Lay couple (husband and wife). The project was documented in the late fifteenth or early sixteenth century, but the tapestry may have never been executed.

This tapestry is described in detail in a text written by a canon of Saint-Urbain and probably intended as directions to the artists responsible for the cartoons of the tapestry. No record of the tapestry survives. A hint as to the identity of the donors is provided in the description of their portrait, which would have been placed before the first episode in the series.

The tapestry was meant to consist of six pieces, containing twenty-two episodes. Each is described in detail in the manuscript (Troyes, Archives départementale de l'Aube, 10 G carton 8), transcribed with minor variations by Philippe Guignard ("Mémoires fournis aux peintres chargés d'exécuter les cartons d'une tapisserie destinée à la collégiale saint-Urbain de Troyes

représentant les légendes de St Urbain et de Ste Cécile," *Mémoires de la Société d'Agriculture, sciences et arts du département de l'Aube* 15 [1849–1850]: 421–534). This text is extremely important because it indicates the role of an adviser in the selection and organization of episodes in a woven *vita* and thereby provides insights into the production process of choir tapestries. The author describes the subject matter of each event, details of costumes, architecture, and landscape, and includes the tituli to be included below each episode.

1. Childhood of Urban with donor portraits.
2. Urban preaches.
3. Urban consecrated; makes donation to the Roman Church.
4. Urban converts Cecilia; is driven from Rome.
5. Cecilia prays to conserve her virginity; she marries Valerian.
6. Valerian seeks out Urban; Urban baptizes an old man; Valerian returns to Cecilia.
7. Angel places wreaths of roses and lilies on their bed; the couple instructs Valerian's brother, Tiburtius.
8. Three find Urban; Tiburtius baptized; Cecilia and Valerian distribute alms.
9. Urban ordains priests.
10. Ulpien and Mammoea plead with Emperor Alexander Severus to stop persecution of Christians; battle of emperor with his enemies; Almachius orders his vicar, Carpasius, to find Christians.
11. Almachius kills Christians; Valerian, Tiburtius, and Cecilia bury them; Almachius forces Valerian and Tiburtius to worship idols.
12. Maximus leads Valerian and Tiburtius to martyrdom; they convert and baptize him and his people; Valerian and Tiburtius decapitated; Maximus sees angels receive their souls.
13. Martyrdom of Maximus; Cecilia buries him; Almachius questions her; she is placed in boiling water; Christ blesses her.
14. Cecilia preaches to the poor, who gather around her; Urban buries her.
15. Carpasius pulls Urban and his followers from the cave where they hide; they are brought before Almachius; brought to prison; put in chains; Christians gain access by bribing jailer.
16. Urban appears before Almachius; he is beaten; back in prison, he receives noble visitors.
17. Avolinus converts; Urban baptizes him; Avolinus decapitated.
18. Urban destroys the temple of Jupiter; Almachius beats Urban and his clergy; death of Lucien; Fortunus buries body.
19. Urban and clergy in prison; Carpasius beats them and cuts off their heads.
20. Christians and three noblemen bury them; Carpasius possessed by a demon; he frightens Almachius.

21. Marmenia, wife of Carpasius, and her daughter Lucinia convert and are baptized by Fortunus and Justin; Fortunus baptizes pagans.
22. Marmenia and her daughter find out from Fortunus where Urban and his companions are buried; they assist at their invention, performed by Fortunus and Justin, who place the bodies in richly ornamented caskets.

§ §

Ursinus, Life of. Collegiate church of Saint-Ursin, Bourges (destroyed). Guillaume du Brueil, canon of Saint-Etienne, Bourges, and prior of Saint-Ursin with his brother Pierre, before 1500. Three extant fragments (Bourges, Musée de la Ville; fig. 45).

The tapestry, which was woven in Tournai, originally consisted of four pieces. The extant fragments measure 1.40 by 1.60 meters and 1.40 by 1.90 meters. The fragments depict the following scenes:

1. Philip presents Ursinus to Christ.
2. Ursinus collecting the blood of Saint Stephen at the moment of his lapidation.
3. Ursinus is expelled from Bourges; Ursinus called back to Bourges.

TITULI
2. "Comment saint Ursin fut present quant on lapide saint Estienne et remassa le sang, lequel depuis il aporta a Bourges."
3. "Comment sainct Ursin fut chassé de Bourges par les ydolatres gouverneurs de la loy a coups de bastons et harie aux chiens." / "Comment saint Ursin esta ——— amoneste de retourner a ——— ."

The donation of the tapestry by Guillaume and his brother Pierre is attested in an inscription on a now-lost panel of the tapestry, transcribed in a note in the genealogy of the du Brueil family (Paris, BN, Cabinet des titres, dossier bl. 133, 2 bis).

Venerable et discrete personne Me Guillaume du Brueil, prieur de ceans et chanoine de l'esglise de Bourges, a fait faire à ses depens cette tapisserie et donné à ladite eglise, et noble homme Me Pierre du Brueil, son frère, conseiller et advocat general du Roy en Berry et baillif du bourg et seigneurie de ladite Eglise. Priez Dieu pour eux. Noble homme Me Nicole du Brueil en son vivant notaire et secretaire du Roy et Damoiselle Marie Chambellaine pere et mere dudit Prieur et advocat (du Roy) qui ont fait faire la chappelle qui est de

l'autre part et doné la croix d'argent du choeur de la paroisse de ceans. Priez Dieu pour leurs ames.

The note explains: "Ce que dessus sont inscrits dans tapisserie du choeur de St. Ursin au dessus des formes avec leurs figures en portraits agenoux, leurs armes."

The book of obits from the church of Saint-Ursin states that the donor stipulated that the tapestry be displayed during specified feast days:

N(otum) S(it) O(mnibus) P(raesentibus) E(t) F(uturis) Q(uod) vener. vir Mag. Guillermus de Brolio, hujus ecclesiae prior et canonicus ecclesiae Bituricensis consiliarusque Regis, dedit huic ecclesiae beatissimi Ursini, ut esset particeps orationum et precum quae fient singulis diebus in eadem ecclesia tapisseriam mirae pulchritudinis, in qua est vita beatissimi Ursini, quam propriis sumptibus fecit fieri in villa de Tournayo.

LITERATURE

Barbarin, Charles. "Quelques faits nouveaux sur les tapisseries de la vie de saint Ursin du musée de Bourges." *Mémoires de la Société des Antiquaires du Centre* 39 (1919–1920): 109–12.

Farcy, Louis de. "Tapisserie de la vie de saint Ursin, 1er évêque de Bourges." *Revue de l'Art Chrétien*, 4th ser., 4 (April 1886): 230.

D. Mater. "Les tapisseries de l'Ancienne Collégiale Saint-Ursin." In *Congrès Archéologique de France*, session 56, Bourges, ed. Société française d'archéologie, 294–304. Paris: Derache, 1898.

§ § §

Vaast, Life of. Abbey of Saint-Vaast, Arras. Donor and date of donation unknown. One fragment (Arras, Musée Saint-Vaast; plate 16).

The fragment depicts the saint taming a bear.

§ § §

Vincent, Life of. Cathedral of Bern. Canon Heinrich Wölfli, 1515 (Bern, Historisches Museum). The tapestry consists of eighteen episodes from the saint's life and the history of his relics. The tapestry is unusual in that the tituli are in Latin and German.

For a detailed discussion of this series, see Anna Rapp Buri and Monica Stucky-Schürer, *Leben und Tod des heiligen Vinzenz. Vier Chorbehänge von 1515 aus dem Berner Münster,* Glanzlichter aus dem Bernischen Historischen Museum 4 (Bern: Bernisches Historisches Museum, 2000); and idem, *Burgundische Tapisserien,* 178–219.

§ § §

Wulfram, Life of. Royal collegiate Church Saint-Vulfran, Abbeville. Donor and date unknown. Lost.

The tapestry was displayed in the choir of Saint-Vulfran until the French Revolution, when it disappeared. A description of the tapestry is preserved in the archives of the Municipal Library of Abbeville. The tapestry, produced in the late fifteenth to early sixteenth centuries, measured 25.98 by 1.30 meters. It contained twenty-five episodes; eleven pertained to the saint's life, fourteen to the miracles performed after his death. The tituli were published in the *Almanach de Picardie* of 1785.

The tapestry included the following events in the life of the saint:

1. Education of Wulfram.
2. Wulfram consecrated archbishop of Sens.
3. Miracle of the paten.
4. Wulfram preaches.
5. Baptism of Radbod's son.
6. Resurrection of a child.
7. Two children saved from death.
8. Wulfram's entry into the abbey of Fontenelle.
9. Healing of a paralytic.
10. The last hours of the saint.
11. Inhabitants of Sens surround the deceased saint.
12. A counterfeiter takes an oath on saint's relics.
13. The relics cure a woman suffering from dropsy.
14. They calm a storm at sea.
15. They save a child from death.
16. They free a prisoner.
17. A thief is captured and then returns the stolen goods.
18 and 19. Two children are healed: the first suffers from a headache; the second has swallowed a needle.
20. Sailors pull a drowned child from the ocean.
21. A child is resurrected.

22. Healing of a charioteer.

23. Healing of a woman.

24. A blind woman regains her sight.

TITULI

 1. "Et primement S. Wulfran des l'enfance
 A prins des lettres cognoissance."
 2. "Aprés qu'atteint eut l'age et sens,
 Fust fait archeveque de Sens."
 3. "O sacree hostie divine
 De la mer rechut sa platine."
 4. "Annonchant la parole de Dieu
 Par luy fut preché en maint lieu."
 5. "Le fils Rabdod, duc des Frisons,
 Baptisa et ses gentiz homs."
 6. "En priant cil qui pitié recort,
 Salva un enfant de mort."
 7. "On luy donna sur ces paroles
 Deux enfans sortis des ecoles,
 Lesquels mis en mer par sort
 Delivra du dangier de mort.
 En les ostant de peine amere,
 Il les ramena a leur mere."
 8. "Pour meriter gloire éternelle
 Le saint vint à Fontenelle."
 9. "La Regnault le paralitique
 Guerit, qui fut oeuvre authentique."
 10. "Ses jours fina en ce saint lieu,
 Prechant la parole de Dieu."
 11. "Et Sens vint graces a Dieu rendre
 Et voir le corps saint sans attendre."
 12. "En Ponthieu monnoie on forgeoit.
 L'ung des forgeurs fraude faisoit,
 Bon poids leal ne juste comte;
 Lequel en ce lieu éprouvé
 Par serment fut laron trouvé."
 13. "Cette femme fut chy guarie

Du grant mal d'hydropisie."

14. "Ung pelerin, par reclamer
Saint Wulfran, fit cesser en mer
L'orage quant gens retournoient
De Jerusalem ou n'avoient
Eté, car le soudan maudit
A tous l'entree défendit."

15. "Ung enfant cheut au radier
D'ung moulin, sy fut en grant dangier.
La mère le recommanda
Au saint, dont de mort eschapa."

16. "Ung prisonnier fit oraison
Au saint, dont fut hors de prison."

17. "Une bourgeoise on dereuba;
Pour ce saint Wulfran reclama;
Elle retournant de cheans
Prinst le larron et tout sen bien."

18. "Ung nommé Raoul deux fils avoit,
Dont l'ung en grant dangier etoit.
Déprier fut pour mal de chef
Saint Wulfran qui le guarit brief."

19. "Et l'autre une aguille avala,
Dont la pointe dessus alla
Pourquoi au saint offrande on fit,
Dont l'aguille en bas descendit."

20. "Ung enfant pour extrarier
Fut en mer, le vent le fit noier.
Les marinier pecquier allerent
Et le corps en leur ret trouverent."

21. "L'ung des parens tant supplie
Saint Wulfran que l'enfant eut vie."

22. "Ung charroier de son char fut rué,
Par saint Wulfran fut continent savé."

23. "Comment cette femme de mal de teste
Sava, dont on fit joie et feste."

24. "Cette femme par foi entiere
S'en venant chy receut lumière."

25. "L'enfant par mal de teste perdit
 Les yeux, le saint les luy rendit;
 Les parents s'en emerveillerent,
 Dont au saint offrande donnerent."

Tituli published by Prarond (*Saint Vulfran*, 156–62), after the Almanach of 1785 and notes left by the magistrate Traullé.

LITERATURE

Delignières, Emile. *Histoire et description de l'église Saint-Vulfran d'Abbeville.* Paris: Inventaire des richesses d'art de la France, 1890.

Durand, Georges. "Abbeville, collegiale Saint-Vulfran." In *Congrès archéologique de France,* session 99, Amiens, ed. Sociéte française d'archéologie. Paris, 1936.

Eglise Collegiale Royale Saint-Vulfran d'Abbeville. Guide de l'office du tourisme, 53–54. Abbeville: F. Paillart, 1988.

Gilbert, Antoine-Pierre-Marie. *Description historique de l'église de l'ancienne abbaye royale de Saint-Riquier en Ponthieu, suivie d'une notice historique et descriptive de l'église de Saint-Vulfran d'Abbeville.* Amiens: Caron-Vitet, 1836.

Prarond, Ernest. "Saint Vulfran d'Abbeville." *Mémoires de la Société d'Emulation d'Abbeville* 9 (1857–1860): 155–62.

Tituli from the *Lives of Piat and Eleutherius,* Notre-Dame, Tournai

Transcription of the tituli of the *Lives of Piat and Eleutherius,* Notre-Dame, Tournai, complemented by the transcription of the now-lost sections of the tapestry in Tournai, Archives of the Cathedral Chapter MS 494.

1. "'J'ai eslut S. Piat pour convertir à la Foy les tournisiens.'
 Comment saint piat vint a Tournai prechier le foy."

 "'I have chosen Saint Piat to convert the people of Tournai to the faith.' / How Saint Piat came to Tournai to preach the faith."

2. "Comment ly tayons et ly taye ly peres et ly mere Saint Lehire furent li prumier qui rechurent le foy des Tournisiens."

 "How the grandfather and grandmother, the father and the mother of Saint Eleutherius were the first among the people of Tournai to receive the faith."

3. "Comment Hireneus li tayons Saint Lehire
 fist le idolle des tournisiens destruire."

 "How Hireneus, the grandfather of Saint Eleutherius, / had the idol of the people of Tournai destroyed."

4. "Comment Saint Piat fonda l'eglise de
 Nostre Dame de Tournai et fist les fons."

 "How Saint Piat founded the church of / Notre-Dame of Tournai and made the baptismal font."

5. "Hireneus qui donna le treffons de l'eglise Nostre Dame de Tournay fut li prumiers baptisies de tous les Tournisiens."

"Hireneus, who gave the property for the church of Notre-Dame of Tournai, was the first of the people of Tournai to be baptized."

Source: *Lives of Piat and Eleutherius*, Notre-Dame, Tournai.

6. "Comment Saint Piat et li desiple furent decolé des tirons Roumains en l'lieu que on apelloit le place ou est maintenant le crois Saint Piat a Tournay."

 "How Saint Piat and the disciples were decapitated by the Roman tyrants on the square one now calls Saint-Piat's Cross in Tournai."

7. "Comment li corps Saint Piat se releva et prist son kief pour porter au lieu de le sepulture et y eut V.M. hommes convertis pour cheli heure."

 "How the body of Saint Piat got up and took his head and carried it to his burial site and at that time there were five thousand men converted."

8. "Comment ly Tournisien par grant devotion convoierent le corps Saint Piat dusques a Seclin."

 "How the people of Tournai, through great devotion, carried the body of Saint Piat to Seclin."

9. "Comment ly corps Saint Piat s'aresta a Seclin et furent ly malade warit de toutes maladies."

 "How the body of Saint Piat stopped at Seclin and there the sick were cured of all their maladies."

10. "Comment Saint Piat fu mis en terre acompagniés de prestres de clers de gens de religions sous l'eglise Saint-Piat de Seclin commeneve et toutte le peuple de le castelenie de Lille converti."

 "How Saint Piat was buried accompanied by clerics, priests, and religious men under the church of Saint-Piat in Seclin and all the people of the castellany of Lille were converted."

11. "Les tout congiit hors tournay
 Taye tayon et amis vray
 Saint Lehiere pour que prumier
 ce furent en fonns vautyier."

"The grandparents and true friends of Saint Eleutherius sent out from Tournai at first were under vaulted crypts."

<div align="right">Source: Tournai, ACT 494, 33.</div>

12. "Quand de Tournay li crestien
 furent escachiet maint paien
 baptisier ce furent au lieu
 nommé Blandaing au nom de Dieu."

"When the Christians were banished from Tournai, a great number of pagans were baptized in the name of God at a place called Blandain."

13. "Mors est l'evesque de Tournay
 pour quoy crestien de coer vray
 a Romme envoient Saint Lehire
 ne voelent autre evesque eslire."

"The bishop of Tournai is dead and the Christians of true heart send Saint Eleutherius to Rome, not wanting to elect another bishop."

14. "Au boin saint l'eveschiet donnee
 est chi du pape et confermee."

"The pope gives the episcopate to the good saint and confirms him."

15. "D'evesques a ce ordenés
 fu li benois sains consacrés."

"The good saint is consecrated by the bishops ordained for this."

16. "La fille tribun va morir + pour ce que ne pot obtenir le fol amour que requeroit + Au saint quand son mantiel tiroit."

"The tribune's daughter is going to die because she could not obtain the foolish love which she requested when she pulled on the saint's robe."

17. "Comment Jhesucrist reclama + le bon saint et ressuscita ychi la fille de tribun + present son pere et le commun."

"How the good saint invoked Jesus Christ to resuscitate the tribune's daughter with her father and the commune present."

18. "Comment li bon sains baptisa + la fille tribun que leva de fons par tres grande mistere + Blande qui au bon saint fu mere."

"How the good saint baptized the tribune's daughter whom Blande, the good saint's mother, lifted from the font by a very great mystery."

19. "Tribuns volt sa fille retraire des crestiens et elle atraire a sa loy dont la mors soudaine en fu tost as paiens prochaine."

The tribune desired to take his daughter back from the Christians and to attract her to his religion on account of which sudden death was soon upon the pagans.

Source: Lives of Piat and Eleutherius, Notre-Dame, Tournai.

20. "Paien livrerent saint Lehire a Tribun qui a grand martire le fist batre et puis enkanier et en la chastre emprisonner."

"The pagans delivered Saint Eleutherius to the tribune, who had him beaten badly and then put him in chains and imprisoned him in the fortress."

21. "Li angles le saint delivra
et la voie li demoustra
a Blandaing en la nuit obscure
qu'il fut mis en la castre dure."

"Angels freed the saint and showed him the way to Blandain during the dark night in which he was put in the cruel cell."

22. "Au saint priant pour la cité fu en la messe revelé a Blandaing qu'il baptisera Tribun et ceulx qui avoer lui a.
Lehire de orison est exauchié."

"It was revealed to the saint while he was praying for the city during the mass that he would baptize the tribune and his followers. / Eleutherius's prayers were heeded."

23. "Pour ce qu'a Tournay fort moroient
et leur ydoles perissoient
constraient vienent au Saint prier
qui les voelle tous baptisier."

"All the people of Tournai whose idols had perished were dying in great numbers; they were constrained to come to the saint and beg him to baptize them all."

24. "Roys Clovis le Saint visiter + vint qui ne s'osait confesser d'un pechiet que li revela + le sains et pardon impetra.
Dieux a oy cette priere."

"King Clovis came to visit the saint and revealed a sin, which he had dared not confess and begged for pardon. / God heard this prayer."

25. "Pour verité entente quise preschier li sains devant l'eglise fu par heretiques batus comme mors navrés et abatus."

"To spread the truth the saint preached before the church where he was beaten again and again by heretics until he died from the wounds."

26. "Preschans et prians trespassa li sains de qui l'ame en ala a Dieu li present ce bien virent et les angles qui le ravirent."

"Preaching and praying, the saint died, and his soul went to God. Those present saw this clearly and angels bore it off."

27. "Ceulx de Blandaing qui fort trayoient a ceulx qui a Tournay portoient le corps saint se sont tost retrait car en eulx retournoient leur trait."

"Those from Blandain who fired on those who carried the saint's body retreated quickly, for their arrows returned to them."

28. "Veschi comment li cytoien de Tournay mettent par grand bien dedens l'eglise le corps saint qui de malades garit maint."

"Look how the citizens of Tournai placed in the church with great ornament the saintly body that healed a great number of the sick."

29. "Chis draps fust fait et achievé en Arras par Pierot Feré l'an mille quatre cens deux en decembre mois graceux.
Vouer a Dieu Toussains prier pour l'ame Tossaint Prier."

"These cloths were made and completed in Arras by Pierot Feré in the year one thousand four hundred and two in December, the month of grace. / Let God of all the saints pray for the soul of Toussaint Prier."

Source: Tournai, ACT, MS 494, 34.

Tituli from the *Life of Gervasius and Protasius*, Saint-Julien, Le Mans, complemented by the transcription of the missing section in Canon Albin, untitled note in *La semaine du fidèle*

1. "Comment Vital a cause de ladicte exortacion par le commandement de Nero fu tiré en travail et depuis enfouy tout vif par le conseil du pretre des ydolles lequel pretre le dyable emporta visiblement."

 "How Vital, because of the aforementioned exhortation, by the command of Nero was stretched on a rack and then buried alive by the order of the presbyter of the idols, which presbyter the devil carried away visibly."

2. "Comment Valerie aprés le trespas de son mary Vital pour ce qu'elle ne voulait adorer les ydolles fut par aucuns païens tant batue qu'ilz la cuyderent morte puis fut portée a Millan et la rendit son ame a Dieu."

 "How Valery, after the death of her husband, Vital, because she did not want to adore the idols, was beaten by pagans to such an extent that they believed she was dead, then she was carried to Milan and there she gave up her soul to God."

3. "Comment saint Gervais et saint Prothais, aprés le trespas de leur pere et mere, vendirent tout leurs biens et en receurent les deniers, lesquels ilz donnerent aux povres puis se revestirent de robes blanches."

 "How Saint Gervasius and Saint Protasius, after the death of their mother and father, sold their property and gave the money which they received to the poor, then clothed themselves in white robes."

4. "Comme saint Gervais et saint Prothais partirent de la cité d'Embrun en la compaignie de Nazare et de l'enfant Celse pour venir a Millan; et la ilz furent baptisez par l'evesque du lieu."

"How Saint Gervasius and Saint Protasius left the city of Embrun in the company of Nazarus and the child Celsus to come to Milan, and there were baptized by the bishop of the place."

5. "Comme saint Gervais et saint Prothais jecterent le diable hors du corps d'une jeune fille, laquelle tantost aprés fut per eulx baptisee aveque son pere."

"How Saint Gervasius and Saint Protasius cast the devil out of the body of a young girl, who immediately thereafter was baptized by them with her father."

6. "Comment saint Nazare accompaigné de saint Gervais et saint Prothais ediffient une chappelle en ung boys et l'enfant Celse leur administroit les pierres."

"How Saint Nazarus, accompanied by Saint Gervasius and Saint Protasius, constructed a chapel in the woods, and the child Celsus carried stones to them."

7. "Comment Neron de ce adverty envoia Deuto et Paulin acompaignez de gens d'armes pour les prendre et les luy amener."

"How Nero, informed of this, sent Deuto and Paulin, accompanied by soldiers, to seize them and bring them to him."

8. "Comment saint Gervais et saint Prothais, acompaignez de saint Nazare et de Celse, furent amenez devant l'empereur Neron pour estre de luy interroguez."

"How Saint Gervasius and Saint Protasius, accompanied by Saint Nazarus and Celsus, were taken before Emperor Nero to be interrogated by him."

9. "Comment la fouldre tomba sur ledit Neron et lui rendit le visaige noir et obscur, et la face desditz saincts martirs resplendissoit comme le soleil."

"How lightning fell on said Nero and rendered his face black and obscure, and the face of the martyr saints shone like the sun."

10. "Comment Neron promist faire grans biens a saint Gervais et saint Prothais pour delaisser la foy, ce qu'ilz refusent en disant que les biens et honneurs mondains n'estoient que fiens et pourriture."

"How Nero promised great wealth to Saint Gervasius and Saint Protasius to renounce their faith, which they refused to do, saying that worldly goods and honors were nothing but smoke and rot."

11. "Comment Neron de rechef fist metre en prison lesdiz saint Gervais et sainct Prothais."

"How Nero had Saints Gervasius and Protasius put in prison."

12. "Comment Dieu envoia ung ange reconforter lesdit saints en les enhortant qu'ilz feussent fermes en la foy et que Neron seroit par eulx confondu."

"How God sent an angel to comfort said saints, exhorting them to be firm in the faith and Nero would be overcome by them."

13. "Comment saint Gervais et saint Prothais par le commandement de Neron furent menez a Nolin, prevost de Millan, pour les executer, lequel tantost les fist mettre en prison."

"How Saint Gervasius and Saint Protasius, by the order of Nero, were taken to Nolin, provost of Milan, to be executed by him, who, on the contrary, had them placed in prison.

14. "Comment ———— et le fait batre descorgees tout ———— entes."

"How ———— and had him beaten with leather straps all ————."

15. "Comment le prevost Nolin present le duc Astaze fait decoler saint Prothais hors la ville mais tantost aprés ung burgoys de la dicte ville et son filz ensevelirent les corps saintz."

"How the provost Nolin, with Duke Astasius present, had Saint Protasius decapitated outside the city, but immediately thereafter a burgher of said city and his son lifted up the saintly bodies."

Source: Life of Gervasius and Protasius, Saint-Julien, Le Mans.

16. "Comment saint Paul, longtemps aprés, revela a saint Ambroise, lors evesque de Millan, les corps des dictz sainctz afin qu'il les fist lever."

"How Saint Paul, much later, revealed to Saint Ambrose, then bishop of Milan, the bodies of said saints, so that he could have them taken away."

17. "Comment aprés leurs corps furent portés dedans l'eglise; ung aveugle et pluseurs malades furent gueris, present sainct Ambroise et pluseurs autres prelatz."

"How after their bodies were carried into the church, a blind person and several sick people were cured, with Saint Ambrose and several other prelates present."

Source: Canon Albin, *La semaine du fidèle. Revue du culte et des bonnes oeuvres* 3, no. 30 (June 17, 1865): 480.

18. "Anno domini millesimo quingentesimo nono, Magister Martinus Guerande, presbiter, natione Andegavus, Cenomanensis ecclesiae canonicus, Reverrendissimorumque patrum, de illustri prosapia natorum, Dominorum Philippi Cardinalis de Lucemburgo, nuper, necnon Francisi de Lucemburgo, ejus nepotis, moderni episcoporum Cenomanensi secretarius, donavit eidem ecclesiae Cenomanenis hanc tapiceriam, pro ornatu chori, ad laudem Dei, beatorumque martyrum Gervasii atque Prothasii, ac totius curiae coelestis. Eidem donatori parcat Deus. Amen."

"In the Year of Our Lord 1509, Master Martin Guerande, priest, from Angers, canon of the church of Le Mans, and secretary of the most venerable fathers born of the illustrious family, Cardinal Philip of Luxembourg, former bishop of Le Mans and of his nephew, Francis of Luxembourg, current bishop of Le Mans, gave to this same church of Le Mans this tapestry, to adorn the choir, in praise of God, of the blessed Gervasius and Protasius, and of the whole celestial court. May God show mercy to the donor. Amen."

Source: Life of Gervasius and Protasius, Saint-Julien, Le Mans.

Tituli from the *Life of Stephen,* Museum of the Middle Ages, Paris

1. "Comment les apostres et disciples de Jhesucrist tindrent conseil pour faire sept dyacres et terminer le discord estant entre les Ebreux et les Grecs nouvellement convertis a la foy chrestienne."

 "How the apostles and disciples of Jesus Christ held council to elect seven deacons and to end the discord between the Hebrews and the Greeks, newly converted to the Christian faith."

2. "Comment saint Estienne avec six autres furent eslus diacres, consacrés par l'imposicion des mains des apostres pour regir les nouveaux chrestiens es choses temporelles.
 'Accipe spiritum sanctum.' "

 "How Saint Stephen, with six others, was elected deacon and was consecrated by the laying on of the apostles' hands to guide the new Christians in temporal affairs.
 'Accept the Holy Spirit.' "

3. "Comment saint Estienne dispute contre ceulx de la signagogue, lesquels ne povoient resiter a la sapience au saint esperit qui parloit par sa bouche."

 "How Saint Stephen disputes with those from the synagogue who could not resist the wisdom of the Holy Spirit who spoke from the saint's mouth."

4. "Comment saint Estienne fut pris et amené au consistoire des juifs et accusé par fauts temoignages de blaspheme contre Dieu et Moïse."

 "How Saint Stephen was taken and led to the Jewish council and accused by false witness of blasphemy against God and Moses."

5. "Comment les juifs estreignoient les dens, estoupoient leurs oreilles quant ilz oÿrent dire a saint Estienne qu'il veoit le ciel ouvert, le fils de l'omme a la dextre de Dieu.
 'Ecce video celos apertos et [filium] hominis stantem a dextris virtutis dei.' "

"How the Jews ground their teeth and covered their ears when they heard Saint Stephen say that he saw the heavens open and the Son of Man on the right hand of God.
 Stephen: 'Behold, I see the heavens open and [the Son] of Man on the right hand of the virtuous God.' "

6. "Comme les juifs poulcent impetueusement et menent violamment monseigner saint Estienne hors de la cité."

"How the Jews impetuously expelled and violently drove Lord Saint Stephen outside the city."

7. "Comment les satalites jectent leurs robes aux pied du adolescent nommé Abthla; aprés dit saint Pol et lapident saint Estienne comandant son esperit a Dieu les genouls a terre; prie Dieu por ceulx qui le lapident.
 'Ecce video celos apertos et filium hominis stantem a dextris virtutis dei.' "

"How the witnesses threw their robes at the feet of a youth named Saul, afterwards called Paul, and stoned Saint Stephen, as he offered his spirit to God and prayed on his knees for those who stoned him."
 Stephen: 'Behold, I see the heavens opening and the Son of Man standing on the right hand of the virtuous God.' "

8. "Comment le corps saint Estienne est delaissé au lieu de son martire et exposé au bestes et par la divine puissance preservé."

"How the body of Saint Stephen was left at the site of his martyrdom and exposed to beasts and was preserved by divine will."

9. "Comment Gamaliel occultement, pour la crainte les juifs, porte le corps saint Estienne en sa ville nomee Caphargamala et le met en son sepulcre."

"How Gamaliel in secret, for fear of the Jews, carried the body of Saint Stephen into his city called Caphargamalia and put it in his tomb."

10. "Comment CCCC XVII ans aprés la mort de saint Estienne, saint Gamaliel s'aparut par troys foys a Lucian prebtre en son dormir, le touchant d'une verge d'or, et luy revele le corps saint Estienne, luy monstrant quatre coffins, troys dorés, l'un plain de roses rouges denoncant le corps saint Estienne, les deux autres de roses blanches les corps du dit

Gamaliel et Nicodeme, et quart argenté de saffran le corps saint Abibas, fils dudit Gamaliel."

"How four hundred and seventeen years after the death of Saint Stephen, Saint Gamaliel appeared three times to the priest Lucien, touching him with a golden wand in his sleep, and revealed the body of Saint Stephen, showing him four coffins, three golden, one full of red roses, marking the body of Saint Stephen, the two others covered with white roses, containing the bodies of said Gamaliel and Nicodemus and the fourth marked with yellow roses, containing the body of Abibas, the son of Gamaliel."

11. "Comment saint Lucian denonce a Jehan, evesque de Jherusalem, sa vision et que c'estoit le vouloir de Dieu que le corps saint Estienne fust exalté par ses merites; et la famine lors regnant cessan en donant habondance de pluye et de biens."

"How Saint Lucien revealed his vision to John, bishop of Jerusalem, and that it was the will of God that the body of Saint Stephen be exalted for his merits and that the famine which reigned end by means of abundant rain and fortune."

12. "Comment Jehan, evesque de Jherusalem, assembla plusieurs evesques et prelas, qui alerent fouir la terre ou lieu ou il pensoyent que lesdis corps fussent que n'y furent point trouvés."

"How John, bishop of Jerusalem, gathered several bishops and prelates who went to search the ground at the place where they thought the body was but did not find it."

13. "Comme Migetius bon religieux, au quel pariellement s'estoit appareu Gamaliel, survient qui enseignia le lieu ou estoient les corps sains, dont s'esjouit le dit Lucian."

"How Migetius, a good monk, to whom Gamaliel appeared at the same time, was shown the place where the body of the saint was, which said Lucien sought."

14. "Sesne comment le corps saint Estienne fust solennellement pourté en l'eglise de Sion et a sa revelasion tunba pluie du ciel, y eust grand odeur et plusieurs malades gueris."

"How the body of Saint Stephen was solemnly carried to the church of Sion and at its appearance rain fell from the sky, there was a sweet odor, and many of the sick were cured."

15. "Comment la femme de Alixandre, senateur de Constantinoble, accompaignet d'un herault portant lettres de par l'empereur, demande congié a l'evesque de Jherusalem de transporter en Constantinoble le corps de son feu mary, lequel sept ans par avant estoit mort en Jherusalem, ensepulturé pres le corps saint Estienne en ung oratouire edifié par le dit senateur en l'oneur du dit saint Estienne."

"How the wife of Alexander, senator from Constantinople, accompanied by a herald, carrying letters from the emperor, requested the permission of the bishop of Jerusalem to transport to Constantinople the body of her husband who had died seven years before and had had his coffin placed in an oratory which he had built in Jerusalem in honor of said Saint Stephen."

16. "Comment icelle dame, cuidant transporter le corps de son mary, print le corps saint Estienne; adont se leva grant tempeste sur la mer mais saint Estienne s'aparut a eulx qui les sauva.
 'Ego sum noli timere.'
 'Sancte dei preciose prothomartir Stephane qui virtute caritatis arcutullus undique dominum pro inimico exorasti populo.'
 'Qui est quod nobis accidit quia spirites clamant post nos de sancto Stephano.'
 'Servus dei venit qui lapidatus est a judeis, vae nobis quia urit nos acriter quo fugiemus minas eius terribilis.' "

"How this woman, believing she was transporting the body of her husband, took the body of Saint Stephen, when a great storm arose on the sea, but Saint Stephen appeared and saved them.
 Stephen: 'It is I, do not fear.'
 The angels: 'Saint Stephen, protomartyr, who, though you were accused from all sides, in your virtue and charity prayed to God for your enemies.'
 The senator's wife: 'How is it that the spirits are speaking behind us of Saint Stephen?'
 The demons: 'The servant of God who was just stoned by the Jews, woe unto us, because he burns us fiercely. Where can we flee these terrible threats?' "

17. "Comme ils vindrent a Bizance ou le corps saint Estienne fut honnorablement receu par Eusebe, evesque du lieu."

"How they arrived in Byzantium where the body of Saint Stephen was honorably received by Eusebius, bishop of that place."

18. "Comme l'empereur envoya deux mullés por mener le dit corps en son palés, ce qu'ils ne firent, car l'ange y estoit qui les empeschoit et neantmoins en les bastoit et frappoit tellement que l'ung desdis mullés comença a dire la volenté de nostre Seigneur.
'Quid nos verberitus virgitis, oportet Stephanum recondi in loco isto.' "

"How the emperor sent two mules to bring said body to his palace, which they did not do because an angel prevented them. Nevertheless, the mules were whipped and beaten to such an extent that one of them began to speak the will of our Lord.
The mule: 'Why do you strike us with those whips, Stephen should be buried here.' "

19. "Comme Eudopia, fille de Theodoze empereur de Rome, estat possessee du deable qui apris plusieurs conjuracions dire qui ne partiroit point qui ne apporteroit le corps sainct Estienne a Rome; le pape a la requeste de l'empereur envoye a Constatinoble querir le corps sainct Estienne, le quel fut baillié en promectant baillié le corps sainct Laurens.
'Nisi Stephanus Romam veniat non exibo quoniam talis est apostolorum voluntas.' "

"How Eudoxia, the daughter of Theodosius, emperor of Rome, is possessed by a devil, who, after several exorcisms, says that he will not leave until the body of Stephen is brought to Rome. The pope, at the request of the emperor, sends an emissary to Constantinople to obtain the body of Saint Stephen in exchange for the body of Saint Lawrence.
The devil: 'If Saint Stephen does not come to Rome, I shall not leave, since this is the will of the apostles.' "

20. "Comment le pape va au devant du corps saint Estienne et le rechoit honnourablement et conduit jusques en l'eglise Saint Pierre ad vincula cuidant, estre le voloir de Dieu qu'il fust la coloqué et honnoré."

"How the pope went to meet the body of Saint Stephen and received it honorably and led it to the church of Saint-Peter-in-Chains, and it was the will of God that he be placed and honored there."

21. "Comme le corps saint Estienne est apporté en l'eglise de Saint Pierre, mays le diable par la bouche de la fille dit que dit saint Estienne voulloit estre prés celuy de saint Laurent."
'Non hic sed cum Laurencio foris moenibus Stephano dabitur locus.' "

"How the body of Saint Stephen is carried into the church of Saint-Peter but the devil, through the mouth of the girl, says that Saint Stephen should be near Saint Lawrence.

The devil, through Eudoxia: 'It is not here, but with Lawrence, outside the walls, that Stephen should lie.' "

22. "Comme ceulx de Constantinoble, cuidans prendre le cors saint Laurens, tumbe a terre comme mors, pour ce que le voulloi de Dieu n'estoit que ils fussent separés."

"How those from Constantinople who take the body of Saint Lawrence fall dead to the ground because it was not the will of God that the two be separated."

23. "Comme le corps sainct Laurens fait place au corps sainct Estienne prés de lui, et incontinent qu'il y fut, la fille de l'empereur fut guerie et parti le dyable hors de son corps et chanterent les anges o felix Roma.
'O felix Roma.' "

"How the body of Saint Lawrence made space near itself for the body of Saint Stephen and right away the emperor's daughter was cured and the devil left her body and the angels sang, o felix Roma.
The angels: 'Oh happy Rome.' "

ABBREVIATIONS

AA SS Acta Sanctorum. 3d ed. Paris: Palmé, 1863–1940.

ACT Archives of the Cathedral Chapter, Tournai.

BM Bibliothèque Municipale.

BN Bibliothèque Nationale.

CCCM Corpus Christianorum Continuatio Mediaevalis. Turnhout: Brepols, 1971–.

DACL *Dictionnaire d'archéologie chrétienne et de liturgie.* Edited by Fernand Cabrol and Henri Leclercq. 15 vols. Paris: Libraire Letouzey and Ané, 1907–53.

DHGE *Dictionnaire d'histoire et de géographie ecclésiastiques.* Edited by Alfred Baudrillart, A. De Meyer, and Etienne Van Cauwenbergh. 27 vols. Paris: Letouzy et Ané, 1912–2000.

PL Patrologiae cursus completus: Series latina. Edited by Jacques-Paul Migne. 222 vols. Paris, 1844–88.

NOTES

CHAPTER 1. Setting the Stage

1. Exod. 26:1–36; Exod. 36:8–35; Exod. 38:9–18 (New Revised Standard Version).

2. These passages from Exodus provided medieval liturgists such as Sicard of Cremona (d. 1215), Honorius Augustodunensis (1075/1080–ca. 1156), and William Durandus (ca. 1230–1296) with the point of reference for descriptions of the liturgical use of textiles. Sicard of Cremona, "De ornatu ecclesiae," in *Mitrale sive de officiis ecclesiasticis summa*, chap. 12 (PL 213:40); Honorius Augustodunensis, "De velo quod suspenditur," in *Gemma animae*, chap. 46 (PL 172:657); William Durandus, "De ecclesia et eius partibus" and "De picturis et cortinis et ornamentis ecclesie," in *Rationale Divinorum Officiorum*, ed. Anselme Davril and Timothy M. Thibodeau, 1.1.6, 1.1.12, and 1.3.35 (CCCM 140:14, 16–17, 46). The biblical description of Solomon's construction and decoration of the temple does not mention textiles directly. However, medieval liturgists include Solomon in references to the ornamentation of the tabernacle. The presence of textiles in the temple of Jerusalem is also indicated by the frequent references to the veil that tore at the moment of Jesus' death.

3. Wolfgang Brassat, *Tapisserien und Politik. Funktionen, Kontexte und Rezeption eines repräsentativen Mediums* (Berlin: Mann, 1992), 17–21. Brassat also points to earlier sources for this tradition in Greek and Persian accounts.

4. For Constantine's donation of textiles to Saint Peter's, see Eugène Müntz and Arthur Lincoln Frothingham, *Il tesoro della basilica di S. Pietro in Vaticano* (Rome: Estratto dall' Archivio della Societa Romana di Storia Patria, 1883), 13, 70.

5. "Vela ferant foribus, seu puro splendida lino, / Sive coloratis textum fucata figuris." Paulinus of Nola 18.31 (PL 61:491).

6. Louis Duchesne, introduction to *Le Liber pontificalis, texte, introduction et commentaire*, ed. Louis Duchesne, 2d ed. (Paris: E. de Boccard), 1:147; Joseph Braun, *Die liturgische Paramente in Gegenwart und Vergangenheit* (Freiburg im Breisgau: Herder, 1924), 223; Stephan Beissel, "Gestickte und gewebte Vorhänge der römischen kirche in der zweiten Hälfte des 8. und der ersten Hälfte des 9. Jahrhunderts," *Zeitschrift für christliche Kunst* 7 (1894): 360.

7. *Le Liber pontificalis* 1.499–501 and 504; other popes also gave vast numbers of textiles. See, for example, ibid., 1.375, 2.53–55, and 2.57–63 (Paschal, 817–824); ibid., 2.74–79, 82 (Gregory IV, 827–44); and ibid., 2.107–14 (Leo IV, 847–55). On the textile collections in Carolingian churches in Rome, see Beissel, "Gestickte und gewebte Vorhänge," 358–74; and John Shearman, *Raphael's Cartoons in the Collection of Her Majesty the Queen and the Tapestries for the Sistine Chapel* (London: Phaidon, 1972), 6–7.

8. Paul Friedländer, *Johannes von Gaza und Paulus Silentiarius: Kunstbeschreibungen justinianischer Zeit* (Leipzig: Tuebner, 1912), 248; Brassat, *Tapisserien und Politik*, 20, 84; Adele Starensier, "An Art Historical Study of the Byzantine Silk Industry" (Ph.D. diss., Columbia University, 1982), 488.

9. Gregory of Tours, *History of the Franks* 2.31 (Monumenta Germaniae Historica, Scriptores rerum

merovingicarum, 1.1), ed. Bruno Krusch and Wilhelm Levison (Hanover: Hahn, 1951), 77; *Gesta Dagoberti regis francorum* 20 (Monumenta Germaniae Historica, Scriptores rerum merovingicarum, 2.407), ed. Bruno Krusch (Hanover: Hahn, 1889).

10. Some of these inventories have been studied. On the cathedrals of Paris and Sens, see Craig Wright, *Music and Ceremony at Notre Dame of Paris, 500–1500* (Cambridge: Cambridge University Press, 1989), 13–17; and Emile Chartraire, "Les tissus anciens du trésor de la cathédrale de Sens," *Revue de l'Art Chrétien* 61 (1911): 261–80, 371–86, and 454–68. For examples in German churches, see Renate Jaques and Ruth Wencker, "Die Textilien im Besitz der Schatzkammer der Kirche St. Servatius in Siegburg," *Heimatbuch der Stadt Siegburg* 2 (1967): 472–572; Leonie von Wilckens, "Die textilen Schätze der Lorenzkirche," in *500 Jahre Hallenchor St. Lorenz 1477–1977*, Nürnberger Forschungen 20 (Nuremberg: Selbstverlag des Vereins für Geschichte der Stadt Nürnberg, 1977), 139–66; and "Die Teppiche der Sebalduskirche," in *600 Jahre Ostchor St. Sebald, Nürnberg 1379–1979*, ed. Helmut Baier (Neustadt a.d. Aisch: Schmidt, 1979), 133–42. For England, the inventories of St. Paul's cathedral provide an indication of the scale of its textile collection. W. Sparrow Simpson, "Two Inventories of the Cathedral Church of St. Paul, London, Dated Respectively 1245 and 1402," *Archaeologia or Miscellaneous Tracts Relating to Antiquity* 50 (1887): 439–524.

11. Louis de Farcy, "Broderies et tissus, conservés autrefois à la cathédrale d'Angers," *Revue de l'Art Chrétien*, n.s., 2 (1884): 270–90.

12. Beissel, "Gestickte und gewebte Vorhänge," 369–71.

13. Silks were called *sericis*, or, more specifically, *sericis deauratis, velveto, baudequin*, or simply *pannus*. French terms, also included in inventories, include *sargerie* or *sarges* and *taffestas*. For references to these textiles and discussions of terminology, see Farcy, "Broderies," 279–82; Francisque Michel, *Recherches sur le commerce, la fabrication et l'usage des étoffes de soie, d'or et d'argent et autres tissus précieux en Occident, principalement en France pendant le Moyen Age*, 2 vols. (Paris: Crapelet, 1852–54); and Victor Gay, *Glossaire archéologique du Moyen Age et de la Renaissance*, 2 vols. (Paris: A. Picard, 1929).

14. Leonie von Wilckens, "Der Michaels-und der Apostelteppich in Halberstadt," in *Kunst des Mittelalters in Sachsen*, Festschrift Wolf Schubert (Weimar: Hermann Böhlaus, 1967), 279–91.

15. For discussions of the symbolism of textile ornamentation in the church, see Joseph Sauer, *Symbolik des Kirchengebäudes und seiner Ausstattung in der Auffassung des Mittelalters* (Freiburg im Breisgau: Herder, 1902), 218–20; and Joseph Braun, *Die liturgische Paramente*, 225–26.

16. Honorius Augustodunensis, "De palliis," in *Gemma animae* 1.137 (PL 172:587).

17. Rupert of Deutz, *Liber de divinis officiis* 2.23.1009–13, ed. Hrabanus Haacke (CCCM 7:59).

18. William Durandus, "De picturas et cortinis et ornamentis ecclesie," in *Rationale Divinorum Officiorum* 1.3.39 (CCCM 140:47–48). The analogy Durandus draws between the colors of hangings and specific virtues coincides with the classification introduced by Sicardus, who argues that the many-colored hangings represent the virtues that cloak the Virgin. *Mitrale sive de Officiis Ecclesiasticis Summa* (PL 213:44).

19. During Lent, for instance, luxury textiles were replaced by linen. This practice is confirmed in Ordinals for use of the cathedrals of Reims, Sens, and Cambrai. Liturgical colors varied by geographic region and over the course of the Middle Ages. Some general, but not steadfast, rules can be laid out. For instance, white textiles were displayed on the feasts of the Virgin and of Christ. Red was associated with Pentecost, green with

Epiphany, and purple with Advent. Black textiles were displayed for masses of the dead. On the liturgical colors of textiles, see Joseph Braun, *Die liturgische Gewandung im Occident und Orient, nach Ursprung und Entwicklung, Verwendung und Symbolik* (Freiburg im Breisgau: Herder, 1907), 728–49; Renate Kroos and Friedrich Kobler, "Farbe, liturgische," in *Reallexikon zur deutschen Kunstgeschichte*, vol. 7, ed. Karl-August Wirth (Munich: Beck, 1981), 54–121.

20. On pulling back the curtain concealing sculptures of the Virgin and Child during the performance of Epiphany plays, see Ilene H. Forsyth, *The Throne of Wisdom: Wood Sculptures of the Madonna in Romanesque France* (Princeton: Princeton University Press, 1972), 56–58, 101. The actions and words of such a play at the cathedral of Rouen, in which [the priests playing] the midwives unveil the [image of] Christ, are transcribed in Armand Gasté, "Les drames liturgiques de la Cathédrale de Rouen: Officium Pastorum," *Revue Catholique de Normandie* 2 (1893): 480.

21. "Velum templi scissum est medium" (Luke 23:44–47, Vulgate). On Lenten cloths, see Johannes H. Emminghaus, "Fastentuch," in *Reallexikon zur deutschen Kunstgeschichte*, vol. 7, ed. Karl-August Wirth (Munich: Beck, 1981), 830–32.

22. On this symbolism of representations of textiles, see Johann Konrad Eberlein, *Apparatio Regis — Revelatio veritatis. Studien zur Darstellung des Vorhangs in der bildenden Kunst von der Spätantike bis zum Ende des Mittelalters* (Wiesbaden: Dr. Ludwig Reichert, 1982); and André Grabar, "Une fresque visigothique et l'iconographie du silence," *Cahiers Archéologiques* 1 (1945): 124–28.

23. "Porro ornamenta ecclesie in tribus consistunt, scilicet in ornatu ecclesie, chori et altaris. Ornatus ecclesie consistit in cortinis et auleis et palleis sericis purpureis et similibus. Ornatus chori in dorsalibus, tapetis, substratoriis et bancalibus; dorsalia sunt panni in choro pendentes a dorso clericorum; substratoria que pedibus substernuntur; tapeta etiam sunt panni qui pedibus substernuntur, quasi stratio pedum, et precipue pedibus episcoporum qui mundana pedibus calcare debent; bancalia sunt panni qui super sedes vel bancas in choro ponuntur. Altaris vero ornatus consistit in capsis, in pallis, in philateriis, in candelabris, in crucibus, in aurifrisio, in vexillis, in codicibus, in velaminibus, et cortinis." William Durandus, *Rationale Divinorum Officiorum* 1.3.23–24 (CCCM 140:42). Unless otherwise noted, all translations from the Latin and French are mine.

24. Durandus expands on the division outlined by Johannes Beleth in his text of 1160. This categorization was adopted in Ordinals, such as those used in the cathedrals of Paris and Tournai.

25. *Dorsalia* were a common component of liturgical hangings. The inventory of Bamberg cathedral from 1128 mentions at least forty *dorsalia*, and references to this type of hanging can be found in the thirteenth-century inventories of Salisbury cathedral and St. Paul's, London. For further examples, see Franz Bock, *Geschichte der liturgischen Gewänder des Mittelalters oder Entstehung und Entwicklung der kirchlichen Ornate und Paramente in Rücksicht auf Stoff, Gewebe, Farbe, Zeichnung, Schnitt und rituelle Bedeutung nachgewiesen und durch zahlreiche Abbildungen erläutert* (Bonn: Cohen, 1871), 3:193–95.

26. "Item sex peciae panni sericei deaurati figurati diversis figuris, quae quidem peciae protenduntur super funes a majori altari usque ad chorum ex utraque parte ecclesiae et in festis solemnibus et vocantur stillicidiae sive longères gallice." Farcy, "Broderies," 277.

27. "Alia paramenta chori, quae solebant poni in circuitu chori antequam tapiceria fierent." Farcy, "Broderies," 277.

28. Adolfo Cavallo, *Medieval Tapestries in the Metropolitan Museum of Art* (New York: Metropolitan Museum of Art, 1993), 61–62.

29. Anna Rapp Buri and Monica Stucky-Schürer, *Zahm und Wild: Basler und Strassburger Bildteppiche des 15. Jahrhunderts* (Mainz: Philipp von Zabern, 1990), 21–22.

30. The list of these guild regulations is published in Etienne Boileau, *Les métiers et corporations de la ville de Paris. XIIIe siècle*, ed. René de Lespinasse and François Bonnardot (Paris: Imprimerie: Nationale, 1879), 102–104, 106–107, 149–52; and G.-B. Depping, ed., *Réglemens sur les arts et métiers de Paris: Rédigés au XIIIe siècle et connus sous le nom du Livre des métiers d'Etienne Boileau* (Paris: Crapelet, 1837), 126–30 and 404–10.

31. "Une manière de tapiciers que l'en appèle ouvriers en la haute lice." Depping, ed., *Réglemens*, 410.

32. Cavallo reminds us that the inconsistent use of these words in medieval documents makes it impossible to define them precisely. Cavallo, *Medieval Tapestries*, 62–64. On the complexity of this terminology and the legislation concerning these groups of weavers, see Geneviève Souchal, "Etudes sur la tapisserie parisienne. Règlements et techniques des tapisseries sarrazinois, hautelissiers et nostrez (vers 1260–vers 1350)," *Bibliothèque de l'Ecole des Chartes* 123 (1965): 35–116; and Francis Salet, "Remarques sur le vocabulaire ancien de la tapisserie," *Bulletin Monumental* 146 (1988): 211–22.

33. Jean Lestocquoy, *Deux siècles de l'histoire de la tapisserie (1300–1500): Paris, Arras, Lille, Tournai, Bruxelles, Arras*, Mémoires de la Commission départementale des monuments historiques du Pas-de-Calais 19 (Arras: Commission départementale des monuments historiques du Pas-de-Calais, 1978), 15.

34. On the first centers of tapestry production, see Lestocquoy, *Deux siècles*.

35. Ibid., 55–56, 98–114. Hillie Smit, "Tapestry Weavers in Italy c. 1420–1520: A Survey and Analysis of the Activity in Various Cities," in *Flemish Tapestry Weavers Abroad: Emigration and the Founding of Manufactories in Europe*, ed. Guy Delmarcel, Symbolae series B, vol. 27 (Leiden: Leiden University Press, 2002), 113–30.

36. On tapestry in German-speaking regions, see Rapp Buri and Stucky-Schürer, *Zahm und Wild*, 47–51; Cavallo, *Medieval Tapestries*, 75.

37. Lestocquoy, *Deux siècles*, 10–11.

38. Anna Rapp Buri and Monica Stucky-Schürer, *Burgundische Tapisserien* (Munich: Hirmer, 2001), 420. On the cloth industry in Arras and its decline, see Henri Laurent, *La draperie des Pays-Bas en France et dans les pays méditerranéens (XIIe–XVe siècle): Un grand commerce d'exportation au Moyen Age* (Paris: Droz, 1935), 160–65; and G. de Poerck, *La draperie médiévale en Flandre et en Artois. Technique et terminologie* (Bruges: De Tempel, 1951), 1:235–45.

39. Lestocquoy, *Deux siècles*, 59–66; Fabienne Joubert, "Les 'tapissiers' de Philippe le Hardi," in *Artistes, artisans et production artistique au Moyen Age*, ed. Xavier Barral i Altet (Paris: Picard, 1990), 3:601–7.

40. The elite clientele for their work is invoked by the makers of *tapis sarrazinois* to justify their exemption from serving on guard duty. Article 17 of Etienne Boileau's presentation of their regulations states that "leur mestier n'apartient qu'aus yglises, et aus gentishomes et aus hauz homes, come au Roy et a contes" (Depping, ed., *Réglemens*, 128; Etienne Boileau, *Les métiers*, 102–104). On the Burgundian dukes as patrons of tapestry, see Rapp Buri and Stucky-Schürer, *Burgundische Tapisserien*, 327–40.

41. It is somewhat ironic that the weavers' guilds, including some that made tapestries, were among the major instigators of the urban rebellions against royal and ducal control in the fifteenth century.

42. Francis Muel, "L'oeuvre," in Muel et al., ed., *La Tenture de l'Apocalypse d'Angers*, Cahier de l'Inventaire 4, 2d ed. (Nantes: Association pour le développement de l'Inventaire Général des Monuments et des Richesses Artistiques en Région des Pays de la Loire, 1987), 61.

43. Brassat, *Tapisserien und Politik,* 164.

44. At that time, the cathedrals of Paris and Toulouse replaced their choir tapestries, which had been produced in the fifteenth and sixteenth centuries. Guillaume Ambroise, Annick Notter, Nicolas Sainte-Fare-Garnot, eds., *La Vierge, le roi et le ministre. Le décor du choeur de Notre-Dame au XVIIe siècle* (Arras: Musée des Beaux-Arts, 1996); Pascal-François Bertrand, "La tenture de *l'Histoire de saint Etienne* de la cathédrale de Toulouse et la peinture dans la capitale du Languedoc vers 1530–1540," *Gazette des Beaux-Arts* 131 (1998): 139–60.

45. On these tapestries, see Rapp Buri and Stucky-Schürer, *Zahm und Wild,* 62–66, 84–86, 387–99. Paul Binski argues that a hanging commissioned by Richard of Barkyng, abbot of Westminster (d. 1246), for his church was a tapestry. See his "Abbot Berkyng's Tapestries and Matthew Paris's Life of St. Edward the Confessor," *Archaeologia or Miscellaneous Tracts Relating to Antiquity* 109 (1991): 85–86, 95–96. If so, this would be an early English example of a choir tapestry. However, the earliest reference to the series is by the fifteenth-century historian of Westminster Abbey, John Flete: "Duas etiam cortinas sive dorsalia chori de historia domini salvatoris et beati regis Edwardi sumptibus propriis et expensis fieri procuravit, ac eidem ecclesie dedit et reliquit." This description does not specify that they were tapestries. A sixteenth-century commentator refers to them as of "faire arras worke" and another in the seventeenth century as "wrought in the cloth of Arras"; but, as Thomas Campbell points out, "arras" refers in sixteenth-century English court documents to tapestries woven with metallic thread ("Tapestry Quality in Tudor England: Problems of Terminology," *Studies in the Decorative Arts* 3, no. 2 [fall–winter 1995–96]: 48). He suggested to me that outside a formal court context, however, the term "arras" was used with less specificity and proposed that the Westminster hangings were examples of *opus anglicanum,* a technique that incorporated metallic thread. This argument is supported by the fashion for the technique in England and the paucity of information relating to tapestry production at this time.

46. Philippe Guignard, "Mémoires fournis aux peintres chargés d'exécuter les cartons d'une tapisserie destinée à la collégiale Saint-Urbain de Troyes représentant les légendes de St. Urbain et de Ste. Cécile," *Mémoires de la Société d'Agriculture, Sciences et Arts du département de l'Aube* 15 (1849–1850): 421–534.

47. These large-scale paintings were preserved in the cathedrals of Paris and Le Mans and in the collegiate church of Notre-Dame, Beaune.

48. Numerous examples attest to payments to a cleric for a written description of a saint's life. For the *Life of Margaret,* made for the parish church of Sainte-Marguerite in Tournai, see Jean Dumoulin, "Comptes de la paroisse Sainte-Marguerite de Tournai au XVe siècle," in *Les grands Siècles de Tournai,* ed. Jacques Pycke and Jean Dumoulin (Tournai: Cathédrale Notre-Dame, 1993), 302. A written description, much less detailed than that for the *Lives of Saint Urbain and Saint Cecilia,* is preserved for the *Life of the Virgin,* made for the collegiate church of Notre-Dame, Beaune. See Alain Erlande-Brandenburg, "La tenture de la vie de la Vierge à Notre-Dame de Beaune," *Bulletin Monumental* 1 (1976): 46–47; Fabienne Joubert, "Nouvelles propositions sur la personnalité artistique de Pierre Spicre," in *La splendeur des Rolin. Un mécénat privé à la cour de Bourgogne,* ed. Brigitte Maurice-Chabard (Paris: Picard, 1999), 171.

49. For a clear critique of this approach, common in scholarship of the nineteenth and early twentieth centuries, see Cavallo, *Medieval Tapestries,* 57–61. The methods of categorizing and describing stylistic changes in tapestry is debated among textile historians. Leonie von Wilckens's review of Cavallo's catalog of

medieval tapestries in the Metropolitan Museum of Art (*Zeitschrift für Kunstgeschichte*, 57, no. 2 [1994]: 279–83) provides a good introduction to the various positions scholars have adopted on this topic.

50. This argument is made forcefully by Rapp Buri and Stucky-Schürer (*Burgundische Tapisserien*, 423). On tapestry merchants, see Rapp Buri and Stucky-Schürer, *Burgundische Tapisserien*, 343–54; Joubert, "Les 'tapissiers,'" 601–607; Salet, "Remarques," 212–13. Tapestry merchants traveled with patterns to show to prospective buyers. In several documented cases, the patron purchased the cartoons, no doubt to assure that his commission would remain unique. A systematic study of the circulation of cartoons or patterns has not been done, but there are many cases in which individual figures or motifs are repeated.

51. For examples of attempts to assign a tapestry to an individual artist through stylistic comparison, see Fabienne Joubert, "La tenture de choeur de Saint-Etienne d'Auxerre et la peinture bruxelloise vers 1500," *Revue de l'Art* 75 (1987): 37–42; idem, "Jacques Daret et Nicolas Froment cartonniers de tapisseries," *Revue de l'Art* 88 (1990): 39–47; and Nicole Reynaud, "Un peintre français cartonnier de tapisseries au XVe siècle: Henri de Vulcop," *Revue de l'Art* 22 (1973): 6–21.

52. Jules Guiffrey, in one of the first surveys of tapestry, pointed to the specificity of this type and identified certain of its characteristics. The studies on individual choir tapestries are limited primarily to exhibition and museum catalog entries. Exceptions are catalogs from exhibitions organized around a single tapestry such as Sophie Lagabrielle ed., *Histoires tissées*, exhibition catalog, Avignon, Palais des Papes, 1999 (Paris: Réunion des Musées Nationaux, 1999), which looks at the *Life of Stephen* from a variety of angles, focusing on its subject matter; and Laura Weigert and Micheline Durand, eds., *Histoire de saint Etienne: La tenture de choeur de la cathédrale d'Auxerre*, exhibition catalog (Auxerre: Musées d'Art et d'Histoire, 2000), which includes essays on the urban, architectural, religious, and ceremonial contexts of this tapestry.

53. For some specific examples of this process, see Thomas Head, *Hagiography and the Cult of the Saints in the Diocese of Orleans, 800–1200* (Cambridge: Cambridge University Press, 1990); Sharon Farmer, *Communities of Saint Martin: Legend and Ritual in Medieval Tours* (Ithaca: Cornell University Press, 1991); André Vauchez, ed., *Saints et les Villes* (Rome: Ecole Française de Rome, 1995). A special issue of *Gesta* (36, no. 1 [1977]) devoted to body part reliquaries provides discussions of relics and the cult of saints from an art historical perspective.

54. Barbara Abou-El-Haj, *The Medieval Cult of Saints: Formations and Transformations* (Cambridge: Cambridge University Press, 1994).

55. Hippolyte Delehaye, *The Legends of the Saints* (Chicago: University of Chicago Press, 1961); and Baudouin de Gaiffier, *Etudes critiques d'hagiographie et d'iconologie* (Brussels: Société des Bollandistes, 1967).

56. For example, Magdalene Carrasco, "An Early Illustrated Manuscript of the Passion of Saint Agatha (Paris, Bibl. Nat., MS Lat. 5594)," *Gesta* 24, no. 1 (1985): 19–32; and Cynthia Hahn, *Passio Kiliani . . . Passio Margaretae, Codices Selecti*, no. 83, facsimile with English introduction and commentary (Graz: Akademische Druck-und Verlaganstalt, 1988); idem, "Picturing the Text: Narrative in the Life of the Saints," *Art History* 13, no. 1 (1990): 1–33; idem, "The Illustrated Life of Edmund, King and Martyr," *Gesta* 30 (1991): 119–39; and idem, *Portrayed on the Heart: Narrative Effect in Pictorial Lives of the Saints from the Tenth through the Thirteenth Century* (Berkeley: University of California Press, 2001); I thank Cynthia Hahn for sharing the introduction to her book with me before its publication.

57. For detailed analyses of the narrative structure

of written hagiographic texts, see Alain Boureau, *La légende dorée. Le système narratif de Jacques de Voragine* (Paris: Editions du Cerf, 1984); and idem, *L'événement sans fin. Récit et christianisme au Moyen Age* (Paris: Les Belles Lettres, 1993); Charles Altman, "Two Types of Opposition and the Structure of Latin Saints' Lives," *Medievalia et Humanistica* 6 (1975): 1–11; Evelyn Birge Vitz, "La Vie de saint Alexis: Narrative Analysis and the Quest for the Sacred Subject," in *Medieval Narrative and Modern Narratology: Subjects and Objects of Desire* (New York: New York University Press, 1989), 126–49.

58. References to narratology abound in the scholarship of medieval art history. I am interested here in studies that propose a method for the interpretation of pictorial narrative. Wolfgang Kemp's work is particularly illuminating in this respect, but I might also mention Louis Marin's "Piero della Francesca à Arezzo," in his *Opacité de la peinture. Essais sur la représentation au Quattrocento* (Paris: Usher, 1989), 101–124; and Michel Costantini, "Narratologie picturale ou O Jocte, Quid de Illo Narrasti" (thèse de Doctorat d'Etat ès Lettres, Université de Paris VIII, Saint Denis, 1993). These examples are characterized by their consistent application of an interpretive framework rather than a collection of what are, in many cases, mutually exclusive narrative theories.

59. Wolfgang Kemp, *Sermo Corporeus: Die Erzählung der mittelalterlichen Glasfenster* (Munich: Schirmer-Mosel, 1987), translated by Caroline Dobson Saltzwedel under the title *The Narratives of Gothic Stained Glass* (Cambridge: Cambridge University Press, 1997). For an introduction to the analytical model proposed by A. J. Greimas, which Kemp applies to these stained-glass windows, see Joseph Courtes, *Introduction à la sémiotique narrative et discursive, méthodologie et application* (Paris: Classiques Hachettes, 1976).

60. I refer specifically to the theoretical usage of the term "performance" in textual analysis to mean the activity through which meaning is constructed. Theories of performance developed in linguistics and literary studies stress the communicative function of texts and the impact of the event of its telling on the meaning of a text. This use of the word is common to what are known as "reader-response" and "speech act" theories. The first of these is represented by the work of Wolfgang Iser, *The Act of Reading: A Theory of Aesthetic Response* (Baltimore: Johns Hopkins University Press, 1978), the second by John R. Searle, *Speech Acts* (Cambridge: Cambridge University Press, 1969), and by John Langshaw Austin, *How to Do Things With Words* (Oxford: Oxford University Press, 1962).

61. Mieke Bal, *Reading "Rembrandt": Beyond the Word-Image Opposition* (Cambridge: Cambridge University Press, 1991); Whitney Davis, *Masking the Blow: The Scene of Representation in Late Prehistoric Egyptian Art* (Berkeley: University of California Press, 1992).

62. For studies in which "reading" is historicized, see Brian Stock's discussions of the changes in reading practices over a broad span of time in *The Implications of Literacy: Written Language and Models of Interpretation in the Eleventh and Twelfth Centuries* (Princeton: Princeton University Press, 1983); and Walter Ong, *Orality and Literacy: The Technologizing of the Word* (New York: Methuen, 1982). For discussions of specific examples relying on individual manuscripts and their internal organization as evidence for "reading" practices at a particular time, see Paul Saenger, "Silent Reading: Its Impact on Late Medieval Script and Society," *Viator: Medieval and Renaissance Studies* 13 (1982): 367–414; Evelyn Birge Vitz, "Chrétien de Troyes: Cler ou ménestrel? Problèmes des traditions orale et littéraire dans les Cours de France au XIIe siècle," *Poétique* 81 (1990): 21–42; and Roberta Krueger, *Women Readers and the Ideology of Gender in Old French Romance* (Cambridge: Cambridge University Press, 1993).

63. Guignard, "Mémoires," 24–25, 81.

64. Ibid., xi; and Saint-Omer, Archives Municipales 2G473; I thank Ludovic Nys for this reference. The number of metal bars, brackets, and hooks used for the display of the choir tapestry in Le Mans is included in the list of items destroyed in 1562 during the religious wars. The cloth ribbons are called *oreilles*; representations of tapestries in illuminated manuscripts indicate what they must have looked like.

65. I have based these observations on general studies on the liturgy, including Aimé-Georges Martimort, ed., *Principes de la liturgie*, and idem, *La liturgie et le temps*, vols. 1 and 3 of *L'Eglise en Prière* (Paris: Desclée, 1983–1984); Robert F. Taft, *Liturgy of the Hours in East and West: The Origins of the Divine Office and Its Meaning for Today* (Collegeville, Minn.: Liturgical Press, 1986); Thomas J. Talley, *The Origins of the Liturgical Year* (New York: Pueblo, 1990); and Marcel Metzger, "Année ou bien cycle liturgique?" *Revue des Sciences Religieuses* 67 (1993): 85–96.

66. For a detailed discussion of the rights and responsibilities of the bishop and the chapter in their respective domains in the cathedral of Paris, see Pierre-Clément Timbal and Josette Metman, "L'évêque de Paris et le chapitre de Notre-Dame: La juridiction dans la cathédrale au Moyen Âge," *Revue d'Histoire de l'Eglise de France* 50, no. 147 (1964): 47–72. The bishop was responsible for the upkeep of the sanctuary, the chapter for that of the canons' choir; each party paid for the candles placed in the two sections of the choir during festivals.

67. A large body of scholarship, primarily in the fields of anthropology and sociology, focuses on "performances," including, ritual, play, and other cultural traditions, as social activities that serve to constitute an individual's or a group's identity. Examples of this kind of analysis of "performance" are Richard Flores, *Los*

Pastores: History and Performance in the Mexican Shepherd's Play of South Texas (Washington: Smithsonian Institution Press, 1995); Richard Bauman, *Story, Performance, and Event: Contextual Studies of Oral Narrative* (Cambridge: Cambridge University Press, 1986); and Victor Turner, *From Ritual to Theatre: The Human Seriousness of Play* (New York: Performing Arts Journal Publications, 1982).

68. Descriptions of the characteristics and rights of this group are included in surveys and dictionaries of medieval institutions: "Institutions ecclésiastiques," *Histoire des institutions françaises au Moyen Age*, ed. Ferdinand Lot and Robert Fawtier (Paris: Presses Universitaires de France, 1962), vol. 3; Pierre Torquebiau, "Chanoines" and "Chapitre de Chanoines," in *Dictionnaire du droit canonique*, ed. Antoine Villier, Etienne Magnin, Raoul Naz, and A. Amanieu (Paris: Letouzey and Ané, 1942), vol. 3, cols. 471–88 and 530–66; Charles Dereine, "Chanoines," in *DHGE*, ed. Alfred Baudrillart, Albert Vogt, and Urbain Rouziès (Paris: Letouzey and Ané, 1953), vol. 12, cols. 353–405; and the collection of essays in *Le Monde des Chanoines (XIe–XIVe s.)*, Cahiers de Fanjeaux, Collection d'histoire religieuse du Languedoc au XIIIe et au début du XIVe siècle 24 (Toulouse: Edouard Privat, 1989).

69. This argument was advanced, for instance, at the exhibition of choir tapestry held in Arras in 1969 and in its accompanying catalog, *Légende dorée de la tapisserie* (Arras: Musée des Beaux-Arts, 1969).

70. Barbara Fleith, in her study of the manuscript versions of the *Golden Legend* in Latin, presents a reasoned critique of the argument that the text was intended primarily for the edification of the laity, suggesting it was used as a manual to be read among groups of clerics or for educational purposes in schools and universities, probably to train students in preaching. See her *Studien zur Überlieferungsgeschichte der Lateinischen Legenda Aurea* (Brussels: Société des Bollandistes, 1991),

37–42. The use of vernacular texts by the clergy is confirmed by inventories of their libraries.

CHAPTER 2. The *Lives of Piat and Eleutherius*

1. This chapter develops certain points presented in my article, "Performing the Past: the Tapestry of the City and Its Saints in Tournai Cathedral," *Gesta* 38, no. 2 (1999): 154–70.

2. The primary source for the placement of the tapestry in the choir is the cathedral's Ordinal. A colophon at the end of the manuscript dates it to 1424 (Tournai, ACT MS 348, 82). This information is supplemented by a description of the tapestry written in the seventeenth century, when it still hung in the choir (*Ruinarum Ecclesiae Tornacensis Memorialis Descriptio,* Tournai, ACT MS 493–94, 1). The first reference to the tapestry specifies when and where it was displayed: "In omni festo cathedrali scilicet natalis domini, paschae, dedicationis ecclesiae, pentechostes, eucharistiae, assumptionis beatae virginis, et omnium sanctorum sic ornatur chorus panni hystorici de gestis sanctorum piati et eleutherii ex dono domini Toussani Pryer canonici appenduntur circa altas formas . . ." (Tournai, ACT MS 348, 1). (On all cathedral feast days, that is Christmas, Easter, the Dedication of the Church, Pentecost, Corpus Christi, The Assumption of the Virgin, and All Saints' Day, the choir is ornamented by the historiated cloths of the deeds of Piat and Eleutherius, donated by lord Toussaint Prier, canon, which are hung around the upper stalls). According to the Ordinal, the tapestry was displayed on the following feasts: Christmas (December 25), Easter, Pentecost, Corpus Christi, the Assumption of the Virgin (August 31), All Saints' Day (November 1), and the Dedication of the Church (May 9). The section entitled *de secundis vesperis* adds that the tapestry was also displayed on the feast days of Piat (October 1)

and Eleutherius (his feast day is February 20; the invention of his relics is celebrated on July 9, their translation on August 25) (Tournai, ACT MS 348, 1 and 13).

3. On the duties of the chapter's lay auxiliaries, including the bell hands, see Jacques Pycke, *Le chapitre cathédrale Notre-Dame de Tournai de la fin du XIe à la fin du XIIIe siècle* (Brussels: Nauwelaerts and Louvain la Neuve, Collège Erasme, 1986), 193.

4. Because the accounts of the cathedral chapter were destroyed in 1560, the first evidence of payments to the bell hands for this job dates to that year. The regularity of payments from that time on suggests that the tapestry continued to be displayed only on prescribed occasions (Tournai, ACT, Comptes de la Fabrique, 1560–1584).

5. Nicolas Raimond, grand vicar, donated these new choir stalls to the cathedral. Jean Warichez, *La Cathédrale de Tournai et son chapitre* (Wetteren: Imprimerie de Meester, 1934), 488.

6. Tournai, ACT MS 348, 1. The nature of these hangings is unknown. The Florentine bishop of Tournai, Ghini Malpighli, donated them to the cathedral. Malpighli's obituary describes them as "duos pannos deauratos ad ymagines" (two golden hangings containing images). On this bishop, see Jacques Pycke, "Ghini Malpighli (André)," in *DHGE*, vol. 20, cols. 1174–77.

7. The placement of the tapestry in the choir is specified in *Ruinarum* (Tournai, ACT MS 493–94), 1.

8. Tournai, ACT MS 348.

9. For instance, Warichez attempts to isolate such facts from the *vita* of Eleutherius, which he considers, "qu'un roman hagiographique, d'une mince valeur historique." Joseph Warichez, "Le XIVe centenaire de saint Eleuthère: Le champ d'action de Saint Eleuthère," *Collationes Diocesis Tornacensis* 75 (1926): 57–66.

10. The church dedicated to Saint Stephen was

abandoned in the ninth century, when the cathedral was reconstructed. Pycke, *Le chapitre*, 37–38.

11. On the dedication of the cathedral, see J. Le Maistre d'Anstaing, *Recherches sur l'Eglise Cathédrale de Notre Dame de Tournai* (Tournai: Massart and Janssens, 1842–1843), 2:4–5, 7–9; and Joseph Warichez, *Les origines de l'église de Tournai* (Louvain: C. Peeters, 1902), 35–37.

12. AA SS (February 20), 186. On the reliquary, which is attributed to Nicolas of Verdun, see J. M. Lequeux, "La chasse de S. Eleuthère, chef d'oeuvre original malgré les restaurations des 19e et 20e siècles," *Mémoires de la Société Royale d'Histoire et d'Archéologie de Tournai* 1 (1980): 181–201; and L. Clocquet, "La chasse de saint Eleuthère à Tournai," *Revue de l'Art Chrétien* 32 (1889): 188–200.

13. One of the readings in the Breviary for the use of Tournai on Eleutherius's feast day states, for example: "Pro sancti eleutherii confessoris atque pontificis qui in presenti requescit ecclesia merita gloriosa." Breviary for use of Tournai (Paris: n.p., 1509) (Paris, Bibliothèque de l'Ecole des Beaux Arts, Masson 264). This formulation is also repeated in a missal (Paris: Johannis Higmani, 1498). The cathedral could not, in fact, claim sole possession of the saint. In 1233, Bishop Walter Marvis donated Eleutherius's head to the monastery of Saint-Martin (AA SS [February 20], 186).

14. Cousin describes this event in detail. The clergy lit a fire in honor of the saint outside the church of Saint-Piat in Seclin, which was blessed by its pastor. Jean Cousin, *Histoire de Tournai ou livres des chroniques, annales ou démonstrations du christianisme de l'évêché de Tournay* (Douai: Imprimerie de Marc Wyon, 1619–1620), 1:110.

15. Piat's relics were moved to Chartres for safekeeping during the Norman invasions in the ninth century. In the twelfth century some of these relics were returned to Seclin; however, the rest stayed in Chartres. Relics of Piat are preserved in modern reliquaries at the church of Saint-Piat, Seclin, and in the Vendôme chapel, Notre-Dame, Chartres (AA SS [October 1], 19–22).

16. AA SS (October 1), 7–26 (the ninth-century *Acta* from the monastery of Anchin [AA SS (October 1), 22–26]); Fulbert of Chartres's hymn, "De sancto Piato Hymnus," 10–11 (PL 141: 341–342). On the manuscript tradition of Piat's *vita*, see S. Pruvost, *Saint Piat, martyr-apôtre du Tournaisis, patron de Seclin*, 3d. ed. (Lille: Desclée de Brouwer, 1922).

17. AA SS (February 20), 185–208.

18. The major studies of this tapestry are Jean Dumoulin and Jacques Pycke, "La tapisserie de Saint-Piat et de Saint-Eleuthère à la cathédrale de Tournai (1402). Son utilisation et son histoire," *Revue des Archéologues et Historiens d'Art de Louvain* 15 (1982): 184–200; J. Voisin, "Notice sur les anciennes tapisseries de la cathédrale de Tournai," *Bulletin de la Société Historique et Littéraire de Tournai* 9 (October 1863): 213–43; Felix Thürlemann, "Robert Campin um 1400 als Malergeselle in Tournai: Ein kennerschaftlicher Versuch zu den Tapisserien der Heiligen Piatus und Eleutherius," *Pantheon* 55 (1997): 24–31; and Weigert, "Performing," 152–68. Because it is one of the few tapestries for which the name of the weaver and the date and place of its production are documented, the *Lives of Piat and Eleutherius* is particularly important for the history of tapestry production; it is mentioned in almost all general histories of tapestry.

19. For a detailed discussion of this part of the history of the tapestry, see Dumoulin and Pycke, "La tapisserie," 191–92.

20. Tournai, ACT MS 494. This document was first published in Weigert, "Performing," 165–67. I thank Canon Jean Dumoulin once again for bringing my attention to it.

21. For these events, see AA SS (February 20), 190–91, 200–201 and AA SS (October 1), 12 and 22.

22. "Tournay" and "les Tournisiens" appear fifteen times within the thirty-two tituli.

23. These two structures still survive in Tournai; they are both located on the central square of the city, close to the cathedral.

24. The distinctive five towers of the cathedral date to the twelfth-century construction campaign. On the cathedral Notre-Dame, see Jean Dumoulin, *La Cathédrale de Notre-Dame de Tournai* (Tournai: Casterman, 1971); Jean Dumoulin and Jacques Pycke, *La Cathédrale Notre-Dame de Tournai et son trésor* (Tournai: Casterman, 1980); Jean Dumoulin, "Description du choeur de la cathédrale de Tournai au XVe siècle," *Mémoires de la Société Royale d'Histoire et d'Archéologie de Tournai* 4 (1983–1984): 99–116; Le Maistre d'Anstaing, *Recherches*; and Warichez, *La cathédrale*.

25. Tournai, ACT 494. See appendix 2.

26. There are also implicit allusions to the history of the monarchy. The saint who transports his own skull to his place of burial was a common motif in hagiographic texts, but the image also recalls the miracle of Saint Denis, who carried his cranium from Paris to what became the abbey of Saint-Denis. The image of Piat baptizing Hireneus creates a visual reference to Saint Remi's baptism of Clovis. It is probably not a coincidence that Remi and Piat share the same feast day, October 1, or that Piat arrived in Gaul with Denis. Through these correspondences, the life of Piat is associated with the founding legends of French history. The fact that Eleutherius has the same name as one of Denis's companions also relates him indirectly to this broader history.

27. Any attempt to discuss the "structure" of a fragmentary text is necessarily constrained by the uncertainty of how the missing elements might contribute to or even revise the pattern or underlying framework proposed. While recognizing this inherent methodological problem, I nevertheless seek to isolate certain features of the structure of the *vitae*. In part, the existence of the transcription of the tituli justifies an analysis of the organization of the chief narrative events within the text as a whole. However, I also aim to discuss the pictorial features of the relationship among these events and the nature of the junctures between them. Here, I move from the evidence the fragment provides to an argument concerning the tapestry as a whole. The consistency of these features within the remaining sections of the text and the fact that they contribute to a convincing reading of the woven *vita* as a whole make it probable that the missing sections included similar pictorial elements.

28. In this respect, the woven story meets the minimum requirements for medieval history or history writing, which were often considered identical. Following Isidore of Seville's definition, history was "true events presented as they really happened." This definition implies that, in history, or in a historical account, events are ordered chronologically. On this point and on definitions of history writing through the medieval period, see Bernard Guenée, "Histoires, annales, chroniques. Essai sur les genres historiques au Moyen Age," *Annales E.S.C.* 28, no. 3 (1973): 997–1016; and idem, *Histoire et culture historique dans l'Occident médiévale* (Paris: Aubier Montaigne, 1980). Of course, once it met these basic requirements, what was considered history took many forms — annals, chronicles, epics, and, in the present case, hagiography.

29. Gabrielle Spiegel discusses how genealogies of rulers serve as structuring devices in thirteenth-century vernacular prose historiography. See Gabrielle Spiegel, "Genealogy: Form and Function in Medieval Historical Narrative," *History and Theory: Studies in the Philosophy of History* 22 (1983): 43–53. She develops this argument in a broader context in *Romancing the Past* (Berkeley: University of California Press, 1993).

30. My discussion of this second "genealogy" relies on the work of Michel Sot, "Historiographie épiscopale et modèle familial en Occident au XIe siècle," *Annales E.S.C.* 33, no. 3 (1978): 433–49.

31. Some written accounts of his life state that he served as bishop of Tournai (AA SS [October 1], 8, 13–14).

32. The presence of this bishop indicates that the citizens of Tournai continued to be baptized after they were banished from their city to Blandain.

33. Classic studies of medieval architecture, such as Jantzen, Focillon, and Bony consider these among the defining characteristics of the Gothic cathedral. These studies focus on stylistic characteristics of cathedrals. Hans Jantzen, *High Gothic: The Classic Cathedrals of Chartres, Reims, Amiens,* trans. James Palmes (New York: Pantheon, 1962); Henri Focillon, *The Art of the West in the Middle Ages,* edited and introduced by Jean Bony, trans. Donald King, 2d ed. (London: Phaidon, 1969), vol. 2; Jean Bony, *French Gothic Architecture of the Twelfth and Thirteeth Centuries* (Berkeley: University of California Press, 1983). Among the few publications that focus specifically on the social, religious, and cultural function of cathedrals within medieval communities and which, in the process, emphasize the organization and use of distinct spaces within these churches, albeit in schematic terms, are Alain Erlande-Brandenburg, *The Cathedral: The Social and Architectural Dynamics of Construction,* trans. Martin Thom (Cambridge: Cambridge University Press), 1994; André Vauchez, "Les cathédrales: Approches historiques," in *La cathédrale. Demeure de Dieu demeure des hommes* (Paris: Desclée, 1988), 51–61; Bernard Chedozeau, *Choeur clos, choeur ouvert. De l'église médiévale à l'église tridentine (France, XVIIe–XVIIIe siècle)* (Paris: Editions du Cerf, 1998).

34. On the choir of Tournai cathedral in the fifteenth century, see Dumoulin, "Description." Although I have relied heavily on this study, I divide the choir into three parts rather than two, and situate one division, between the canons' choir and the sanctuary, after the seats of the bishop and officiants.

35. Tournai, ACT MS 348, fols. 1, 15; Dumoulin, "Description," 106.

36. Tournai, ACT 348, fol. 16.

37. During Lent, the sanctuary was blocked by a veil, which stretched across its western entrance (ACT 348, fol. 19).

38. No study of the demographic and social composition of the chapter, which Jacques Pycke (*Le chapitre*) describes in significant detail for the period between the end of the eleventh and the end of the thirteenth centuries, exists for the fifteenth century. Many of the general trends he outlines continued into the fifteenth century. In cases where this earlier model is not appropriate, I have based my conclusions on specific information about Tournai and comparative material from other cathedral chapters.

39. Its recipient received two-thirds the amount of the other prebends and could not take part in chapter meetings and decisions (Pycke, *Le chapitre,* 104, 220–21).

40. Pycke, *Le chapitre,* 90–93.

41. The number of local appointments dropped from 73 percent between 1080 and 1180 to 16 percent between 1261 and 1300 (Pycke, *Le chapitre,* 81). This number increased at the end of the fourteenth century but did not exceed 40 percent, which it reached during the period 1398–1417. See Olivier de Waele, *Etude prosopographique des chanoines de Tournai (1378–1460)* (M.A. thesis, University of Louvain-la-Neuve, 1993), 61–66.

42. The chapter elected its head, the dean. The bishop, pope, and king, however, were responsible for the initial appointment of canons. Pycke, *Le chapitre,* 56–60.

43. On the circumstances of Toussaint Prier's eccle-

siastical career, see Dumoulin and Pycke, "La tapis-serie," 184–88; and Weigert, "Performing," 164–65.

44. These indications of communal life had disappeared by the end of the eleventh century. Pycke, *Le chapitre*, 125–26.

45. On the process of "installation," see Pycke, *Le chapitre*, 104–6.

46. For the less profitable occasions, the chapter appointed chaplains and vicars to perform the canons' liturgical duties in the choir and at other altars in the cathedral. In 1340, for instance, 43 canons received prebends and the chapter employed 12 vicars and 33 chaplains. See Jacques Pycke, "Les chanoines de Tournai aux études, 1330–1340," in *Les universités à la fin du moyen âge*, Acts of the International Congress of Louvain, ed. Jacques Paquet and Jozef Ijsewijn (Louvain: Institut d'Etudes Médiévales, 1978), 598–99.

47. So long as the level of education provided by the cathedral schools was adequate, canons remained in residence in their city during their studies. By the thirteenth century, however, these schools could not serve the needs of the chapter, which required its members to be proficient in the legal and theological matters taught at the university. Furthermore, a higher level of education was required for canonical appointments. This factor also contributed to the rise of appointments from outside Tournai and its diocese (Pycke, "Les chanoines," 600–605; idem, *Le chapitre*, 69–70).

48. Jacques Pycke, "Les pèlerinages de dévotion dans la première moitié du XIVe siècle," *Horae Tornacenses (1171–1971): Recueil d'études d'histoire publiées à l'occasion du VIIIe centenaire de la consécration de la cathédrale de Tournai* (Tournai: Archives de la Cathédrale, 1972), 111–30.

49. Pycke comes to this conclusion and argues that the institution of vicars in Tournai, who took over many of the canons' duties, was a result of the canons' absence in the city (Pycke, *Le chapitre*, 184–91).

50. On the changing regulations of residence for the members of Tournai's cathedral chapter, see Pycke, *Le chapitre*, 115–25.

51. Pycke provides examples of the fee received for attending certain ceremonies. The largest was given to canons who participated in six of the cathedral feast days. A donation from Canon Joseph of Bruges raised the fee given for participation in the feast of the Assumption of the Virgin and another was added for any processions that left the cloister. Pycke, *Le chapitre*, 204–11.

52. Over a ten-year period in the thirteenth century, seventy exemptions from residence were accorded to a chapter consisting of forty-two canons (Pycke, *Le chapitre*, 287–88). On the education of Tournai's canons, see also Pycke, "Les chanoines," 598–605.

53. For example, the directions for the celebration of vespers on cathedral feast days include a list of potential substitutes in the case of an absent official. The cellarer rules the choir at vespers if the cantor is absent. At first vespers and matins, the cellarer intones if the cantor is absent. The dean celebrates mass in the absence of the bishop and of other high officials. In this case, the dean rules the choir from his side. If the dean is absent, the archdeacon rules the choir. If the archdeacon is absent, the guardian takes his place. Finally, if the latter is absent, the cantor (or in his absence, the cellarer) rules the choir (Tournai, ACT MS 348, fol. 2).

54. Pycke, *Le chapitre*, 245, 127–77, 136, 219–22.

55. Warichez, *La cathédrale*, 2:53–54; Le Maistre d'Anstaing, *Recherches*, 1:167.

56. Tournai, ACT 348, fol. 8.

57. Pycke, *Le chapitre*, 231–33.

58. On the political role of the bishop, see Jacques Pycke, "De Louis de Trémoille à Ferry de Clugny (1388–1483): Cinq évêques tournaisiens au service des ducs

de Bourgogne," in *Les grands siècles de Tournai (12e–15e s.)*, ed. Jean Dumoulin and Jacques Pycke (Tournai: Cathédrale Notre-Dame, 1993), 209–38; and Edouard de Moreau, "Un évêque de Tournai au XIVe siècle, Philippe d'Arbois," *Revue Belge de Philologie et d'Histoire* 1 (1923): 23–60.

59. Pycke, *Le chapitre*; and Paul Rolland, *Histoire de Tournai*, 2d ed. (Tournai: Casterman, 1957), 94–109.

60. Clement VII, with the approval of Charles VI and Philip the Bold, appointed Louis de la Trémoille bishop in 1388; his episcopate lasted until 1410. On this bishop, see Cousin, *Histoire*, 4:184–86; Le Maistre d'Anstaing, *Recherches*, vol. 2; P. Piétresson de Saint-Aubin, "Trois formulaires et recueils de jurisprudence de l'église de Cambrai," *Revue du Nord* 30 (1948): 238, 482n. 100; Pycke, "De Louis de Trémoille," 210–11, 223.

61. The bishop's status within the ecclesiastical hierarchy was one reason he was placed on the epistle side of the choir, which was traditionally the more honored side. This point is made again and again in the literature on liturgy and ceremony.

62. On seats assigned to various officials in the choir, see Le Maistre d'Anstaing, *Recherches*, 2:165–67; Warichez, *La cathédrale*, 53–55; the chapter archives preserve a list of canons with the date of their nomination and their stall in the choir, compiled in 1406 (ACT, copy of the *Liber longus*, fol. 41).

63. Tournai, ACT 348, fols. 12, 19, 22, 29, 38, 42, 76.

64. The cloister was destroyed in the seventeenth century. See Paul Rolland, *La Cathédrale de Tournai*, vol. 2: *La chapelle paroissale et le cloître*, Recueil des Travaux du Centre de Recherches Archéologiques 5 (Antwerp: De Sikkel, 1944), 46–47, 50–51, 54–71. Cousin, in a document destroyed in 1940, located the closed cemetery reserved for canons to the north of the cathedral as well. The cloister served as the site of burial for members of the bourgeoisie of Tournai and of the cathedral chapter (Rolland, *La Cathédrale*, 46–47, 67).

65. The tomb of Letbert le Blond, the only dean and member of the chapter buried in the choir, was placed according to this spatial division of the choir, in front of the dean's stall (Pycke, *Le chapitre*, 239).

66. Tournai, ACT 494.

67. Tournai, ACT 348, fol. 1.

68. I discuss the relationship between individuals represented in tapestry and those seated in the choir in chapter 3.

69. Edouard de Moreau, *Histoire de l'Eglise en Belgique*, vol. 4: *L'Eglise aux Pays-Bas sous les ducs de Bourgogne et Charles Quint, 1378–1559* (Brussels: Edition universelle, 1959), 15–38; and Pycke, "De Louis de Trémoille," 209–38.

70. Cousin, *Histoire*, 4:184–86; Le Maistre d'Anstaing, *Recherches*, vol. 2; Piétresson de Saint-Aubin, "Trois formulaires," 238 and 482n. 100; and Pycke, "De Louis de Trémoille," 210–11, 223.

71. Edouard Perroy, "Un évêque urbaniste protégé de l'Angleterre, Guillaume de Coudenberghe, évêque de Tournai et de Bâle," *Revue d'Histoire Ecclésiastique* 26 (1930): 103–109.

72. Louis de la Trémoille was met with empty churches in Bruges and Sluis in 1393 (Cousin, *Histoire*, 4:185–86; Pycke, "De Louis de Trémoille," 211).

73. Pycke, in Dumoulin and Pycke, *Les grands siècles*, 223. Philip the Bold's intervention in the advancement of his career is evidenced in the duke's encouragement of the chapter of Cambrai to endow Louis de la Trémoille with the additional title of bishop of Cambrai. Pope Benedict XIII, however, had his own candidate appointed to the episcopal throne of Cambrai (Piétresson de Saint-Aubin, "Trois formulaires," 238).

74. Tournai, ACT 348, fol. 1.

75. Ibid.

76. Ibid., fol. 2.

77. Pycke, *Le chapitre*, 261. It is also worth noting in this respect the parallel that the Breviary for use in

Tournai draws between Eleutherius and Saint Peter, both recognized for their founding roles as bishops. See the printed Breviary for use of Tournai (February 20) (Paris: n.p., 1509), unpaginated.

CHAPTER 3. The Gift of the *Life of Gervasius and Protasius* and Its Donor

1. Paul L. Piolin, *Histoire de l'Eglise du Mans* (Paris: Julien Lanier, 1861), 5:221–22.

2. Ambrose, *Ep. XXII* (PL 16:1019–26).

3. AA SS (June 19), 820–22.

4. *Datiana historia ecclesiae Mediolanensis*, ed. Luigi Biraghi (Milan: Boniardo-Polianea, 1848), 19–21, 22–26.

5. Antonio Rimoldi, "Gervais et Protais," in *DHGE*, vol. 20, cols. 1073–76.

6. "S. Innocens in consummata quam S. Victurus struere erat exorsus ecclesia, loco praecipuo repositurus, in Orientali, quam exaltarat parte, altare fecit, in quo iam dictas Reliquias Sanctorum Gervasii et Protasii collocavit." "Et taliter mutatum est eiusdem ecclesiae nomen, propter virtutes scilicet quae ibidem innumerabiliter, in memoria Sanctorum Gervasii et Protasii, factae sunt" (AA SS [June 19], 835, 859).

7. AA SS (June 19), 835.

8. Inscribed next to the figures are the names "Gerba" (for "Gervasius") and "Prota" (for "Protasius"), and, below the gate, "Caenom" (for "Cenomensis," that is, Le Mans). On the gem in the treasury of the cathedral, see Raffaele Garrucci, *Storia della Arte Christiana* (Prato: Gaetano Guasti, 1880), 6:121, pl. 478, no. 40. The coin is reproduced in Eugène Hucher, "Essai sur les monnaies frappées dans le Maine," *Mémoires de l'Institut des Provinces de France*, 2d ser., 1, no. 28 (1845).

9. Although the precise date at which the cathedral was rededicated to Julien is not documented, this event is most likely related to the translation of his relics in the ninth century. The early history of the cathedral is preserved in the *Actus Pontificum* of Le Mans, compiled in the ninth century. Bishop Aldric (832–857) translated the body of Julien in about 840 from the cemetery of the Benedictine abbey of Saint-Julien-du-Pré, to the cathedral, founding his cult. When miracles were attributed to Julien, Bishop Maynard (940–960) constructed an altar dedicated to the saint and moved his relics to a new reliquary behind the altar dedicated to the Virgin and Gervasius and Protasius. This is the first time Julien is described as the patron of the cathedral. André Mussat et al., *La Cathédrale du Mans* (Paris: Berger-Levrault, 1981), 20–22.

10. Ambroise Ledru, ed., *Plaintes et doléances du chapitre du Mans après le pillage de la cathédrale par les Huguenots en 1562*, Archives Historiques du Maine 3 (Le Mans: Au Siège de la Société, 1903), 216.

11. The passage from Martin Guerande's will, included in the necrology, pertaining to the *Life of Gervasius and Protasius* reads:

This same Martin donated to our church a certain impressive and valuable tapestry, to adorn the choir, in which was beautifully depicted the life and history of the blessed martyrs Gervasius and Protasius, in whose memory our present church was originally founded. The said tapestry should be unrolled, hung, and displayed in the stalls of the choir, behind the canons, all in their seats, on certain holy days.

Hic Martinus donavit et eidem nostrae ecclesiae quamdam speciosam et pretiosam tapiceriam, ad ornatum chori, in qua pulchre depingitur vita et historia beatorum martirum Gervasii et Prothasii, in quorum memoriam dudum haec praesens nostra ecclesia primitus exstitit fundata. Quae tapiceria in cathedris chori, a tergo canonicorum in illis sedentium, certis anni solemnitatibus, explicabitur, extendetur et ostendetur.

Martyrologium Capituli Cenomanensis (Le Mans, Médiathèque Louis Aragon, MS 244), fol. 180; G. Busson and Ambroise Ledru, eds., *Nécrologe-Obituaire de la cathédrale du Mans,* Archives historiques du Maine 7 (Le Mans: Au Siège de la Société, 1906), 297–301.

12. "Maynardus episcopus DCCCCXL consecratus, tabulam argenteam, ante altare sanctorum Martyrum Gervasii et Protasii positam, ex novo fabricari constituit, atque ante idem altare Sanctorum decentissime collocavit ... Hildebertus Episcopus, post annos circiter XIII, tabulam altaris sanctorum Martyrium Gervasii et Protasii, parti ex argento, quod bonae memoriae Domnus Hoëllus Episcopus, antecessor eius, ad hoc opus reliquerat" (AA SS [June 19], 836).

13. "Johannes Brisart ... dedit duas ymagines sanctorum Gervasii et Prothasii argento et cupro deaurato fabrica." Busson and Ledru, *Nécrologe-Obituaire* (December 7, 1477), 326–27. On the changes to the altar under Philip of Luxembourg, see Ambroise Ledru, *La cathédrale du Mans au Moyen Age (disposition intérieure)* (Le Mans: L. Chaudourne, 1920), 15–19.

14. On other occasions, the chapter may have replaced the tapestries with the painted cloths that had served as their model and that remained in the chapter's possession until 1562, when a large part of the cathedral's treasure was destroyed. These painted cloths are described as, "les portraictz de toile de la grande tapisserie du cueur" (Ledru, *Plaintes,* 204).

15. Anno domini millesimo quingentesimo nono, Magister Martinus Guerande, presbiter, natione Andegavus, Cenomanensis ecclesiae canonicus, Reverrendissimorumque patrum, de illustri prosapia natorum, Dominorum Philippi Cardinalis de Lucemburgo, nuper, necnon Francisci de Lucemburgo, ejus nepotis, moderni episcoporum Cenomanensium secretarius, donavit eidem ecclesiae Cenomanensi hanc tapiceriam, pro ornatu chori, ad laudem Dei, beatorumque martyrum Gervasii et Prothasii, ac totius curiae coelestis. Eidem donatori parcat Deus. Amen.

16. The *Life of Martin of Tours* in the collegiate church of Montpezat is another case in which the arms of the donor span the length of the tapestry (see appendix 1, fig. 47).

17. The only study devoted to this choir tapestry is Xavier Barbier de Montault, "Les tapisseries des saints Gervais et Protais à la cathédrale du Mans," *Bulletin Monumental* 64 (1899): 209–17, 240–48, 311–52.

18. The existence of a panel representing the martyrdom of Vital and Valery's friend Ursinus is plausible but cannot be confirmed. The violence of the religious wars in Le Mans resulted in the destruction of a piece of the tapestry in 1562. Canon Albin, who played a major role in the restoration of the tapestry, states that this piece represented the death of Ursinus and that it was located at the beginning of the series. However, he provides no proof for this theory (in his untitled note in *La semaine du fidèle. Revue du culte et des bonnes oeuvres* [June 17, 1865], 480). The episode depicting Saint Paul's appearance to Saint Ambrose was stolen in 1858 when Albin removed the *Life of Gervasius and Protasius* from the cathedral for safekeeping before its restoration in Angers. Albin transcribed the titulus that accompanied this episode prior to its disappearance (Laura Weigert, "Reconstructing Medieval Pictorial Narrative in the Nineteenth Century: Louis Joubert's Tapestry Restoration Project," *Art Journal* 54, no. 2 [1995]: 67–72).

19. On this tapestry, see Jules Guiffrey, *Histoire générale de la tapisserie,* vol. 1: *Tapisserie française* (Paris: Société anonyme des publications périodiques, 1880), 60; and Alfred Darcel, "Fragment de tapisserie dans la cathédrale de Soissons (XVe siècle)," *Revue des Sociétés Savantes des Départements,* 7th ser., 5 (1882): 325–26 and appendix 1.

20. François Bucher, *The Pamplona Bibles* (New Haven: Yale University Press, 1970), 1:274, 2:504.

21. Jacobus de Voragine, *Legenda Aurea*, ed. Th. Graesse (Osnabrück: Otto Zeller, 1965), 354–56; and idem, *The Golden Legend*, trans. William Granger Ryan (Princeton: Princeton University Press, 1993), 1:326–28.

22. "Comment la fouldre tomba sur ledit neron et lui rendit le visaige noir et obscur et la face desditz saincts martirs replendissoit comme le soleil" (see appendix 3).

23. Albin, *Semaine*, 480.

24. Alain Boureau, *La légende dorée. Le système narratif de Jacques de Voragine* (Paris: Editions du Cerf, 1984), 219–20.

25. Embrun is not mentioned in any of the other *vitae* of Gervasius and Protasius. It is possible that this city is included in order to relate the saints more directly to France. This city was the seat of the archbishopric of Hautes-Alpes until 1790, when it became a bishopric; finally, in 1822, it was incorporated into the archbishopric of Aix. The first church, dedicated to the Virgin, was constructed in the fourth century, when the bishop, Artemius, translated the relics of Nazarus and Celsus. Both Charles VIII and Louis XII stopped in Embrun on their way to Italy and made generous donations to the church (L. Gaillard in *DHGE*, vol. 15, cols. 378–79).

26. The function of dualism has been addressed from philosophical and anthropological standpoints. One example of the former is David Maybury-Lewis and Uri Almagor, eds., *The Attraction of Opposites: Thought and Society in the Dualistic Mode* (Ann Arbor: University of Michigan Press, 1989). Studies in anthropology show that social responses to the birth of twins have ranged from killing the children to venerating them as gods. J. Rendel Harris, *The Cult of the Heavenly Twins* (Cambridge: Cambridge University Press, 1906); and Alfred Métraux, "Twin Heroes in South America," *Journal of American Folklore* 59 (1946): 114–23. Claude Lévi-Strauss

(*L'Histoire de Lynx* [Paris: Plon, 1991]) analyzes the structure of stories about twins and addresses their function within various social contexts. Claudie Voisenat addresses the implications of the theme of twins as rivals in myths by relating it to contemporary Greek political thought ("La rivalité, la séparation et la mort. Destinées gémellaires dans la mythologie grecque," *L'Homme* 28, no. 105 (1988): 88–104).

27. "O quam gloriosa certaminis causa! ubi pariter coronantur, quos unus uterus maternus effudit" (*AA SS* [June 19], 841); Jacobusde Voragine, *Legenda Aurea*, 354. The word *effudit* is usually used for animals and only contemptuously for women (*Oxford Latin Dictionary* [London: Clarendon Press, 1982], 593); it is not clear whether the text confirms or refutes the negative association made between twin births and animal births.

28. Saint Martin adopts the most common pose for accompanying patrons, suggesting introduction, presentation, or recommendation. Corine Schleif, *Donatio et Memoria: Stifter, Stiftungen und Motivationen an Beispielen aus der Lorenzkirche in Nürnberg* (Munich: Deutscher Kunstverlag, 1990), 15.

29. For an analysis of the function of different types of donor portraits, see Corine Schleif, "Hands That Appoint, Anoint and Ally: Late Medieval Donor Strategies for Appropriating Approbation through Painting," *Art History* 16, no. 1 (1993): 1–32.

30. For discussions of the complex relationship between a donor portrait and the event depicted, focusing on fifteenth-century paintings, see Craig Harbison, "Visions and Meditations in Early Flemish Painting," *Simiolus* 15, no. 2 (1985): 95–106; Hermann Kamp, *Memoria and Selbstdarstellung. Die Stiftungen des burgundischen Kanzlers Rolin* (Sigmaringen: Thorbecke, 1993), 158–65; Bret Rothstein, "Vision and Devotion in Jan van Eyck's Virgin and Child with Canon Joris van der Paele," *Word and Image* 15, no. 3 (1999): 262–76.

31. Ledru, *Plaintes*, 240.

32. Eugène Hucher, *Le jubé du cardinal Philippe de Luxembourg à la cathédrale du Mans et décrit d'après un dessin d'architecte du temps et des documents inédits* (Le Mans: E. Monnoyer, 1870).

33. The surviving fragment from Soissons contains three episodes: the saints donate their possessions to the poor, they perform an exorcism, and they construct a chapel. In the last scene, the soldiers approach in the background to lead the saints to Nero. It is unlikely that their baptism could have occurred after that event (see appendix 1).

34. According to the *Datiana historia ecclesiae Mediolanensis,* the saints were converted to Christianity during the episcopate of Saint Caius (63–85), although his episcopate actually took place at the beginning of the third century. It is possible that, in addition to the contemporary bishop of Le Mans, the tapestry also refers to this bishop of Milan from the distant past. Biraghi, *Datiana,* 19–21; *DHGE,* vol. 20, col. 1074.

35. Piolin, *Histoire,* 5:246.

36. For instance, his will, the deliberations of the cathedral chapter, and the inscription on the final panel of the *Life of Gervasius and Protasius* address Philip by the title "cardinal." The dedication in his missal refers to him as "Cardinal Luxembourg" (Le Mans, Médiathèque Louis Aragon MS 254), fol 1.

37. Ibid.; on the rood screen, see Hucher, *Jubé,* 12.

38. Piolin, *Histoire,* 5:261–84.

39. On Ambrose's political and religious agenda, see Ernst Dassmann, "Ambrosius und die Martyrer," *Jahrbuch für Antike und Christentum* 18 (1975): 49–68; Hans von Campenhausen, *Ambrosius von Mailand als Kirchenpolitiker,* Arbeiten zur Kirchengeschichte 12 (Berlin: Walter de Gruyter, 1929); Neil B. McLynn, *Ambrose of Milan: Church and Court in a Christian Capital* (Berkeley: University of California Press, 1994).

40. Philip inherited the episcopal throne from his father, Thibault, and passed it on to his nephew, Francis.

41. Piolin, *Histoire,* 5:246, 289.

42. Hucher, *Jubé,* 42–43; Missal of Philip of Luxembourg (Le Mans, Médiathèque Louis Aragon MS 254).

43. Piolin, *Histoire,* 5:289–90.

44. Ibid., 287–88.

45. Peter Brown, *The Cult of the Saints* (Chicago: University of Chicago Press, 1981), 97.

46. Peter Brown comments on Ambrose's use of these saints to unify the Christian community in Milan. "He [Ambrose] moved them after only two days from the shrine of Saints Felix and Nabor, where they had been unearthed, into the new basilica which he had built for himself; and he placed them under the altar, where his own sarcophagus was to have stood. By this move, Gervasius and Protasius were inseparably linked to the communal liturgy, in a church built by the bishop, in which the bishop would frequently preside. In that way, they would be available to the community as a whole" (Brown, *Cult,* 37). On Ambrose's political use of saints, see also Dassmann, *Ambrosius,* 54–55; and Campenhausen, *Ambrosius,* 215–17.

47. "Addidit et aliam minorem tapisseriam, in qua XII Apostoli, quator ecclesie Doctores, quator Virtutes cardinales, cum XII Sibillis magnifice depinguntur; que desuper et in cristis dictarum cathedrarum et ad opperimentum earum pariformiter explicabitur" (Busson and Ledru, *Nécrologe-Obituaire,* 300).

48. For the numerous actions he performed on behalf of Philip of Luxembourg in Le Mans, see Piolin, *Histoire,* 5:261–72.

49. The following discussion locates itself within recent scholarship on the dynamics of gift giving and the social function of foundations in the Middle Ages. On the former, see Gadi Algazi, Bernhard Jussen, Valentin Groebner, eds., *Negotiating the Gift: Pre-modern Figurations of*

Exchange (Göttingen: Vandenhoeck Ruprecht, 2003). On foundations, see Karl Schmid, "Stiftungen für das Seelenheil," in *Gedächtnis, das Gemeinschaft stiftet*, ed. Karl Schmid (Freiburg: Katholische Academie, 1985), 51–73; Gerhard Jaritz, ed. *Materielle Kultur und Religiöse Stiftung im Spätmit-telalter*, Veröffentlichungen des Instituts für Mittelalterliche Realienkunde Osterreichs 12 (Vienna: Osterreichischen Akademie der Wissenschaften, 1990); Martial Staub, "Memoria im Dienst von Gemeinzohl und Offentlichkeit. Stiftungspraxis und kultureller Wandel in Nürnberg um 1500," in *Memoria als Kultur*, ed. Otto Gerhard Oexle (Göttingen: Vandenhoeck Ruprecht, 1995), 285–34; Schleif, *Donatio*; and Christine Sauer, *Fundatio und Memoria. Stifter und Klostergründer im Bild 1100–1350* (Göttingen: Vandenhoeck Ruprecht, 1993).

50. Jacques Chiffoleau, *La comptabilité d'au-delà. Les hommes, la mort et la religion dans la région d'Avignon à la fin du moyen âge (1320–vers 1480)* (Rome: Ecole Française de Rome, 1980), 323–39.

51. Portraits that, through their liturgical use, preserved the memory of a group or an individual are described as "Memorialbilder" in Otto Gerhard Oexle, "Memoria und Memorialbild," in *Memoria. Der geschichtliche Zeugniswert des liturgischen Gedenkens im Mittelalter*, ed. Karl Schmid and Joachim Wollasch (Munich: Wilhelm Fink, 1984), 387–88; and idem, "Memoria als Kultur," in Oexle, *Memoria als Kultur*, 43–48. This process is the focus of art historical studies: see Corine Schleif, *Donatio*; Christine Sauer, *Fundatio*; and Heide Wunder, " 'Gewirkte Geschichte': Gedenken und 'Handarbeit.' Uberlegungen zum Tradieren von Geschichte im Mittelalter und zu seinem Wandel am Beginn der Neuzeit," in *Modernes Mittelalter: Neue Bilder einer populären Epoche*, ed. Joachim Heinzle (Frankfurt am Main: Insel, 1994), 324–54.

52. Michel Lauwers, *La mémoire des ancêtres, le souci des morts* (Paris: Beauchesne, 1997), 179–82; Chiffoleau, *Comptabilité*, 302–7.

53. This conception of the dead as people with legal and social status, rather than as corpses, is a defining feature of medieval attitudes towards death, which, according to Otto Gerhard Oexle, began to change only in the eighteenth century. By the beginning of the nineteenth century, upon his or her death a person ceased to exist; he or she could only be remembered. Oexle characterizes the process of commemoration of the dead that takes place within Church ceremony as liturgical memory, as opposed to historical memory, the fame or recollection of the deceased. Otto Gerhard Oexle, "Die Gegenwart der Toten," in *Death in the Middle Ages*, ed. Herman Braet and Werner Verbeke (Leuven: Leuven University Press, 1983), 27–30.

54. Piolin, *Histoire*, 5:221.

55. Ibid., 221.

56. "O Martine inclite, et presulum omnis caterva. Suscipe nunc pia et nostra clemens precata. Anime omnium fidelium defunctorum requiescant in pace. Amen" (Busson and Ledru, *Nécrologe-Obituaire*, 297).

57. "Eidem donatori parcat" (ibid., 297).

58. These feast days probably corresponded to those on which the bishop officiated in his cathedral. In addition to the major feasts in honor of Christ and the Virgin — the Purification of the Virgin, Easter, Pentecost, Corpus Christi, the Assumption of the Virgin, and Christmas — these feasts were: the feast of Gervasius and Protasius, that of Philip and James, that of Julien and of the translation of his relics; the dedication of the cathedral; and All Saints' Day. He also officiated on Holy Wednesday and Maundy Thursday, the final days of Lent, during which the tapestry would not have been displayed (Le Mans, Médiathèque Louis Aragon, MS 254, fol. 1).

59. Corine Schleif documents a similar function of donations within the city of Nuremberg. She also makes the important point that the stipulations made

in individual foundations concerning the use and display of artworks served, in many cases, as a major factor in their preservation (Schleif, *Donatio*, 232–36).

60. Busson and Ledru, *Nécrologe-Obituaire*, 15.

61. "The tapestry should be unrolled, hung, and displayed behind the canons [seated] in their stalls on certain solemn festivals."

62. This clause evokes the tantalizing possibility that individual chapters lent out their choir tapestries, a practice to which I have found no other references.

63. A. Fremaux, "Donation à l'église Saint-Etienne de Lille par Jean Ruffault de 314 aulnes de tapisserie de haute-lisse, représentant la vie et passion de saint Etienne, 31 juillet 1518," *Souvenir de la Flandre Wallonne* 5 (1885): 124–28; appendix 1.

64. Marcel Mauss recognized the complexity of this process of exchange, which often engaged more than just a donor and a recipient, in his theory of the gift. See *The Gift: Forms and Functions of Exchange in Archaic Societies*, trans. Ian Cunnison (New York: Norton, 1967), 15–16.

65. Quoted by Natalie Davis in *The Gift in Early Modern France* (Madison: University of Wisconsin Press, 2000), 103. For other expressions of this attitude, see Lauwers, *Mémoire*, 176.

66. Robert Triger, "La Maison du chanoine Martin Guerande et l'Hôtellerie de l'écu de France, rue de Saint-Vincent, au Mans," in *Etudes historiques et topographiques sur la ville du Mans* (Le Mans: C. Monnoyer, 1926; repr. Marseille: Lafitte, 1977)), 9–10.

67. Ibid.

68. Peter Jezler argues that works of art represented a much smaller investment than did the foundation of an anniversary and explores the methodological implications of this point in "Jenseitsmodelle und Jenseitsvorsorge — Eine Einführung," introduction to the exhibition catalog *Himmel, Hölle, Fegefeuer. Das Jenseits im Mittelalter*, ed. Peter Jezler (Zurich: Schweizerisches Landesmuseum, 1994), 13,

22–26. For an extended study of one case, see Christine Göttler and Peter Jezler, "Doktor Thüring Frickers 'Geistermesse.' Die Seelgerätskomposition eines spätmittelalterlichen Juristen," in *Materielle Kultur und Religiöse Stiftung im Spätmittelalter*, ed. Gerhard Jaritz, Veröffentlichungen des Instituts für Mittelalterliche Realienkunde Osterreichs 12 (Vienna: Verlag des Osterreichischen Akademie der Wissenschaften, 1990), 187–199.

69. Le Mans, Archives of the Chapter, B/1, 76.

CHAPTER 4. The *Life of Stephen*

1. Eugen Ewig, "Die Kathedralpatrozinien im Römischen und im Fränkischen Gallien," *Historisches Jahrbuch* 79 (1960): 1–61; Les Bénédictins de Paris, eds., *Vies des saints et des bienheureux selon l'ordre du calendrier, avec l'historique des fêtes* (Paris: Letouzey et Ané, 1956), 12:700.

2. PL 41:807–16, 817–22.

3. "Haec est hactenus basilica in honorem protomartyris Stephani christianis populis frequentata." Louis M. Duru, ed., *Gesta pontificum Autissiodorensium* (Auxerre, BM MS 142), Bibliothèque historique de l'Yonne: Collection des légendes, chroniques, et documents divers pour servir à l'histoire des differentes contrées qui forment aujourd'hui ce département, vol. 1 (Auxerre: Perriquet, 1850), 315.

4. Duru, ed., *Gesta*, 416; Jean Lebeuf, *Mémoires concernant l'histoire civile et ecclésiastique d'Auxerre et de son diocèse* (1743, reprint and new edition by Maximilien Quantin and Ambroise Challe [Auxerre: Perriquet, 1855]), 1:294.

5. Duru, ed., *Gesta*, 480–81; Lebeuf, *Mémoires*, 1:392–93. The fifteenth-century inventory includes:

"De brachio prothomartyris Stephani, in jocali collato a domina d'Estempes

De lapidibus quibus fuit lapidatus, in alia majori imagine ejusdem.

De ossibus ejusdem, in tabello B. Marie et domini Theobaldi."

Rome, Vatican Library, MS 1283, in Lebeuf, *Mémoires*, 4:240, no. 352.

6. "Processionem in vigilia beati Stephani hyemali post vesperas de Nativitate sollemnem singulis in capis sericis deferentibus accensorum luminaria cereorum." Duru, ed., *Gesta*, 469; Lebeuf, *Mémoires*, 1:379. On William of Seignelay, see Duru, ed., *Gesta*, 451–85; Lebeuf, *Mémoires*, 1:365–96; Constance Bouchard, *Spirituality and Administration: The Role of the Bishop in Twelfth-Century Auxerre* (Cambridge, Mass.: Medieval Academy of America, 1979), 121–40.

7. Auguste Coulon, *Inventaire des sceaux de la Bourgogne recueillis dans les dépôts d'archives, musées et collections particulières des départements de la Côte d'Or, de Saône et de l'Yonne* (Paris: E. Leroux, 1912), 86, 197, 158.

8. For a description of the life and cult of Germain, see AA SS (July 31), 184–304. On the textual tradition of his *vita* in Auxerre, see Virginia Raguin, *Stained Glass in Thirteenth-Century Burgundy* (Princeton: Princeton University Press, 1982), 143–44.

9. Eugène Monceau, "Les tapisseries de l'ancien chapitre d'Auxerre et la légende des reliques de Saint Etienne," *L'Art* 28 (1882): 106–17. The same argument is made by Véronique Notin, "La tenture de choeur de la cathédrale Saint-Etienne conservée au Musée de Cluny" (master's thesis, University of Paris IV, 1983), 23; and Fabienne Joubert, *La tapisserie médiévale au Musée de Cluny* (Paris: Editions de la réunion des musées nationaux, 1987), 48.

10. The four feasts are included in a fourteenth-century Breviary and Missal (Auxerre, BM MS 56; Paris, BN MS lat. 17316) and in a fifteenth-century Breviary (Auxerre, BM MS 57), all for the use of Auxerre. A thirteenth-century Missal (Paris, BN MS lat. 17312) and the Missal that François of Dinteville, Jean Baillet's successor, commissioned (Paris, BN MS lat. 9446) do not include Stephen's translation to Rome.

11. The incorporation of four feasts in honor of Stephen differentiates Auxerre's liturgical calendar from that of Sens. A fifteenth-century Missal for use in Sens includes his feast on December 26 and his invention, celebrated as annual feast days with octaves (Paris, BN MS lat. 880). Although another fifteenth-century Missal for the use of Sens includes a third feast, the saint's translation to Constantinople, it is celebrated as a regular feast day (Paris, BN MS lat. 864). On these manuscripts, see Victor Leroquais, *Les sacramentaires et les missels manuscrits des bibliothèques publiques de France* (Paris: Chez l'auteur, 1924), 3:27 and 229.

12. For instance, the procession before Stephen's feast day is called a "processio(nem) in vigilia beati Stephani hyemali post vesperas de Nativitate." Duru, ed., *Gesta*, 469.

13. The four major feast days in honor of the Virgin celebrate her Birth, Annunciation, Assumption, and Coronation; those honoring Christ mark his Birth, Resurrection, and Ascension, and the Pentecost.

14. "Clemens V dedit quolibet anno in Nativitate Christi, Resurrectione, Ascensione, Pentecoste, et quatuor principalibus festis Beate-Marie, et quolibet die octavarum, centum dies indulgentiarum, et quatuor festi B. Stephani. Ille idem per aliam bullam dictis diebus dominicis dies indulgentie." Lebeuf, *Mémoires*, 4:242.

15. *Secundum usum ecclesie Autissiodorensis* (Auxerre, BM MS 52). This manuscript is listed in the inventory compiled in 1531 (Auxerre, Archives départementales de l'Yonne G 1824, transcribed in Abbé Bonneau, Henri Monceaux, and Francis Molard, eds., *Inventaire du trésor de la Cathédrale d'Auxerre* [Auxerre: Imprimerie de la Constitution, 1892], 161).

16. *Missale ad usum Autissiodorensem* (Paris: Ionnes de Prato, n.d.), extant in two copies: Paris, Bibliothèque Saint-Geneviève, and Paris, Bibliothèque de l'Institut de

France. Joseph B. Van Praet, *Catalogue des livres imprimés sur velin de la bibliothèque du roi*, 2d ser. (Paris: De Bure Frères, 1822–1828), no. 251; William Henry James Weale and Hans Bohatta, *Catalogus Missalium ritus latini ab anno 1474* (1928; repr. Stuttgart: Anton Hiersemann, 1990), 22; Robert Amiet, *Missels et Breviaires imprimés*, supplement to William Henry James Weale and Hanns Bohatta, *Propres des saints* (Paris: Centre National de la Recherche Scientifique, 1990), 12. *Breviarium Antissiodorense* (Chablis: Jean le Rouge for Pierre le Rouge, 1483) survives in four copies: a complete copy at the National Library, Madrid, and three fragmentary copies, two at the Municipal Library, Auxerre, and one at the National Library, Paris. Kommission für den Gesamtkatalog der Wiegendrücke, *Gesamtkatalog der Wiegendrücke* (Leipzig: Karl W. Hiersemann, 1932), 5:187, no. 5253. On the Breviary, see Henri Monceaux, "Notes sur le Bréviaire Auxerrois publié à Chablis en 1483," *Bulletin de la Société des Sciences Historiques et Naturelles de l'Yonne* 53 (1899): xix–xxii.

17. *DACL* 5:646. On Lucien's letter, see Les Bénédictins, *Vies*, 12:691–95.

18. *DACL* 5:647. An alternate account relates that Stephen's relics remained in Jerusalem but were translated to a basilica constructed by Eudoxia, wife of Theodosius II, in 460. This same princess was responsible for the arrival of the right hand of Stephen in Constantinople in 415, the same year the wife of Alexander supposedly mistook the body of Stephen for that of her husband and transported it to Constantinople (*DACL* 5:648). In this version, the body of the saint, which remains intact in the tapestry, is divided between Constantinople and Jerusalem. At least twelve churches in Constantinople that had acquired Stephen's relics were dedicated to the protomartyr. Beginning in 418, cities all over Africa claimed to possess relics of the saint that were performing miracles (Les Bénédictins, *Vies*, 12:697).

19. This legend might be derived from the mosaics depicting the translation of Stephen's relics to Rome, added to the basilica of San Lorenzo by Pope Pelagius II (578–90). Les Bénédictins, *Vies*, 12:699.

20. Notin, "La tenture de choeur," 27–34; Joubert, *La tapisserie médiévale*, 50–53.

21. Gamaliel's appearance to Migetius is included in the readings for Lauds on August 3. The discovery of Stephen's relics by Bishop John of Jerusalem and Migetius forms the readings, comprised of three lessons, for the Octave of the Invention of the Saint, celebrated on August 11 (*Breviarium Antissiodorense* [Chablis: Jean le Rouge for Pierre le Rouge, 1483], unpaginated).

22. "Convocansque eusebium episcopum dixit. Vade ad navim cum multitudine populi. Et ego mittam plaustrum; et ferte mei loculum in palatium. Ivit ergo episcopus et omnis populus cum cereis cucurrit. At vero episcopus descendens in navim, tulit loculum. Quo posito in carruca, festinavit introire in palatium. Mule autem incedebant violenter tracte ab angelis. Et venientes in locum qui dicitur constantinianus; steterunt et ultra non valebant transire. Percutiebant ergo animantia. Una vero earum per angelicam virtutem voce humana locuta est, coram omni populo dicens. Quid percutitis facies nostras. Hic oportet eum recondi in loco hoc, et nolite laborare frustra. Alioquim signa et prodigia habetis videre. Episcopus vero tremefactus, et tormentum non sustines. Nunciavit imperatori, qua non possum afferre sancti corpus." [Summoning the bishop Eusebius, the emperor said to him: "Go to the ship with the multitude of people. For my part, I will send a wagon and bring the casket to me in the palace." So the bishop went and the whole populace ran with candles. And the bishop, going down to the ship, took the casket. When it was placed in the wagon, he hastened to enter the palace. But the mules advanced violently, pulled by angels. And com-

ing to a place called Constantinianus, stood still and could advance no further. Then they beat the animals. But through an angelic force, one of them spoke in a human voice, saying directly to the whole populace: "Why are you beating our bodies? It is proper to bury him here in this place, so do not labor in vain. And besides you see the signs and marvels." The bishop trembling, "You will not suffer torment." He made the announcement to the emperor: "From this place I can't move the saint's body."] Paris, BN MS lat. 9446, fol. 40v. On François de Dinteville, see Lebeuf, *Mémoires,* 2:105–16.

23. *Les vitraux du Centre et des Pays de la Loire,* vol. 2 of *Recensement des vitraux anciens de la France,* ed. Louis Grodecki, Françoise Perrot, Jean Taralon (Paris: Editions du Centre national de la recherche scientifique, 1981), 173. Charles Cahier and Arthur Martin, *Monographie de la cathédrale de Bourges* (Paris: Poussielgue-Rusand, 1841–1844), 232–34.

24. Jacobus de Voragine, *Legenda Aurea,* ed. T. Graesse (Osnabrück: Otto Zeller, 1965) 49, 461; idem, *Golden Legend,* trans. William Granger Ryan (Princeton: Princeton University Press, 1993), 1:45–50; 2:40–44.

25. These stalls, made by the woodworker Laurent Adam, were destroyed in 1567. Charles Porée, *La Cathédrale d'Auxerre* (Paris: H. Laurens, 1926), 14.

26. M. Liger, canon of Auxerre, *Sur divers usages de l'Eglise d'Auxerre* (Auxerre, BM MS 159, eighteenth century).

27. "Per manum sancti Stephani super altare ipsius." Duru, ed., *Gesta,* 416; Lebeuf, *Mémoires,* 1:294.

28. Information on the early bishops of the cathedral of Auxerre can be found in the *Gesta pontificum Autissiodorensium,* a compilation begun in the ninth century, which provides brief accounts of bishops from the foundation of the see on. Eleventh- and twelfth-century biographers expanded these accounts of bishops (Bouchard, *Spirituality,* 5–9). The twelfth-century copy with later additions (Auxerre, BM MS 142) forms the basis for Duru's edition.

29. "Hic idem pontifex ciborium super altare Sancti-Stephani auro argentoque mirifice composuit." Duru, ed., *Gesta,* 352.

30. "Ante altare Sancti-Stephani tres coronas argenteas precipui ponderis preparavit." Duru, ed., *Gesta,* 352.

31. "Coronas argenteas quatuor instituit circa altare Sancti-Stephani tabulas argenteas." Duru, ed., *Gesta,* 354.

32. "Caput quoque ecclesiae super altare Sancti-Stephani, mirabili et preciosa pictura decoravit." Duru, ed., *Gesta,* 404. On this bishop, see Bouchard, *Spirituality,* 17–37.

33. "In honore sancti Stephani unam manum auream gemmis politam." Duru, ed., *Gesta,* 375.

34. Duru, ed., *Gesta,* 352, 354, 404, 375, 380.

35. These observations are, of course, not limited to Auxerre. On liturgical time, see Jacques Le Goff, "Temps," in *Dictionnaire raisonné de l'Occident médiévale,* ed. Jacques Le Goff and Jean-Claude Schmitt (Paris: Fayard, 1999), 1113–17; Aimé-Georges Martimort, *L'Eglise en prière,* vol. 4: *La liturgie et le temps* (Paris: Desclée, 1984), 13–19.

36. Jacobus de Voragine explains the reasons for the particular placement of the feasts of the martyrdom of Stephen and the invention of his relics. The death of Stephen actually occurred on August 3, the day his invention is celebrated. The two feasts were reversed to emphasize the significance of Stephen's martyrdom through its proximity to the feast of Jesus' birth. Jacobus de Voragine, *Legenda Aurea,* 461; idem, *Golden Legend,* 2:41–42.

37. For instance, the ceremony on August 3 begins in Jean Baillet's Missal with the words: "Cuius corporis

hodie in terris collisis inventionem, acquiret vobis" (Auxerre, BM MS 52, fol. 250).

38. For ceremony in Auxerre, see the Pontifical of Auxerre (Auxerre, BM MS 53, first half of fourteenth century), described in Victor Leroquais, *Les pontificaux manuscrits des bibliothèques publiques de France* (Paris: Chez l'auteur, 1937), 1:45–49; M. Liger, *Sur divers usages de l'Eglise d'Auxerre* (Auxerre, BM MS 159, eighteenth century); Lebeuf, *Mémoires*, 4:301. On processions into the choir on feast days in general, see Martimort, *L'Eglise*, 2:67–70.

39. On this bishop, see Lebeuf, *Mémoires*, 2:86–90.

40. "Taffetas pers," "estoilles d'argent de Paris," and "doublez de boguerant rouges." Bonneau, Monceaux, and Molard, *Inventaire*, 57.

41. "Item trois draps de taffetas pers, en lung le martir sainct Estienne, lautre une annonciation nostre Dame, lautre a ung crucifix, le tout de brodure dor de Paris, armoyez de figures et est estoilles dargent de Paris, doublez de boguerant rouges, servant aux dymanches de la dicte, baille par feu monseigneur Signard, evesque d'Auxerre." Bonneau, Monceaux, and Molard, *Inventaire*, 57. These embroidered vestments were still in the possession of the cathedral at the time of the inventory compiled in 1569.

42. "Look, I see the sky opening and the Son to the right of God."

43. This phrase is repeated in the reading from Acts, the Alleluia, and the Communion for the mass of all the feasts celebrated in Sephen's honor. Auxerre, BM MS 52, fol. 14v–15v.

44. Fabienne Joubert argues that the repetition of this phrase was a mistake on the part of the tapestry maker. Rather than repeating the first phrase, he should have rendered Stephen's plea, "Domine ne statuas illis hoc peccatum." Joubert, *La tapisserie médiévale*, 50.

45. Auxerre, BM MS 52, fol. 250. See n. 48 below.

46. The Missal specifies that December 26 commemorates "memoria de nativitate." It was on this day that Stephen achieved his status as a martyr-saint and was born into the celestial hierarchy.

47. In each case the phrase in the Preface, "we celebrate his birth," is substituted with the event celebrated on that particular feast. Auxerre, BM MS 52, fol. 230v, 250, 276v.

48. "Sacri gleba corporis longo lapsu temporis viluit incondita.... Quievit reconditus luciano cognitus tandem per miraculum. In calati specie rosarum effigie revelari docuit. Qui quasi flos roseus flagrans et purpureus martirio floruit." [The unentombed corpse of the saintly body was debased for a long period of time.... Buried, it reposed but was recognized through a miracle by Lucien. He instructed that he, who, blazing like a rosy flower, bloomed crimson in martyrdom, would be revealed by the appearance and shape of roses in a wicker basket.] Auxerre, BM MS 52, fol. 250.

49. Auxerre, BM MS 52, fol. 276v.

50. Auxerre, BM MS 52, fol. 230v.

51. The *joyau* is described in detail in the inventory of 1531. "Item ung reliquaire dargent doré appellé le joyau ... en laquelle est enmaillée ung crucifix et l'ymage de nostre Dame et saint Jehan; ... et au dessus du dit joyau y a deux grands anges tenant a leur senestre chacun ung ensansier, et a leur dextre sous tenant ung ront en forme de raye de soleil, et audessus ung crucifix et lymage de nostre Dame et saint Jehan, ... au quel joyau on porte le corpus Domini le jour de saint Sacrament, le tout pesant soixante et ung marcs." Bonneau, Monceaux, and Molard, *Inventaire*, 149.

52. Vincent Tabbagh argues that the *joyau* was an ostensory rather than a reliquary. The golden rays at its apex, common to such depositories for the Host, provide additional support that it served this function. "Jean Baillet, un magistrat devenu pasteur," in *Histoire de*

saint Etienne. La tenture de choeur de la cathédrale d'Auxerre, ed. Laura Weigert and Micheline Durand, exhibition catalog (Auxerre: Musées d'Art et d'Histoire, 2000), 32.

53. On the career of this bishop, see Lebeuf, *Mémoires*, 2:90–103; Geneviève Souchal, "Précisions historiques sur l'histoire de saint Etienne d'Auxerre (Musée de Cluny) et la famille parisienne des Baillet (vers 1500)," *Artes Textiles* 11 (1986): 25–36; Vincent Tabbagh, "Les évêques d'Auxerre à la fin du Moyen Age (1296–1513)," *Annales de Bourgogne* 67 (1995): 89–91; idem, "Jean Baillet, un magistrat," 17–35.

54. Vincent Tabbagh argues that Signart's support of Charles the Bold made it impossible for him to retain his title after the city returned to the French Crown. Tabbagh, "Jean Baillet, un magistrat," 23–24.

55. On the eighteenth-century changes in the cathedral, see Lebeuf, *Mémoires*, 4:361–62; Charles Demay, "Les travaux de décoration exécutés dans la cathédrale d'Auxerre pendant le XVIIIe siècle," *Bulletin de la Société des Sciences Historiques et Naturelles de l'Yonne* 53 (1899): 13–61.

56. In the printed Missal for use of Auxerre of 1738 (*Missale sanctae Autissiodorensis ecclesiae* [Troyes: Pierre Michelin, 1738] fifteen copies; Weale and Bohatta, *Catalogus*, 23) and the printed Breviary of 1736 (*Breviarium sanctae Antissiodorensis ecclesiae* [Paris: Jacques Vincent, 1736]; Amiet, *Missels et Bréviaires imprimés*, 221; and Hans Bohatta, *Bibliographie der Breviere 1501–1850* [Leipzig: Karl W. Hiersemann, 1931], 166), only the Feast of Stephen (December 26) and the Invention of his Relics (August 3) are included.

CHAPTER 5. Woven *Vitae* of the Saints and Clerical Identity

1. On the *Lives of Cyricus and Julitta*, see appendix 1.

2. The single extant fragment of the *Life of Vaast* is on display at the Musée des Beaux-Arts in Arras. See appendix 1.

3. Xavier Barbier de Montault, "Appendice aux Actes de Saint Florent Prêtre et Confesseur," *Mémoires de la Société Impériale d'Agriculture, Sciences et Arts d'Angers*, 2d ser., 8 (1863): 20–25, 61–70, 93–105; Victor Godard-Faultrier, *Tapisserie de Saint-Florent, dessinée par P. Hawke* (Angers: Cosnier and Lachese, 1842); Victor Godard-Faultrier, "Découverte récente de deux fragments de la tapisserie de Saint-Florent-lez-Saumur," *Réunion des Sociétés des Beaux-Arts des Départements*, 12th session (Paris: Plon-Nourrit, 1888), 715–17; appendix 1.

4. Louis Réau, *Iconographie de l'art chrétien;* vol. 3: *Iconographie des saints* (Paris: Presses Universitaires de France, 1958), 505.

5. The eighth piece of the tapestry depicts Florent saving Saumur from a monstrous serpent and the ninth piece depicts the veneration of his relics in Saumur by pilgrims. See appendix 1.

6. D. Mater, "Les tapisseries de l'ancienne collégiale saint-Ursin," *Congrès Archéologique de France*, 65th session, 1898 (Paris: Alph. Picard, 1900), 294–304.

7. Bernard Prost, "La tapisserie de Saint-Anatoile de Salins," *Gazette des Beaux Arts* 3, no. 8 (1892): 496–507.

8. In 1643, Canon Quentin de la Fons compiled a detailed description of these now-lost reliquaries that contained the relics of Quentin, Victor, and Cassien. A. Bacquet, "La tapisserie de Saint-Quentin," in *Bulletin Archéologique du Comité des Travaux Historiques et Scientifiques 1938–1940* (Paris: Imprimerie Nationale, 1942), 116–17.

9. This tapestry is not dated, nor is its donor documented. Stylistic similarities with the *Life of Stephen* in Auxerre suggest it was produced in about 1500 (Joubert, *La tapisserie médiévale au Musée de Cluny* [Paris: Réunion des Musées Nationaux, 1987], 58). On this tapestry, see Louis de Farcy, *Histoire et description des tapisseries de l'Eglise Cathédrale d'Angers* (Angers: Germain and G. Grassin, 1897), 41–43; and Heinrich Göbel, *Wandteppiche*, vol. 1: *Die Niederlande* (Leipzig: Klinkhardt and Biermann, 1928), 299–300.

10. On this tapestry, see Joubert, *La tapisserie médiévale,* 17–35.

11. Peter Brown, *The Cult of the Saints* (Chicago: University of Chicago Press, 1981), 88–95.

12. Examples are Henk van Os, ed., *The Art of Devotion in the Late Middle Ages in Europe 1300–1500,* trans. Michael Hoyle (London: Merrell Holberton, 1994); Jeffrey Hamburger, *The Visual and the Visionary: Art and Female Spirituality in Late Medieval Germany* (New York: Zone Books and Cambridge, Mass.: MIT Press 1998); and idem, "La Bibliothèque d'Unterlinden et l'art de la formation spirituelle," in *Les dominicaines d'Unterlinden,* ed. Jean-Claude Schmitt (Colmar: Unterlinden Museum, 2000), 1:110–59.

13. Each chapter of canons merits an individual study, and some fundamental distinctions between secular and monastic chapters must be acknowledged. The current project of a research group within the Centre National de la Recherche Scientifique, directed by Hélène Millet, is preparing volumes on a number of different chapters; those on the cathedral chapters of Amiens, Besançon, Rouen, and Reims have already been published. In addition to these, the studies by Monique Maillard-Luypaert, Hélène Millet, and Jacques Pycke provide detailed examinations of an individual cathedral chapter. See Monique Maillard-Luypaert, *Papauté, clercs et laïcs: Le diocèse de Cambrai à l'épreuve du Grand Schisme d'Occident (1378–1417)* (Brussels: Publications des Facultés universitaires Saint-Louis, 2001); Hélène Millet, *Les chanoines du chapitre cathédral de Laon, 1272–1412* (Paris: Ecole Française de Rome, 1982); Pycke, *Le chapitre.* One of the few studies that deals specifically with the fifteenth and sixteenth centuries is Eliane Deronne, "Les origines des chanoines de Notre-Dame de Paris, 1450–1550," *Revue d'Histoire Moderne et Contemporaine* 28 (1971): 1–29.

14. For an overview of these councils and the role of the Gallican Church within them, see Pierre Imbart de la Tour, *Les origines de la réforme* (Paris: Hachette, 1905; 2d ed., Melun: Librairie d'Argences, 1946–48), vol. 2; Victor Martin, *Les origines du Gallicanisme* (Paris: Bloud and Gay, 1939), 2:153–325; Noël Valois, *La France et le Grand Schisme d'Occident* (Paris: Picard, 1910), vol. 4. On the related issues addressed by the councils from the broader perspective of the Latin Church in general, see Joseph Gill, *Constance et Bâle-Florence* (Paris: Editions de l'Orante, 1965); Etienne Delaruelle, Edmond René Labande, Paul Ourliac, eds., *L'Eglise au temps du Grand Schisme et de la crise conciliare (1378–1449),* Histoire de l'Eglise depuis les origines jusqu'à nos jours 14, ed. Augustin Fliche and Victor Martin (Paris: Bloud and Gay, 1962), 3–292. A concise overview is provided in Paul Ourliac, "Le schisme et les conciles (1378–1449)," in *Un Temps d'épreuves (1274–1449),* vol. 6 of *Histoire du Christianisme,* ed. Michel Mollat du Jourdin and André Vauchez (Paris: Desclée-Fayard, 1990), 89–138.

15. Colette Beaune, *Naissance de la nation française* (Paris: Gallimard, 1985), 207–29; Martin, *Les origines,* 1:71–96; Delaruelle, Labande, and Ourliac, *L'Eglise,* 329–44.

16. On the extent of papal intervention in the granting of benefices and titles, see Bernard Guillemain, "L'Eglise dans le royaume de France," in Mollat du Jourdin and Vauchez, *Histoire,* 632–34.

17. François André Isambert, Athanase Jean Léger Jourdan, and Decrusy, eds., *Recueil général des anciennes lois françaises, depuis l'an 420 jusqu'à la révolution de 1789,* vol. 9: *1438–1461* (Paris: Belin-Leprieur, 1825), 3–47. The most thorough discussions of the Pragmatic Sanction remain Noël Valois, *Histoire de la Pragmatique Sanction de Bourges sous Charles VII* (Paris: Picard, 1906); Martin, *Les origines,* 2:303–15; Delaruelle, Labande, and Ourliac, *L'Eglise,* 352–68.

18. This concession allowed the king and princes to

"exercise their kindly and benevolent prayers on behalf of people of merit who were devoted to the common good of the kingdom" ("Nec credit ipsa congregatio Bituricensis fore reprehensibile, si rex et principes regni sui, cessantibus tamen omnibus comminationibus et quibuslibet violentiis, aliquando utantur precibus benignis atque benivolis, et pro personis benemeritis et zelantibus bonum reipublice et regni Delphinatus"). Isambert, Jourdan, and Decrusy, *Recueil*, 21; Martin, *Les origines*, 2:305.

19. Imbart de la Tour, *Les origines*, 2:228–42.

20. Imbart de la Tour mentions fifty-five instances of disputed episcopal titles between 1483 and 1516. For a general discussion of the diversity of the legislation dictating the relationship between bishops and their chapters and points of collaboration and conflict, see Jean Gaudemet, "Evêques et chapitres (Législation et doctrine à l'âge classique)," in *Mélanges Jean Dauvillier* (Toulouse: Centre d'Histoire Juridique Méridionale, 1979), 317–28.

21. Vincent Tabbagh, "Jean Baillet, un magistrat devenu pasteur," in *Histoire de saint Etienne. La tenture de choeur de la cathédrale d'Auxerre*, ed. Laura Weigert and Micheline Durand, exhibition catalog (Auxerre: Musées d'Art et d'Histoire, 2000), 23–24.

22. Vincent Tabbagh, "Effectifs et recrutement du clergé séculier français à la fin du Moyen Âge," in *Le clerc séculier au Moyen Âge*, ed. Sociéte des historiens médiévistes de l'enseignement supérieur public, XXIIe Congrès de la Société des historiens médiévistes de l'enseignement supérieur public (Paris: Publications de la Sorbonne, 1993), 181–90.

23. For a summary of these decrees, see Martin, *Les origines*, 2:308–12.

24. "Réunis pour prier en commun, ils ne resteront point bouche close, mais tous, et spécialement les plus élevés en dignité, moduleront avec entrain psaumes, hymnes et cantiques." Martin, *Les origines*, 2:309.

25. Gill, *Constance*, 83–113, 201–32; Delaruelle, Labande, and Ourliac, *L'Eglise*, 636–56, 885–1105; Francis Rapp, "Caractères nationaux au sein de la chrétienté, La France," in *Histoire du christianisme*, vol. 7: *De la Réforme à la Réformation (1450–1530)*, ed. Marc Venard (Paris: Desclée-Fayard, 1994), 341–67; Marc Venard, "Les Vaudois"; Viviane Barrie-Curien, "Les Lollards"; Jerzy Kloczowski, "L'héritage de Jean Hus," in *Histoire du christianisme*, vol. 7, 437–66. Documents concerning the councils' response to these movements are printed in C. M. D. Crowder, *Unity, Heresy and Reform, 1378–1460: The Conciliar Response to the Great Schism* (London: Edward Arnold, 1977), 84–105, 156–59.

26. Hélène Millet and Emmanuel Poulle, eds., *Le vote de la soustraction d'obédience en 1398* (Paris: Editions du Centre national de la recherche scientifique, 1988).

27. "Nostre saint père le pape, les cardinaux et le saint siège apostolique." Prost, "La tapisserie," 498.

28. On these changes, see Mathieu Lours, "Espace et liturgie du concile à la Révolution," in *20 siècles en Cathédrales*, ed. Jacques le Goff (Paris: Editions du Patrimoine, 2001), 255–62; and Bernard Chedozeau, *Choeur clos, choeur ouvert. De l'église médiévale à l'église tridentine (France, XVIIe — XVIIIe siecle)* (Paris: Editions du Cerf, 1998), 45–94.

29. Lours, "Espace," 256.

30. Ibid., 260–61.

31. Ibid., 259.

32. "Les tapisseries causant aux voix un très grand préjudice, ne seraient plus tendues." De Farcy, *Histoire*, 69.

33. Joseph Pierre, "Décoration du choeur de la cathédrale de Bourges de 1754 à 1773," *Réunion des Sociétés des Beaux-Arts des Départements*, 25th session (Paris: Plon-Nourrit, 1901), 185.

34. D. Mater, "Les anciennes tapisseries de la Cathédrale de Bourges. Pierre de Crosses," *Mémoires de la Société des Antiquaires du Centre* 27 (1903): 341.

35. In 1742, following the chapter's instructions, the *Lives of Piat and Eleutherius* was removed from the choir and placed on the walls of the *chambre de cellier* (Tournai, ACT, *Actes capitulaires,* June 1, June 12, and June 16, 1742; September 3, 1751 and November 9, 1767; Jean Dumoulin and Jacques Pycke, "La tapisserie de Saint-Piat et de Saint-Eleuthère à la cathédrale de Tournai (1402). Son utilisation et son histoire." *Revue des Archéologues et Historiens d'Art de Louvain* 15 (1982): 192).

36. "Comme on a récemment purgé la vie des saints des fables qui les défiguraient, il faut aussi supprimer les images qui représentent ces légendes, sortes d'images qui ne servent qu'à exciter les railleries des libertins et des incrédules" Jean Lebeuf, *Histoire de la prise d'Auxerre par les Huguenots* (Auxerre: Troche, 1723), 137–38.

37. "mêlée de traits fabuleux." Auxerre, Archives de l'Yonne, G.1855.

38. "Toute cette histoire paraissait parfaitement agencée; elle était faite pour impressionner vivement les âmes naïves du moyen âge, toujours prêtes à bien accueillir les faits merveilleux. Mais à tout cela, il ne manquait qu'une chose, la vérité. . . . Il n'est donc pas étonnant que cette partie de la légende des reliques de saint Etienne, repudiée par les membres instruits du clergé de nos contrées, ait été abandonnée." [The entire story seems to be entirely fabricated; it was made to deeply impress the naïve souls of the Middle Ages, always ready to welcome marvelous events. But from all of this only one thing was missing: the truth. . . . It is therefore not surprising that this part of the legend of Stephen's relics, renounced by the learned members of the clergy of our region, was abandoned.] Eugène Monceau, "Les tapisseries de l'ancien chapitre d'Auxerre et la légende des reliques de saint Etienne," *L'Art* 28 (1882): 115. Dumonthier makes a similar argument, "La première partie de cette histoire paraît conforme à la version acceptée par l'Eglise, mais la seconde est du domaine de la pure fantaisie. . . . On sait combien, au moyen âge, étaient en faveur les récits où le réel se mêlait au merveilleux, combien le public de ces temps reculés appréciait les contes mystiques bien propres à émouvoir les âmes simples et naïves où Satan et ses possédés jouaient le rôle principal." [The first part of this story seems to conform to the version accepted by the Church, but the second (invention and two translations) is from the realm of pure fantasy. . . . One knows how much the Middle Ages favored narratives in which the real is mixed with the marvelous, how the public of these backward times appreciated the mystic legends so suited to moving simple and naïve souls, in which Satan and those he possesses play the principal roles.] E. Dumonthier, "Les tapisseries de saint Etienne du Musée de Cluny," *Renaissance de l'Art Français* 2, no. 1 (1919): 249.

BIBLIOGRAPHY

MANUSCRIPT SOURCES

Angers, Episcopal Archives
 O.P. cathédrale, series 9.8
Auxerre, Archives départementales de l'Yonne
 G.1824
 G.1855
Auxerre, Bibliothèque Municipale
 MS 52 Missal of Jean Baillet
 MS 53 Pontifical for Auxerre, first half of fourteenth century
 MS 56 Breviary, fourteenth century
 MS 57 Breviary, fifteenth century
 MS 159 M. Liger, canon, *Sur divers usages de l'Eglise d'Auxerre*, eighteenth century
Brussels, Bibliothèque Royale
 MS 13762-68 Manuscript Dufief
Le Mans, Médiathèque Louis Aragon
 MS 206 bis *De vitis pontificum Cenomanensium*
 MS 254 Missal of Philip of Luxembourg
Le Mans, Archives départementales de la Sarthe
 G 925 Deliberations of the cathedral chapter, 1528–1529
Le Mans, Archives of the cathedral chapter
 B/1
Paris, Bibliothèque Nationale
 MS lat. 17316 Missal for use of Auxerre, fourteenth century
 MS lat. 17312 Missal for use of Auxerre, thirteenth century
 MS lat. 864 Missal for use of Sens, fifteenth century
 MS lat. 880 Missal for use of Sens, fifteenth century
 MS lat. 9446 Missal of François of Dinteville
 MS fr. 8579–93 Guillaume Hermant, *Histoire ecclésiastique et civile de Beauvais et du Beauvaisis rapporté à la vie de chacun de ses évêques*
Tournai, Archives of the Cathedral Chapter
 Chapter Decisions (June 1, June 12, and June 16, 1742) Comptes de la Fabrique, 1560–1584

MS 348 Cathedral Ordinal 1424

MS 493-94 *Ruinarum Ecclesiae Tornacensis Memorialis Descriptio*

PRINTED SOURCES CITED IN THE TEXT (EXCLUDING APPENDIX 1)

Abou-El-Haj, Barbara. *The Medieval Cult of Saints: Formations and Transformations.* Cambridge: Cambridge University Press, 1994.

Acta Sanctorum. 3d ed. Paris: Palmé, 1863–1940.

Albin. Untitled note. In *La semaine du fidèle. Revue du culte et des bonnes oeuvres* 3, no. 30 (June 17, 1865): 478–80.

Algazi, Gadi, Valentin Groebner, and Bernhard Jussen, eds. *Negotiating the Gift: Pre-modern Figurations of Exchange.* Göttingen: Vandenhoeck Ruprecht 2003.

Altman, Charles. "Two Types of Opposition and the Structure of Latin Saints' Lives." *Medievalia et Humanistica* 6 (1975): 1–11.

Ambroise, Guillaume, Annick Notter, and Nicolas Sainte-Fare-Garnot, eds. *La Vierge, le roi et le ministre. Le décor du choeur de Notre-Dame au XVIIe siècle.* Arras: Musée des Beaux-Arts, 1996.

Ambrose. *Epistola XXII.* PL 16:1062–1069.

Amiet, Robert. *Missels et Breviaires Imprimés.* Supplement to *Propres des Saints,* by William Henry James Weale and Hanns Bohatta. Paris: Centre National de la Recherche Scientifique, 1990.

Austin, John Langshaw. *How to Do Things with Words.* Oxford: Oxford University Press, 1962.

Bacquet, A. "La tapisserie de Saint-Quentin." In *Bulletin archéologique du Comité des Travaux historiques et scientifiques 1938–1940,* 116–17. Paris: Imprimerie Nationale, 1942.

———. "Tapisserie française du XVe siècle représentant un miracle de saint Quentin." *Mémoires de la Société Académique de Saint-Quentin* 51 (1935): 307–31.

Bal, Mieke. *Reading "Rembrandt": Beyond the Word-Image Opposition.* Cambridge: Cambridge University Press, 1991.

Barbier de Montault, Xavier. "Appendice aux Actes de Saint Florent, Prêtre et Confesseur." *Mémoires de la Société Impériale d'Agriculture, Sciences et Arts d'Angers,* 2d ser., 8 (1863): 20–25, 61–70, 93–105.

———. "Les tapisseries des saints Gervais et Protais à la cathédrale du Mans." *Bulletin Monumental* 64 (1899): 209–17, 240–48, 311–52.

Baudot, Jules, and Léon Chaussin, eds. *Vies des saints et des bienheureux selon l'ordre du calendrier, avec l'historique des fêtes.* 13 vols. Paris: Letouzey et Ané, 1935–1959.

Bauman, Richard. *Story, Performance, and Event: Contextual Studies of Oral Narrative.* Cambridge: Cambridge University Press, 1986.

Beaune, Colette. *Naissance de la nation française.* Paris: Gallimard, 1985.

Beissel, Stephan. "Gestickte und gewebte Vorhänge der römischen Kirche in der zweiten

Hälfte des 8. und der ersten Hälfte des 9. Jahrhunderts." *Zeitschrift für christliche Kunst* 7 (1894): 360.

Bertrand, Pascal-François. "La tenture de *l'Histoire de saint Etienne* de la cathédrale de Toulouse et la peinture dans la capitale du Languedoc vers 1530–1540." *Gazette des Beaux-Arts* 131 (1998): 139–60.

Binski, Paul. "Abbot Berkyng's Tapestries and Matthew Paris's Life of St. Edward the Confessor." *Archaeologia or Miscellaneous Tracts Relating to Antiquity* 109 (1991): 85–100.

Biraghi, Luigi, ed. *Datiana historia ecclesiae Mediolanensis.* Milan: Boniardo-Polianea, 1848.

Bock, Franz. *Geschichte der liturgischen Gewänder des Mittelalters oder Entstehung und Entwicklung der kirchlichen Ornate und Paramente in Rücksicht auf Stoff, Gewebe, Farbe, Zeichnung, Schnitt und rituelle Bedeutung nachgewiesen und durch zahlreiche Abbildungen erläutert.* Vol. 3. Bonn: Cohen, 1871.

Boileau, Etienne. *Les métiers et les corporations d la ville de Paris. XIIIe siècle.* Edited by René de Lespinasse and François Bonnardot. Paris: Imprimerie Nationale, 1879.

Bonneau, Abbé, Henri Monceaux, and Francis Molard, eds. *Inventaire du trésor de la Cathédrale d'Auxerre.* Auxerre: Imprimerie de la Constitution, 1892.

Bony, Jean. *French Gothic Architecture of the Twelfth and Thirteenth Centuries.* Berkeley: University of California Press, 1983.

Bouchard, Constance. *Spirituality and Administration: The Role of the Bishop in Twelfth-Century Auxerre.* Cambridge, Mass.: Medieval Academy of America, 1979.

Boureau, Alain. *La légende dorée. Le système narratif de Jacques de Voragine.* Paris: Editions du Cerf, 1984.

———. *L'événement sans fin. Récit et christianisme au Moyen Age.* Paris: Les Belles Lettres, 1993.

Brassat, Wolfgang. *Tapisserien und Politik. Funktionen, Kontexte und Rezeption eines repräsentativen Mediums.* Berlin: Mann, 1992.

Braun, Joseph. *Die liturgische Gewandung im Occident und Orient, nach Ursprung und Entwicklung, Verwendung und Symbolik.* Freiburg im Breisgau: Herder, 1907.

———. *Die liturgische Paramente in Gegenwart und Vergangenheit.* Freiburg im Breisgau: Herder, 1924.

Breviary for use of Tournai. Paris: n.p., 1509.

Breviarium Antissiodorense. Chablis: Jean le Rouge for Pierre le Rouge, 1483.

Breviarium sanctae Antissiodorensis ecclesiae. Paris: Jacques Vincent, 1736.

Brown, Peter. *The Cult of the Saints.* Chicago: University of Chicago Press, 1981.

Bucher, François. *The Pamplona Bibles.* 2 vols. New Haven: Yale University Press, 1970.

Busson, G., and Ambroise Ledru. *Nécrologe-Obituaire de la cathédrale du Mans.* Archives historiques du Maine 7. Le Mans: Au Siège de la Société, 1906.

Cahier, Charles, and Arthur Martin. *Monographie de la cathédrale de Bourges.* Paris: Poussielgue-Rusand, 1841–1844.

Campbell, Thomas. "Tapestry Quality in Tudor England: Problems of Terminology." *Studies in the Decorative Arts* 3, no. 2 (fall–winter 1995–1996): 29–50.

Campenhausen, Hans von. *Ambrosius von Mailand als Kirchenpolitiker.* Arbeiten zur Kirchengeschichte 12. Berlin: Walter de Gruyter, 1929.

Carrasco, Magdalene. "An Early Illustrated Manuscript of the Passion of Saint Agatha (Paris, Bibl. Nat., MS Lat. 5594)." *Gesta* 24, no. 1 (1985): 19–32.

Cavallo, Adolfo. *Medieval Tapestries in the Metropolitan Museum of Art.* New York: Metropolitan Museum of Art, 1993.

Chartraire, Emile. "Les tissus anciens du trésor de la cathédrale de Sens." *Revue de l'Art Chrétien* 61 (1911): 261–80, 371–86, 454–68.

Chedozeau, Bernard. *Choeur clos, choeur ouvert. De l'église médiévale à l'église tridentine (France, XVIIe–XVIIIe siècle.* Paris: Editions du Cerf, 1998.

Chiffoleau, Jacques. *La comptabilité d'au-delà. Les hommes, la mort et la religion dans la région d'Avignon à la fin du moyen âge (1320–vers 1480).* Rome: Ecole Française de Rome, 1980.

Clocquet, L. "La chasse de saint Eleuthère à Tournai." *Revue de l'Art Chrétien* 32 (1889): 188–200.

Costantini, Michel. "Narratologie picturale ou O Jocte, Quid de Illo Narrasti." Thèse de Doctorat d'Etat ès Lettres, Université de Paris VIII, Saint Denis, 1993.

Coulon, Auguste. *Inventaire des sceaux de la Bourgogne recueillis dans les dépôts d'archives, musées et collections particulières des départements de la Côte d'Or, de Saône et de l'Yonne.* Paris: E. Leroux, 1912.

Courtes, Joseph. *Introduction à la sémiotique narrative et discursive, methodologie et application.* Paris: Classiques Hachette, 1976.

Cousin, Jean. *Histoire de Tournai ou livres des chroniques, annales ou démonstrations du christianisme de l'évêché de Tournay.* 4 vols. Douai: Imprimerie de Marc Wyon, 1619–1620.

Crowder, C. M. D. *Unity, Heresy and Reform, 1378–1460: The Conciliar Response to the Great Schism.* London: Edward Arnold, 1977.

Darcel, Alfred. "Fragment de tapisserie dans la cathédrale de Soissons (XVe siècle)." *Revue des Sociétés Savantes des Départements,* 7th ser., 5 (1882): 325–26.

Dassmann, Ernst. "Ambrosius und die Martyrer." *Jahrbuch für Antike und Christentum* 18 (1975): 49–68.

Davis, Natalie. *The Gift in Early Modern France.* Madison: University of Wisconsin Press, 2000.

Davis, Whitney. *Masking the Blow: The Scene of Representation in Late Prehistoric Egyptian Art.* Berkeley: University of California Press, 1992.

Delaruelle, Etienne, Edmond René Labande, and Paul Ourliac, eds. *L'Eglise au temps du Grand Schisme et de la crise conciliare (1378–1449).* Vol. 4 of *Histoire de l'Eglise depuis les origines jusqu'à nos jours.* Paris: Bloud and Gay, 1962.

Delehaye, Hippolyte. *The Legends of the Saints.* Chicago: University of Chicago Press, 1961.

Demay, Charles. "Les travaux de décoration exécutés dans la cathédrale d'Auxerre pendant le XVIIIe siècle." *Bulletin de la Société des Sciences Historiques et Naturelles de l'Yonne* 53 (1899): 13–61.

Depping, G.-B., ed. *Réglemens sur les arts et métiers de Paris rédigés au XIIIe siècle et connus sous le nom du Livre des métiers d'Etienne Boileau.* Paris: Crapelet, 1837.

Dereine, Charles. "Chanoines." In *DHGE*, vol. 12, cols. 353–405.

Deronne, Eliane. "Les origines des chanoines de Notre-Dame de Paris, 1450–1550." *Revue d'Histoire Moderne et Contemporaine* 28 (1971): 1–29.

Dictionnaire d'archéologie chrétienne et de liturgie. Edited by Fernand Cabrol and Henri Leclercq. 15 vols. Paris: Libraire Letouzey et Ané, 1922–1953.

Duchesne, Louis, ed. *Le Liber pontificalis, texte, introduction et commentaire.* 2d ed. 4 vols. Paris: E. de Boccard, 1955.

Dumonthier, E. "Les tapisseries de saint Etienne du Musée de Cluny." *Renaissance de l'Art Français* 2, no. 1 (1919): 247–54.

Dumoulin, Jean. *La Cathédrale de Notre Dame de Tournai.* Tournai: Casterman, 1971.

——. "Description du choeur de la cathédrale de Tournai au XVe siècle." *Mémoires de la Société Royale d'Histoire et d'Archéologie de Tournai* 4 (1983–1984): 99–116.

Dumoulin, Jean, and Jacques Pycke. *La cathédrale Notre-Dame de Tournai et son trésor.* Tournai: Casterman, 1980.

——. "La tapisserie de Saint-Piat et de Saint-Eleuthère à la cathédrale de Tournai (1402). Son utilisation et son histoire." *Revue des Archéologues et Historiens d'Art de Louvain* 15 (1982): 184–200.

——, eds. *Les grands siècles de Tournai (12e–15e s.).* Tournai: Casterman, 1993.

Durandus, William. *Rationale Divinorum Officiorum.* Edited by A. Davril and T. M. Thibodeau. 3 vols. CCCM 140, 1995.

Duru, Louis M., ed. *Gesta pontificum Autissiodorensium.* Auxerre, BM MS 142. Bibliothèque historique de l'Yonne: Collection des légendes, chroniques et documents divers pour servir à l'histoire des differentes contrées qui forment aujourd'hui ce département. Vol. 1. Auxerre: Perriquet, 1850.

Eberlein, Johann Konrad. *Apparatio Regis — Revelatio veritatis. Studien zur Darstellung des Vorhangs in der bildenden Kunst von der Spätantike bis zum Ende des Mittelalters.* Wiesbaden: Dr. Ludwig Reichert, 1982.

Emminghaus, Johannes H. "Fastentuch." In *Reallexikon zur deutschen Kunstgeschichte*, vol. 7, edited by Karl-August Wirth, 830–32. Munich: Beck, 1981.

Erlande-Brandenburg, Alain. "La tenture de la vie de la Vierge à Notre-Dame de Beaune." *Bulletin Monumental* 1 (1976): 46–47.

——. *The Cathedral: The Social and Architectural Dynamics of Construction.* Translated by Martin Thom. Cambridge: Cambridge University Press, 1994.

Ewig, Eugen. "Die Kathedralpatrozinien im Römischen und im Fränkischen Gallien." *Historisches Jahrbuch* 79 (1960): 1–61.

Farcy, Louis de. *Histoire et description des tapisseries de l'Eglise Cathédrale d'Angers.* Angers: Germain and G. Grassin, 1897.

———. "Broderies et tissus, conservés autrefois à la cathédrale d'Angers." *Revue de l'Art Chrétien,* n.s., 2 (1884): 270–90.

Farmer, Sharon. *Communities of Saint Martin: Legend and Ritual in Medieval Tours.* Cornell: Cornell University Press, 1991.

Fleith, Barbara. *Studien zur Überlieferungsgeschichte der Lateinischen Legenda Aurea.* Brussels: Société des Bollandistes, 1991.

Flores, Richard. *Los Pastores: History and Performance in the Mexican Shepherd's Play of South Texas.* Washington: Smithsonian Institution Press, 1995.

Focillon, Henri. *The Art of the West in the Middle Ages.* Edited and introduced by Jean Bony. Translated by Donald King. 2d ed. Vol. 2. London: Phaidon, 1969.

Forsyth, Ilene H. *The Throne of Wisdom: Wood Sculptures of the Madonna in Romanesque France.* Princeton: Princeton University Press, 1972.

Fremaux, A. "Donation à l'église Saint-Etienne de Lille par Jean Ruffault de 314 aulnes de tapisserie de haute-lisse, représentant la vie et passion de saint Etienne, 31 juillet 1518." *Souvenir de la Flandre Wallonne* 5 (1885): 124–28.

Friedländer, Paul. *Johannes von Gaza und Paulus Silentiarius: Kunstbeschreibungen justinianischer Zeit.* Leipzig: Teubner, 1912.

Fulbert of Chartres. "De sancto Piato Hymnus." PL 141: 341–42.

Gaiffier, Baudouin de. *Etudes critiques d'hagiographie et d'iconologie.* Brussels: Société des Bollandistes, 1967.

Garrucci, Raffaele. *Storia della Arte Christiana.* Vol. 6. Prato: Gaetano Guasti, 1880.

Gasté, Armand. "Les drames liturgiques de la cathédrale de Rouen: Officium Pastorum." *Revue Catholique de Normandie* 2 (1893): 480.

Gaudemet, Jean. "Evêques et chapitres (législation et doctrine à l'âge classique)." In *Mélanges Jean Dauvillier.* Toulouse: Centre d'Histoire Juridique Méridionale, 1979, 317–26.

Gay, Victor. *Glossaire archéologique du Moyen Age et de la Renaissance.* 2 vols. Paris: A. Picard, 1929.

Gerson, Paula, and Caroline Walker Bynum, eds. *Gesta* 36, no. 1 (1997). Special issue on body-part reliquaries.

Gill, Joseph. *Constance et Bâle-Florence.* Paris: Editions de l'Orante, 1965.

Göbel, Heinrich. *Wandteppiche.* Vols. 1–2. Leipzig: Klinkhardt and Biermann, 1923, 1928.

Godard-Faultrier, Victor. *Tapisserie de Saint-Florent, dessinée par P. Hawke.* Angers: Cosnier and Lachese, 1842.

———. "Découverte récente de deux fragments de la tapisserie de Saint-Florent-lez-Saumur." *Réunion des Sociétés des Beaux-Arts des Départements,* 12th session, 715–17. Paris: Plon-Nourrit, 1888.

Göttler, Christine, and Peter Jezler. "Doktor Thüring Frickers 'Geistermesse.' Die

Seelgerätskomposition eines spätmittelalterlichen Juristen." In *Materielle Kultur und Religiöse Stiftung im Spätmittelalter*, edited by Gerhard Jaritz, 187–99. Veröffentlichungen des Instituts für Mittelalterliche Realienkunde Osterreichs 12. Vienna: Verlag des Osterreichischen Akademie der Wissenschaften, 1990.

Grabar, André. "Une fresque visigothique et l'iconographie du silence." *Cahiers Archéologiques* 1 (1945): 124–28.

Gregory of Tours. *History of the Franks.* Edited by Bruno Krusch and Wilhelm Levison. Monumenta Germaniae Historica. Scriptores rerum merovingicarum, 1.1. Hanover: Hahn, 1951.

Grodecki, Louis, Françoise Perrot, and Jean Taralon, eds. *Les vitraux du Centre et des Pays de la Loire.* Vol. 2 of *Recensement des vitraux anciens de la France.* Paris: Editions du centre national de la recherche scientifique, 1981.

Guenée, Bernard. "Histoires, annales, chroniques. Essai sur les genres historiques au Moyen Age." *Annales E.S.C.* 28, no. 3 (1973): 997–1016.

———. *Histoire et culture historique dans l'Occident médiéval.* Paris: Aubier Montaigne, 1980.

Guiffrey, Jules-Joseph. *Histoire de la tapisserie depuis le Moyen Age jusqu'à nos jours.* Tours: A. Mame et fils, 1886.

Guiffrey, Jules-Joseph, Eugène Müntz, and Alexandre Pinchart. *Histoire générale de la tapisserie.* 3 vols. Paris: Société anonyme de publications périodiques, 1880.

Guignard, Philippe. "Mémoires fournis aux peintres chargés d'exécuter les cartons d'une tapisserie destinée à la collégiale Saint-Urbain de Troyes représentant les légendes de St Urbain et de Ste Cécile." *Mémoires de la Société d'Agriculture, Sciences et Arts du département de l'Aube* 15 (1849–1850): 421–534.

Hahn, Cynthia. *Passio Kiliani . . . Passio Margaretae.* Facsimile with English introduction and commentary. Codices Selecti 83. Graz: Akademische Druck- und Verlaganstalt, 1988.

———. "Picturing the Text: Narrative in the Life of the Saints." *Art History* 13 (1990): 1–33.

———. "The Illustrated Life of Edmund, King and Martyr." *Gesta* 30 (1991): 119–39.

———. *Portrayed on the Heart: Narrative Effect in Pictorial Lives of the Saints from the Tenth through the Thirteenth Century.* Berkeley: University of California Press, 2001.

Hamburger, Jeffrey. *The Visual and the Visionary: Art and Female Spirituality in Late Medieval Germany.* New York: Zone Books and Cambridge, Mass.: MIT Press, 1998.

———. "La Bibliothèque d'Unterlinden et l'art de la formation spirituelle." In *Les dominicaines d'Unterlinden*, edited by Jean-Claude Schmitt, 1:110–59. Colmar: Unterlinden Museum, 2000.

Harbison, Craig. "Visions and Meditations in Early Flemish Painting." *Simiolus* 15, no. 2 (1985): 87–118.

Harris, J. Rendel. *The Cult of the Heavenly Twins.* Cambridge: Cambridge University Press, 1906.

Head, Thomas. *Hagiography and the Cult of the Saints in the Diocese of Orleans, 800–1200.* Cambridge: Cambridge University Press, 1990.

Honorius Augustodunensis. *Gemma animae.* PL 172.

Hucher, Eugène. *Le jubé du cardinal Philippe de Luxembourg à la cathédrale du Mans et décrit d'après un dessin d'architecte du temps et des documents inédits.* Le Mans: E. Monnoyer, 1870.

———. "Essai sur les monnaies frappées dans le Maine." *Mémoires de l'Institut des Provinces de France,* 2d ser., 1 (1845): 695–96.

Imbart de la Tour, Pierre. *Les origines de la réforme.* 2 vols. Paris: Hachette, 1905. 2d ed. Melun: Librairie d'Argences, 1946–48.

Isambert, François André, Athanase Jean Léger Jourdan, and Decrusy, eds. *Recueil général des anciennes lois françaises, depuis l'an 420 jusqu'à la révolution de 1789.* Vol. 9, *1438–1461.* Paris: Belin-Leprieur, 1825.

Iser, Wolfgang. *The Act of Reading: A Theory of Aesthetic Response.* Baltimore: Johns Hopkins University Press, 1978.

Jacobus de Voragine. *Legenda Aurea.* Edited by T. Graesse. Osnabrück: Otto Zeller, 1965.

———. *The Golden Legend.* Translated by William Granger Ryan. 2 vols. Princeton: Princeton University Press, 1993.

Jantzen, Hans. *High Gothic: The Classic Cathedrals of Chartres, Reims, Amiens.* Translated by James Palmes. New York: Pantheon, 1962.

Jaques, Renate, and Ruth Wencker. "Die Textilien im Besitz der Schatzkammer der Kirche St. Servatius in Siegburg." *Heimatbuch der Stadt Siegburg* 2 (1967): 472–572.

Jezler, Peter. "Jenseitsmodelle und Jenseitsvorsorge — Eine Einführung." Introduction to *Himmel, Hölle, Fegefeur. Das Jenseits im Mittelalter,* edited by Peter Jezler. Exhibition catalog. Zurich: Schweizerisches Landesmuseum, 1994.

Joubert, Fabienne. *La tapisserie médiévale au Musée de Cluny.* Paris: Réunion des Musées Nationaux, 1987.

———. "Les 'tapissiers' de Philippe le Hardi." In *Artistes, artisans et production artistique au moyen âge,* edited by Xavier Barrel i Altet, 3:601–7. Paris: Picard, 1990.

———. "La tenture de choeur de Saint-Etienne d'Auxerre et la peinture bruxelloise vers 1500." *Revue de l'Art* 75 (1987): 37–42.

———. "Jacques Daret et Nicolas Froment cartonniers de tapisseries." *Revue de l'Art* 88 (1990): 39–47.

———. "Nouvelles propositions sur la personnalité artistique de Pierre Spicre." In *La splendeur des Rolin. Un mécénat privé à la cour de Bourgogne,* edited by Brigitte Maurice-Chabard. Paris: Picard, 1999.

Jubinal, Achille. *Les anciennes tapisseries historiées, ou Collection des monuments les plus remarquables de ce genre qui nous soient restés du moyen-âge, à partir du XIe siècle au XVIe inclusivement.* Paris: Galerie d'armes de Madrid, 1838.

Kamp, Hermann. *Memoria and Selbstdarstellung. Die Stiftungen des burgundischen Kanzlers Rolin.* Sigmaringen: Thorbecke, 1993.

Kemp, Wolfgang. *Sermo Corporeus: Die Erzählung der mittelalterlichen Glasfenster.* Munich: Schirmer-Mosel, 1987. Translated by Caroline Dobson Saltzwedel under the title *The Narratives of Gothic Stained Glass.* Cambridge: Cambridge University Press, 1996.

Kommission für den Gesamtkatalog der Wiegendrücke. *Gesamtkatalog der Wiegendrücke.* Vol. 5. Leipzig: Karl W. Hiersemann, 1932.

Kroos, Renate, and Friedrich Kobler. "Farbe, liturgische." In *Reallexikon zur deutschen Kunstgeschichte,* vol. 7, edited by Karl-August Wirth, 54–121. Munich: Beck, 1981.

Krueger, Roberta. *Women Readers and the Ideology of Gender in Old French Romance.* Cambridge: Cambridge University Press, 1993.

Krusch, Bruno, ed. *Gesta Dagoberti regis Francorum.* Monumenta Germaniae Historica. Scriptores rerum merovingicarum 2.407. Hanover: Hahn, 1889.

Lagabrielle, Sophie, ed. *Histoires tissées.* Exhibition catalog, Avignon, Palais des Papes, 1999. Paris: Réunion des Musées Nationaux, 1999.

Laurent, Henri. *La draperie des Pays-Bas en France et dans les pays méditerranéens (XIIe–XVe siècle): Un grand commerce d'exportation au Moyen Age.* Paris: Droz, 1935.

Lauwers, Michel. *La mémoire des ancêtres, le souci des morts.* Paris: Beauchesne, 1997.

Lebeuf, Jean. *Histoire de la prise d'Auxerre par les Huguenots.* Auxerre: Troche, 1723.

———. *Mémoires concernant l'Histoire Civile et Ecclésiastique d'Auxerre et de son Diocèse.* 1743. 4 vols. Reprint and new edition by Maximilien Quantin and Ambroise Challe. Auxerre: Perriquet, 1855.

Ledru, Ambroise. *La Cathédrale du Mans au Moyen Age (disposition intérieure).* Le Mans: L. Chaudourne, 1920.

———, ed. *Plaintes et doléances du chapitre du Mans après le pillage de la cathédrale par les Huguenots en 1562.* Archives Historiques du Maine 3. Le Mans: Au Siège de la Société, 1903.

La Légende Dorée de la Tapisserie. Exhibition catalog. Arras: Musée des Beaux-Arts, 1969.

Le Goff, Jacques, and Jean-Claude Schmitt, eds. *Dictionnaire raisonné de l'Occident médiévale.* Paris: Fayard, 1999.

Le Maistre d'Anstaing, J. *Recherches sur l'Eglise Cathédrale de Notre-Dame de Tournai.* 2 vols. Tournai: Massart and Janssens, 1842–1843.

Le Monde des Chanoines (XIe–XIVe s.). Cahiers de Fanjeaux. Collection d'Histoire religieuse du Languedoc au XIIIe et au début du XIVe siècle 24. Toulouse: Edouard Privat, 1989.

Lequeux, J. M. "La chasse de S. Eleuthère, chef d'oeuvre original malgré les restaurations des 19e et 20e siècles?" *Mémoires de la Société Royale d'Histoire et d'Archéologie de Tournai* 1 (1980): 181–201.

Leroquais, Victor. *Les sacramentaires et les missels manuscrits des bibliothèques publiques de France.* Vol. 3. Paris: Chez l'auteur, 1924.

———. *Les pontificaux manuscrits des bibliothèques publiques de France.* Vol. 1. Paris: Chez l'auteur, 1937.

Lestocquoy, Jean. *Deux siècles de l'histoire de la tapisserie (1300–1500): Paris, Arras, Lille, Tournai, Bruxelles, Arras.* Mémoires de la Commission départementale des Monuments Historiques du Pas-de-Calais 19. Arras: Commission départementale des Monuments Historiques du Pas-de-Calais, 1978.

Lévi-Strauss, Claude. *L'Histoire de Lynx.* Paris: Plon, 1991.

Lot, Ferdinand, and Robert Fawtier, eds. *Histoire des institutions françaises au Moyen Age.* Vol. 3. Paris: Presses Universitaires de France, 1962.

Lours, Mathieu. "Espace et liturgie du concile à la Révolution." In *20 siècles en Cathédrales,* edited by Jacques le Goff. Paris: Editions du Patrimoine, 2001, 255–62.

Maillard-Luypaert, Monique. *Papauté, clercs et laïcs: Le diocèse de Cambrai à l'épreuve du Grand Schisme d'Occident (1378–1417).* Brussels: Publications des Facultés universitaires Saint-Louis, 2001.

Marin, Louis. "Piero della Francesca à Arezzo." In *Opacité de la peinture. Essais sur la représentation au Quattrocento.* Paris: Usher, 1989, 101–124.

Martimort, Aimé-Georges. *L'Eglise en Prière.* 4 vols. Paris: Desclée, 1984.

Martin, Victor. *Les origines du Gallicanisme.* 2 vols. Paris: Bloud et Gay, 1939.

Mater, D. "Les anciennes tapisseries de la cathédrale de Bourges. Pierre de Crosses." *Mémoires de la Société des Antiquaires du Centre* 27 (1903): 341.

———. "Les tapisseries de l'ancienne collégiale saint-Ursin." Congrès Archéologique de France, 65th session, 1898. Paris: Alph. Picard, 1900, 294–304.

Mauss, Marcel. *The Gift: Forms and Functions of Exchange in Archaic Societies.* Translated by Ian Cunnison. New York: Norton, 1967.

Maybury-Lewis, David, and Uri Almagor, eds. *The Attraction of Opposites: Thought and Society in the Dualistic Mode.* Ann Arbor: University of Michigan Press, 1989.

McLynn, Neil B. *Ambrose of Milan: Church and Court in a Christian Capital.* Berkeley: University of California Press, 1994.

Métraux, Alfred. "Twin Heroes in South America." *Journal of American Folklore* 59 (1946): 114–23.

Metzger, Marcel. "Année ou bien cycle liturgique?" *Revue des Sciences Religieuses* 67 (1993): 85–96.

Michel, Françisque. *Recherches sur le commerce, la fabrication et l'usage des étoffes de soie, d'or et d'argent et autres tissus précieux en Occident, principalement en France pendant le Moyen Age.* 2 vols. Paris: Crapelet, 1852–1854.

Migne, Jacques-Paul., ed. *Patrologiae cursus completus: Series latina.* 222 vols. Paris, 1844–1888.

Millet, Hélène. *Les chanoines du chapitre cathédral de Laon, 1272–1412.* Paris: Ecole Française de Rome, 1982.

Millet, Hélène, and Emmanuel Poulle. *Le vote de la soustraction d'obédience en 1398.* Paris: Editions du centre national de la recherche scientifique, 1988.

Missal for Use of Tournai. Paris: Johannis Higmani, 1498.

Missale ad usum Autissiodorensem. Paris: Ionnes de Prato, n.d. (fifteenth century).

Missale sanctae Autissiodorensis ecclesiae. Troyes: Pierre Michelin, 1738.

Mollat du Jourdin, Michel, and André Vauchez, eds. *Histoire du christianisme.* Vol. 6, *Un temps d'épreuves (1274–1449).* Paris: Desclée-Fayard, 1990.

Monceau, Eugène. "Les tapisseries de l'ancien chapitre d'Auxerre et la légende des reliques de saint Etienne." *L'Art* 28 (1882): 106–17.

Monceaux, Henri. "Notes sur le Bréviaire Auxerrois publié à Chablis en 1483." *Bulletin de la Société des Sciences Historiques et Naturelles de l'Yonne* 53 (1899): xix — xxii.

Moreau, Edouard de. "Un évêque de Tournai au XIVe siècle, Philippe d'Arbois." *Revue Belge de Philologie et d'Histoire* 1 (1923): 23–60.

———. *Histoire de l'Eglise en Belgique.* Vol. 4, *L'Eglise aux Pays-Bas sous les ducs de Bourgogne et Charles Quint, 1378–1559.* Brussels: Edition universelle, 1959.

Muel, Francis, et al., eds. *La tenture de l'Apocalypse d'Angers.* Cahiers de l'Inventaire 4. 2d ed. Nantes: Association pour le développement de l'Inventaire général des monuments et des richesses artistiques en région des Pays de la Loire, 1987.

Müntz, Eugène, and Arthur Lincoln Frothingham. *Il tesoro della basilica di S. Pietro in Vaticano.* Rome: Estratto dall' Archivio della Societa Romana di Storia Patria, 1883.

Mussat, André, et al. *La Cathédrale du Mans.* Paris: Berger-Levrault, 1981.

Notin, Véronique. "La tenture de choeur de la cathédrale Saint-Etienne conservée au Musée de Cluny." Master's thesis, University of Paris IV, 1983.

Oexle, Otto Gerhard. "Memoria und Memorialbild." In *Memoria. Der geschichtliche Zeugniswert des liturgischen Gedenkens im Mittelalter,* edited by Karl Schmid and Joachim Wollasch, 384–440. Munich: Wilhelm Fink, 1984.

———. "Memoria als Kultur." In *Memoria als Kultur,* edited by O. G. Oexle, 9–78. Göttingen: Vandenhoeck Ruprecht, 1995.

———. "Die Gegenwart der Toten." In *Death in the Middle Ages,* edited by Herman Braet and Werner Verbeke, 19–77. Leuven: Leuven University Press, 1983.

Ong, Walter. *Orality and Literacy: The Technologizing of the Word.* New York: Methuen, 1982.

Paulinus of Nola. *Poem XVIII.* PL 61:491.

Perroy, Edouard. "Un évêque urbaniste protégé de l'Angleterre, Guillaume de Coudenberghe, évêque de Tournai et de Bâle." *Revue d'Histoire Ecclésiastique* 26 (1930): 103–9.

Pierre, Joseph. "Décoration du choeur de la cathédrale de Bourges de 1754 à 1773." *Réunion des Sociétés des Beaux-Arts des Départements*, 25th session, 179–85. Paris: Plon-Nourrit, 1901.

Piétresson de Saint-Aubin, P. "Trois formulaires et recueils de jurisprudence de l'église de Cambrai." *Revue du Nord* 30 (1948): 223–39, 482.

Piolin, Paul L. *Histoire de l'Eglise du Mans.* Vol. 5. Paris: Julien Lanier, 1861.

Poerck, G. de. *La draperie médiévale en Flandre et en Artois. Technique et terminologie.* 2 vols. Bruges: De Tempel, 1951.

Porée, Charles. *La Cathédrale d'Auxerre.* Paris: H. Laurens, 1926.

Prost, Bernard. "La tapisserie de Saint-Anatoile de Salins." *Gazette des Beaux Arts*, 3d ser., 34, no. 8 (1892): 496–507.

Pruvost, S. *Saint Piat, martyr-apôtre du Tournaisis, patron de Seclin.* 3d ed. Lille: Desclée de Brouwer, 1922.

Pycke, Jacques. "Les pèlerinages de dévotion dans la première moitié du XIVe siècle." In *Horae Tornacenses (1171–1971): Recueil d'études d'histoire publiées à l'occasion du VIIIe Centenaire de la consécration de la cathédrale de Tournai*, 111–30. Tournai: Archives de la Cathédrale, 1972.

———. "Les chanoines de Tournai aux études, 1330–1340." In *Les Universités à la fin du Moyen Age*, edited by Jacques Paquet and Jozef Ijsewijn, 598–613. Acts of the International Congress of Louvain. Louvain: Institut d'Etudes Médiévales, 1978.

———. *Le chapitre cathédral Notre-Dame de Tournai de la fin du XIe à la fin du XIIIe siècle. Son organisation, sa vie, ses membres.* Brussels: Nauwelaerts and Louvain la Neuve, Collège Erasme, 1986.

———. "Ghini Malpighli (André)." In *DHGE*, vol. 20, cols. 1174–77.

Raguin, Virginia. *Stained Glass in Thirteenth-Century Burgundy.* Princeton: Princeton University Press, 1982.

Rapp Buri, Anna, and Monica Stucky-Schürer. *Burgundische Tapisserien.* Munich: Hirmer, 2001.

———. *Zahm und Wild: Basler und Strassburger Bildteppiche des 15. Jahrhunderts.* Mainz: Verlag Philipp von Zabern, 1990.

Réau, Louis. *Iconographie de l'art chrétien.* Vol. 3, *Iconographie des saints.* Paris: Presses Universitaires de France, 1958.

Reynaud, Nicole. "Un peintre français cartonnier de tapisseries au XVe siècle: Henri de Vulcop." *Revue de l'Art* 22 (1973): 6–21.

Rimoldi, Antonio. "Gervais et Protais." In *DHGE*, vol. 20, cols. 1073–76.

Rolland, Paul. *La Cathédrale de Tournai.* Vol. 2, *La chapelle paroissiale et le cloître.* Recueil des Travaux du Centre de Recherches Archéologiques 5. Antwerp: De Sikkel, 1944.

———. *Histoire de Tournai.* 2d ed. Tournai: Casterman, 1957.

Rothstein, Bret. "Vision and Devotion in Jan van Eyck's Virgin and Child with Canon Joris van der Paele." *Word and Image* 15, no. 3 (1999): 262–76.

Rupert of Deutz. *Liber de Divinis Officiis.* Edited by Hrabanus Haacke. CCCM 7, 1967.

Saenger, Paul. "Silent Reading: Its Impact on Late Medieval Script and Society." *Viator: Medieval and Renaissance Studies* 13 (1982): 367–414.

Salet, Francis. "Remarques sur le vocabulaire ancien de la tapisserie." *Bulletin Monumental* 146 (1988): 211–22.

Sauer, Christine. *Fundatio und Memoria. Stifter und Klostergründer im Bild 1100–1350.* Göttingen: Vandenhoeck Ruprecht, 1993.

Sauer, Joseph. *Symbolik des Kirchengebäudes und seiner Ausstattung in der Auffassung des Mittelalters.* Freiburg im Breisgau: Herder, 1902.

Schleif, Corine. *Donatio et Memoria: Stifter, Stiftungen und Motivationen an Beispielen aus der Lorenzkirche in Nürnberg.* Munich: Deutscher Kunstverlag, 1990.

———. "Hands that Appoint, Anoint and Ally: Late Medieval Donor Strategies for Appropriating Approbation through Painting." *Art History* 16, no. 1 (1993): 1–32.

Schmid, Karl. "Stiftungen für das Seelenheil." In *Gedächtnis, das Gemeinschaft stiftet,* edited by Karl Schmid. Freiburg: Katholische Academie, 1985, 51–73.

Searle, John. *Speech Acts.* Cambridge: Cambridge University Press, 1969.

Shearman, John. *Raphael's Cartoons in the Collection of Her Majesty the Queen and the Tapestries for the Sistine Chapel.* London: Phaidon, 1972.

Sicard of Cremona. *Mitrale sive de officiis ecclesiasticis summa.* PL 213.

Simpson, W. Sparrow. "Two Inventories of the Cathedral Church of St. Paul, London, Dated Respectively 1245 and 1402." *Archaeologia or Miscellaneous Tracts Relating to Antiquity* 50 (1887): 439–524.

Smit, Hillie. "Tapestry Weavers in Italy c. 1420–1520: A Survey and Analysis of the Activity in Various Cities." In *Flemish Tapestry Weavers Abroad: Emigration and the Founding of Manufactories in Europe,* edited by Guy Delmarcel, 113–30. Symbolae series B, vol. 27. Leiden: Leiden University Press, 2002.

Sot, Michel. "Historiographie épiscopale et modèle familial en Occident au XIe siècle." *Annales E.S.C.* 33, no. 3 (1978): 433–49.

Souchal, Geneviève. "Précisions historiques sur l'histoire de saint Etienne d'Auxerre (Musée de Cluny) et la famille parisienne des Baillet (vers 1500)." *Artes Textiles* 11 (1986): 25–36.

———. "Etudes sur la tapisserie parisienne. Règlements et techniques des tapisseries sarrazinois, hautelissiers et nostrez (vers 1260–vers 1350)." *Bibliothèque de l'Ecole des Chartes* 123 (1965): 35–116.

Spiegel, Gabrielle. "Genealogy: Form and Function in Medieval Historical Narrative." *History and Theory: Studies in the Philosophy of History* 22 (1983): 43–53.

———. *Romancing the Past.* Berkeley: University of California Press, 1993.

Starensier, Adele. "An Art Historical Study of the Byzantine Silk Industry." Ph.D. diss., Columbia University, 1982.

Staub, Martial. "Memoria im Dienst von Gemeinzohl und Offentlichkeit. Stiftungspraxis und kultureller Wandel in Nürnberg um 1500." In *Memoria als Kultur*, edited by Otto Gerhard Oexle, 285–334. Göttingen: Vandenhoeck Ruprecht, 1995.

Stock, Brian. *The Implications of Literacy: Written Language and Models of Interpretation in the Eleventh and Twelfth Centuries.* Princeton: Princeton University Press, 1983.

Tabbagh, Vincent. "Effectifs et recrutement du clergé séculier français à la fin du Moyen Âge." In *Le clerc séculier français au Moyen Âge*, edited by the Sociéte des historiens médiévistes de l'enseignement supérieur public, 181–90. XXIIe Congrès de la Société des historiens médiévistes de l'enseignement supérieur public. Paris: Publications de la Sorbonne, 1993.

———. "Les évêques d'Auxerre à la fin du Moyen Age (1296–1513)." *Annales de Bourgogne* 67 (1995): 89–91.

———. "Jean Baillet, un magistrat devenu pasteur." In *Histoire de saint Etienne. La tenture de choeur de la cathédrale d'Auxerre*, edited by Laura Weigert and Micheline Durand, 17–35. Exhibition catalog. Auxerre: Musées d'Art et d'Histoire, 2000.

Taft, Robert F. *Liturgy of the Hours in East and West: The Origins of the Divine Office and Its Meaning for Today.* Collegeville, Minn.: Liturgical Press, 1986.

Talley, Thomas J. *The Origins of the Liturgical Year.* New York: Pueblo, 1990.

Thürlemann, Felix. "Robert Campin um 1400 als Malergeselle in Tournai: Ein kennerschaftlicher Versuch zu den Tapisserien der Heiligen Piatus und Eleutherius." *Pantheon* 55 (1997): 24–31.

Timbal, Pierre-Clément, and Josette Metman. "L'évêque de Paris et le chapitre de Notre-Dame: La juridiction dans la cathédrale au Moyen Âge." *Revue d'Histoire de l'Eglise de France* 50, no. 147 (1964): 47–72.

Torquebiau, Pierre. "Chanoines" and "Chapitre de Chanoines." In *Dictionnaire du droit canonique*, edited by Antoine Villier, Etienne Magnin, Raoul Naz, and A. Amanieu, vol. 3, cols. 471–88, 530–66. Paris: Letouzey and Ané, 1942.

Triger, Robert. "La maison du chanoine Martin Guerande et l'Hôtellerie de l'écu de France, rue de Saint-Vincent, au Mans." In *Etudes historiques et topographiques sur la Ville du Mans.* Le Mans: C. Monnoyer, 1926. Reprint, Marseille: Lafitte, 1977.

Turner, Victor. *From Ritual to Theatre: The Human Seriousness of Play.* New York: Performing Arts Journal Publications, 1982.

Valois, Noël. *Histoire de la Pragmatique Sanction de Bourges sous Charles VII.* Paris: Picard, 1906.

———. *La France et le Grand Schisme d'Occident.* 4 vols. Paris: Picard, 1910.

Van Os, Henk, ed. *The Art of Devotion in the Late Middle Ages in Europe 1300–1500.* Translated by Michael Hoyle. London: Merrell Holberton, 1994.

Van Praet, Joseph B. *Catalogue des livres imprimés sur velin de la bibliothèque du roi.* 2d ser. Paris: De bure Frères, 1822–1828.

Vauchez, André. "Les cathédrales: Approches historiques." In *La cathedrale. Demeure de Dieu demeure des hommes*. Paris: Desclée, 1988, 51–69.

———, ed. *Saints et les Villes*. Paris: Ecole Française de Rome, 1995.

Venard, Marc, ed. *Histoire du christianisme*. Vol. 7, *De la Réforme à la Réformation (1450–1530)*. Paris: Desclée-Fayard, 1994.

Vitz, Evelyn Birge. *Medieval Narrative and Modern Narratology: Subjects and Objects of Desire*. New York: New York University Press, 1989.

———. "Chrétien de Troyes: Cler ou ménestrel? Problèmes des traditions orale et littéraire dans les Cours de France au XIIe siècle." *Poétique* 81 (1990): 21–42.

Voisenat, Claudie. "La rivalité, la séparation et la mort. Destinées gémellaires dans la mythologie grecque." *L'Homme* 28, no. 105 (1988): 88–104.

Voisin, J. "Notice sur les anciennes tapisseries de la cathédrale de Tournai." *Bulletin de la Société Historique et Littéraire de Tournai* 9 (1863): 213–43.

Waele, Olivier de. "Etude prosopographique des chanoines de Tournai (1378–1460)." Master's thesis, University of Louvain-la-Neuve, 1993.

Warichez, Joseph. *Les origines de l'église de Tournai*. Louvain: C. Peeters, 1902.

———. "Le XIVe Centenaire de saint Eleuthère: Le champ d'action de Saint Eleuthère." *Collationes Diocesis Tornacensis* 75 (1926): 57–66.

———. *La Cathédrale de Tournai et son chapitre*. Wetteren: Imprimerie de Meester, 1934.

Weale, William Henry James, and Hans Bohatta. *Catalogus Missalium ritus latini ab anno 1474*. 1928. Reprint, Stuttgart: Anton Hiersemann, 1990.

Weigert, Laura. "Reconstructing Medieval Pictorial Narrative in the Nineteenth Century: Louis Joubert's Tapestry Restoration Project." *Art Journal* 54, no. 2 (1995): 67–72.

———. "Performing the Past: The Tapestry of the City and Its Saints in Tournai Cathedral." *Gesta* 38, no. 2 (1999): 154–70.

Weigert, Laura, and Micheline Durand, eds. *Histoire de saint Etienne. La tenture de choeur de la cathédrale d'Auxerre*. Auxerre: Musées d'Art et d'Histoire, 2000.

Wilckens, Leonie von. "Der Michaels- und der Apostelteppich in Halberstadt." In *Kunst des Mittelalters in Sachsen*, 279–91. Festschrift Wolf Schubert. Weimar: Hermann Böhlaus Nachfolger, 1967.

———. "Die textilen Schätze der Lorenzkirche." In *500 Jahre Hallenchor St. Lorenz 1477–1977*, 139–66. Nürnberger Forschungen 20. Nuremberg: Selbstverlag des Vereins für Geschichte der Stadt Nürnberg, 1977.

———. "Die Teppiche der Sebalduskirche." In *600 Jahre Ostchor St. Sebald-Nürnberg 1379–1979*, edited by Helmut Baier, 133–42. Neustadt a.d. Aisch: Schmidt, 1979.

———. Review of *Medieval Tapestries in the Metropolitan Museum of Art*, by A. Cavallo. *Zeitschrift für Kunstgeschichte* 57, no. 2 (1994): 279–83.

Wright, Craig. *Music and Ceremony at Notre Dame of Paris, 500–1500.* Cambridge: Cambridge University Press, 1989.

Wunder, Heide. " 'Gewirkte Geschichte': Gedenken und 'Handarbeit.' Uberlegungen zum Tradieren von Geschichte im Mittelalter und zu seinem Wandel am Beginn der Neuzeit." In *Modernes Mittelalter: Neue Bilder einer populären Epoche,* edited by Joachim Heinzle, 324–54. Frankfurt am Main: Insel, 1994.

ILLUSTRATION CREDITS

INDEX

ment of, 114, 199nn. 49, 50, 52, 53; status
of, 79–80
Canterbury, 147
Cantor, 43–45
Caphargamalia, 180
Cappadocia, 136
Cardinal's cap, 71
Carpasius, 163–64
Cathedrals, 198n. 33
Cecilia, 162–63
Celsus, 134, 176, 203n. 25
Ceremony: depiction of, in tapestry, 107; and
display of tapestry, 5, 9, 14; and donor,
57; financial investment in, 14–15; and his-
toricized reading, 14; of imperial court, 3,
11; regulation of performance of, 115; and
unification, 49
Chaise-Dieu, abbey church of Saint-Robert,
9, 17, 147
Chapel of the Holy Spirit (Tournai), 19
Chapters: as addressees of Tournai tapestry,
19–22; and appointments by king, 44;
composition of, 15–18, 40–42, 198n. 38;
construction of history of, 39–40, 47;
and cultural production, 17; distinctions
among, 212n. 13; and divisions of choir,
38–39; financial incentives for, 15, 45; as
participant in telling of story, 51
Charity Hospital of Auxerre, 81
Charles the Bold, duke of Burgundy, 211n. 54
Charles VI, King, 200n. 60
Charles VII, King, 113, 150
Charles VIII, King, 72–73, 115, 203n. 25
Charles (Martel), 125
Chartres, 196n. 15
Chartres, cathedral of, 23
Chastel-Belin, hermitage at, 121–22

Chiffoleau, Jacques, 74
Choir: canons', 14–15, 38–39; and division of
church, 5–6; divisions of, 14–15, 38–39,
44–46, 48, 198n. 34, 200n. 65; sacredness
of site of, 98; seating arrangement of, 71
Choreography, 112
Christ, Jesus, 153–54, 157, 163, 172
Christ Church (Canterbury), 147
Christianization: of Gaul, 33, 35; role of
bishop in, 48; of Tournai, 20, 22, 27, 30,
35, 37–38
Church Fathers, 110
Citizens of Tournai (*Tournisiens*), 27, 40,
197n. 22, 198n. 32
Clement, Pope, 138
Clement V, Pope, 88
Clement VII, Pope, 113, 200n. 60
Clergy, 2, 15–17, 35, 111. *See also* Canons; Chap-
ters
Cletus, 107, 116, 149, 152
Clèves, Charles de, 126
Climent, Jehan, nephew of, 10
Climent, Thibault, 10, 152
Cloths, painted, 202n. 14
Clovis, 4, 22, 35, 37, 174, 197n. 26
Cluny Museum, 81. *See also* Museum of the
Middle Ages (Paris)
Cohesion, 35, 41–43, 48, 111–14. *See also* Unity
Color, 188–89nn. 18, 19
Columns, 64–65
Comminges, cathedral of, 146
Concordat of Bologna, 113
Condensation, 62–63, 66–67
Conseil, Canon Léon, 76–77, 114–15, 141
Constantinople: as center of Christianity,
98–99; and Saint Anathoile, 121–22, 124;
and Saint Lawrence, 184; translation of

Maurice, Saint, 107, 112, 148

Maurille, 148

Maximian, Emperor, 128, 130

Maximilian, Emperor, 72

Maximus, 163

Maynard, bishop of Le Mans, 55, 201n. 9

Merchants, tapestry, 11

Migetius (monk), 85, 181, 208n. 21

Milan, 54, 66, 68–73, 79, 175–77, 204n. 34

Millet, Hélène, 212n. 13

Millet, Jean, bishop of Soissons, 60, 133

Missal, Ambrosian, 68

Missals, 5, 91, 68, 93

Monarchy, French, 8, 35, 72, 197n. 26

Monceaux, 92

Montpezat, collegiate church of, 202n. 16

Morellet, 126

Moses, 3, 80

Museum of the Middle Ages (Paris), 81, 179

Narrative theory, 12–13, 110, 193n. 58

Nazare, Saint, 133

Nazarus, 176, 203n. 25

Nero: and Gervasius and Protasius, 58, 60–64, 66, 134, 176–77, 204n. 33; reign of, 54; and Saint Peter, 149, 152–54

Nevers, 105, 126

Nicodemus, 100, 181

Nicolas of Lyra, 125–26

Nicolas of Verdun, 196n. 12

Nolin (provost), 61–62, 134, 177

Notin, Véronique, 92, 162

Notre-Dame, cathedral of (Bayeux), 143

Notre-Dame, cathedral of (Bruges), 124

Notre-Dame, cathedral of (Paris), 145

Notre-Dame, cathedral of (Reims), 147

Notre-Dame, cathedral of (Tournai), 9, 18–19, 38, 41, 105–6, 155, 170, 197n. 24

Nys, Ludovic, 149

Obligations, 77, 79

Octave of the Invention of the Saint, 208n. 21

Ordinals: on absenteeism, 43; on bishop's presence, 48; and categorization of textiles, 6; directives of, 39; on hierarchy of chapter, 44; and placement of tapestry, 189n. 24, 195n. 2; and ritual gestures, 38; on social origin of canons, 41; for Tournai tapestry, 20

Ornament, 1–3, 5–6, 39, 111

Pairing of saints, 73

Pamplune, 158

Papal Palace, 81

Paris, 45, 72, 191nn. 44, 47, 197n. 26

Passion of the Saints, 54

Patron saints: community's understanding of, 12; and connection to particular church, 106; and devotion, 11; and distribution of power, 12; Gervasius and Protasius as, 79; and place of French Church, 54; and politico-economic status, 11; recurring topoi in lives of, 12–13; as subject of tapestry, 9

Patterns, 192n. 50

Pau, 136

Paul, Saint: appearance of Ambrose to, 53, 58, 71, 134, 177, 202n. 18; and Nero, 149; and Saturnin, 157; and stoning of Stephen, 83, 180;

Paulin, 134, 176

Paulinus of Nola, 3, 63

Pelagius II, Pope, 91, 208n. 19